Great Houses *of the* South

Great Houses

of the South

Laurie Ossman

Photography by Steven Brooke

RIZZOLI
NEW YORK

New York Paris London Milan

Contents

HALF-TITLE PAGE
*View from porch at Longwood,
Natchez, Mississippi*

TITLE PAGE
*Formal gardens, Vizcaya Museum
and Gardens, Miami, Florida*

FACING PAGE
*Mantel detail, Drayton Hall,
Charleston, South Carolina*

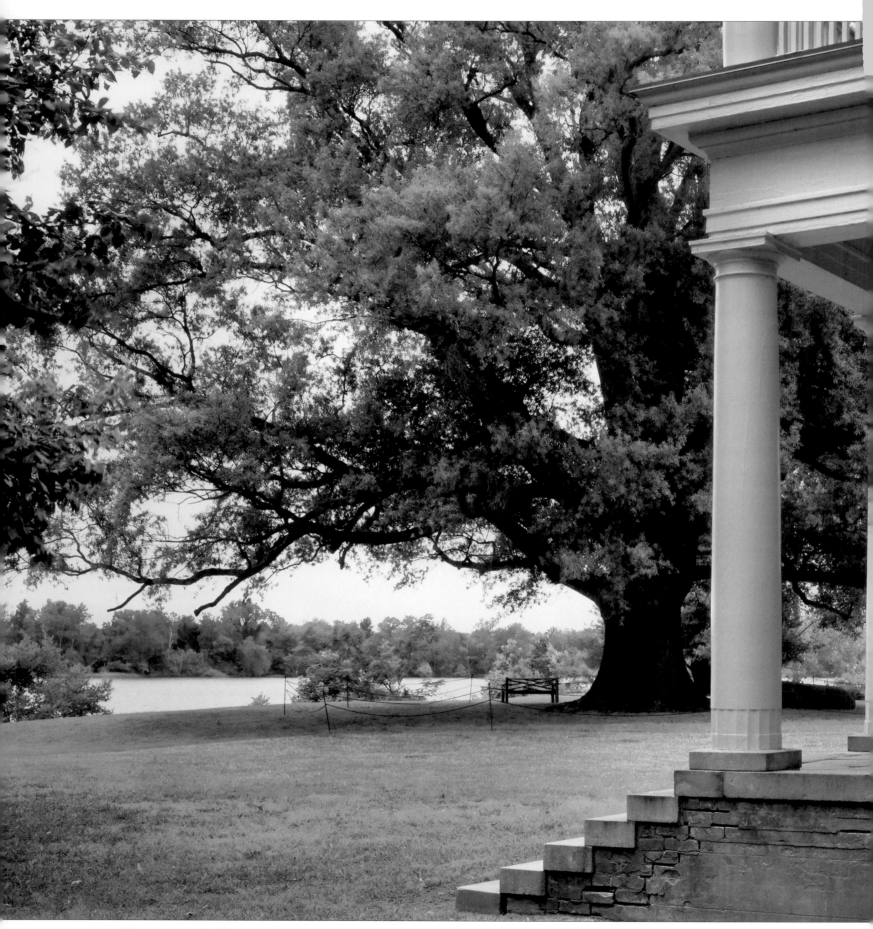

View toward the James River from the portico of Shirley, Charles City County, Virginia

Introduction

The first American house museum, Mount Vernon, was founded by a Southerner (Ann Pamela Cunningham of South Carolina) in the South (Virginia). George Washington understood that his home would be viewed as a representation not only of his character as an individual, but of the virtues and beliefs he embodied on behalf of the nation. And so he, like other real Southern gentlemen (and some aspiring ones), constructed his house as a performative act of self-representation. Cunningham, fifty-five years after Washington's death, understood the primal cultural need for shrines, be they religious or, in the case of house museums, secular. Mount Vernon remains the most visited house museum in the United States, where people of all regions and, indeed, of all nations go to find some kind of understanding of the American character and experience through material intimacy with the relics of its apotheosis, George Washington. And while most Americans could identify an image of Mount Vernon or Monticello, how many of us could so readily identify a photograph of John Adams's Peacefield, in Quincy, Massachusetts, or even the Lincoln house in Springfield, Illinois? The great house of the South stands at the center of the architectural iconography of America.

The title *Great Houses of the South* seems straightforward, but it prompted two persistent refrains throughout the process of researching, visiting, photographing, and writing this book. The first, usually asked by scholars and curators, was, "How are you defining 'great house'?" The corollary—"But why aren't you including {blank}?"—inevitably followed. The second question, asked by absolutely everyone from hotel clerks in Mississippi to museum directors in Washington, DC, was, "How are you defining 'the South'?" Thus, the act of selecting sites to include in this study was, in sum, rather daunting.

The houses in this book were selected for several reasons. One criterion was that each site be open to the public on a regular basis. While generous people open their historic houses (many of them "great" by any definition) to the public during annual pilgrimages and garden weeks, readers may not have the flexibility to visit at such a specific time. In addition, historic sites and house museums rely on visitors for the funding required to maintain these remarkable places for the future. A listing in the back of the book provides addresses and websites for each featured property.

Choosing sites that are open to the public also allowed us to touch upon the issue of historic preservation as a social phenomenon as well as a matter of individual choice. Several featured houses are privately owned and operated by descendants of the builder or other historically significant occupant, and are thus celebrating their own heritage as well as that of the community. But whenever a group of people choose to restore or recreate an historic house for the public, they are reifying values that they

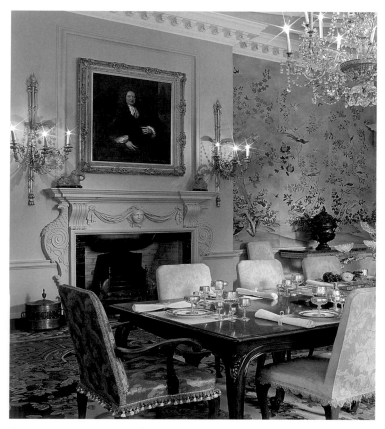

Dining room, Swan House, Atlanta, Georgia

believe inhere in that place and implicitly affirm that these values remain important in their own lives.

Over time, the way that these houses have been presented to the public has often changed drastically, reflecting changes in perception and in social values. Sites that opened in the 1950s or 1960s, usually by unsung women's groups, often showcased elegant silver tea sets, crystal chandeliers, oriental rugs, damask draperies, and fine antiques regardless of their specific relevance to the site (or even to the period). The impeccably decorated house museum served as a testament to the gentility of the community and its ancestors. Many of these sites, in light of scholarship and material research, continue to work to make the presentation more "authentic" in appearance, emphasizing the visitor's empathetic understanding of the intimate and mundane daily lives of historical figures, rather than enforcing a reverent social distance. The topic of slavery was often swept under the proverbial rug in the genteel, decorative-arts-showcase house museums of the mid-twentieth century. The comfort with which antebellum sites address the importance of slavery to their historic existence, creation, and daily operations now varies widely, with some fully addressing the experience of enslaved people and others simply acknowledging it. As an element of added interest, several sites in this book were chosen because their owners were Northerners who chose to move to the South and also participate in slavery. As additional research brings fuller information to light, the representation of enslaved people as individuals intrinsic to the site narratives, rather than a mass of "others" in the backyard, will change at more sites and, once

again, alter our understanding of the collective social meaning of the "great house."

For the purposes of this discussion, a "great house" is one in which the owner had the economic and intellectual means to construct his home as a vehicle of self-representation. The featured houses were selected to represent ideas and concepts that can be applied to an understanding of other houses of the period, especially—but not exclusively—in the South. Dozens of houses worthy of the designation "great" were not included simply because they reiterated forms and concepts more clearly seen or better documented elsewhere. In addition, while most readers will likely tend to read only selected entries, the featured properties do, in fact, illustrate a progression of ideas that can also be read as a continuous narrative.

The goal of building and decorating a "great house" (an option available to the wealthiest 5 percent of the population, at most) was almost always to create an architectural expression of personal refinement. The styles and specifics changed over time, but great houses were all calculated as displays of the personal attributes of knowledge and cultural sophistication, as well as wealth. For the years covered by this book (1700–1940), the language of self-representation is always the architectural past and most often the vocabulary is that of classicism. Classical literature was the basis of all cultivated discourse until at least the mid-nineteenth century. Classical architecture was known through European travel—a sign of gentility—and, most of all, from books. For the gentleman-architect of the eighteenth century, his house was like a string of Latin quotations: each motif served as demonstration of one's mastery of the literature of aristocratic education and refinement.

As Richard Bushman has noted, the American standard of architectural refinement was established in eighteenth-century Virginia.[1] The American colonies were literally as well as figuratively provincial, and the wealthiest inhabitants were painfully aware that by European standards they were big fish in a very small, distant pond. Naturally, people of means and ambition sought to assert themselves by emulating the "homeland" aristocracy as best they could. Books, particularly expensive illustrated books of villa designs by Renaissance architect Andrea Palladio or his followers in France and England, furnished the rhetorical grammar for the gentleman-architect to build his great house to indisputably elevated classical standards. By the end of the century, some critics complained that Virginians had gone too far in their architectural assertions of aristocratic identity. But as settlement spread westward in the late eighteenth century, Virginians carried their Anglo-Palladian building traditions and cultural aspirations across the mountains.

Once a representational language, such as architectural classicism, is established through precedent, it is fairly hard to shake. In the early nineteenth century, throughout the South, new people from the North, from Europe, and from within the region itself rose within society and challenged the hegemony of the traditional architectural style of the old Virginia gentry. As wealth, education, and travel became more widespread, the region's cultural frame of reference expanded. New variations on the classical theme were introduced to express refinement both in town and in the country. While most white families lived in two- or four-room wooden dwellings, the prosperous few erected Federal, Neoclassical, and Greek Revival mansions as emblems of dominion and sophistication. All the styles were, notably, variants of classicism, which indicated (some-

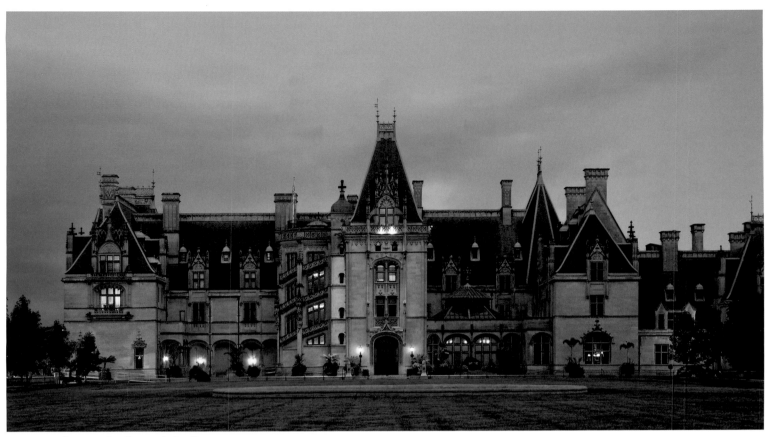

Sunrise at Biltmore, Asheville, North Carolina

times falsely) that the owner possessed the educational prerogatives and, perhaps, the ancestral advantage of aristocracy.

While that aristocratic classicism formed the basis for self-representation, post-Independence Americans jostled to define a version of classicism that had the legible cachet of the British aristocracy without, perhaps, as much direct imitation. The dawning of the architectural profession in the same period meant that a few practitioners, like Benjamin Henry Latrobe, would create national monuments that, in turn, established a new architectural hierarchy within the American social system. Hiring an architect associated with the Capitol, like Latrobe or Thornton, indicated that an owner saw himself as part of the larger national picture of status and historical self-consciousness. But even when owners hired architects, they often used the plans as starting points and imposed their own adaptations to improve functionality, to conform to what local craftsmen could manage, or simply, as in the case of Commodore Stephen Decatur, to save money. The rise of builder's guides at the turn of the nineteenth century made architectural classicism accessible to a wider audience. This audience of wealthy merchants, professionals, and entrepreneurs might not have possessed the full classical education of the eighteenth-century gentleman-architect, but they knew what they liked.

The Greek Revival house, while not exclusive to the South, became emblematic of plantation culture, particularly after the Civil War and particularly in the minds of Northerners who not-so-secretly envied the architectural grandeur and aristocratic connotations of the antebellum great house. Stylistically evolved from Neoclassicism and rhetorically bolstered

by news of the Greek War of Independence (as nineteenth-century Americans tended to identify with revolutionaries), the Greek Revival mansion hit the South just as cotton fortunes hit the builders' bank accounts. It was a style that evoked temples, an image equally apt for a city hall, a merchant's exchange, or, indeed, a great house at the center of a plantation—the agricultural basis for the region's civic and commercial growth. Some have suggested that the planter aristocracy particularly identified with the ancient Greeks as slaveholders within a strictly hierarchical, yet democratic, society.[2] The boldly geometric Greek Revival was, primarily, an exterior—therefore public—representational style. The interiors of most Greek Revival great houses manifest a distinctly different aesthetic.

Boosted by the mass production of highly ornamental architectural elements and furnishings, and wrapped in densely patterned wall coverings and plush textiles, the Romantic or picturesque taste for visual complexity coincided with the Greek Revival. Architecturally, the visual complexity of the picturesque challenged the hegemonic classical matrix, but always with some (at least quasi-) historical pretext: Gothic cottages, Renaissance Tuscan villas, Orientalist fantasy pavilions. Cheap, readily available architectural pattern books by A. J. Downing, Samuel Sloan, and O. S. Fowler capitalized on a rising middle class with the financial means and inclination to build great houses. They also introduced new stylistic vocabularies. The styles were still based in the idealized world depicted in books, but instead of translations of Pliny or Palladio, inspiration came from the novels of Sir Walter Scott and Stendhal; the poetry of Goethe; Washington Irving's *Tales of the Alhambra*; or illustrated travel

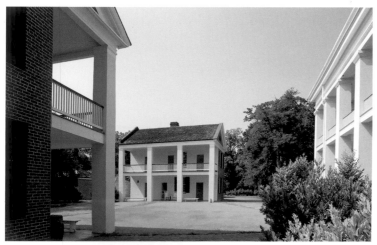

The Melrose service yard, with great house at right, contains dependencies that once housed a dairy, a kitchen, and quarters for some of the estate's enslaved people.

FACING PAGE
Front door, Hammond-Harwood House, Annapolis, Maryland

features in the popular magazines that arose at mid-century. A more cosmopolitan frame of reference meant that wealthy builders in the South, as in the North, looked to places other than England and ancient Rome for historical models for their self-representation.

The picturesque impulse survived the Civil War and became associated with a strong cult of middle-class domesticity, derived from Victorian social movements but particularly acute in the South as its people struggled to reestablish stable institutions (or in the case of black homeowners, establish an independent, respected lifestyle) in the wake of Reconstruction. The picturesque remained the middle-class vocabulary of choice until the Colonial Revival provided an alternative, in the form of smaller-scale versions of the historical great houses, most especially those of the now-fabled past of eighteenth-century Virginia. Restorations and reconstructions at Colonial Williamsburg and Tryon Palace in North Carolina reestablished the image of colonial gentry as templates for middle-class domestic aspiration.

But for great houses, a new kind of academic classicism came back with a vengeance at the turn of the twentieth century. This classicism was the purview of the professional architect, not the gentleman-amateur (although the most successful architects still tended to come from the social elite). Introduced to the United States by architect Richard Morris Hunt, the Renaissance-based classicism of the French architectural academy at the École des Beaux-Arts brought full-blown European monumentality to America. Appropriately, the skill and means to build American buildings on the scale of a European monarchy arrived just at the moment in which Americans recognized that their newfound political and economic ascendancy had made them the heirs apparent to the great Western cultural tradition. The Beaux-Arts architect offered the New South's builder a range of plutocratic options for his great house, including the French Renaissance château, the North Italian Renaissance villa, or even the Spanish colonial *palacio* (albeit with a Neoclassical portico).

While Gilded Age houses of the South followed the same stylistic patterns as those of the North, what eventually emerged was a tendency to interpolate regionally specific imagery and forms into the European matrix.

In some cases, such as Vizcaya in Miami, the local color is really all in the adaptation to climate, and supported by a fictional narrative invented to support the basis of the style in an imagined historical connection between the house and sixteenth-century European explorers. In other cases, such as Longue Vue in New Orleans, the putative regional influence is almost completely subsumed into the overall stylistic matrix of international Beaux-Arts classicism—with a few hints of Modernism for good measure.

After following the great house, its people, and the overarching story of architectural representations of refinement in the South from 1700 to World War II, the inevitable question emerges: Is there a "South"? Entire shelves of books by academics and other very smart people document the debate over the topic of Southern identity and, more recently, whether or not a distinct regional culture ever really existed at all.

In 1785, Thomas Jefferson and the Marquis de Chastellux corresponded on the topic. Jefferson concluded that there was a difference between the Northern and Southern character, based on climate. The Northerner was cold, therefore (and I paraphrase) hardworking, considerate, holier-than-thou, and a bit dull. The Southerner was hot, therefore sybaritic, passionate, lazy, and inconsiderate. Chastellux, for his part, said that the institution of slavery and the stratification of society that resulted had created a cultural identification with aristocracy that was, and would remain, indelible.[3] This view supports the idea, codified in the "Lost Cause" mythology of the region that emerged after the Civil War, that Southern society was established and forever determined in its course by royalist Cavaliers, while the Northern settlers' bourgeois Puritanism was nationally determinative, ergo "normative," for Americans. Until recently the blame for slavery was also assigned exclusively and universally to the South, which placed the region in an ineluctable position of collective moral inferiority. (In fact, three-quarters of white Southerners in 1860 did not own any slaves at all, while a small but nonetheless surprising number of Northerners did).[4] It is fairly clear why modern Southerners, characterized as the deviant exception that proves the Yankee rule, do not particularly like the notion that the South is different.

The great houses of the South are distinct from those of the North by degrees. From the archetypal American great houses of Washington and Jefferson to the Neoclassical refinement of the Nathaniel Russell house and Greek Revival grandeur of Oak Alley, the Southern great house is distinct and recognizable, partly because of the Southern builders' awareness of the importance of domestic architecture as a form of social self-representation. As the country grew more culturally unified through transportation, trade, and everyday communication, the representational agenda of the great house grew less regionally pronounced. What remained distinct, however, was the South's heightened awareness of its own regional past as the defining ingredient of its cultural and, by extension, architectural identity, whether by choice or through imposition by others.

Although recent scholarship has tended to refute the notion of Southern exceptionalism, in the popular imagination it persists as the "red state/blue state" division of presidential election maps or the space within the "Sweet Tea Line" (which someone has actually charted). The facts that the Midwest and West each contain a fair share of "red" states and that McDonald's now sells sweet tea nationwide suggest that the division is not so clear-cut anymore. So as James C. Cobb has noted, the notion of Southern identity today may rely more on faith than on evidence.[5] But we believe in the South, and so it is.

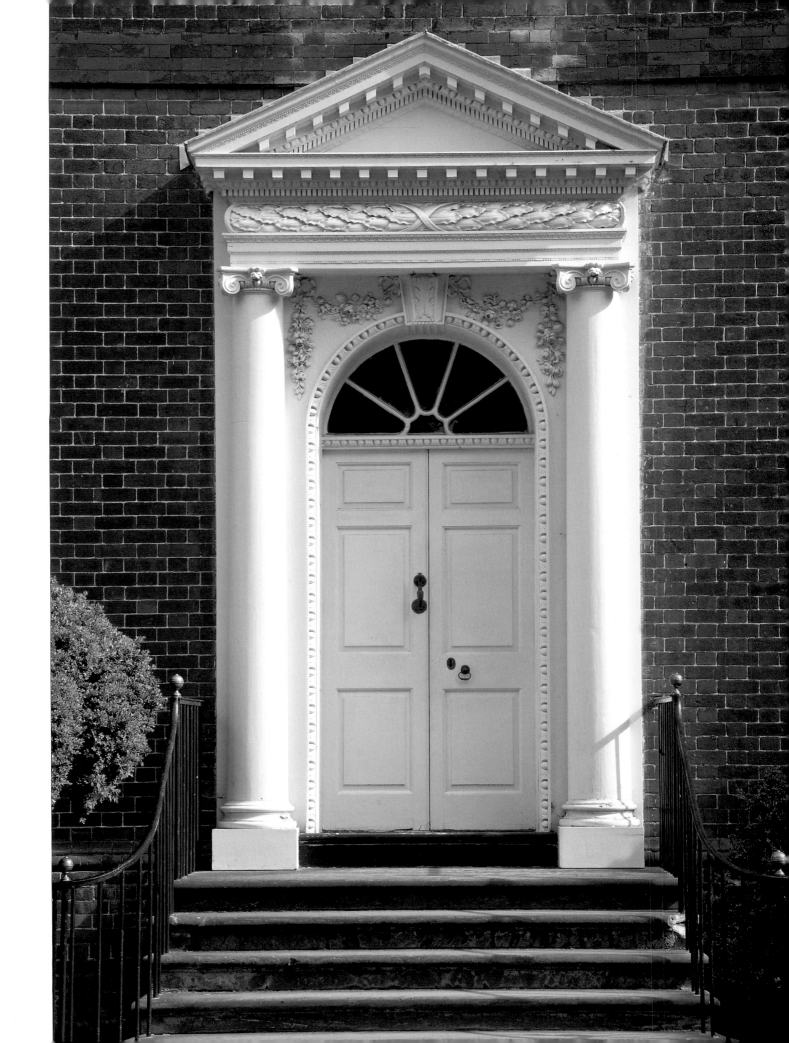

PART I

1700–1800

Monticello, southwest portico overlooking the West Lawn

The Governor's Palace

Williamsburg, Virginia
Built 1706–22; renovated 1749–52; burned 1781; reconstructed 1932–34
Builders: Henry Cary (contractor, 1706–10); John Tyler (1710–18) and
Alexander Spotswood (supervision, 1710–18); Richard Taliaferro
(contractor, 1751–52)
Architects of the reconstruction: Thomas Tileston Waterman,
in association with Perry, Shaw and Hepburn (1932–34)
Owned and operated by the Colonial Williamsburg Foundation

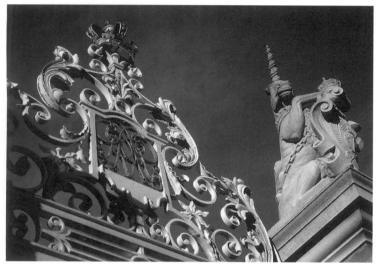

ABOVE
*The elaborate ironwork gate to the Governor's Palace is flanked by statues
of a lion and a unicorn, heraldic supporters of the British royal coat of arms.*

RIGHT
*Drawings by Thomas Jefferson, General Assembly records, and an engraving
discovered at Oxford University's Bodleian Library provided supporting evidence
for the 1932–34 reconstruction of the Governor's Palace.*

Historians have debated whether the first recorded use of the term "palace" to refer to the colonial Virginia governor's residence in 1714 was a political barb aimed at the ever-escalating cost of construction. As the word "palace" was the accepted term for the residence of any colonial British governor at the time, it seems likely that it was foremost a functional designation. Certainly, by the time of its completion in 1722, the Governor's Palace at Williamsburg was as grand a residence as America had to offer, but compared with Blenheim Palace (1705–22), its exact contemporary in England, it is also possible that some may have used the term sarcastically, to highlight just how truly provincial colonial America really was.

As early as 1684, the Virginia House of Burgesses sent plans for an official governor's residence to London for review, but it took until 1706 to gain their approval. The approved plans specified a two-story brick structure, measuring forty-eight by fifty-four feet in ground plan, with sash windows, dormers, and a cupola, suggesting that the design was

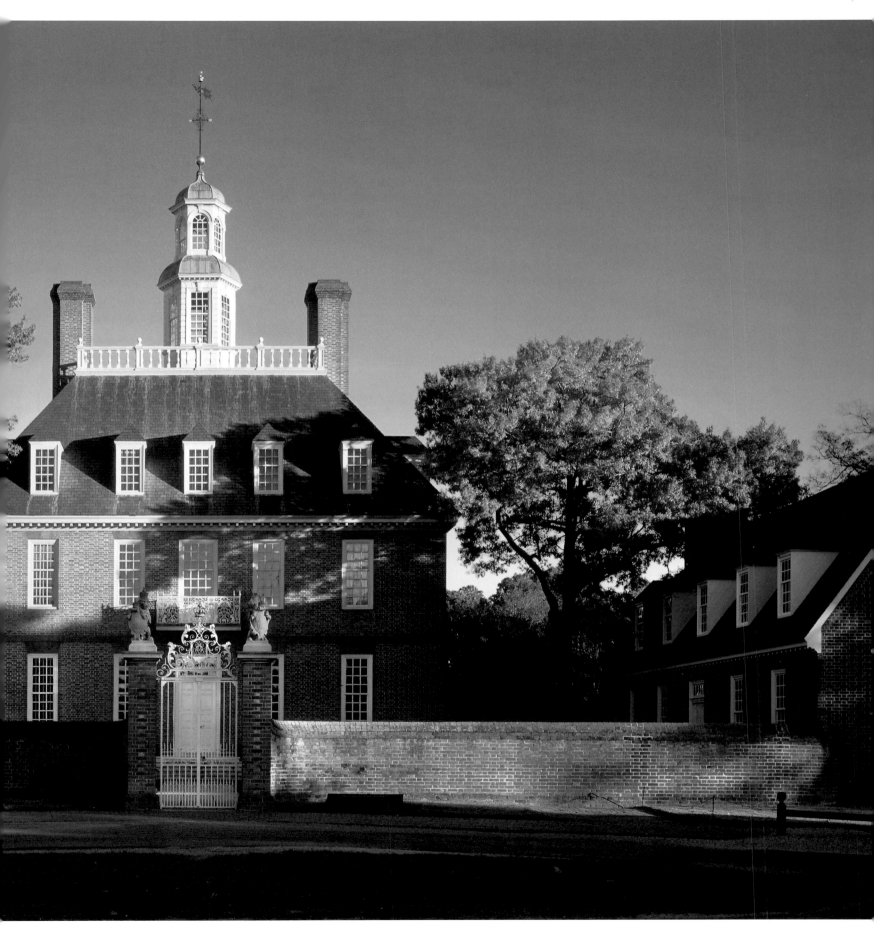

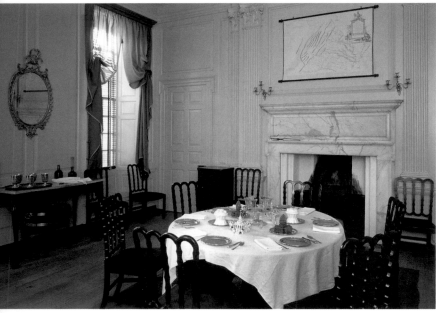

TOP

The ballroom overdoor, with its broken-scroll pediment, is embellished with the royal monogram GR (Georgius Rex) as a reminder of omnipresent royal authority.

ABOVE

Governor Botetourt (in office 1768–70) conducted official business in the dining room, whereas Governor Dunmore (in office 1771–76) used it more as a family and social space.

RIGHT

The ballroom, added to the palace in the 1750s, was likely among the most impressive spaces in the colonies. Coronation portraits of King George III and Queen Charlotte, by the studio of Scottish painter Allan Ramsay, flank the doorway.

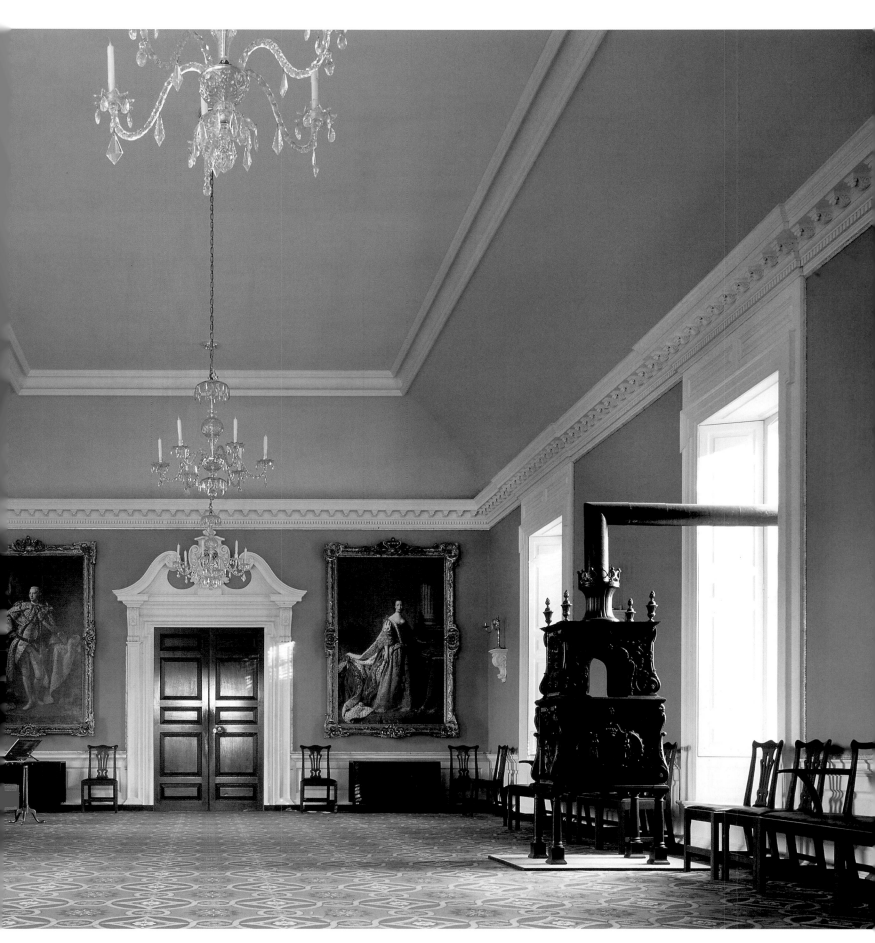

ter wall. The ostentation of these elements by Virginia standards almost inevitably led the House of Burgesses to chastise Spotswood for "lavishing away all the country's money" on the building.[2] Spotswood, in response, offered to pay for some of the work himself, and moved into the still-incomplete residence in 1718.

This building, which later Governors Patrick Henry and Thomas Jefferson, among others, inhabited during their terms of office, boasted over ten thousand square feet of living space on three floors and a cellar with eleven wine bins (surely appreciated by oenophile Jefferson). By contrast, most people in Virginia—yeoman farming whites and both free and enslaved black people—lived with their families in one- or two-room wooden structures. Visitors approached the Governor's Palace through a gateway flanked by a lion and a unicorn (heraldic emblems of the British crown) and passed into a forecourt defined by one-and-a-half-story service buildings arrayed at right angles to the strictly symmetrical facade, with at least a half-dozen supporting buildings arrayed in service yards beyond. The formal gardens behind the building gave way to a naturalistic landscape, a carefully crafted metaphorical expression of the contrast between the highly refined precinct of the palace and the wilderness that lay beyond the capital. At least two dozen servants and slaves worked to maintain this carefully constructed image of the governor, the crown, and the state. Still, by 1751 the building was considered in "ruinous condition," and renovations began, followed by the 1752 reconfiguration of the ballroom and supper room, indicative of the importance of social gatherings to the business of state. In 1779, Governor Thomas Jefferson sketched the floor plan of the building with an eye to remodeling, but the following year, the capital was moved to Richmond and the Governor's Palace became an obsolete relic of the pre-Revolutionary past. After the Battle of Yorktown, the structure served as a hospital for wounded soldiers, 156 of whom were buried in the ground of Spotswood's vanished formal gardens. In December 1781, the building burned to the ground, possibly a result of arson. In the final act of eradication, Union troops in 1862 demolished the two remaining approach buildings, sentinels to an empty lot where Spotswood's testament to the grandeur of the crown and its authority had stood.

The Governor's Palace might have remained an architectural legend, and Williamsburg itself a footnote in history, if not for the vision of the Reverend Dr. W. A. R. Goodwin, rector of Williamsburg's venerable Bruton Parish Church; the fortune of John D. Rockefeller; and the cultural zeitgeist that we now term the Colonial Revival. In 1926 Goodwin contacted Rockefeller (who had recently funded postwar restoration work at Versailles) with the idea that Williamsburg presented the opportunity to

likely influenced by the existing capitol building as well as the main building of the adjacent College of William and Mary (now known as the Wren Building). Like those structures, the palace was stylistically Georgian, more specifically "Anglo-Dutch" in its cubical form, verticality, and simple facade. Conveniently, its exterior had no ostentatious sculptural program or ornamentation that would have required costly importation of artisans and materials to achieve. While books of classical architecture, most notably Sebastiano Serlio's *Architettura*, may have been consulted, the Virginia governor's palace was a distinctly American construction.[1]

As with most government building projects before and since, construction on the Governor's Palace lagged and costs skyrocketed. The first contractor was fired for financial mismanagement, and a second hired and closely supervised by Governor Alexander Spotswood (1676–1740). Like many distinguished Virginia gentlemen, notably George Washington and Thomas Jefferson, Spotswood probably owned or had access to architectural treatises and thus fancied himself an architect. He is credited with a definitive role in the design of not only the finely paneled and furnished interiors but also the formal gardens, outbuildings, and a perime-

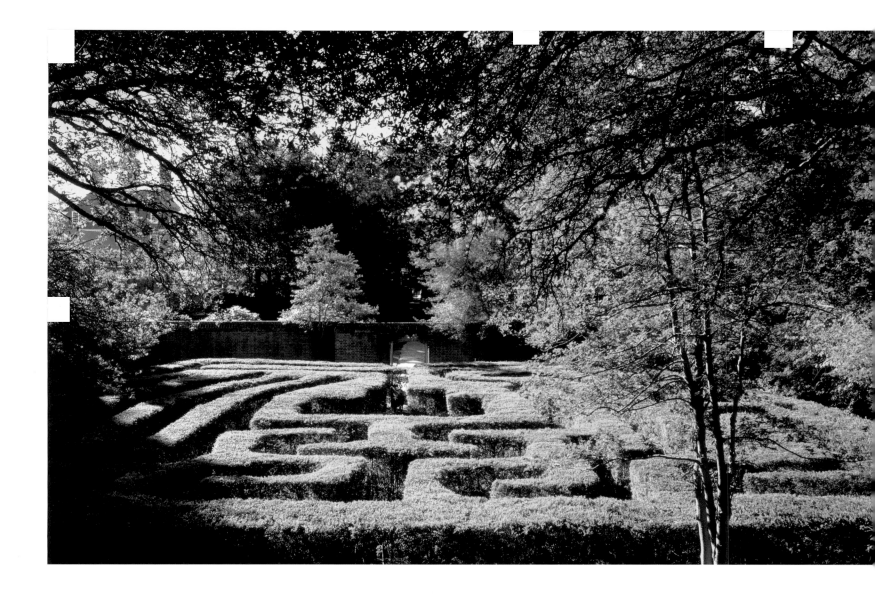

recreate an entire pre-Revolutionary American town—not just a single monument like Boston's Old North Church or Philadelphia's Independence Hall.

A visit to the town convinced Rockefeller, who began acquiring property and restoring buildings—anonymously, at first. By 1928 Rockefeller's architects had completed restoration of the Wren Building at William and Mary and the capitol building. Anxious to complete the third monument on the major cross axis of the colonial city, Rockefeller purchased the site of the Governor's Palace in 1928.

By today's standards, the restorations at Williamsburg took questionable liberties in the effort to depict the past in a manner that fit contemporary notions of good taste and appropriate gentility. Where evidence did not exist, architectural fragments, materials, or designs from contemporary buildings were substituted, a practice considered unacceptable to preservationists today. Even at the time, however, extensive research backed up the architects' choices. Jefferson's 1779 floor plan, records of legislative appropriations, inventories, and written accounts as well as archaeological excavations—all provided fragmentary evidence of the whole. Still, the appearance of major parts of the building, most

notably the facade, remained speculative until the so-called "Bodleian Plate" was discovered at Oxford University's Bodleian Library in 1929. The circa 1740 printing plate remains the only known depiction of the major public buildings of Williamsburg as they appeared in the mid-eighteenth century. With this new evidence as a guide, reconstruction of the Governor's Palace began in earnest, and the site opened to the public in 1934. Furnished with fine antiques, the palace presented visitors—wearied by the Depression, the Second World War, and later, those inspired by the Bicentennial—a place to reaffirm conventional notions of the founding fathers as gentlemen of cultural and aesthetic refinement.

Since the 1980s, extensive research and reinterpretation have sought to bring new authenticity to bear on the reconstructed Governor's Palace. In 2006 a focus on the period of residence of the palace's final royal governor, John Murray, 4th Earl of Dunmore (1771–76), led to a recreation of the family's rooms and a new, highly accurate replication of the arms arrangement in the front hall. Like its companion, North Carolina's Tryon Palace (built 1767–70; burned 1798; reconstructed 1952–59), scholars and curators continue to strive to achieve authenticity within the fabric of the twentieth-century building.

Shirley

Charles City County, Virginia
Built 1723–38; portico added after 1771; altered 1831
Owner-Builder: John Carter (1696–1742)
Owned and operated by Shirley Plantation, LLC

ABOVE
Shirley retains many of its original outbuildings, including the smokehouse (above).
The cupola's bell signaled the beginning and end of the working day.

RIGHT
A 1742 land survey map of Shirley refers to the family residence as "the Great
House," seen here from the courtyard approach.

While the main house at Shirley dates to the 1730s, the name reflects the estate's even earlier origins. Its first English owner, Sir Thomas West, 3rd Lord De La Warr and royal governor of Virginia, received a land grant from James I of England and named a four thousand-acre tract of his Virginia property in honor of his wife, Lady Cessalye Sherley, in 1613. (West was not in Virginia at the time, during which one of his deputies fatefully captured Chief Powhatan's daughter, Pocahontas, and took her to nearby Jamestown as a hostage.) After West's death, Edward Hill I, a member of the Virginia House of Burgesses, was granted 450 acres of the plantation in 1638, which he used to grow tobacco, the foundation of Virginia's early economy. With the proceeds of over a century in the tobacco trade, and over two thousand five hundred additional acres purchased by Hill, his grandson, Edward Hill III, began construction on a new, grand house in 1723. In 1726, his daughter, Elizabeth, and her husband, John Carter, inherited the property and completed the house we know today as Shirley.

While Elizabeth Hill was wealthy in her own right, her husband was even wealthier. John Carter was the eldest son of Robert "King" Carter, the richest man in America, with three hundred thousand acres of Virginia land, much of it used to cultivate tobacco, and worked by at least

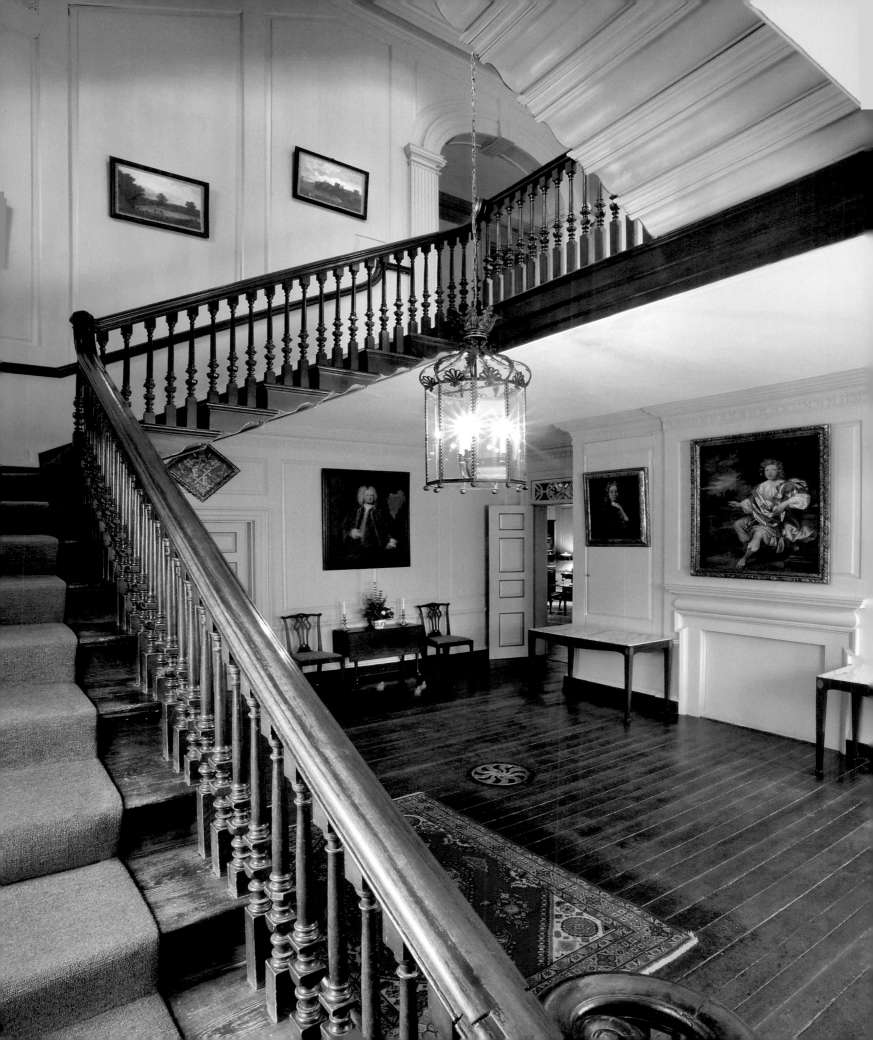

LEFT

The hall features original furnishings and family portraits of the Hills and the Carters. The hand-carved walnut and pine square-rigged "flying" staircase rises an impressive three stories.

ABOVE

The broken-scroll pediment over the doorway from the parlor to the dining room displays the high level of craftsmanship that signaled the family's parity with the aristocracy of England.

ABOVE

The dining room is decorated with original eighteenth-century European travel prints and Carter family silver. The cellaret (foreground), another original family piece, served many guests with spirited entertainment.

one thousand enslaved African people. While the Carters were completing Shirley, John Carter's sister and her husband, Benjamin Harrison, were building Berkeley (1726). The Carters' daughter would marry William Byrd III of nearby Westover (circa 1730). Shirley was built in Virginia's Golden Age of prosperity, and the house and its inhabitants were at the center of an elite social circle that defined power, gentility, and architectural fashion in the colonial South.

The three-story brick house, a near-perfect forty-eight-foot cube in form, was likely inspired by Alexander Spotswood's Governor's Palace in Williamsburg, which was, at that time, the grandest dwelling Virginia had to offer. When the Carters moved into their completed house in 1738, Shirley's great house was not merely grand in its own right, but it stood as the centerpiece of the complex of buildings that not only fulfilled the functional requirements of the working plantation but also

made a stunning visual declaration of aristocratic dominion.

The distinctive verticality of Shirley (a proportional legacy of the Dutch influence in English Georgian building) was moderated in its original form by the visual weight of symmetrical, flanking three-story outbuildings, located thirty-six feet from either side of the main block. These outbuildings, housing a laundry and kitchen with slave quarters above, not only isolated the laborious and unseemly work of plantation life from the private activities of the family in the main house but also architecturally punctuated the sequential transition from distant wilderness to cultivated field—from spaces of labor to the great house's precinct of refined leisure. The solidly built brick outbuildings at Shirley were notably nicer than the majority of Virginia houses. They were status symbols, indicating the vast scale of the agricultural operations and the great quantity of valuable possessions (including the enslaved people). Beyond

The parlor showcases a host of family portraits. In 1793, Anne Hill Carter married Revolutionary War hero "Lighthorse Harry" (Henry) Lee in this room. They became the parents of General Robert E. Lee.

this ceremonial forecourt, a granary, icehouse, storehouse, dovecote, and barns extended the built environment well into the adjacent landscape, further transforming the labor of agricultural life into a display of processional grandeur. In the context of its time, the impression of wealth and power conveyed by this architectural composition on the cultivated landscape can scarcely be overstated.[3]

The great house, framed by the cultivated landscape of refinement, originally displayed a flat facade with a classical pediment suggested by gauged brick and an elevated gable over the center bay. The riverfront of the property was likely the main ceremonial entrance for distinguished guests and rival relatives (often one and the same), as the James was not only the main artery of commerce but also the conduit of social communication and travel to nearby Williamsburg, Jamestown, and, later, Richmond. The intended audience for Shirley's grandeur, however, was the visiting gentry of England, who tended to look down upon the colonial planters. Shirley served as an architectural announcement that the Carters of Virginia were playing in the major league.

Generations of Carter descendants placed their stamp on the house, refining its architectural details to maintain the representational impact of the family home. In 1771, following Elizabeth Hill Carter's death, her son Charles embarked on extensive and stylish updates, replacing the tile roof with slate and adding the distinctive classical porticos (undocumented but likely inspired by one of the English editions of Palladio), practical shutters, and casement-style windows to the exterior. He also commissioned distinguished paneling and ornamental woodwork to update the interiors. In the 1830s, the original columns of the house were replaced with the current Doric order—a stylish nod to Greek Revival taste. In 1862, Shirley was occupied and sacked by Union troops engaged in the nearby Battle of Malvern Hill. Wounded Union soldiers, left on the plantation by Major General George McClellan upon retreat, were well tended by Mrs. Hill Carter in spite of the depredation their fellow soldiers had wrought upon her family's property. In recognition of Mrs. Carter's generosity, McClellan promptly granted a federal order of safeguard on Shirley and its residents. Marion Carter Oliver, four years old at the time of McClellan's occupation, eventually inherited Shirley and owned it until her death in 1952.

After 371 years, Shirley remains the home of the Carter family, whose farming interests on the remaining seven hundred acres make Shirley Plantation the oldest family-owned business in the United States. Since 1952, the family has opened the main house and grounds to visitors as an historic site. In 2007, the current residents, eleventh-generation descendants of Edward Hill I, placed both the land and the buildings of Shirley under preservation easements with the Commonwealth of Virginia to ensure the property's protection from encroaching development.

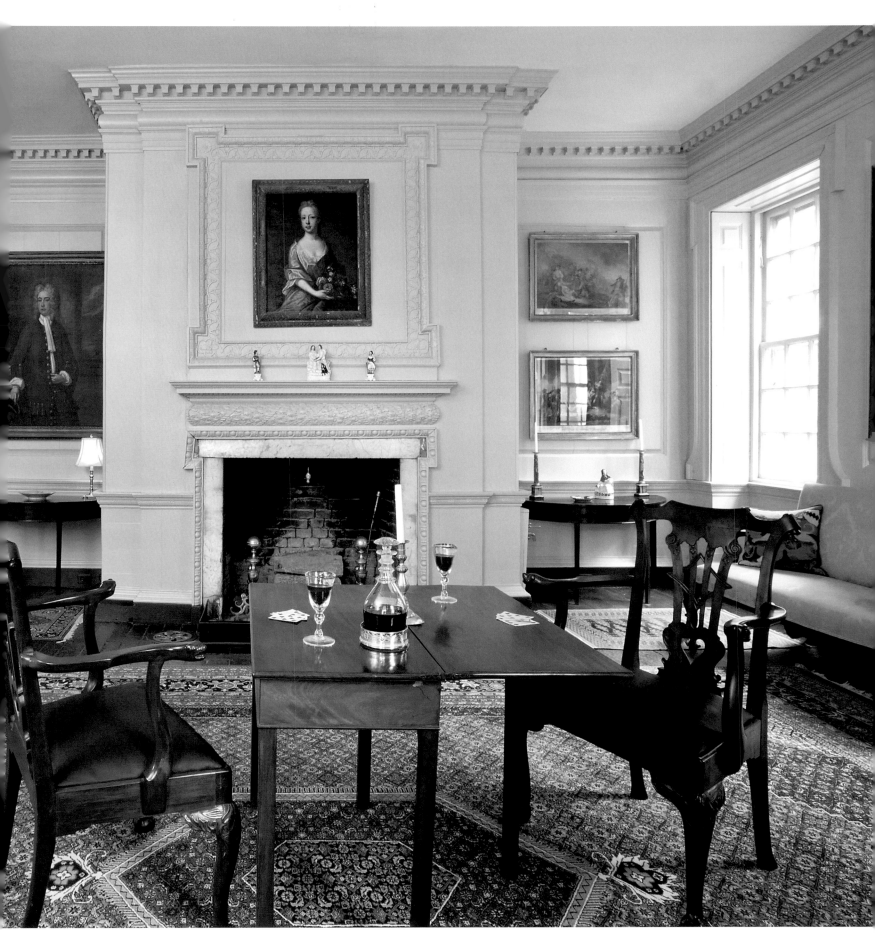

Drayton Hall

Charleston, South Carolina
Built 1738–42
Owner-Builder: John Drayton; interior alterations, Charles Drayton, 1802;
roof altered 1845–52; great hall ceiling rebuilt 1850–60; portico repaired
1932
Owned and operated by the National Trust for Historic Preservation

ABOVE
Looking across the garden from the house toward the Ashley River

RIGHT
*After seven generations of family ownership (1738–1974), Drayton Hall and its
surrounding landscape convey an authentic story of continuity and change over time.*

Drayton Hall not is only the best surviving example of domestic
Georgian-Palladian architecture in the United States but also
has remarkably unaltered interiors, which are more than 250
years old and offer visitors a unique glimpse of what colonial rooms
"really" looked like. Inextricably linked to the story of Drayton Hall's
architecture is the site's African-American heritage, and the stories of the
enslaved and free black residents of the plantation have been as carefully
researched and preserved as the architectural fabric of the great house.

The builder of Drayton Hall, John Drayton, sought both general
design ideas and specific motifs from architectural books, as befit a "gen-
tleman-architect." By relying on books, Drayton (like Washington, Jef-
ferson, and others) elevated his involvement in architecture above the
purely mechanical work of building to an intellectual exercise in classi-
cal and mathematical learning. Drayton's neighbor, Henry Middleton,
owned Isaac Ware's 1737–38 English translation of Venetian architect
Andrea Palladio's *Four Books of Architecture* (1570), which featured designs
too similar to those of Drayton Hall to have been merely coincidental.[4]
The two-storied classical portico, the rigid bilateral symmetry, cubic
geometry, and interiors calculated on canonic Greek proportions of 3:5
and 4:5 were Palladian tropes that, when skillfully applied by an English
gentleman, not only produced an elegant house but also demonstrated
one's mastery of classical learning.

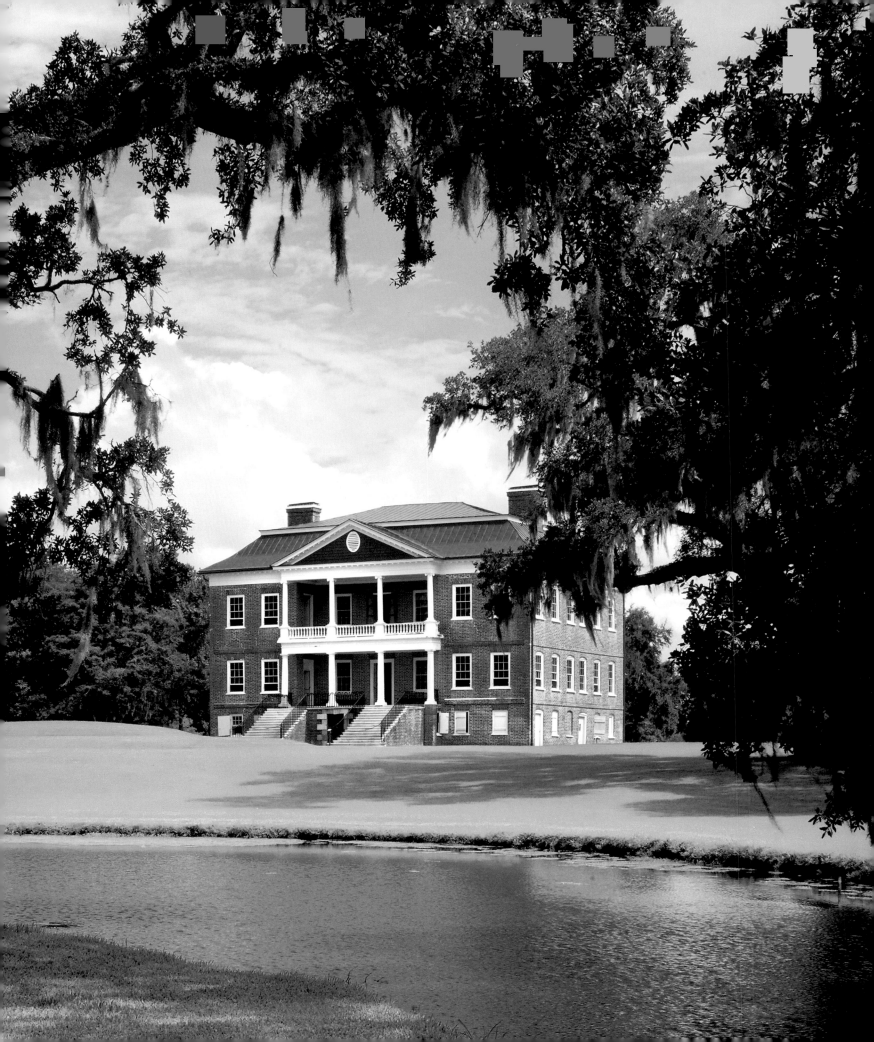

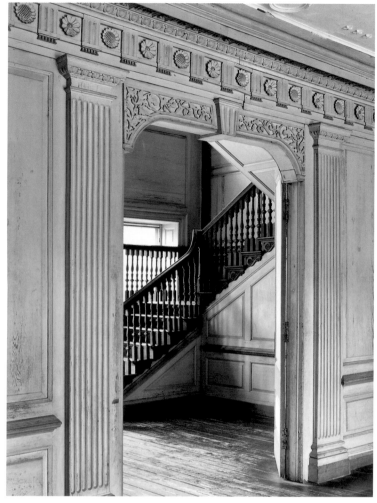

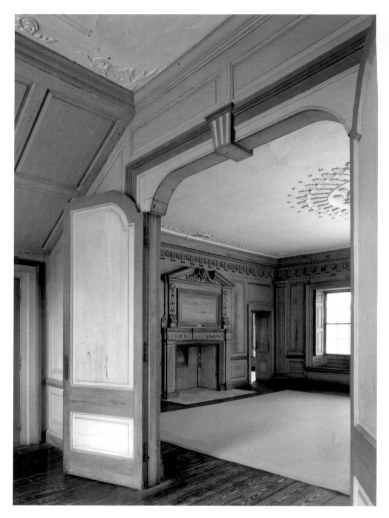

As seen from the great hall toward the stairs, the original, hand-carved Doric pilasters and entablature retain a coat of blue paint added circa 1880.

The great hall features the original mantel and overmantel, created locally from a design selected by John Drayton from William Kent's Designs of Inigo Jones *(1727). The cast-plaster ceiling dates from the 1850s.*

The elaborate stair hall originally incorporated imported and vermillion-stained mahogany balusters, handrails, brackets, and carved panels.

Drayton Hall was built with money made from raising cattle, and its creation was part of a social shift by the Draytons from wealthy but middle-status ranchers to high-status rice farmers. Just as John Drayton sent his sons to prestigious English boarding schools to acquire the polish and education of true gentlemen, his house, with its elegant furnishings, and formal gardens were designed to announce the family's aristocratic values and status. As if Drayton's learning were not already manifest, the Great Hall overmantel's design is clearly taken from another erudite architecture book (in this case, William Kent's *Designs of Inigo Jones*, published in 1727).[5] Although Kent's original was executed in marble, Drayton's painted version (of local tulip poplar) not only had the advantage of style but also tacitly asserted the ability of American craftsmen and materials to "keep up." From his father's estate, Drayton had inherited at least a dozen enslaved people, and he purchased others, at least half of whom were likely involved in the laborious business of creating the earthworks nec-

essary for rice cultivation. Whether Drayton brought trained craftsmen to the site or hired others to train them on the job, it is certain that Drayton Hall was not only built of bricks molded, fired, and set by enslaved people but also finished with fine carving, carpentry, glazing, plasterwork, and surface treatments created, in large part, by enslaved artisans.

Occupied by British troops during the siege of Charleston in 1780 and later by American troops, the estate was devastated in the Revolutionary War, with outbuildings in ruined or collapsed condition and its gardens and recently established crops of wheat, corn, and indigo destroyed. After the war, Charles Drayton purchased the plantation from his stepmother and set about restoring and updating the great house. He replaced three first-floor mantels with more fashionable ones in 1802 and 1804. Following a hurricane a decade later, he replaced the original windows. Like his correspondent Thomas Jefferson, Charles also had an interest in technology and gadgets, and installed some of the first "Rumford

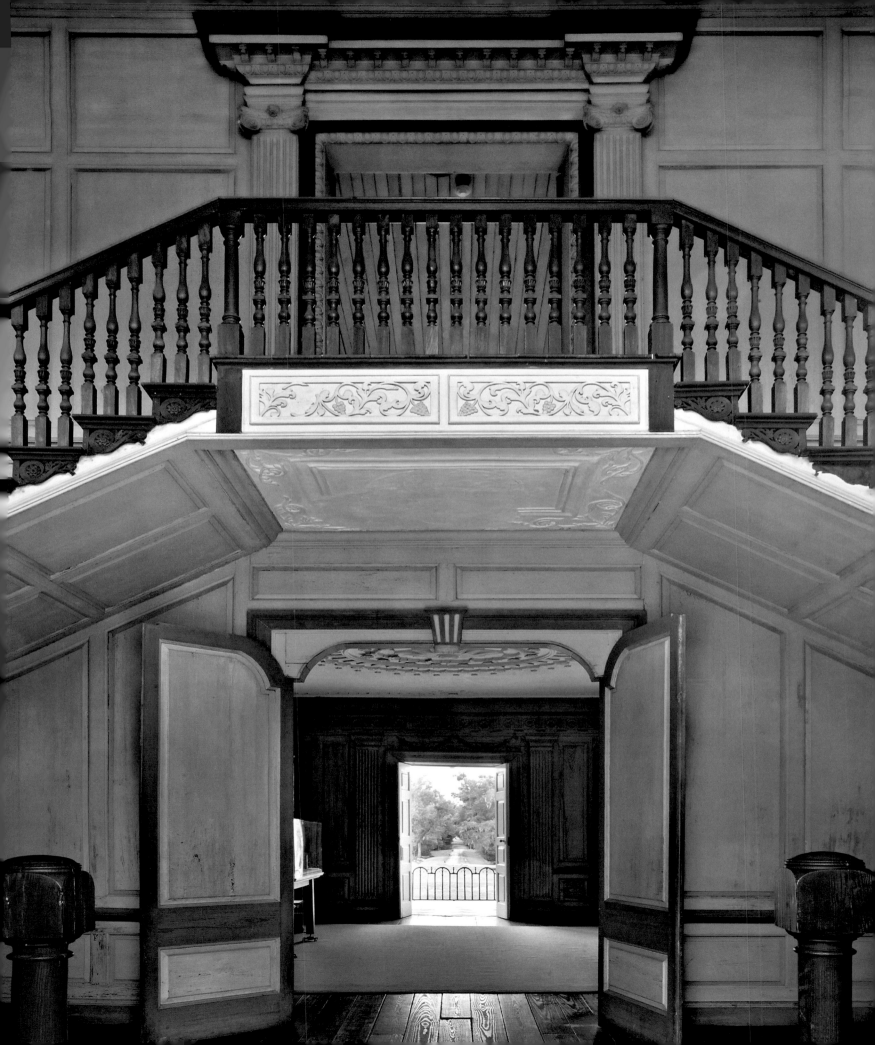

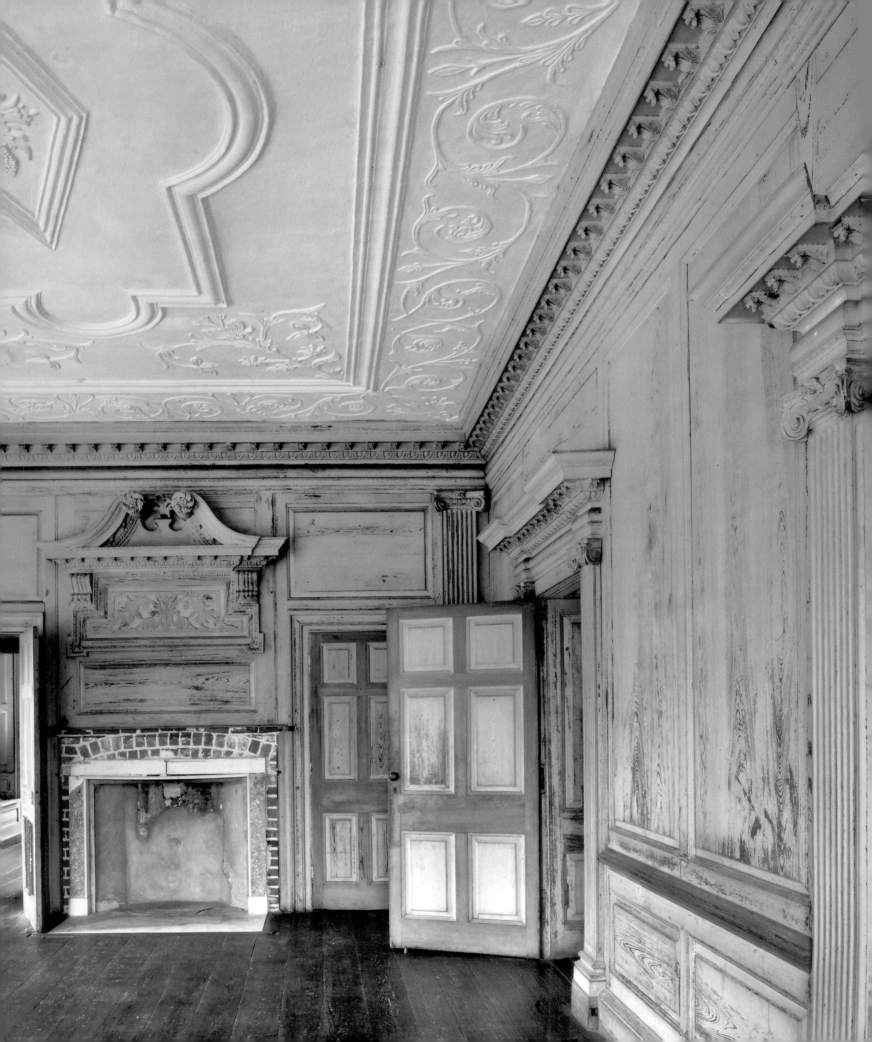

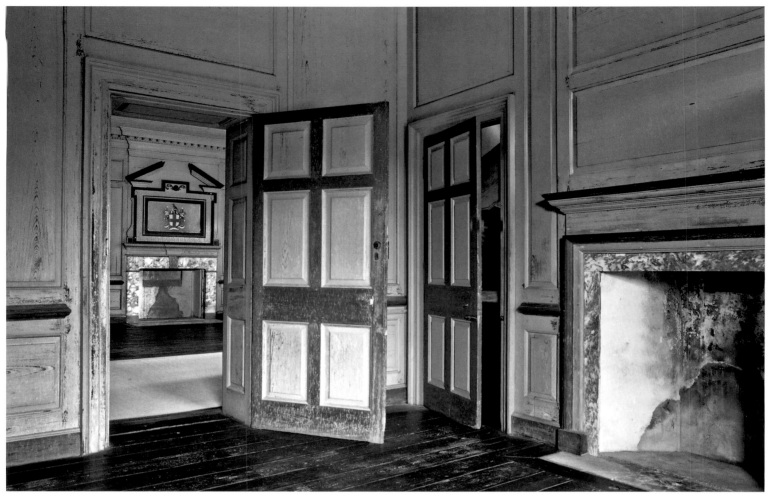

The withdrawing room contains its original hand-carved plaster ceiling, one of the earliest surviving examples in the United States.

The upper great hall, seen here from an adjacent bedroom, was considered the most important room in the house. It features the hierarchically elevated Corinthian order.

fireboxes" at Drayton Hall to improve heating efficiency. His son and grandson, increasingly challenged to make ends meet in the changing agricultural and social world of the mid-nineteenth century, did little to alter the house other than to replace the Great Hall's plaster ceiling after it collapsed in the 1850s. At the start of the Civil War, thirty enslaved people were left at Drayton Hall. A few, like Caesar Bowens, chose to stay after emancipation.

Drayton Hall was one of only three Ashley River plantations to survive the Civil War. John Drayton, disgusted by war, by agriculture, or by both, went west and rented the plantation land to a phosphate mining company. A nephew, Charles Drayton, eventually took over management. Caesar Bowens's son, Richmond Bowens, Sr., was among the people who worked in the mines at Drayton Hall, where generations of his family had lived in bondage.

Thanks to the mines, prosperity returned to the Drayton family in the late nineteenth century and the house received some much-needed repairs and a few fashionable updates: interior walls were repainted in shades of blue; wooden shingles replaced brickwork in the pediments on both facades; a long-lost balustrade was replaced on the upper portico. New machine-made balusters and newel posts completed the damaged staircase in the stair hall, a new roof was added, and an ornamental pond was created on the landside lawn. In the 1930s, Charles Drayton's daughter Charlotta made the last changes to Drayton Hall, painting two rooms yellow with brown trim and repairing the portico, which had partially collapsed in the 1920s.

After thoughtful consideration of the ever-increasing costs to maintain their ancestral home, Charlotta's heirs sold the house and 125 acres to the National Trust for Historic Preservation in 1974. After careful study, the National Trust made the bold decision to conserve the existing materials, rather than to attempt to recreate their original appearance. Richmond Bowens, a descendant of Caesar Bowens, worked as the gatekeeper to the historic site for twenty-four years and assisted archaeologists and historians with research and interpretation. Recently, the visitor experience at Drayton Hall has moved beyond the history of the great house and its conservation to encompass the evolution of the landscape and the narratives of its African-American residents, most notably the Bowens family.

Mount Vernon

Mount Vernon, Fairfax County, Virginia
Built *circa* 1743; extensive repairs 1754; with additions and alterations
circa 1757 and 1775–87
Owner-Builder: Lawrence Washington (attributed); George Washington
Owned and operated by the Mount Vernon Ladies' Association

ABOVE
View of the Potomac River from the piazza

RIGHT
*The asymmetrical west front of Mount Vernon reflects a series of building campaigns
that transformed Washington's small, inherited farmhouse into a gentleman's seat
befitting its occupant's importance to the nation.*

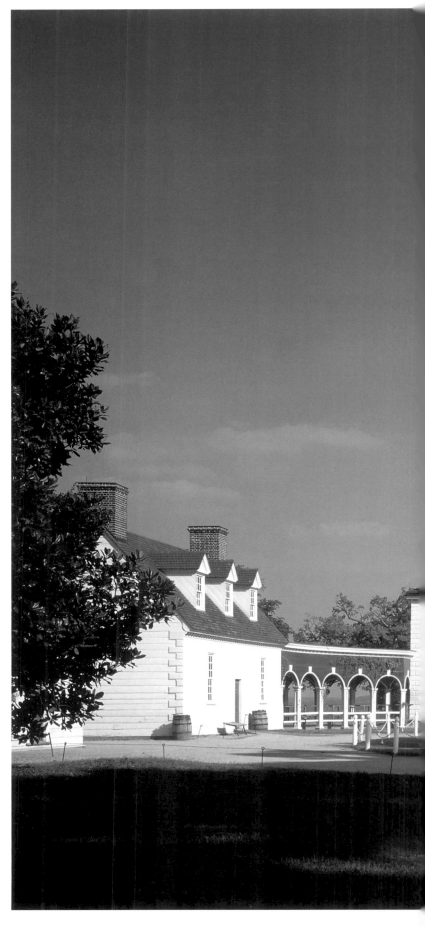

With the arguable exception of The White House, no house is more of an American icon than George Washington's Mount Vernon. The cultural tendency to associate a house with the personality, achievements, and ineffable spirit of its resident is nowhere more apparent than in the history of Mount Vernon as a home and, more importantly, as a national shrine to our first president.

Like other eighteenth-century American gentleman-builders, Washington's architectural choices at Mount Vernon reflect a desire to portray cultural refinement. In Washington's case, however, this representation served not only himself as an individual but also his fellow Americans as an architectural declaration of national respectability. Mount Vernon's exterior classicism, like that of John Drayton's Drayton Hall, was a statement of erudition, while the interior arrangements of spaces and finishes depicted, even when empty, social behaviors indicative of elevated social status. Part of what makes the structure fascinating is that, unlike contemporaries who built from scratch, Washington's Mount Vernon was a series of deliberate editorial comments on each preceding phase of building—both a critique and a positive statement. As its design evolved during Washington's lifetime and beyond, Mount Vernon has always epitomized contemporary notions of the domestic behavior and personal character of the American ideal.

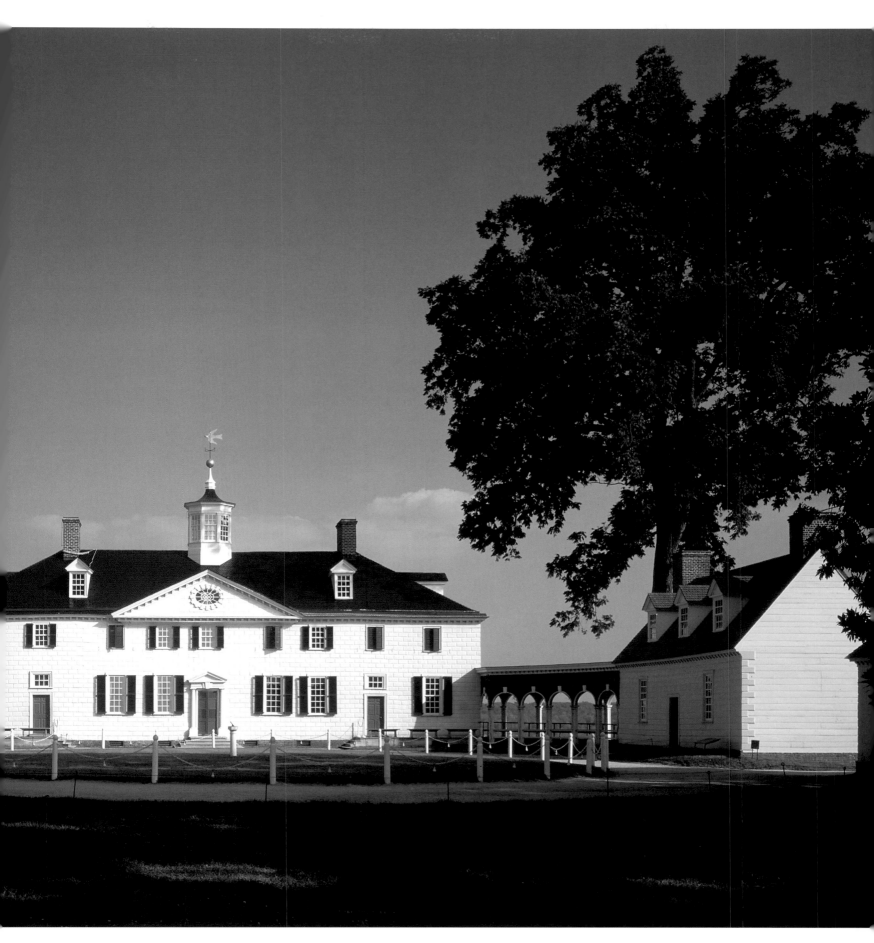

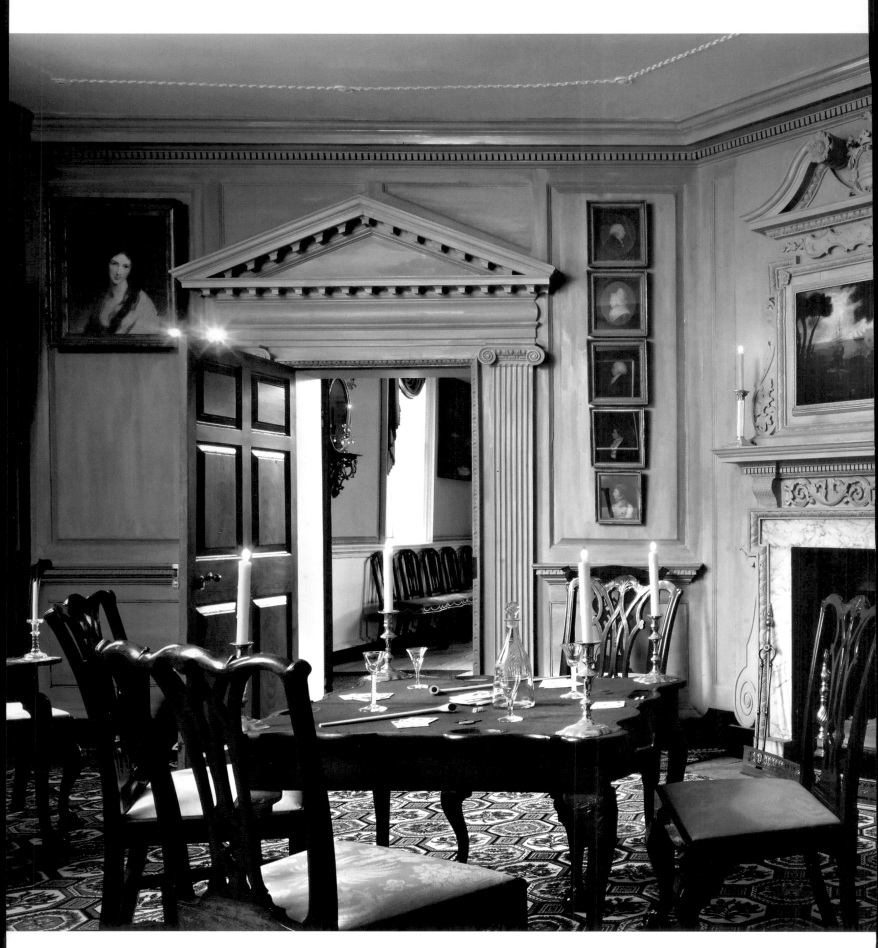

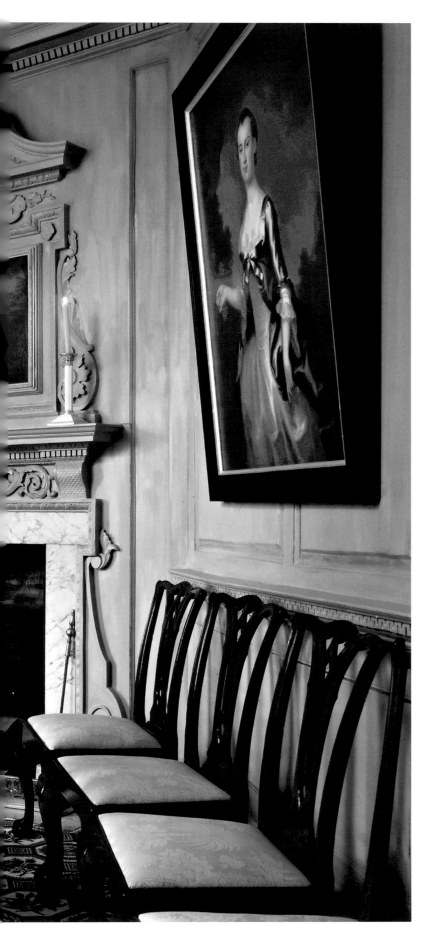

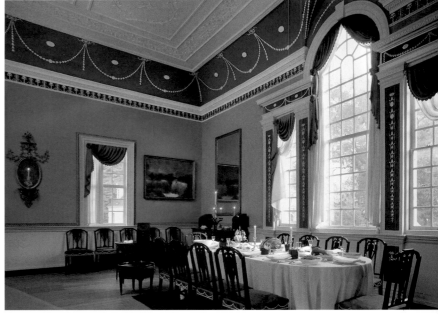

LEFT
The Washingtons received guests in this parlor, which boasts a wealth of sophisticated architectural elements gleaned from books as well as costly Prussian blue paint (added in 1787).

ABOVE
In a characteristically personal touch, the dining room's classical plasterwork incorporates motifs of agricultural tools and crops grown by Washington on his estates.

George Washington (1732–99) was the eldest son of his father's second marriage, an unfortunate position in a society in which inheritance tended to favor the firstborn. He grew up mainly near Fredericksburg, Virginia, at Ferry Farm, one of several family properties dating back to the 1670s. After his father's death in 1743, most of the family wealth went to his older half-brothers, and, as a result, Washington was denied the formal, classical education of a conventional English gentleman (including facility in Latin and French). Lacking that prerogative, with no chance of attending college, and with no significant inheritance on the horizon, the ambitious and self-aware fifteen-year-old Washington compiled various clues to gentlemanly conduct (including a reminder not to spit fruit pits on the table) into a social how-to manual entitled *Rules of Civility & Decent Behaviour in Company and Conversation: a Book of Etiquette*. Fortunately his older half-brother Lawrence took an interest in the boy and invited him to live at Lawrence's five-hundred-acre estate, Mount Vernon. There, Lawrence effectively tutored Washington on the fine points of being a gentleman-farmer and introduced him to the powerful Thomas Fairfax, 6th Lord Fairfax of Cameron. Fairfax not only helped Washington's early career as a surveyor but also provided a glimpse of the beliefs, behaviors, and—at his estate, Belvoir (not extant)—the domestic environment of a bona fide English aristocrat. When Lawrence Washington died in 1752, George inherited not only his half-brother's place in the Virginia militia (thus making a fortuitous entry into the military) but also, in short order, Mount Vernon itself. The estate that had served as the campus for Wash-

In 1797, Washington converted a small bedroom into a family parlor and purchased a harpsichord to encourage his resident step-granddaughter, Eleanor Custis, in the ladylike cultivation of music.

ington's practical education in the gentlemanly arts was now, as a result of Lawrence's tuberculosis, his home.

Sometime prior to his marriage in 1759, Washington began tinkering with the modest, four-room, one-and-a-half-story farmhouse at Mount Vernon, located on the banks of the Potomac River approximately seven miles south of Alexandria. On the exterior, he applied a technique called "rustication" to make the wooden clapboards resemble the ashlar masonry that would have been typical of European manor houses and palaces he had read about in books and knew from nearby Alexandria's Carlyle House, General Braddock's Virginia headquarters. On the inside, using the old house as a core, he expanded both upwards and outwards, adding pine paneling (later painted to resemble mahogany) and an impressive staircase to the center passage, the most

public area of the house. The improvements announced that he had established himself as a man of means.

In 1774, around the same time that he was chosen as one of Virginia's representatives to the Continental Congress, Washington began adding additional rooms for formal dining and study, suggesting that he may have anticipated an increase in social activity, as well as an opportunity to advertise his gentlemanly pursuit of knowledge. Perhaps to make up for his lack of formal education, Washington owned 884 books—an astounding number for the time. He began redecorating the interiors at Mount Vernon with mantels and paneling carved to designs he found in versions of Palladio that had been translated, printed, and engraved with the English gentleman-architect in mind. Motifs at Mount Vernon have been traced to various Palladian treatises, including James Gibbs's *A Book of Architec-*

ture (1728), William Kent's *Designs of Inigo Jones* (1727), and Batty Langley's *The City and Country Builder's and Workman's Treasury of Designs* (1740, 1759).[6] Langley, while the least doctrinaire classicist of the bunch, was particularly favored by Freemasons, the quasi-mystical fraternal organization to which George Washington was devoted. Interrupted by the Revolutionary War and national service, neither the dining room nor study room was completed until the 1780s. In 1777, however, the distinctive "piazza" was added, its form suggesting classical temples while the choice of terminology suggests his likely reliance on Langley's book. The choice to use square piers rather than the classical columns was unorthodox and arguably provincial, yet their use by Washington has made the double-story square-columned portico an iconic American architectural trope.

The extensive changes to Mount Vernon initiated by Washington in the 1780s suggest that he was quite aware of his status as the iconic national hero and that he sought to create a suitable environment to represent himself in a manner to fulfill contemporary expectations. The front parlor of the old house received a coat of ostentatiously expensive Prussian-blue paint as well as an elaborate plaster ceiling and a new mantel, based on a design in Abraham Swan's *The British Architect*, significantly customized with the Washington family heraldic coat of arms.[7] While Washington may have helped to vanquish the monarchy, his choices at Mount Vernon show that he naturally remained subject to the visual iconography of English social class and aristocracy.

Following Washington's death in 1799, the vast acreage of Mount Vernon and Washington's other five farms were divided amongst various relatives. Mount Vernon passed to Washington's nephew, Supreme Court Justice Bushrod Washington, and thence to his son and grandson, all of whom were forced to sell land to pay the bills. Pestered by visitors on secular pilgrimages who damaged original artifacts as they sought to gather relics of the national hero, Washington's heirs carefully considered various offers for the property before settling on the persuasive entreaties of Ann Pamela Cunningham in 1856. Over the next several years, Cunningham and the Mount Vernon Ladies' Association (MVLA) raised funds to purchase the house for the purposes of preservation and public visitation. The only objects left from Washington's lifetime were the key to the Bastille, a clay bust of Washington by French sculptor Jean-Antoine Houdon, a bust of the Marquis de Lafayette, a globe, and some camp equipment.

The Regents of the Mount Vernon Ladies' Association gathered the finest antiques from their home states to furnish the house, a gesture of homage to Washington's importance to the entire nation and to his gentility. By defining Mount Vernon as a national shrine and by opening it to the public, the MVLA helped ensure that Mount Vernon survived the Civil War as a kind of demilitarized zone. While nearby plantations were occupied by both North and South, subject to raids at various times, the house at Mount Vernon and its immediate surroundings, including Washington's tomb, were sacrosanct. During Reconstruction, while the nearby city of Washington and the monument designed to honor the first president struggled to achieve their imperative grandeur, Mount Vernon was already well-established in the popular imagination as the place to contemplate Washington as an extraordinary individual whose deeds and image were emblematic of American values.

It took decades of dedicated service by the MVLA, and by the many former Washington slaves and their descendants who worked there tend-

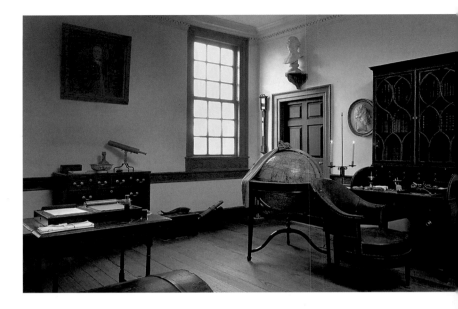

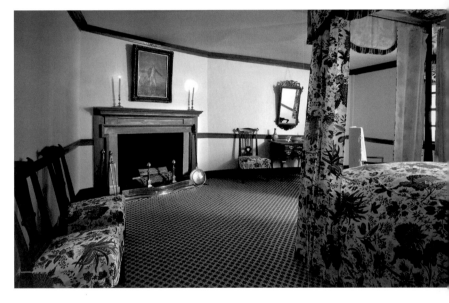

TOP
Washington's study (added between 1774 and 1776) served both as his estate office and as his private sanctuary. The collection of 884 books testifies to his wide-ranging intellectual curiosity.

ABOVE
Added to the original farmhouse in 1758, this bedchamber was used by the Marquis de Lafayette when he visited Mount Vernon.

ing their own family traditions alongside Washington's, to strip away the later alterations and decay that had occurred after Washington's death. The house itself has become virtually inseparable from our image of Washington as the aristocratic hero of the democracy who led when duty called, forged an image of leadership to suit the dignity of the new nation, and then, like the Roman general Cincinnatus, humbly stepped aside to tend his farm. Today, the MVLA pursues meticulous scholarly research to reveal a more authentic picture of the house and estate as Washington knew them.

Hammond-Harwood House

Annapolis, Maryland
Built 1774–78
Architect-Builder: William Buckland
Owned and operated by the Hammond-Harwood House Association

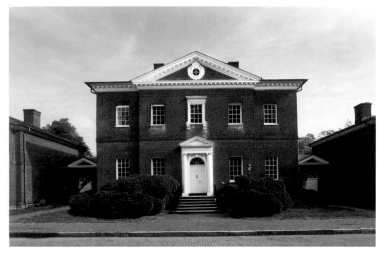

ABOVE

In 1774, tobacco-fortune heir Matthias Hammond hired architect William Buckland to design a Palladian villa on four one-acre lots in downtown Annapolis.

RIGHT

The garden front's brick pilaster strips and pediment serve as schematic reminders of the house's basis in the classical temple form.

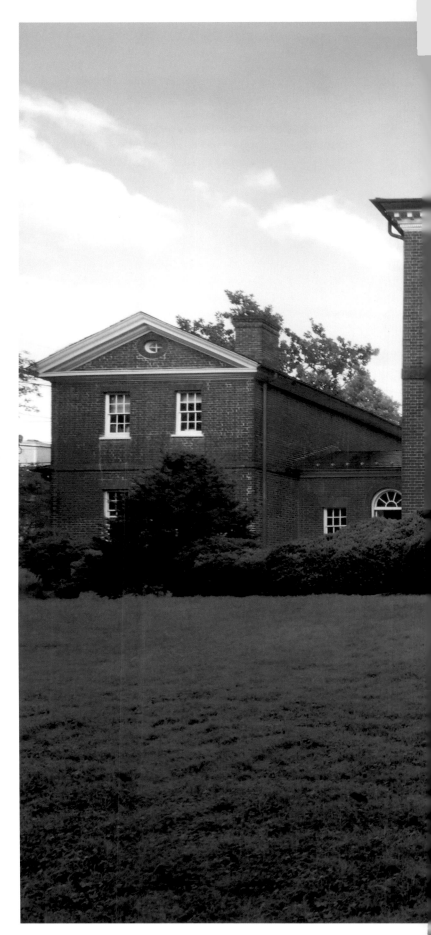

Within a year of his election to Maryland's General Assembly as the representative of the capital city of Annapolis, twenty-five-year-old tobacco heir Matthias Hammond purchased four acres in downtown Annapolis and commissioned a house suited to his new role in society. Unlike gentleman-architects like Washington, Jefferson, and Drayton, Hammond hired an architect to design and oversee construction of his house.

The architect, William Buckland (1734–74), had been trained as a carpenter and furniture maker in his uncle's London workshop. At age twenty-one, he came to Virginia as an indentured servant and soon made a name for himself as the designer and builder of the interiors at George Mason's Gunston Hall (1755–59). Mason's connections and references helped establish the newly free Buckland, and he set up shop in Richmond County with another London-trained carver and some apprentices, making finely carved furniture and architectural elements for the landed gentry. Buckland recognized that the greater opportunity for social advancement lay with the gentlemanly pursuit of architecture, as opposed to the artisanal business of cabinetmaking. The opportunity to design the interior woodwork for Edward Lloyd IV's townhouse in Annapolis (1771–73, now known as the Chase-Lloyd House) prompted Buckland and three of his workmen to pull up stakes and move to Maryland's booming capital city. Matthias Hammond need only have looked across the street from

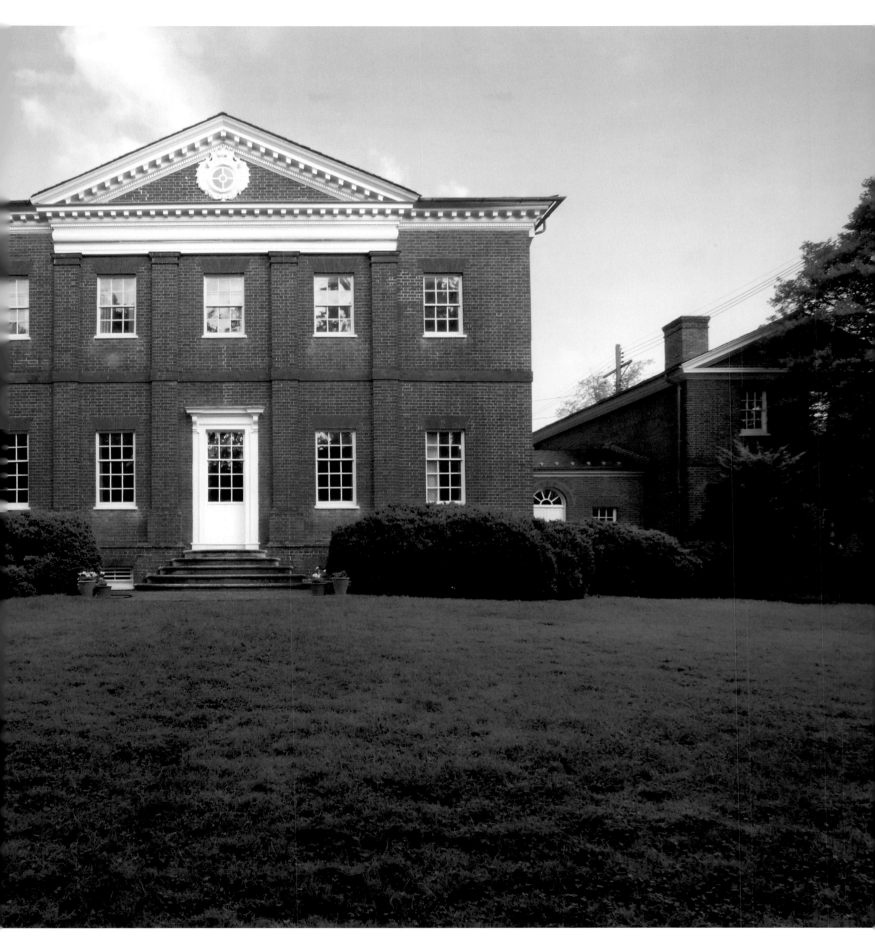

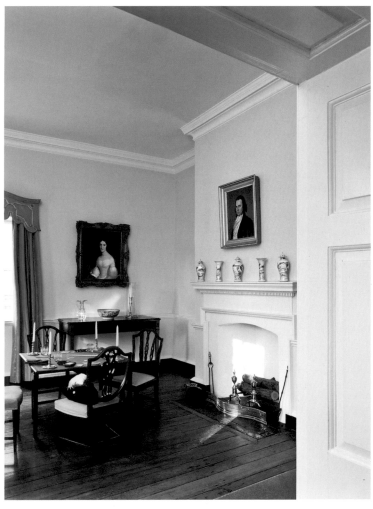

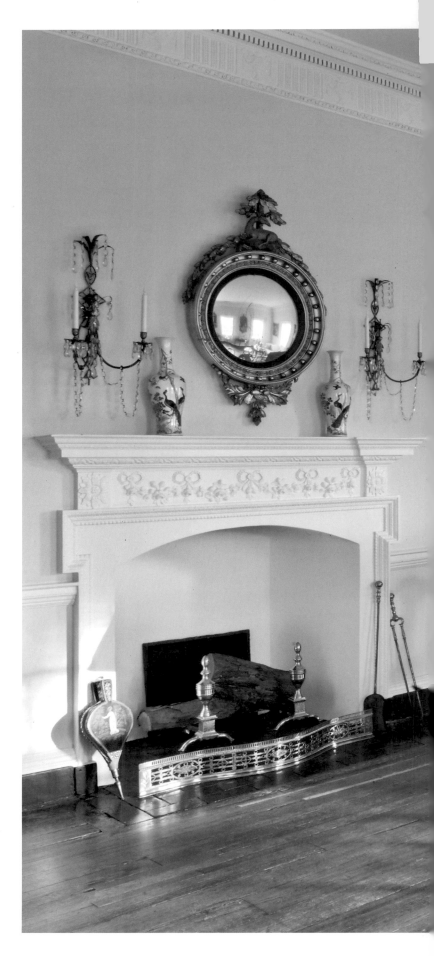

ABOVE

The gaming room is furnished with a card table (circa 1800) by John Shaw and Chinese export porcelain, indicative of the sophisticated social and cultural milieu of Federal-era Annapolis.

RIGHT

The large parlor features Neoclassical architectural elements that may postdate Buckland's lifetime. The chairs (circa 1785) belonged to the Harwood family; the John Broadwood & Sons piano dates to 1806.

his own property to have seen the work in progress at Lloyd's elegant house and to have decided to procure Buckland's services for himself.

It was during this period that Buckland began to call himself an architect. This was quite a jump up the social ladder from "joiner" (Buckland's original designation) or even "builder," because the term "architect" implied that he possessed the aristocratic attribute of classical learning in addition to practical knowledge (which, by virtue of its practicality, belied his lower-class origins). At a time in which books of any kind were luxury commodities, Buckland owned thirty-eight volumes, most of them expensive, illustrated books of architecture and design. Oversized volumes with intricate engravings like Thomas Chippendale's *The Gentleman and Cabinet-maker's Director* (1st ed. London, 1754) and James Gibbs's *A Book of Architecture* (1st ed. London, 1728) were impressive status symbols as well as useful reference works. Buckland's library also con-

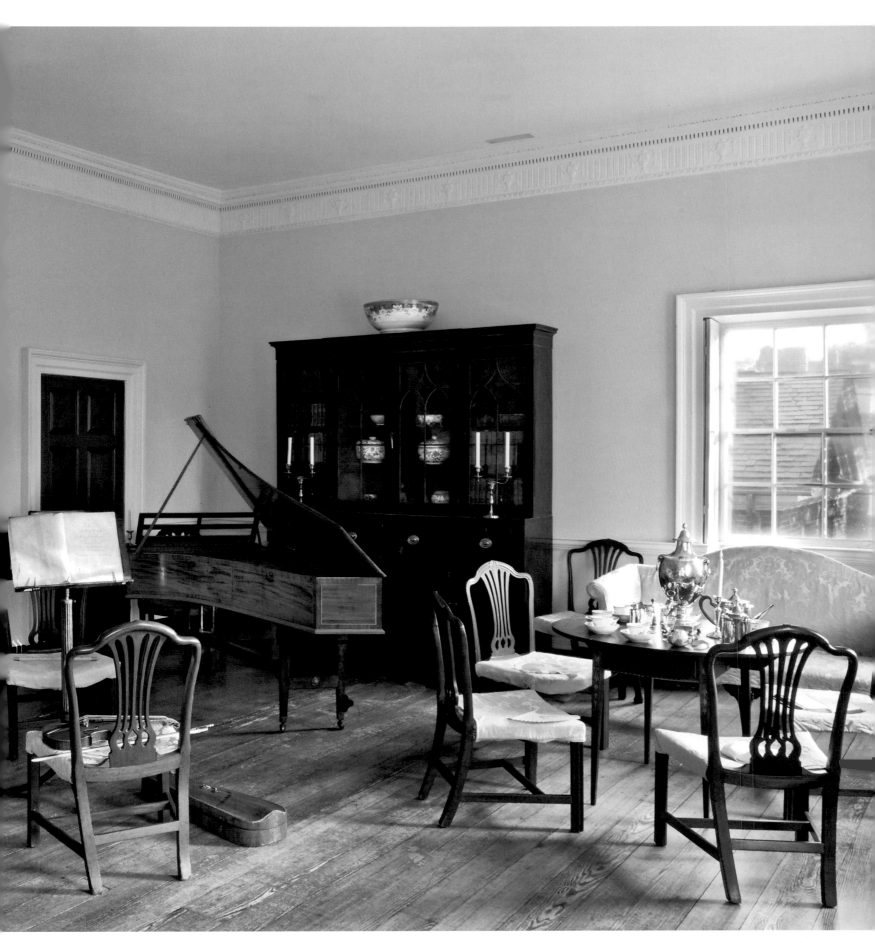

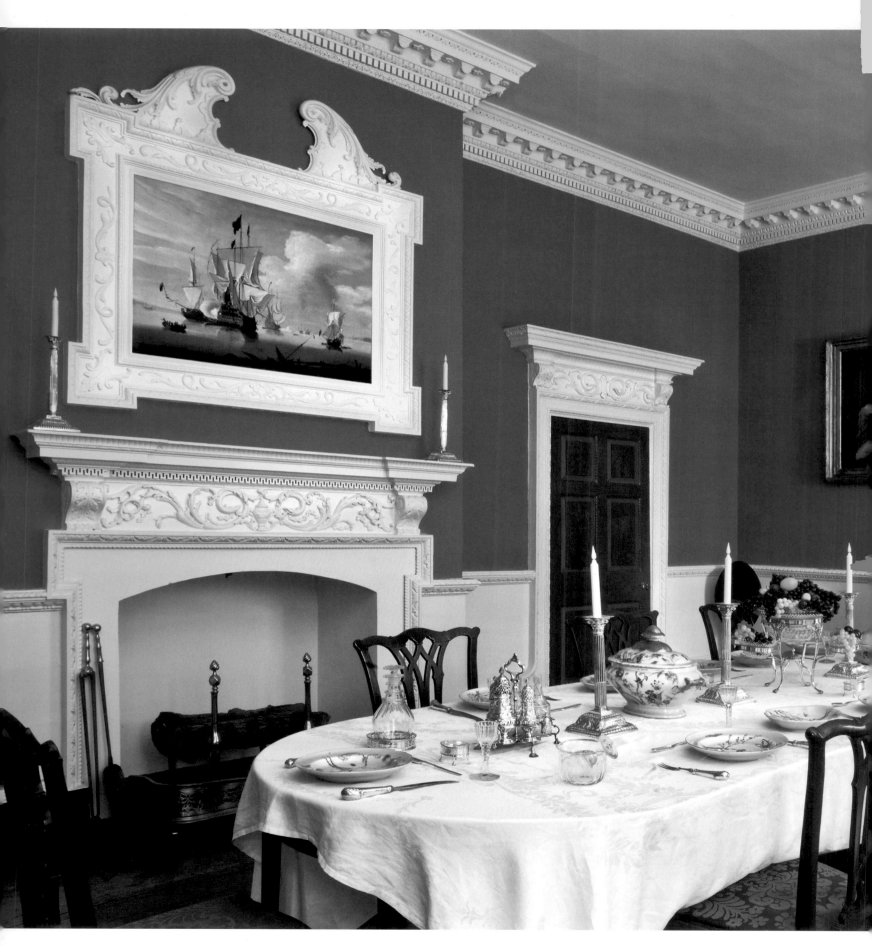

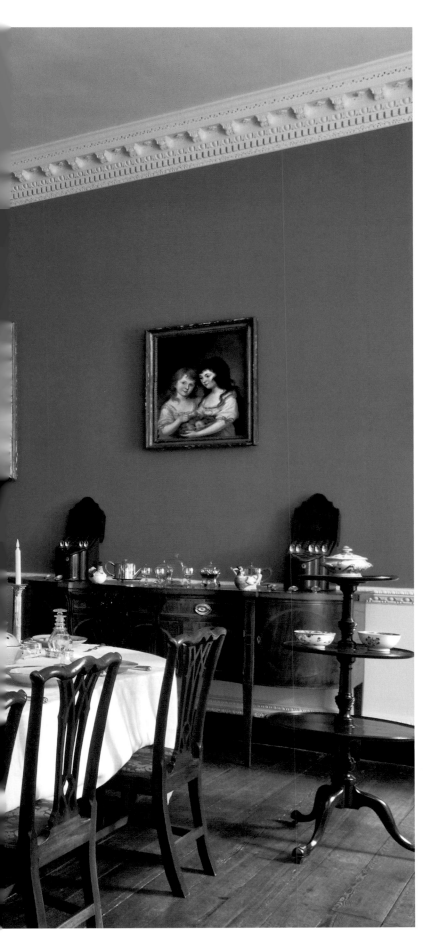

*Portraits of Buckland's daughter Sarah Buckland Callahan
(1789) and her children Sally and Polly Callahan (1791) by
Charles Willson Peale hang in the dining room. Virtually all
of the furnishings are Harwood family pieces.*

*By the time Buckland designed Hammond's house, he employed
highly trained carvers and joiners to execute his designs. The tall
case clock is attributed to John Shaw.*

tained instructional volumes such as Edward Hoppus's *Practical Measur-
ing Made Easy to the Meanest Capacity, by a New Set of Tables* (1st edition
London, 1736).[8]

While Buckland's work began at Gunston Hall and the Lloyd House
after the exterior shell had been designed, Hammond offered the aspir-
ing craftsman the chance to apply his knowledge and skills to the whole
building, exterior as well as interiors. Buckland was so proud at his new
level of accomplishment that he promptly commissioned Charles Will-
son Peale to paint his portrait, with the plans of the Hammond House
clearly visible on the table before him. The Hammond House was
undoubtedly a declaration of gentility for the wealthy client, but it was
even more so for his upwardly mobile designer.

Buckland's skillful adaptation of Palladio's design of the Villa Pisani
at Montagnana, as illustrated in *The Four Books of Architecture* (most likely
by way of neighbor Edward Lloyd IV's copy of Giacomo Leoni's 1742
edition), has often been cited as the Hammond House's claim to greatness
(the claim itself further evidence that Americans still liked to measure
distinction by proximity to European standards). The application of the
five-part arrangement of a center house block flanked by symmetrical
subsidiary structures, joined by arcades or passageways, was characteris-

ABOVE
*A 1789 portrait of William Goldsborough by Charles Willson Peale hangs
to the left of the secretary desk in the parlor. Remarkably, the actual chair in which
Goldsborough is seated in the portrait stands in the same room (foreground).*

RIGHT
A 1728 edition of James Gibbs's A Book of Architecture (*a book owned by
Buckland*) *features a cartouche design strikingly similar to those of the exterior
pediments of the Hammond-Harwood House.*

tic of the rural villa type in Palladio's schema, but Buckland adapted the
form to the urban lot, and made it work. In fact it is the freshness of his
adaptation, drawing not only on theoretical knowledge and precedent
but also on his practical understanding of materials and craftsmanship,
that distinguishes Buckland's work at the Hammond House. The entry-
way demonstrates Buckland's mastery of the Ionic order and proportional
systems of classical architecture, elevated far above its contemporaries by
the crisp, elegant carving of the moldings and ornamental work, from
the Grinling Gibbons–inspired spandrel swags and the frieze, seamlessly
adapted from one of Gibbs's mantelpiece designs.

Tragically, Buckland died at age forty in December 1774, only eight
months after construction on Hammond's house had commenced. While
construction continued, the Revolution intervened and Hammond fled
the city, never to return (or at least not to live in the house he had built).
Thomas Jefferson so admired the house that he sketched it during a visit
to Annapolis in 1783–84.

In 1779, Hammond rented part of the house to Judge Jeremiah
Townley Chase, who eventually purchased the entire property in 1811.
In a fitting coda to Buckland's rags-to-riches story, his great-grandson
married Judge Chase's granddaughter, thus the architect's descendants
became masters of the house until 1924. In 1926, the house was pur-
chased by St. John's College. After a mercifully brief tenure as a frater-
nity house, the Hammond House (now called Hammond-Harwood, in
recognition of its final occupant) was opened as a house museum by the
Federated Garden Clubs of Maryland in 1938. In 1940, the Hammond-
Harwood House Association was established to preserve the house and
its decorative arts collections. In addition to Buckland's magnificent
building, visitors to the site today enjoy a remarkable collection of the
highest quality art of Annapolis's Golden Age, including ten works by
Charles Willson Peale, numerous other works of the Peale painting
dynasty, Chinese export porcelain, and furniture by Annapolitan cabi-
netmaker John Shaw.

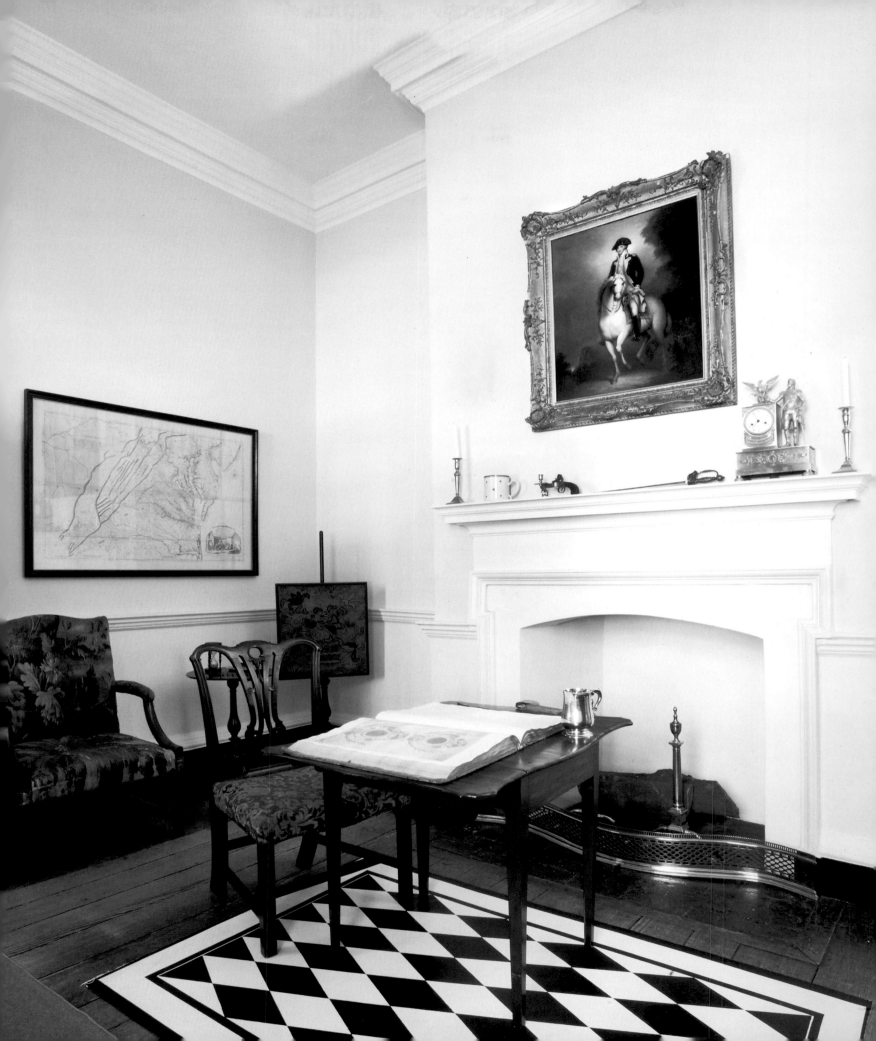

Monticello

Near Charlottesville, Virginia
Begun 1769–74; substantially rebuilt 1796–1809
Owner-Architect: Thomas Jefferson
Owned and operated by the Thomas Jefferson Memorial Foundation, Inc.

ABOVE
Monticello seen from the east, with the southeast piazza (Jefferson's "greenhouse") and the east Venetian porch in the foreground

RIGHT
Jefferson's Monticello was both the functional centerpiece of his five-thousand-acre plantation and a series of architectural experiments aimed at discovering an ideal American classicism.

As a personality, Thomas Jefferson is generally accepted as the most elusive of the founding fathers, whose voluminous letters and writings contain carefully reasoned arguments for contradictory points of view on nearly any topic of the day (except American independence). But when it came to architecture, Jefferson seems never to have faltered in his belief that classicism was the one true language of design. More specifically, Jefferson believed in classicism as codified by Renaissance architect and theorist Andrea Palladio (1507–70): he owned not one but seven versions of Palladio's *I Quattro Libri dell'Architettura.*[9] Palladian classicism—sometimes in its English or French variations and other times in its purely documentary form—drew upon archaeological and literary evidence of antiquity to define an architectural manner which uniquely suited (and may have helped shape) Jefferson's idealized view of rural democracy in America.

Jefferson was an architectural determinist, believing strongly that the right kind of buildings would not merely represent the ideals of the new republic but actually help to promote their achievement. For other gentleman-architects of the age, the audience for the display of architectural erudition and wealth was usually one's neighbors or, in Washington's case, a nation in search of an emblem of its postcolonial identity. For Jefferson, while he undoubtedly had the nation's best interest at heart, the

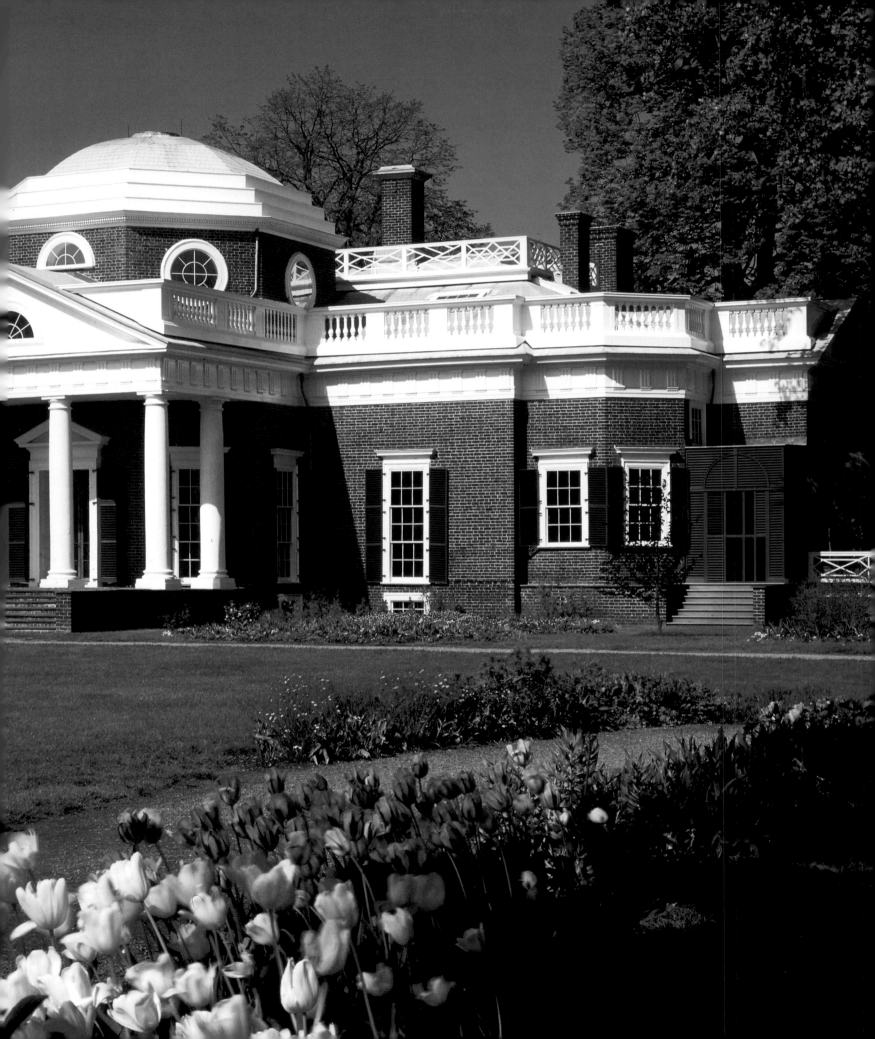

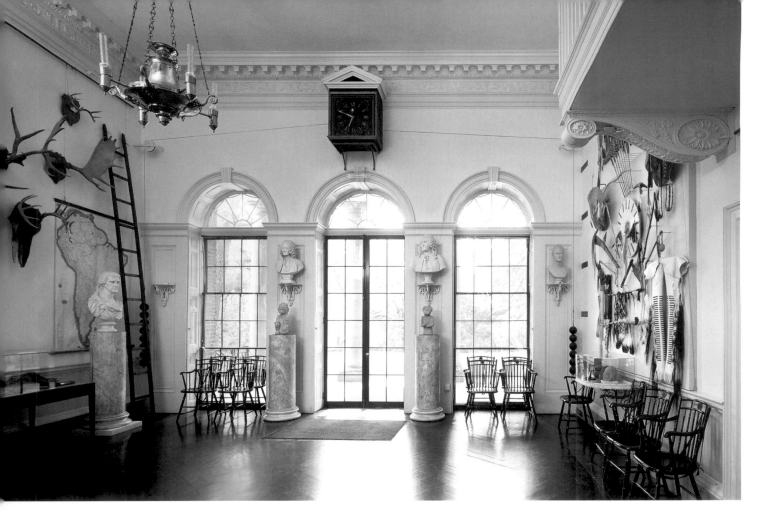

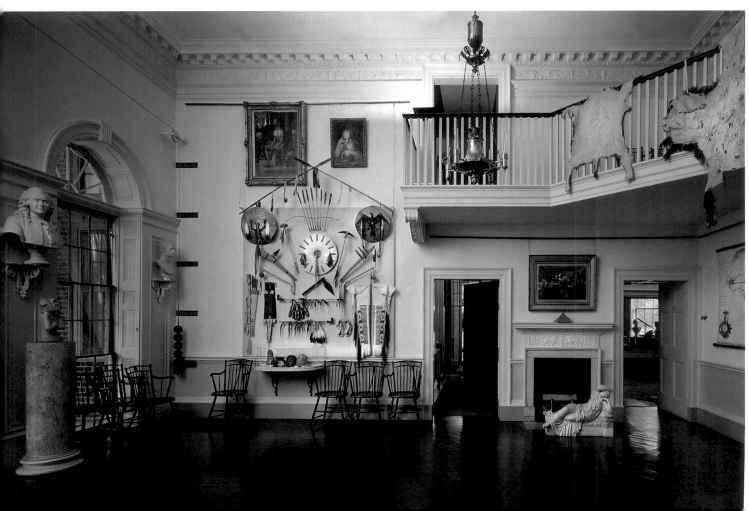

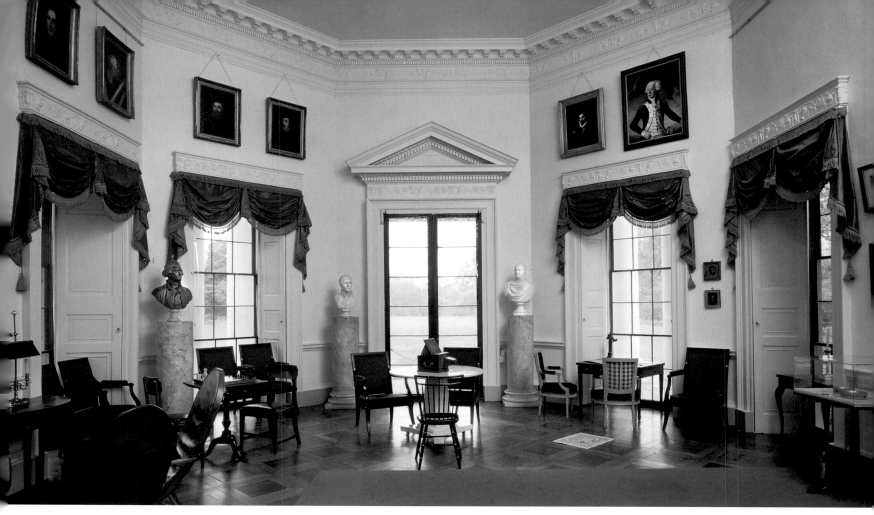

LEFT, TOP
In the entrance hall, Jefferson displayed a polymath's array of natural history specimens, Native American artifacts, works of art, maps, and gadgetry, including the plantation's "Great Clock."

LEFT, BOTTOM
The entrance hall's architecture was another form of didactic display. The frieze ornaments, copied from a French architectural book, represent the Roman temple of Antoninus and Faustina.

ABOVE
The parlor's Corinthian-order frieze and cornice express the social formality and elevated function of the space, while the triple-hung windows and projecting bow lend an essentially Jeffersonian lightness and transparency.

primary audience for his architectural efforts seems always to have been himself, and never more so than at his own house, Monticello. Designs emerged like geometric proofs from an extended process of study, correspondence with knowledgeable friends and architects, and, ultimately, from a kind of Socratic dialogue within his own imagination.

Jefferson (1743–1826) was born near Charlottesville at Shadwell, a typical 1730s Virginia upper-middle-class, one-and-a-half-story wooden farmhouse with four main rooms and a passage on the first floor. He spent much of his youth living with relatives at Tuckahoe plantation, sixty miles east, or away at school. After his father died in 1757, Jefferson inherited Shadwell and its surrounding one thousand four hundred acres (legally transferred when he turned twenty-one in 1764), but the old place was not what he had in mind. Somewhere along the line, his classical education had spawned a passion for classical building, and he began buying architecture books, the first while studying law at the College of William and Mary in Williamsburg.[10] He had already cleared a nearby mountaintop site and begun constructing a new house when Shadwell

burned to the ground in February 1770. Following the fire, Jefferson moved to the mountaintop and began work in earnest on the first version of Monticello.

The first building was a one-room (plus basement) brick structure, now known as the South Pavilion. For at least a year after he married in 1772, Jefferson, his wife Martha, their infant daughter, and Martha's enslaved maid, Betty Brown, lived in the 18' x 18' space. Other enslaved people (including Martha's Hemings relatives) tended the kitchen on the lower level and ensured the civilities of planter social life continued for the Jeffersons while the main house was under construction.[11] The family moved into the main block around 1773 but, in fact, it is not clear if the first Monticello, with its design constantly under thoughtful reconsideration, was ever completely finished: as late as 1794, Jefferson likened his domestic milieu to "living in a brick kiln."[12]

Admittedly, Jefferson had had other matters on his mind in the interim. In addition to keeping up a voluminous correspondence throughout these twenty-two years of near-absence from Monticello, he

While in Paris, Jefferson consciously studied buildings for ideas that he could bring home to the United States in general and to Monticello in particular. He wrote that he became "violently smitten" with an aristocrat's house under construction near the Tuileries gardens, the Hôtel de Salm (built 1782–88), and used to contemplate it during his daily strolls. He noted that all the "new and good houses appear to be a single story," with the main public rooms (parlor, dining room, ballroom) of double height, and the bedroom stories of a more modest 8- to 10-foot ceiling level concealed behind the facade.[14] From his rented French residence, the Hôtel de Langeac, he gained an appreciation for the use of skylights to illuminate interior passageways and stairways as well as the delights of indoor plumbing. Jefferson also encountered French books on Palladian architecture, which featured slightly different rules and applications of the orders than he had previously known.

And, in his irresistibly pedantic way, Jefferson ensured that the second Monticello displayed an academically correct sequence of classical orders: Doric, Ionic, Corinthian, and Attic. (Jefferson did not include the Composite order, which was expressly forbidden by Roland Fréart de Chambray, author of the first complete French translation of Palladio in 1650).[15] Jefferson also included variations of the classical orders by other authoritative French theorists, especially those who had made direct study of ancient Roman buildings. In social behavior as well as in food and wine, Jefferson certainly wanted to live like a Frenchman, but his French influences are better understood as part of a broader effort to absorb the essential principles and details of an absolute, ideal classicism.

While Jefferson would again be absent from Monticello much of the time while serving as the third president of the United States (1801–09), the 1796 designs for Monticello seem to have been fairly well achieved by the time he returned in 1809. Although Jefferson left office $30,000 in debt (equivalent in buying power to at least $500,000 today), he plunged into decorating, expanding, and refining Monticello as well as completing his octagonal retreat, Poplar Forest, ninety miles away. Visitors to Monticello found a peculiar mixture of grandeur and simplicity in the place and its owner. In 1816 Richard Rush found the place, "Artificial to a high degree; in many respects superb. If it had not been called Monticello, I would call it Olympus." Still others found the grounds overgrown, the house chaotically piled with books, and the quirky gadgets and experiments of the renowned owner baffling to their expectations of aristocratic formality.[16] But to Jefferson, aristocracy was primarily an intellectual rather than a social condition. By this definition, Monticello was definitively aristocratic.

While, in his retirement, Jefferson endlessly pondered his reputation for future generations of historians, he apparently did not worry much about the next generations of his own family—he incurred more and more catastrophic debt, to the extent that he petitioned the Virginia legislature for permission to hold a lottery for his financial relief. Following his death in 1826, Monticello, its contents, and even its enslaved people were sold to pay the price for Jefferson's insistent representation of himself as a gentleman, architect, democratic role model, and classical idealist. Nearly a century later, in 1923, the not-for-profit Thomas Jefferson Foundation was founded to represent and interpret Jefferson's legacy through the preservation, restoration, operation, and ongoing study of Monticello.

wrote *A Summary View of the Rights of British America*, the *Declaration of Independence*, the *Statute of Virginia for Religious Freedom*, and *Notes on the State of Virginia*. By the time he returned to Monticello (for a few years, at least) in 1796, he had served as a member of the Virginia House of Burgesses; delegate to the Second Continental Congress; and governor of Virginia, followed by five years spent in Paris as U.S. minister to France and four in New York and Philadelphia (where he could not refrain from remodeling his rented house) as Washington's secretary of state.

The decision to expand his barely completed eight-room house at Monticello to twenty-one rooms in 1796 seems to reflect the enlarged scope of his experiences in the interim, particularly his eye-opening years in Europe.

Like Washington at Mount Vernon, Jefferson built around the old house, five rooms of which remain at the core of Monticello as it exists today. Most striking, of course, is the application of a dome to the house, a form previously associated in the United States with public buildings. On a 1786 visit with John Adams in London, Jefferson had visited Lord Burlington's Chiswick (1726–29), a quintessential Anglo-Palladian villa featuring, like Monticello, an octagonal drum dome and Roman bathform window over the pediment. Ironically, given the similarity, Jefferson wrote that Burlington's dome had an "ill effect." (Jefferson's version has a proportionally shorter drum).[13]

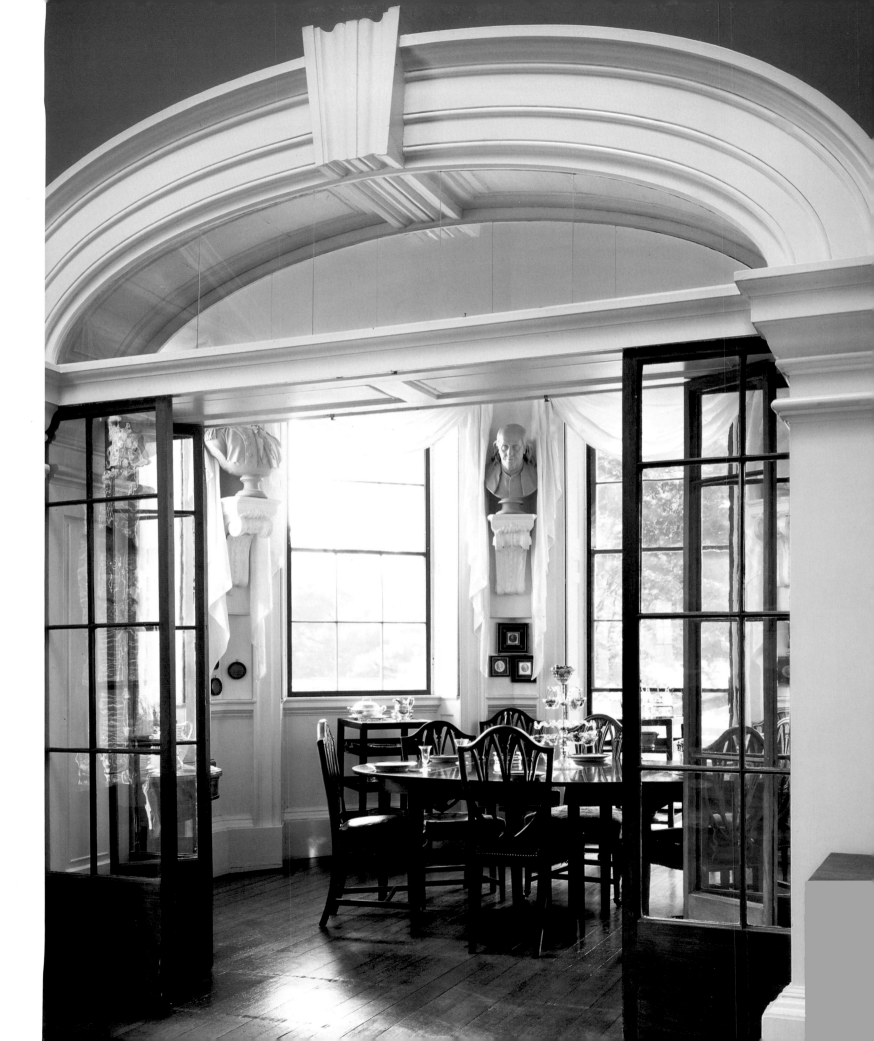

Tryon Palace

New Bern, North Carolina
Built 1767–70; burned 1798; reconstructed 1952–59
Architect: John Hawks
Owned and operated by the State of North Carolina Department of
Cultural Resources, Office of Archives and History; North Carolina
Historic Sites; Tryon Palace Historic Sites & Gardens

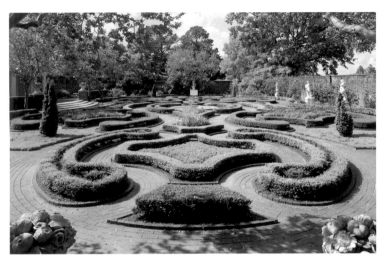

ABOVE
*The Tryon Palace historic site includes three house museums and thirteen gardens
representing periods of North Carolina's history from the colonial era through the
Civil War.*

RIGHT
*Tryon Palace was reconstructed in the 1950s using architect John Hawks's original
plans from the 1760s.*

Royal Governor William Tryon (1725–88) was a good "company man," which has not served his reputation particularly well in post-Revolutionary American historical accounts. A distinguished military officer in England, his main charge as governor of North Carolina (1765–71) was to represent increasingly unpopular royal authority. One of his first acts as governor was to suspend the colonial assembly rather than risk their passing a resolution in protest of the Stamp Act.

In spite of this action, in December 1766 the chastened assembly authorized the expenditure of 5,000 pounds for Tryon's pet project, the building of a Governor's Palace. Tryon had brought an architect, John Hawks, along with him when he sailed from England a year and half earlier, suggesting that the construction of a suitably authoritative royal building may have been part of his official charge. Final plans were submitted to the crown in early 1767, and later that year Tryon sent for Alsatian cartographer, engineer, and landscape architect Claude Joseph Sauthier (author of the 1763 book *A Treatise on Public Architecture and Garden Planning*) to map the region and, not coincidentally, to design formal gardens for the palace. While the architect Hawks journeyed to Philadelphia to recruit experienced woodcarvers for the palace project, Tryon convinced the legislature to levy a three-year statewide tax to raise

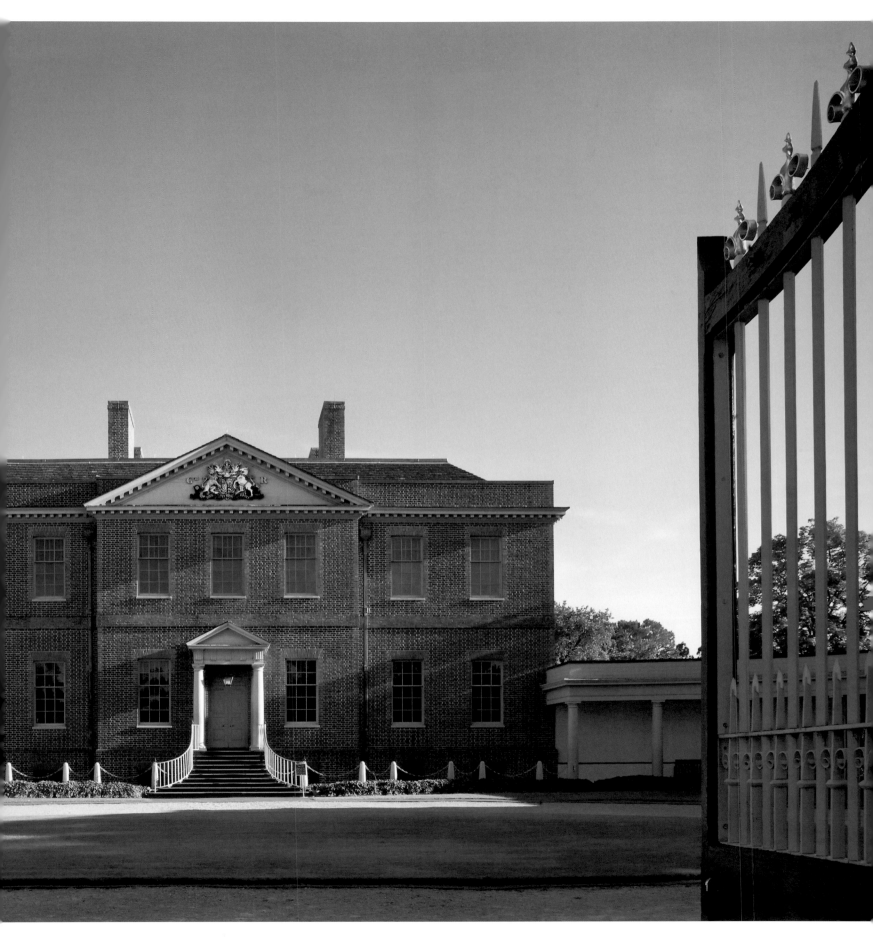

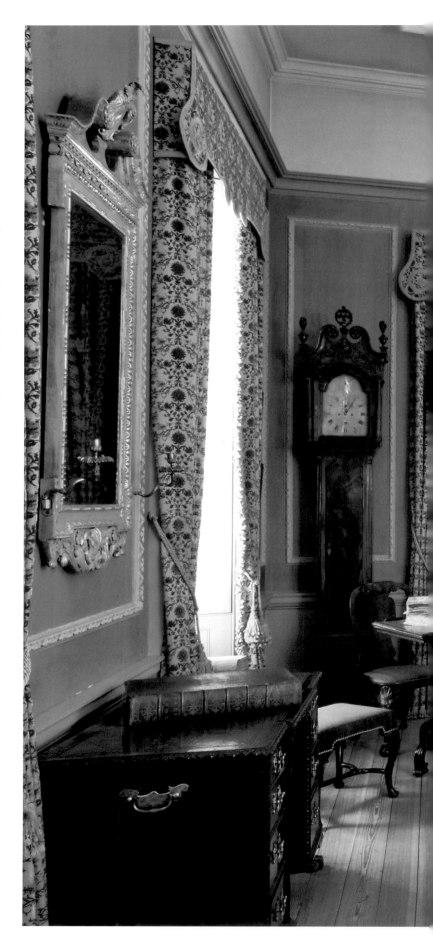

additional funds to pay for it. This did not sit well with many people, particularly residents of the western mountains.

Hawks's Anglo-Palladian building, based on a design from James Gibbs's *A Book of Architecture* (1728), was surely calculated to compete with the Virginia Governor's Palace in Williamsburg, which was still in royalist fashion almost fifty years after its completion. Built of red brick, Hawks's palace design spanned a full seven bays wide, with a pedimented frontispiece upon which were displayed the royal coat-of-arms. The forecourt between its two wings stretched 146 feet in width. Underlying the whole was an extensive cellar featuring state-of-the-art lead pipes and clay sanitary lines for indoor plumbing, installed by a plumber brought over from London for the job. While the palace faced the town, the rear facade and grounds overlooking the Trent River were also attractively finished for ceremonial arrivals by boat. The interiors featured marble floors, elaborately carved fireplaces in rare imported marble, and a showcase of woodworking and joinery. With the lavish new building completed, Tryon petitioned the crown for funds to purchase appropriately grand furnishings.

While members of the assembly thanked the governor for his supervision and enthusiastically approved the "elegant and noble" building in December 1770, not everyone was so eager to accept Tryon's palace as a symbol of royal authority and collective pride.[17] Western protestors seized upon the palace as a symbol of class inequality and, specifically, their own oppression by the coastal elite. Following several incidents in which royal judges refused to hear cases for fear of violent reprisals, Tryon sent in a militia which defeated two thousand Western "regulators" in the Battle of Alamance in May 1771. Tryon's reward for defending royal authority in North Carolina and its symbol, the governor's palace, was an almost immediate transfer to the governorship of New York, where he arrived on July 8, 1771. Sauthier, the garden designer, went with him as official mapmaker. Hawks, the architect, remained in North Carolina.

North Carolina's new royal governor, Josiah Martin, arrived during August 1771, and was even less popular than Tryon. Seeing the proverbial writing on the elegant and noble walls, soon after the fateful gunshots at Lexington and Concord in April 1775, Martin fled the palace and the state.

After the Revolution, the former palace was rechristened the new state capitol, and George Washington dined and attended a ball there in 1791. Nonetheless, it was unceremoniously abandoned when Raleigh became the new capital city in 1792. Tryon's extravagant emblem of royal authority was rented for a variety of non-royal uses including a Masonic lodge, a boardinghouse, and a dancing school. In 1798, fire destroyed the main building. The flanking kitchen building survived until the early nineteenth century; the original stable building remains intact today.

In the 1930s, spurred by the example of Colonial Williamsburg, a

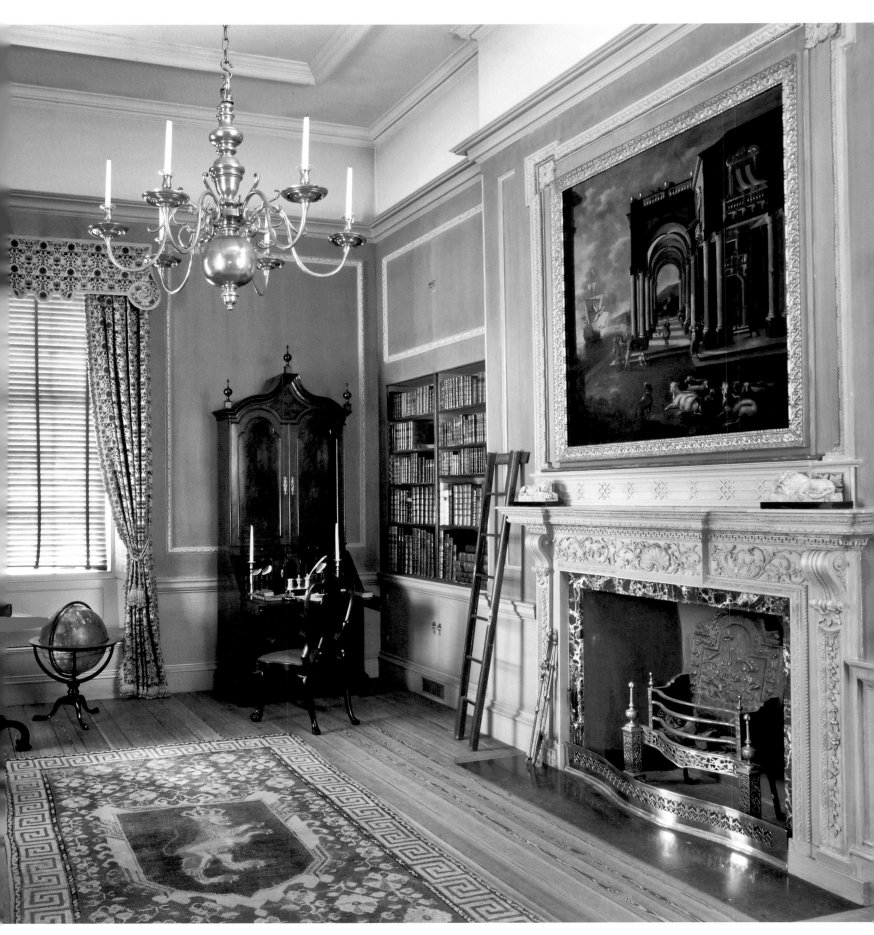

ABOVE
The skylit mahogany and walnut "floating" staircase is one of the most dramatic features of architect Hawks's design.

RIGHT
Fine architectural details, meticulously recreated in the 1950s, emphasize the craftsmanship and elegant lifestyle enjoyed by the colonial-era governors.

movement to reconstruct North Carolina's first capitol gained strength when volunteers discovered John Hawks's original architectural plans in a British archive. Descriptions, maps, and drawings attributed to Sauthier, some located in Venezuela, provided additional and compelling evidence upon which to proceed. Efforts stalled during World War II, but a group of advocates challenged the state government to support the privately funded reconstruction efforts. In 1945, the legislature created a commission to oversee the reconstruction, and the state agreed to maintain and operate the completed site. The reconstructed palace, involving craftsmen and materials imported from across the United States and Europe, was finally opened to the public in 1959.

While it is not clear if Governor Tryon ever got the royal decorating allowance he had requested, he did make a detailed inventory of his possessions less than two years after he had left New Bern. While this inventory provided a broad outline of what furnishings Tryon might have had at New Bern, the palace interiors were restored in the 1950s to showcase the finest eighteenth-century English and American decorative arts, even when that goal tended to exaggerate the (already considerable) quality of Tryon's known collection. In recent years, Tryon Palace's curatorial staff has conducted new research and reinstalled many interiors to more accurately reflect the appearance and social milieu of the governor's controversial household during the colonial period.

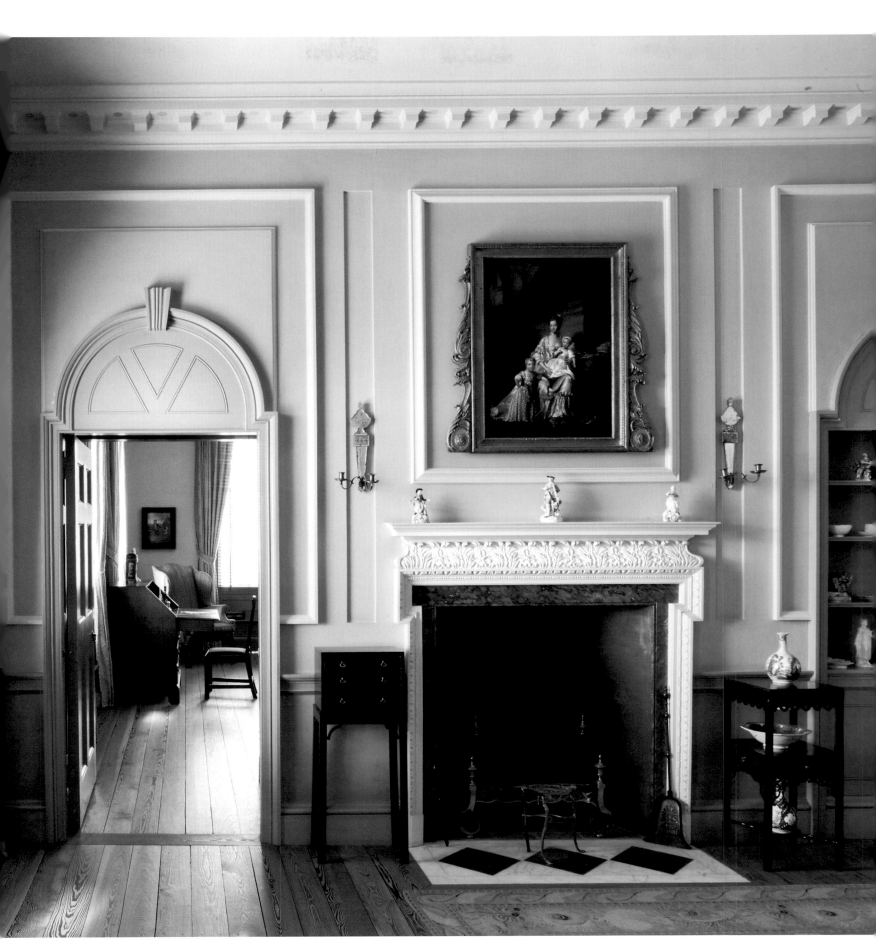

PART II

1800–1820

The Hermitage, home of Andrew Jackson, Nashville, Tennessee

Homewood

Baltimore, Maryland
Built: 1801–06
Owner-Builder-Designer: Charles Carroll of Homewood;
Robert and William Edwards, contractors
Owned and operated by the Johns Hopkins University

In 1752, Baltimore had twenty-five buildings (including a tavern and a church) to accommodate its two hundred residents. The shipping trades in sugar and tobacco led to rapid growth, and, by 1774, the town boasted 560 houses and a population of nearly six thousand (about the same size as Manhattan, Charleston, or Boston). With the growth of commerce came the beginning of a gradual shift from the exclusive domination by the landed gentry of cultural, economic, and political spheres to the increasing influence of a mercantile, patron class that identified with the urban landscape as the primary locus of prestige. Homewood was built by the scion of a great planter family that learned to capitalize on the new economy, and demonstrates the willful cultivation of a new-found urban cosmopolitanism that was skillfully interwoven with well-established notions of the Palladian villa type as the architectural manifestation of gentlemanly virtue.

Homewood is the creation of Charles Carroll, Jr. (1775–1825), the son of Charles Carroll of Carrollton (helpfully designated "The Signer") whose grandfather had immigrated to Maryland in 1688 to escape anti-Catholic persecution in the family's native Ireland. By the time of the Revolution, The Signer was generally believed to be the wealthiest individual in the colonies, the standout in an extended family well-stocked with diligent, patriotic overachievers, including the first Roman Catholic bishop in the United States. The only Roman Catholic signer of the Declaration of Independence, Carroll outlived Jefferson and Adams, surviving until 1832. His longevity and business acumen gave him ample time to leverage his extensive landholdings and enter the lucrative field of commercial banking and the brand new business of railroads.

In 1800, The Signer gave his one surviving son, Charles Carroll, Jr., a generous wedding present of 130 acres of land just north of Baltimore City, a hilltop retreat far from the pestilential fug of the crowded commercial waterfront. Less kindly, perhaps, was the allowance of $1,500 to fix up some undistinguished frame buildings on the site. The Carroll family knew about the importance of architecture as a public declaration of identity; most of the great plantation houses of the region, such as Hampton and Mount Clare, as well as distinguished townhouses in Annapolis, bore some connection to the family. The Signer had recently built the much-remarked Palladian-style villa Brooklandwood (1787) for Junior's sister and her husband, and his wife's sister was mistress of nearby and much-remarked Belvidere (1794). The intimation that Junior should make due with a fixer-upper hints at the tenor of the father's opinion of the son. Spurred perhaps by sibling rivalry, driven by a sense of dynastic entitlement, and either in defiance of or oblivious to his father's opinion, Charles Carroll, Jr., leveraged the impending arrival of his first child to prod The Signer into granting him an additional $10,000 to build a better house, worthy of a Carroll heir. Hoping that the project would at least

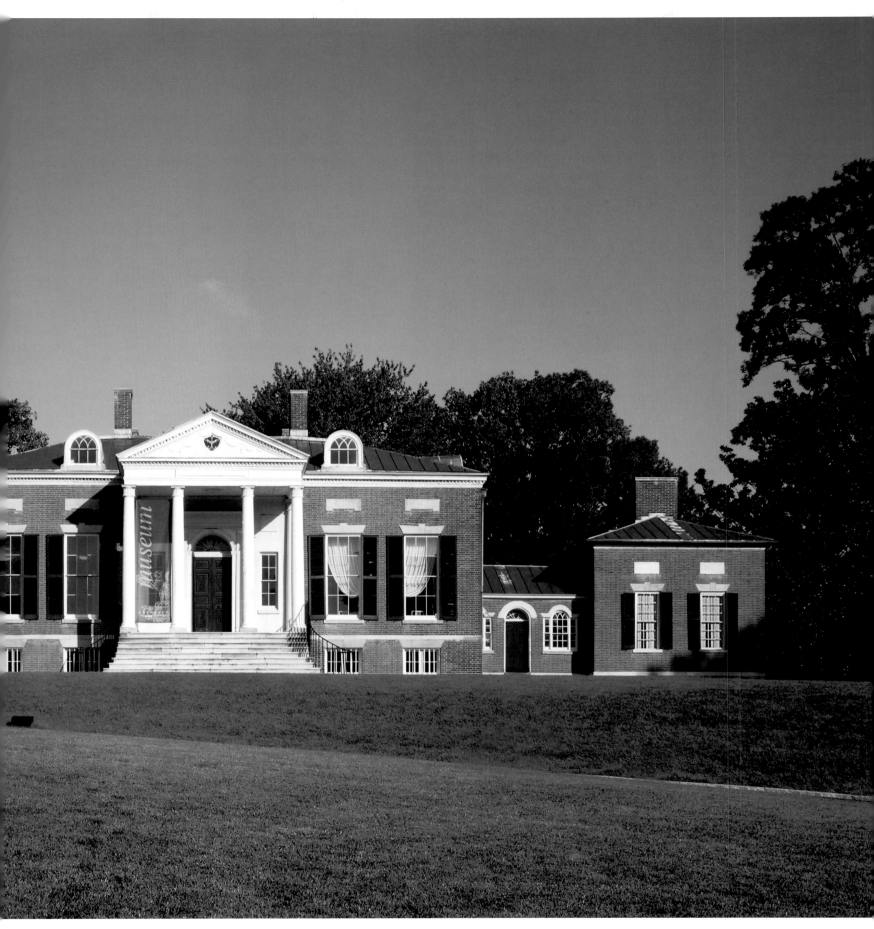

PREVIOUS PAGES
Homewood's five-part plan is quite conservative, perhaps a statement of the Carroll family's wealth and long-standing presence in Maryland, while its architectural details are fully Federal in style.

ABOVE
Carefully planned vistas invite visitors from one space to the next. Throughout the house, cornices are cast plasterwork, while all other decorative elements are carved wood.

RIGHT
The light and airy feel of the house was not only a stylistic choice but also a practical one: large window openings kept the house cool during sweltering Baltimore summers.

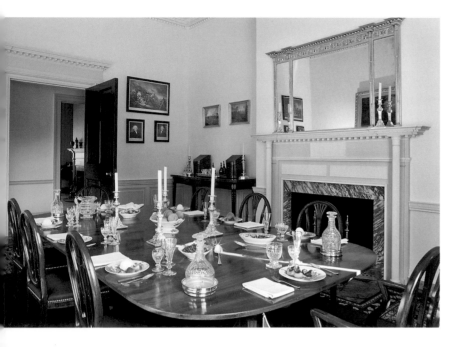

TOP

The dining room chimneypiece includes the unusual detail of freestanding columns. King of Prussia marble is used for the firebox surrounds and hearths throughout the house.

ABOVE

The side chamber was primarily used as an office and retains original shelving in the cupboards. It connects to a bedchamber and may have sometimes been used as a dressing room.

RIGHT

An imported cast-iron fanlight and sidelights are surrounded by extravagantly carved wooden details. Designs throughout the house have been identified in William Pain's The Practical House Carpenter *and* British Palladio.

teach his son good management skills, The Signer handed over the first of many deeply begrudged sums to build Homewood.

The resulting great house was a showplace of high-style design inspired by published works of Palladio and Scottish Neoclassicist Robert Adam, seamlessly melded with local craftsmanship of the highest order. Carroll updated the by now axiomatic five-part Anglo-Palladian villa plan, altering the proportions to make the blocks appear to be only one story in height, with children's and guest bedrooms concealed under eaves, lit by dormers. The frontispiece features a pedimented portico with Corinthian columns, an assertive choice given that Jefferson himself was using the less elaborate Doric order in his near-contemporary work on Monticello's west portico. Carroll's use of the elaborate Corinthian order not only connoted a higher status of function or occupant in the canonic socio-architectural hierarchy of the period but also demonstrated considerable expense and access to skilled woodcarvers. The pediment is punctured by an elaborate cartouche-shaped window, allowing light to enter the attic, and ornamented with delicate swags, typical of the Adamesque decorative vocabulary that came to dominate the Federal period in the United States.

In plan, Homewood has a traditional axial center hall with two rooms on either side. While Carroll eschewed the trendy oval or polygonal rooms just arriving in fashion, he did animate the front and rear hallways with shallow, elaborately ornamented plaster groin vaults, indicative of the new taste for more plastic space and visual complexity. Large wall openings suggest the rising Romantic interest in landscape views, but there was also more than a bit of conspicuous consumption in the display of expensive glass windows and fanlights embellished with intricate Neoclassical tracery patterns, inspired by arcane ancient sources, as known from expensive, rare books. In addition to the main house, Homewood included a carriage barn and privy (both of which still stand) as well as a bathhouse, a dairy, a smokehouse, an icehouse, and quarters for Carroll's seventeen enslaved African-American workers.

Although Carroll may have moved into Homewood as early as 1802, work continued for another six years. His father kept threatening to cut off funding and complained of his son's extravagance, which he attributed to either "want of thought or a silly pride."[1] Carroll, Jr., already a well-known alcoholic, probably did not benefit much from his father's constant reminders of how much of a disappointment he was, but he also was not deterred from spending more. Homewood ultimately cost The Signer a well-documented $40,000—four times the original budget and a quite astonishing sum at the time. In 1816, Carroll's wife gave up on him and, with support from The Signer, took their five children and moved back to live with her family in Philadelphia. Carol died in a religious retreat house—an early-nineteenth-century rehabilitation clinic—in 1825.

In 1838, Carroll heirs sold Homewood to the Wyman family, who bequeathed it to the Johns Hopkins University as the center of its new campus (named, and architecturally inspired by, Homewood) in 1902. The university used it for a variety of purposes until restoring it and opening it in 1987 as a house museum, furnished with an impeccable collection of period antiques and decorative arts. Charles Carroll, Jr., was not quite the chip off the old block his father had hoped for, but his determination to represent his family's status, wealth, and influence has made his house an enduring and worthy tribute to the illustrious Carroll family name, and to the dawning of Baltimore's Golden Age.

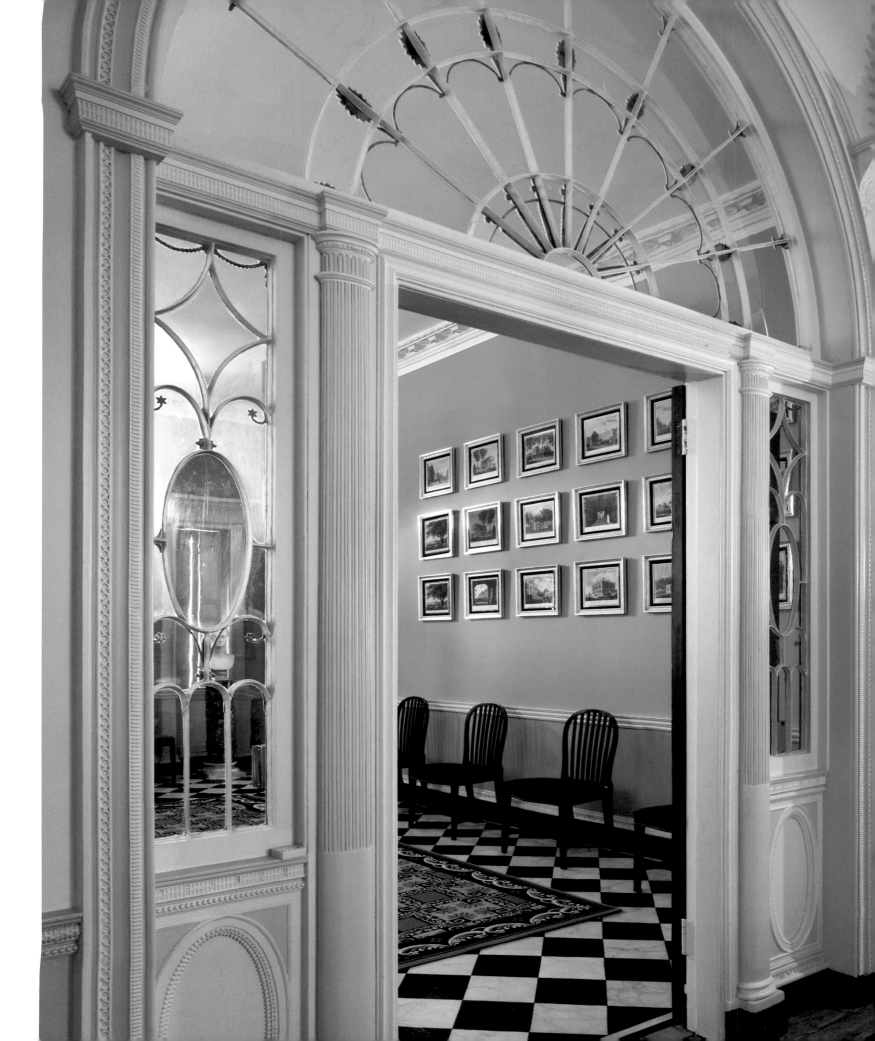

Tudor Place

Georgetown, Washington, DC
Built 1805–16
Architect: William Thornton
Owned and operated by The Tudor Place Foundation, Inc.

ABOVE

*Tudor Place's center hall, called "The Saloon," boasts a semicircular wall
of windows that creates a dynamic play between the interior space and the exterior.*

RIGHT

*The grand five-part house rises from a commanding site in Georgetown
that once overlooked the Potomac River below.*

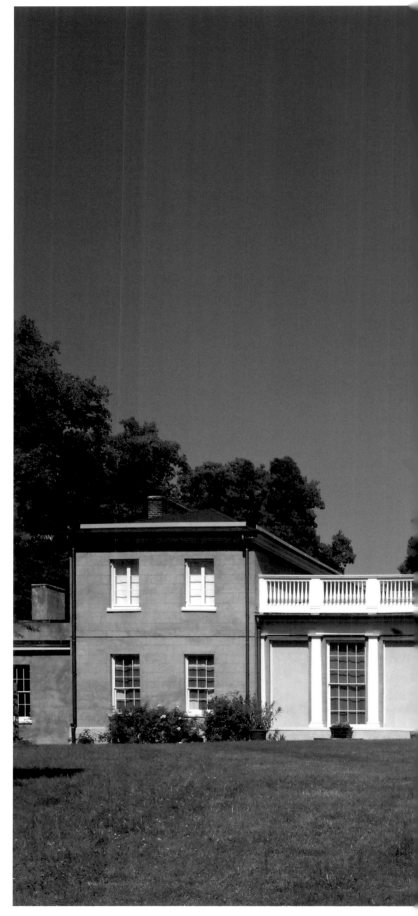

Tudor Place reflects both its owners' and its architect's adaptation
of the new architectural language of official American buildings
to the domestic sphere. At Tudor Place, the connection is particu-
larly direct, insofar as the occupants not only resided in the new capital
city of Washington, DC, but also held a particularly strong wish to con-
vey their status and identity as heirs of George Washington.

The owner of Tudor Place, Thomas Peter, was the son of the mayor of
Georgetown and heir to a sizeable tobacco fortune, but the definitive fam-
ily link was that of his wife, Martha Peter, née Custis, who was Martha
Washington's granddaughter via Mrs. Washington's first marriage to
Daniel Parke Custis. Because the Washingtons had no children of their
own and because of the untimely death at Yorktown in 1781 of Martha's
last surviving child, John Parke Custis, his children became wards of the
first president. The two youngest Custis children, Eleanor and George,
were raised by the Washingtons, while the older two, including Martha,
were sent off to school. Still, the four Custis children considered Mount
Vernon their home, and Washington their stepfather.

Although there were several architects anxious to make their mark on
the new capital city in the 1790s, the Custis children all selected archi-
tects of the Capitol building itself to design their houses. It was surely not
mere coincidence that Dr. William Thornton designed houses for three
Custis women.

With some backstage coaching from Jefferson and Washington (a fel-
low Freemason), the gentleman-physician-scientist-architect Thornton

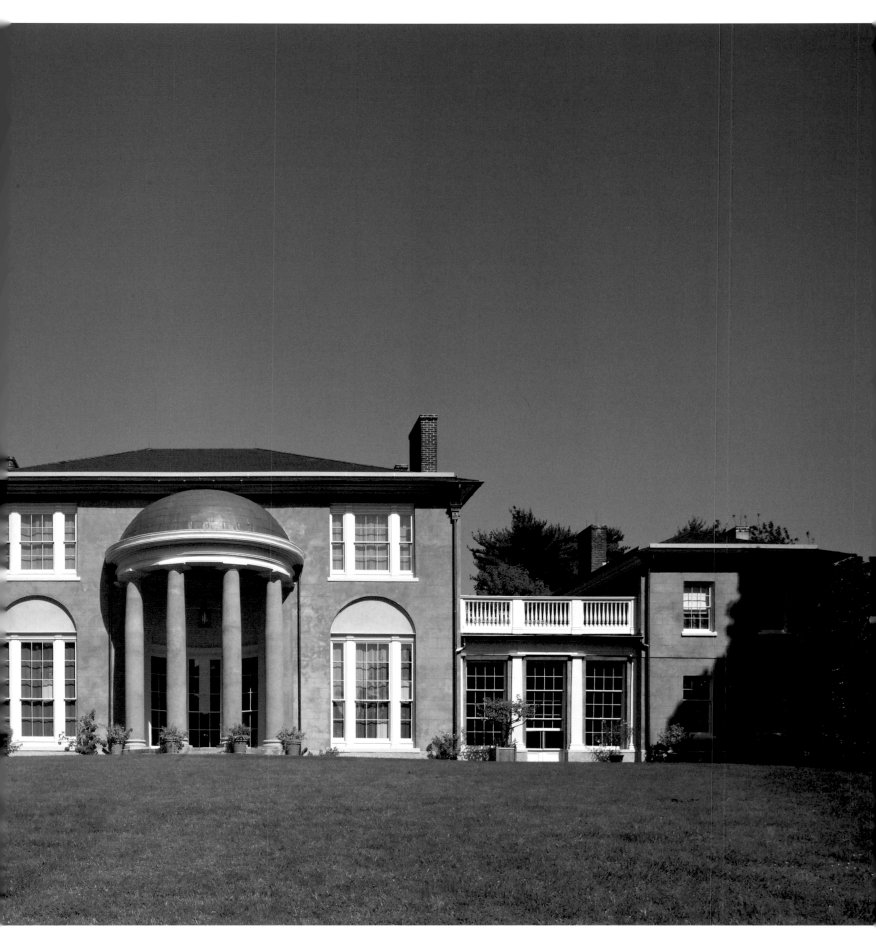

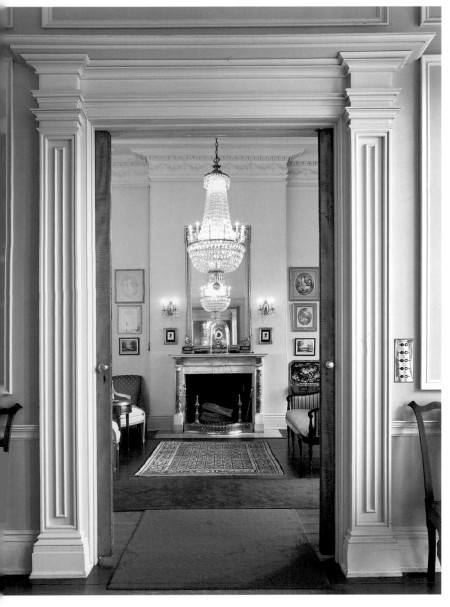

The drawing room displays a characteristically seamless mix of artifacts from six generations of the Peter family, descendants of Martha Washington.

RIGHT
Sam Collins, an African-American craftsman, made the plaster entablature for the drawing room circa 1810. The room was the scene of many formal entertainments, including an 1824 reception for the Marquis de Lafayette.

had won the design competition for the U.S. Capitol in 1793 (much to the chagrin of full-time architect and eternal rival Benjamin Latrobe). Thornton, born in the West Indies and educated in England and Scotland as a physician, was a personal friend of Thomas Jefferson, James Madison (with whom he had shared a boardinghouse in Philadelphia operated, aptly, by a woman named Mrs. House), and, most importantly, George Washington. Thornton was called upon by the family to attend the dying Washington (whom he planned to resuscitate with transfusions of sheep's

blood) and referred to the president as "the best friend I had on Earth."[2] He served eight years on the commission charged with overseeing the new capital city's layout and construction and, from 1802 to 1828, as first superintendent of the U.S. Patent Office. While Thornton did design John Tayloe's house and occasionally advised Jefferson on the design of the University of Virginia (specifically, Pavilion VII), he did not pursue architecture actively as a career. To have done so may have been too close to "work" to conform to notions of gentlemanly service as appropriate to his social status. Thus, Thornton was not a fashionable architect whose services were available to just anyone. His identity as George Washington's architect of choice for the Capitol and trusted family friend qualified him as the appropriate architect to represent the status of the Custis children as heirs to the Washington dynasty.

The oldest sister Eliza and her husband, Thomas Law, consulted Thornton about designing a house for them on Capitol Hill in 1798. The project never came to fruition, although the plan they commissioned may have been the basis for Tayloe's Octagon House (1799–1800), Thornton's only non-Custis residential commission. Eleanor, the youngest sister, married George Washington's nephew Lawrence Lewis in 1799, and they commissioned Thornton to design Woodlawn, a conservative but highly refined five-part country house set on two thousand acres given to them by Washington near Mount Vernon. In 1806, the sole brother, George Washington Parke Custis, broke the mold by hiring George Hadfield, one of Thornton's successors (and contentious rival) on the U.S. Capitol project, to design his house at Arlington as a self-proclaimed "shrine" to George Washington in a boldly declarative Neoclassical style. Hadfield, like Thornton, did not usually design private residences, indicating that the Custis children and the architects may have seen these particular houses as unusual—perhaps even semipublic—in their architectural, social, and historical significance.

Thornton's design for Tudor Place combines traditional functional arrangements of space with a new treatment of geometric forms and surfaces that was part of the new international wave of Neoclassicism, stylistically associated with republican politics in the United States and France. (The less consistent political uses of the English and German versions could easily be overlooked, or transformed by the new American context). The Romantic idea of the house as a garden pavilion drew on classical literature and landscape paintings that depicted classical subjects, such as those of Claude Lorrain. The Peter family referred to the circular portico as "the temple."[3] The use of a domed, half-projecting, half-recessed temple form on a private house, probably linked to designs by British architect John Soane, was highly unusual in the United States at the time, and was hardly a gesture of self-effacement by the Peter family.[4]

The previous owner of the site had begun construction of the two flanking structures, and Peter's desire to retain those buildings dictated the scale and siting of Thornton's design. Although strongly Neoclassical in its detailing and assertive geometric simplicity—emphasized by the flat surface stucco finish concealing the grid of rough-textured red brick—the house still retains the Palladian five-part arrangement typical of Virginia and Maryland houses for the past century. Aside from the concave wall in the saloon, occasioned by the temple portico, the rest of the rooms are conventional rectangles. The safety and comfort of keeping the kitchen equipment and mess away from the main house

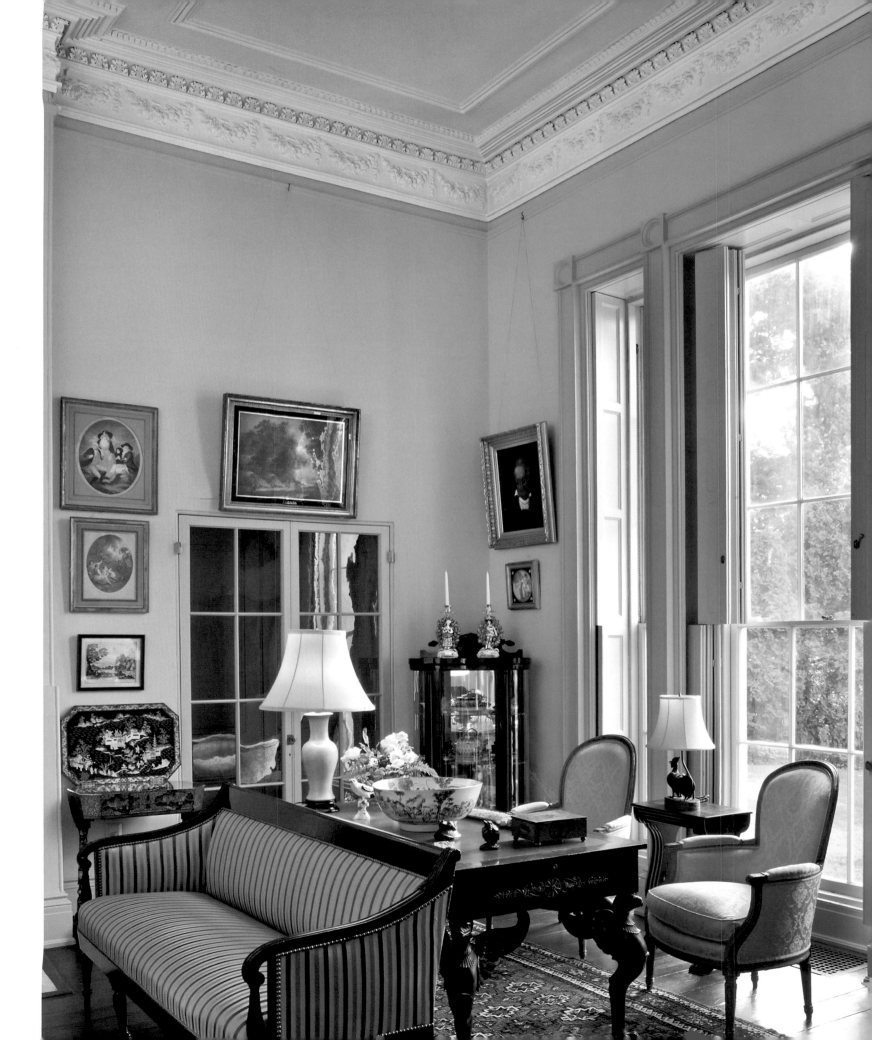

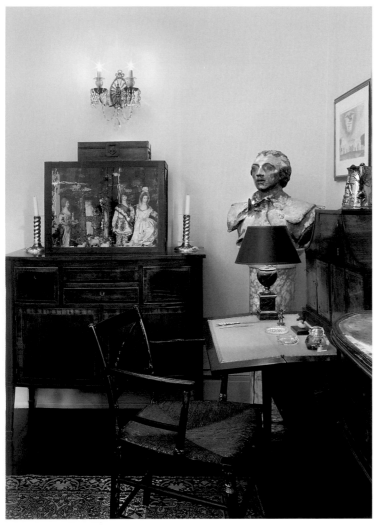

The parlor displays many Washington family pieces, including a waxwork tableau (on top of the cabinet) presented to Martha Washington in 1783. The Paul Wayland Bartlett bust of Lafayette dates to circa 1907.

RIGHT
Originally the bedroom of Martha Custis Peter, this space was turned into a dining room in the early twentieth century.

made the Palladian form a practical, as well as an aesthetic, convention of the time.

Martha Peter was at the center of Federal-era society and retained a friendship with Thornton's French-born wife, with whom she watched the British burning of the Capitol from Tudor Place in 1814. Thomas and Martha Peter's daughter Brittania (other sisters were more patriotically named Columbia and America) lived at Tudor Place until her death in 1911. Her grandson Armistead Peter III left the property to the Tudor Place Foundation, which has operated the site as a house museum since 1988. Today, Tudor Place interprets the cultural and social history of the capital from the perspective of six generations of the Peter family, descendants of Martha Washington.

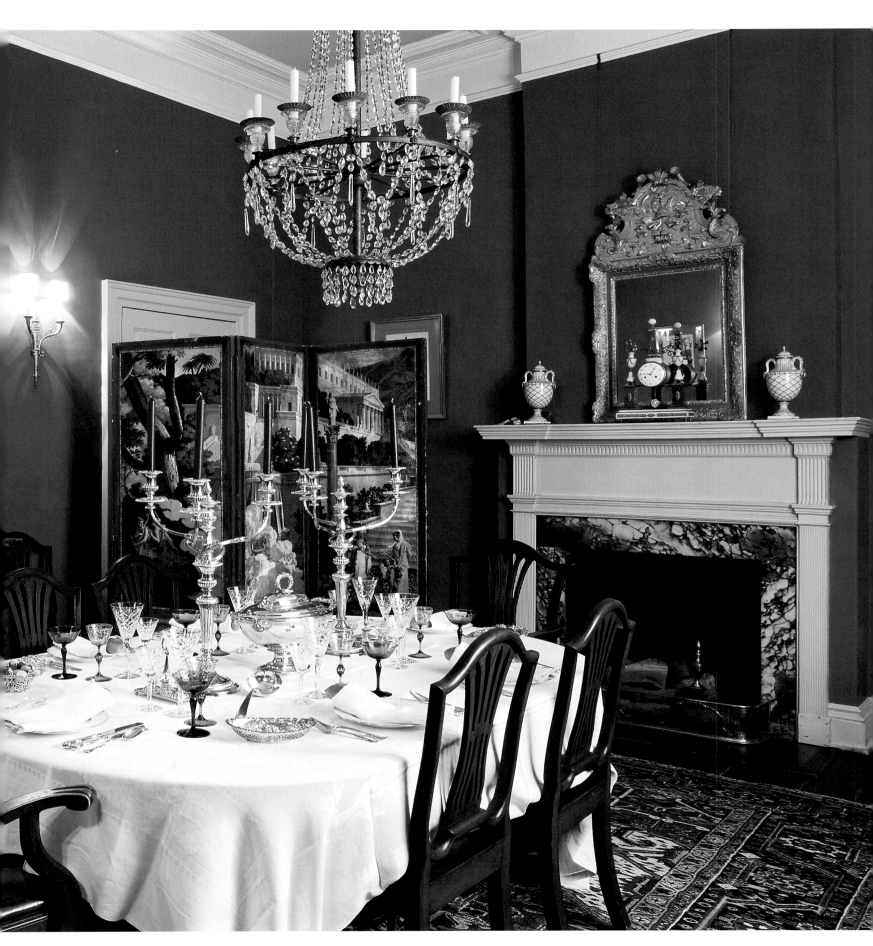

Double doors defined the limits of the public space of Russell's office at the front of the house, while permitting visitors a glimpse of the grand private space beyond.

RIGHT
Today, the Nathaniel Russell House epitomizes Charlestonian refinement, in spite of the fact that Russell viewed himself as a lifelong outsider in the city.

The Nathaniel Russell House

Charleston, South Carolina
Built 1803–08
Architect/Builder: Unknown
Owned and operated by the Historic Charleston Foundation

The Nathaniel Russell House stands as a testament to the unparalleled wealth and cosmopolitanism of Charleston in the Federal era. It also underscores the mutability of social identity that made its owner, Nathaniel Russell (1738–1820), so determined to create the finest house in the nation's most refined city.

Russell came to Charleston in 1765, a self-described "shipping agent" from Bristol, Rhode Island. Although the South is generally associated with the "Triangle Trade" slave economy, Rhode Island controlled between 60 and 90 percent of the American slave trade in the eighteenth century. Russell's hometown accounted for over one-third of the statewide total.[5] After an auspicious patriotic career in the colonial militia and election to the state's Third General Assembly in 1779, Russell was barred from conducting business by occupying British forces following the fall of Charleston in 1780. In response, he fled to England and took the oath of loyalty to the Crown. This betrayal of the Revolutionary cause led his erstwhile colleagues in the General Assembly of South Carolina to confiscate his property. When Russell returned to Charleston, he had to petition the legislature for the right to get off the ship.[6] Perhaps this explains, in part, why Russell remained a self-proclaimed, lifelong outsider in Charleston, in spite of his considerable prestige and social participation. He gradually reestablished himself after the war, boosting his local credibility as well as his finances when he married local heiress Sarah Hopton in 1788. The outbreak of war between England and France in 1793 provided just the trading opportunity Russell needed to make a new fortune. By 1803, he was ready to build a great house in town for his wife and daughters.

The house is set back from the street by thirty feet and surrounded by a landscaped garden, an unusual choice in a city and time during which it was typical to build to the very edge of the street-front lot line and back lots were given over to workspaces and slave quarters. Setting the house back from the street emphasized the division between public thoroughfare and private property, while adding an effective dash of the landscape setting that was so crucial to the classical mystique of English Neoclassical architecture. A polygonal bay on the garden side further animates the familiar block of the townhouse type. Coincidentally, the setback also allows the passerby to better admire the facade and to note Russell's monogram entwined in the wrought-iron balcony rail above the front door.

The plan is dramatic in its use of a full circle, an oval, and a rectangle to create brightly lit and spatially varied rooms on each floor. Unlike the contemporary work at Tudor Place, the Russell House thoroughly absorbs the rigorous geometry of the Neoclassical style in its interior spaces. Most striking, the "flying" elliptical staircase rises three stories without visible bracing or supports, indicative of the remarkable engineering skills and craftsmanship available in Charleston at the time. Ornamental moldings and mantels, among the finest in the country, draw upon plates from

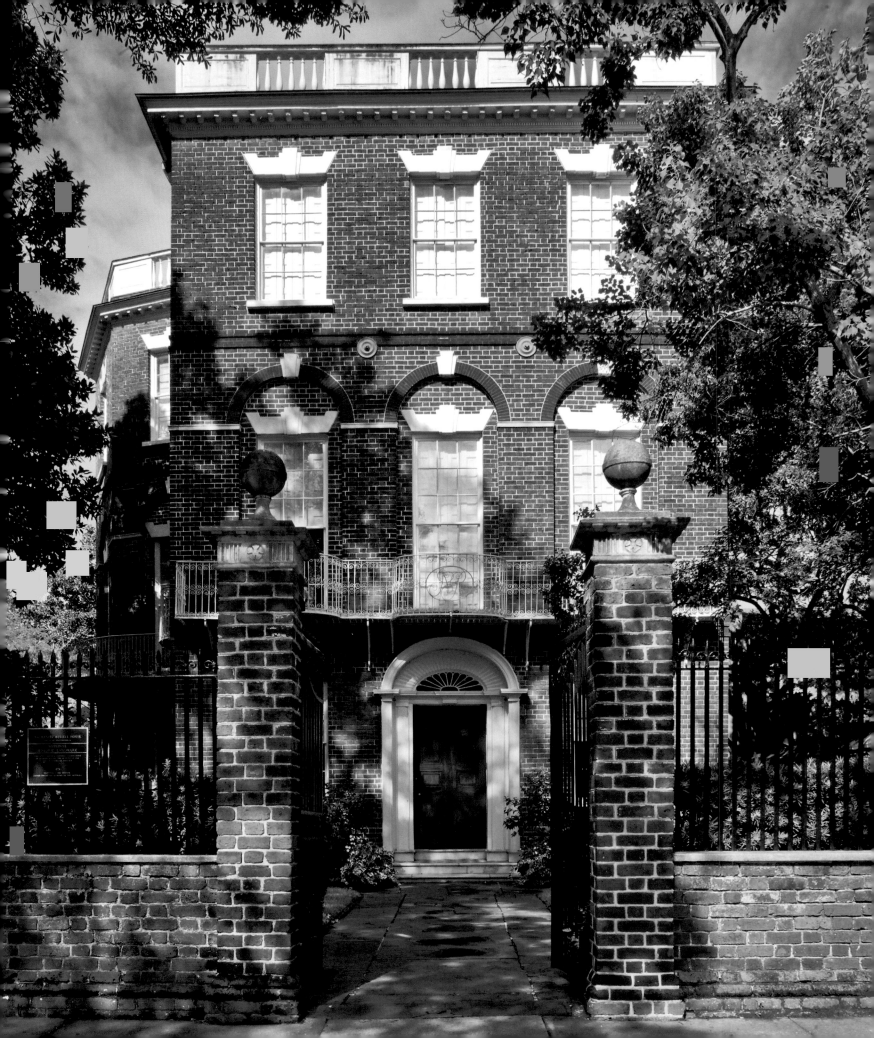

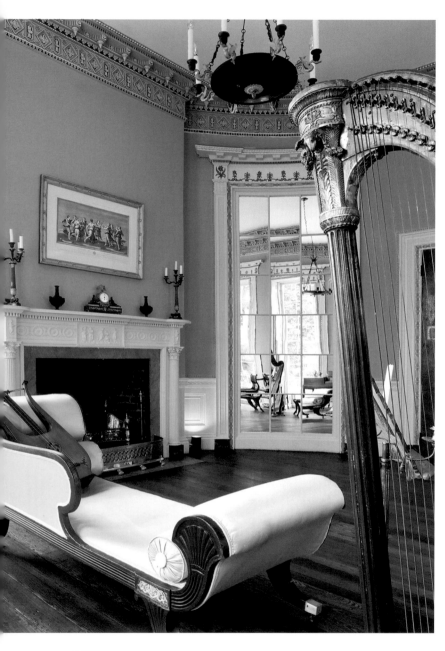

ABOVE
The use of mirrored doors, which are identical in design to the windows, visually expands the space of the music room (also known as the drawing room).

RIGHT
Gilded moldings and elaborate architectural details derive from published studies by Scottish Neoclassical scholar and architect Robert Adam (1728–92).

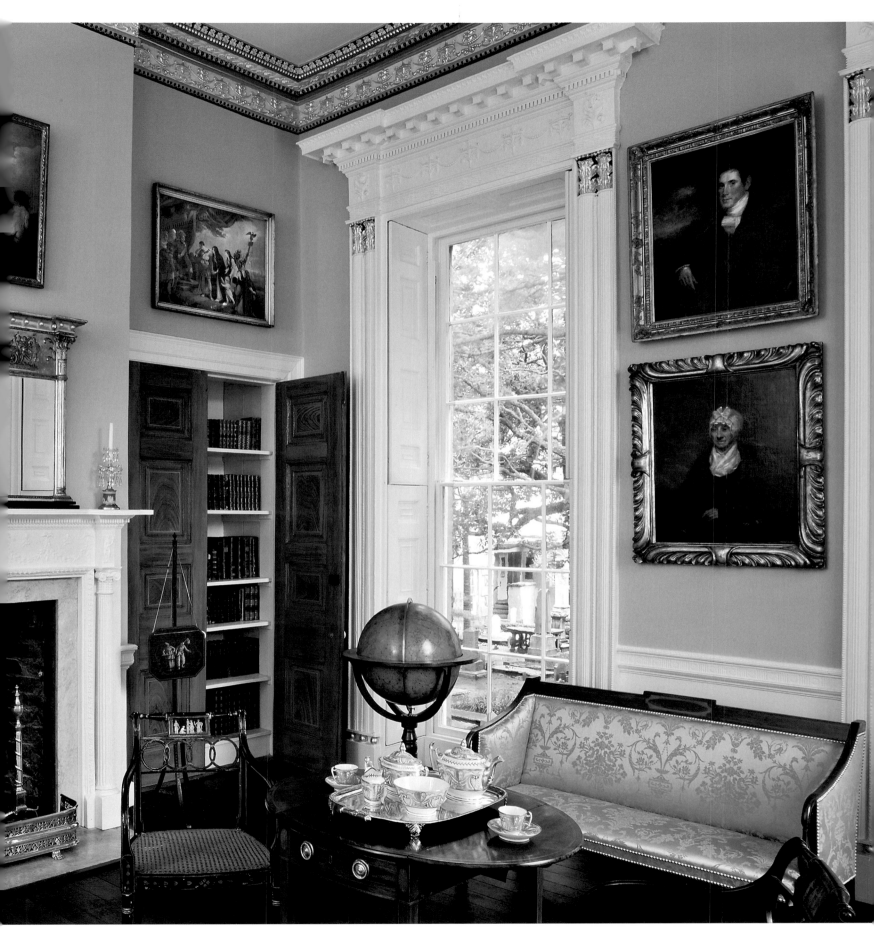

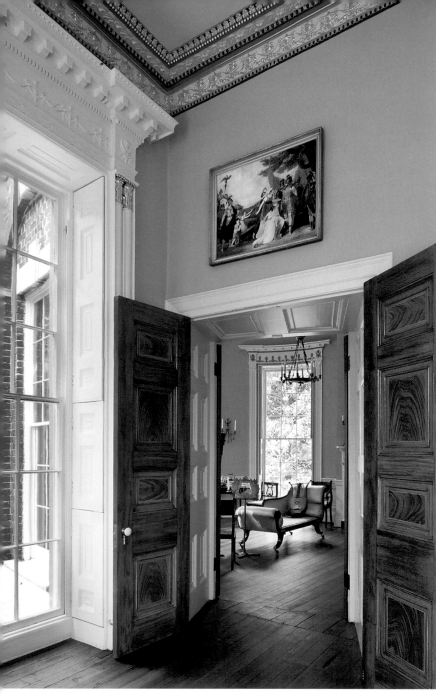

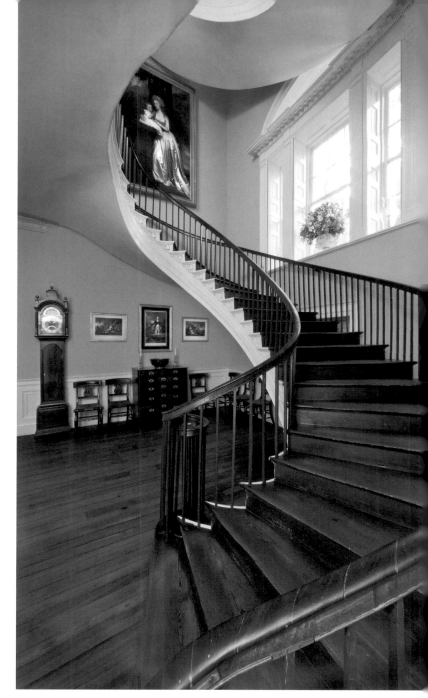

ABOVE

The spatial fluidity of the plan not only allowed guests to circulate freely but also provided optimal light and cross ventilation.

ABOVE

The remarkable elliptical staircase defiantly intersects the fanlight of the Palladian-inspired window. Visible at the top of the stairs is a 1786 George Romney portrait of Charlestonian Mary Rutledge Smith and her infant son.

FACING PAGE

The grand staircase is believed to be the work of African-American craftsmen.

published works of Scottish Neoclassicist Robert Adam (published 1773–78, with a second volume in 1779), more for aesthetic inspiration than the previous generations' desire to demonstrate a mastery of classical texts. The lightness of proportions, delicacy of finish, and assembly of fine art and furnishings from Europe distinguished the Russell House, even in a city that was not easily impressed.

The Russells were both notably devout (he Congregationalist, she Episcopalian) and supported many charitable causes and foundations in the city. In 1819, Russell became the first president of the New England Society, a charitable club of wealthy merchants who celebrated their own Puritan virtues and ancestry and, pointedly, provided financial support and aid specifically to New Englanders who fell on hard times while in Charleston. After sixty-four years spent (mostly) in the city, Russell still considered himself an outsider, asserting his Mayflower ancestry and "New England type of manhood." Fortunately for posterity, thrift and restraint in architecture and design do not appear among the "sturdy" Puritan virtues Russell endorsed.[7]

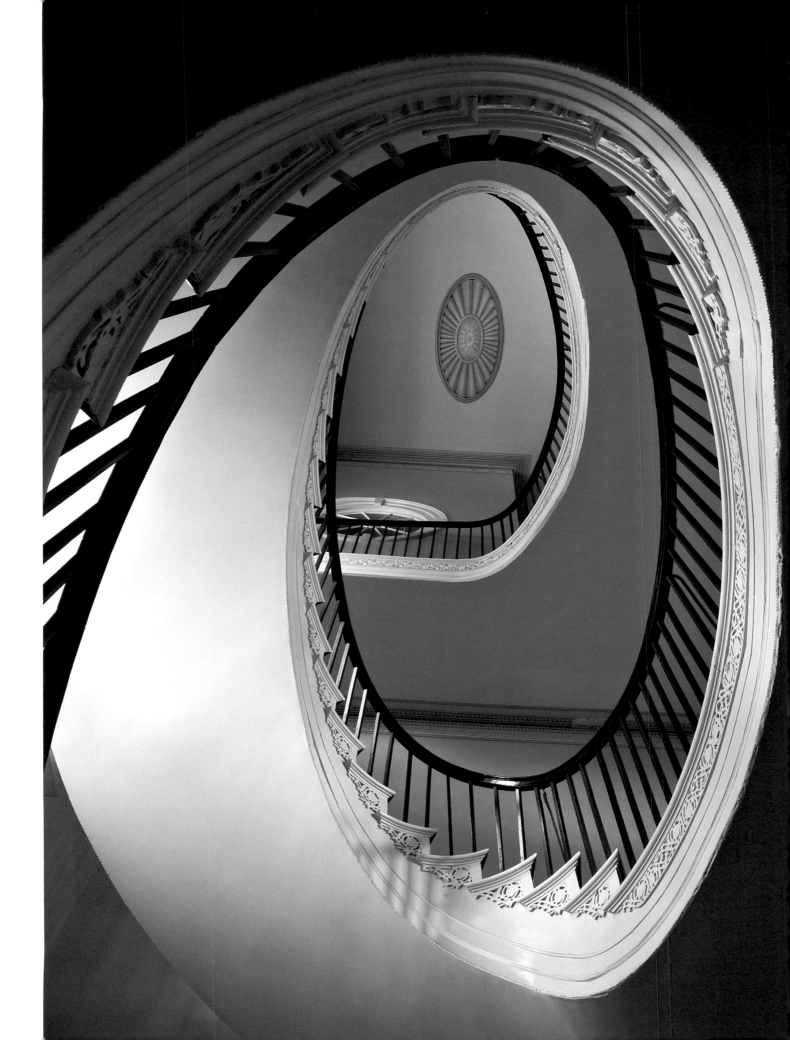

The Wickham House

Richmond, Virginia
Built 1812–15
Architect: Alexander Parris
Owned and operated by the Valentine Richmond History Center

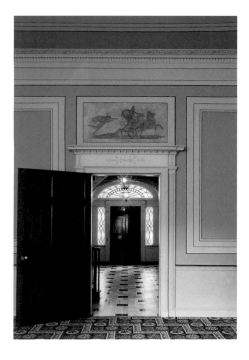

ABOVE

As seen from the drawing room toward the front door, the Neoclassical overdoor panel in this hub of household life features a rather gruesome revenge scene, based on an illustration from an 1805 edition of The Iliad.

RIGHT

Prominent attorney John Wickham commissioned architect Alexander Parris to design his Richmond house in 1811.

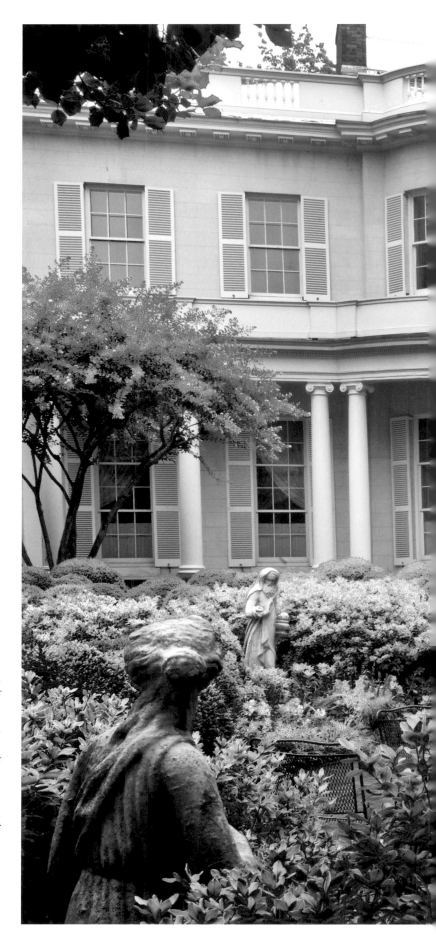

The Wickham House was built by attorney John Wickham for his family, which included his second wife Elizabeth, at least ten of his nineteen children, his father-in-law, and fourteen enslaved people who worked for them. The number of residents serves as a reminder that the airy architectural elegance of the American Neoclassical house that is so appealing today was probably belied by the bustle of human activity that the house originally accommodated.

Wickham, a New Yorker by birth, made his money as a debt collector—for the British—after the Revolutionary War. One of his Virginia colleagues later described Wickham as "distinguished by a quickness of look, a sprightly step, and that peculiar jaunty air, which I have heretofore mentioned as characterizing people of New York. It is an air, however, which (perhaps because I am a plain son of John Bull) is not entirely to my taste. Striking, indeed it is, highly genteel and calculated for éclat; but then I fear, it may be censured as being too artificial."[8] Virginians

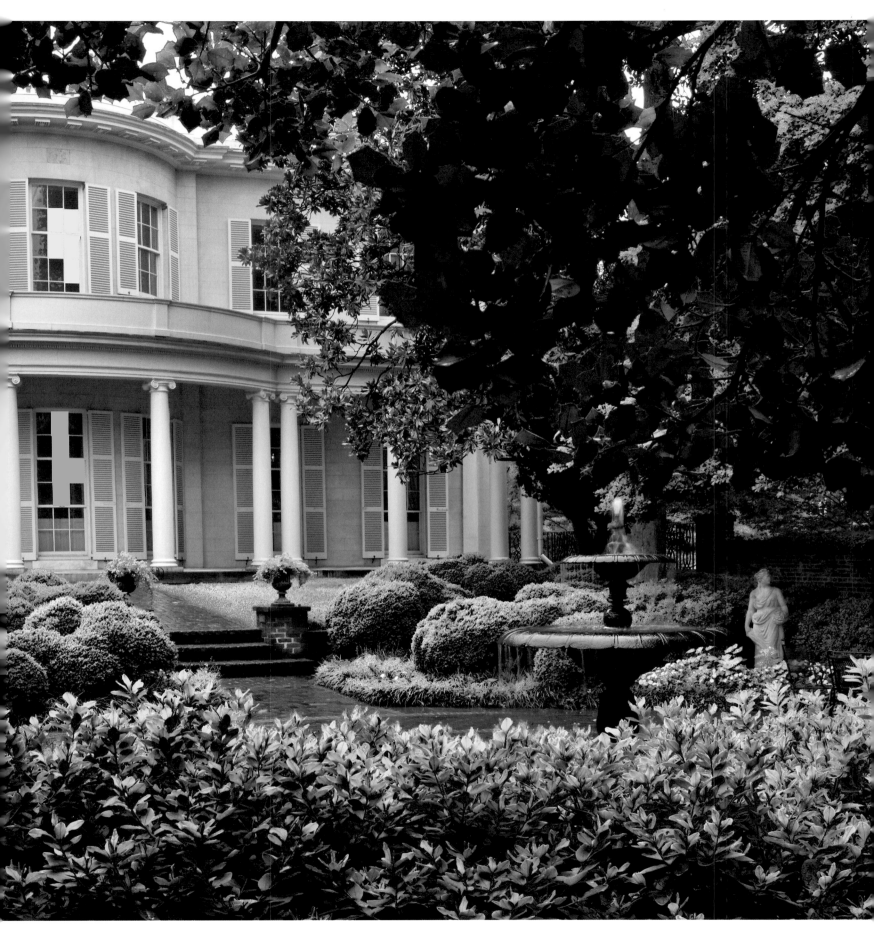

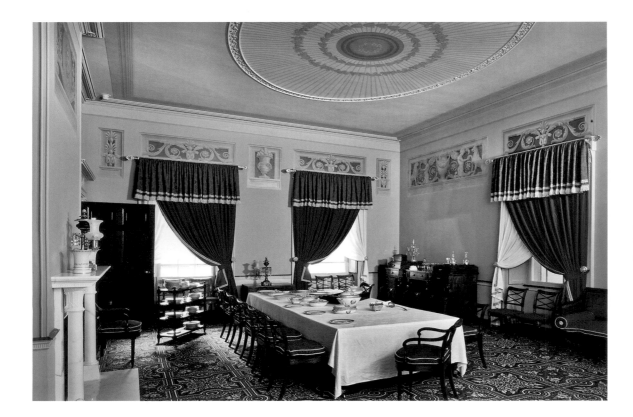

had a heartier notion of refinement, but Wickham managed to triumph in spite of his pronounced regional difference. He served as one of Aaron Burr's defense attorneys during the latter's 1807 treason trial. In a fine display of Southern graciousness (or legal strategy), Wickham famously invited both his client and the trial judge, Wickham's neighbor John Marshall, to the same dinner party. (The jury found Burr not guilty.) Between his wealth and her refined taste and manners, the Wickhams were unassailable leaders of society and, in fact, so manifestly "great" that one commentator noted that guests were more intimidated than entertained.

Wickham bought the lot for his house, covering an entire city block, in 1795. The family lived in the existing house until 1811, when Wickham hired Alexander Parris, recently arrived from Maine. A native of Massachusetts, Parris was originally trained as a builder of wooden houses in the New England tradition of fine joinery derived from shipbuilding practice. He must have learned masonry after coming to Richmond, and may not have been Wickham's first choice for the job. Wickham sent Parris's initial designs to architect Benjamin Henry Latrobe (who happened to have designed a house for the family from whom Wickham had purchased his property) for review. Latrobe, who rarely had anything nice to say about other architects' work, responded that the windows were too big, the staircase needed a landing, the chimneys were in the wrong places, and, most unkindly of all, that Parris had incorrectly used the hierarchy of the classical orders in the interior spaces. Latrobe, who was busy working on the U.S. Capitol at the time, did not mince words: "The expense of this decoration of wooden columns, pilasters, & niches is your affair—mine is its taste. Reform it altogether. It is wrong."[9] Parris incorporated some of the architect's suggestions, ignored others, and ultimately produced a design that holds its own against Latrobe's best.

The severe, somewhat clumsy street facade schematizes the central pavilion into a shadow-line projection, then squashes the verticality with an extremely low-hipped roof. The entrance portico is not pedimented and displays a severe version of the Doric order (not even indicated on Parris's sketch, which must have annoyed the doctrinaire Latrobe). Parris's sketch does show a graceful, wrought-iron curving double staircase leading to the portico, but this design was replaced in the execution by a strict, axial flight. Parris really came into his own on the garden facade, with its graceful projecting oval bow and Ionic loggia. The treatment of the projecting bow on the second level allows it to transition seamlessly into the graceful parapet balustrade, above which the twin chimney stacks rise from the center of the roof. The openings, much larger than on the street side, effectively punctuate with shadow the assertive planarity of the stucco facade.

In plan, basically rectangular reception rooms (save the oval bow overlooking the garden in the parlor) surround a circular stair hall that serves as the spatial pivot point of the house. The staircase itself, cantilevered on iron bars that project from the masonry walls into the individual stair treads, was surely calculated to make an impression on arriving guests. Significantly, the design is based on a diagram from Asher Benjamin's *The American Builder's Companion* (1806) and not a grand folio version of Palladio. While the classical stylistic matrix remains constant, the Wickham House demonstrates a step away from the more intellectualized approach of the eighteenth century toward the more practical builder's literature of the nineteenth century. Little wonder that Latrobe, a colleague of the arch-idealist Jefferson, reacted so negatively to Parris's design, which carried a distinct whiff of Benjamin's "how-to" book about it.

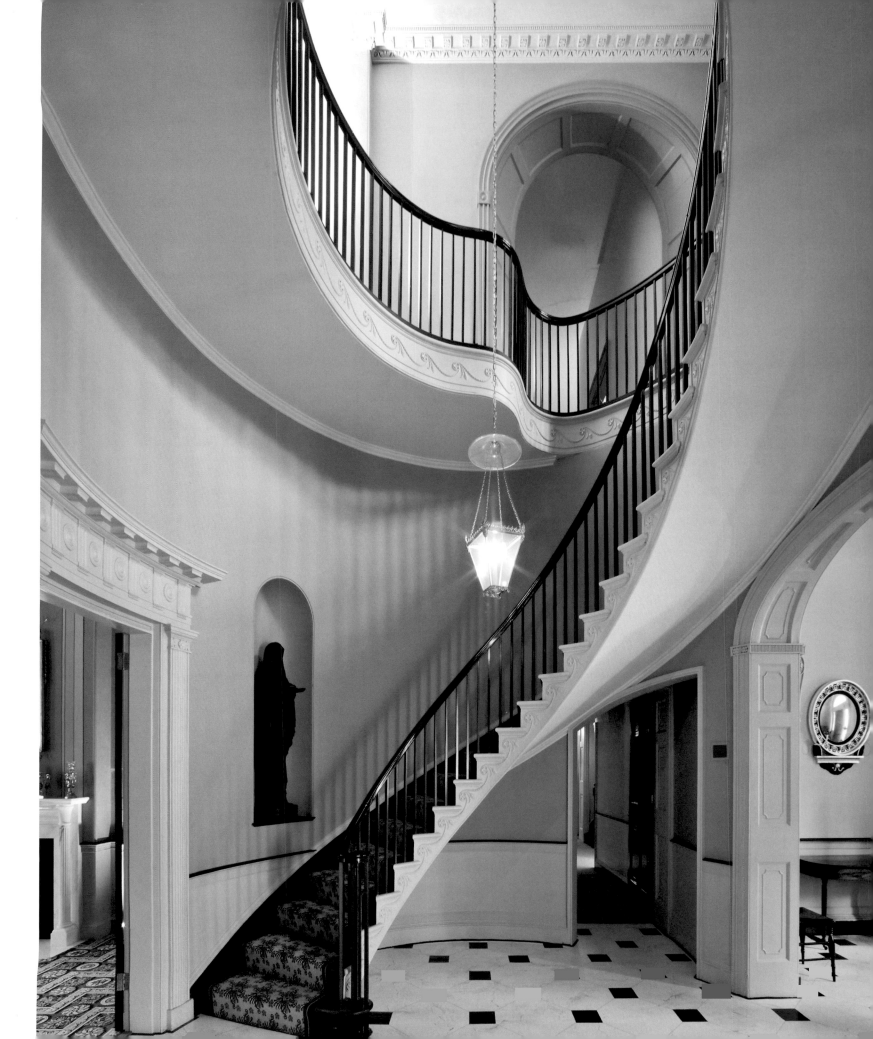

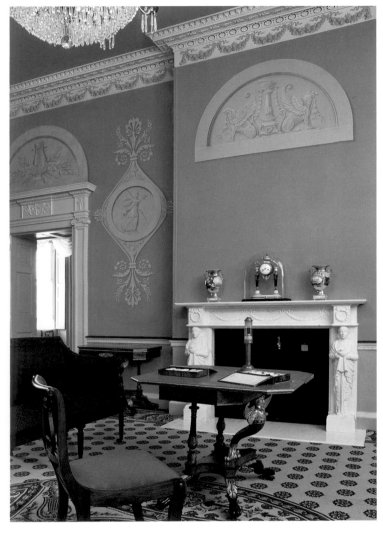

Guests would have been impressed by the scale, decor, and furnishings (such as the Neoclassical card tables by French-born New York cabinet-maker Charles-Honoré Lannuier) in the drawing room.

RIGHT
The parlor features portraits of John Wickham (attributed to John Wesley Jarvis, 1825) and his second wife, Elizabeth Selden McClurg Wickham (Gilbert Stuart, circa 1802).

Parris left the project to fight in the War of 1812. Armed with more books, a big bank account, and a gifted pool of local craftsmen, Wickham himself oversaw the completion of the house. He deserves particular credit for selecting scenes for the distinguished wall paintings in the major reception rooms. Themes and motifs were, as per Benjamin's advice, to suit the function of the room: the dining room features scenes of Bacchus, Silenus, and harvest imagery, while the scenes from John Flaxman's illustrations of *The Iliad* in the drawing room may wryly imply that each of the ladies within is a Helen of Troy in her own right. Painted over in the mid-nineteenth century, these murals were restored in the 1980s and 90s, happily representing the best that Richmond and, indeed, the United States has to offer in terms of Neoclassical painted decoration.

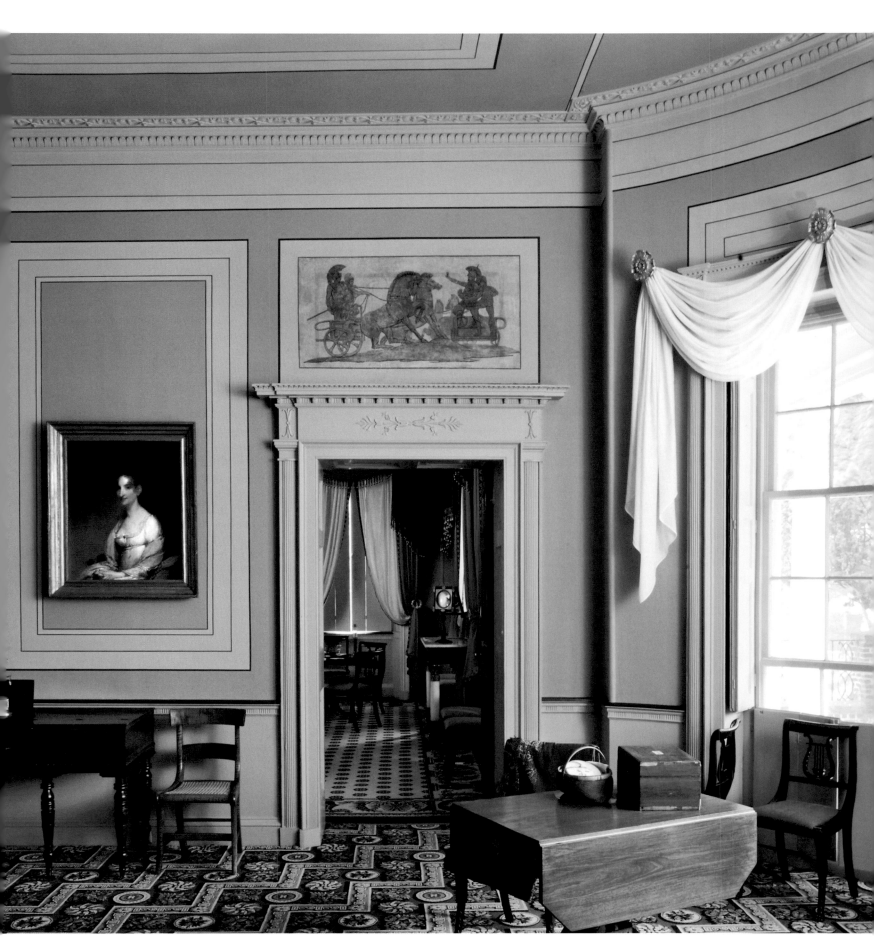

The Hunt-Morgan House

Lexington, Kentucky
Built 1814
Architect-Builder: Unknown
Owned and operated by The Bluegrass Trust for Historic Preservation

Originally called "Hopemont," the Hunt-Morgan House transported the Federal style to the growing American "West."

John Wesley Hunt became known as "the first millionaire west of the Alleghenies" and counted John Jacob Astor among his business associates.

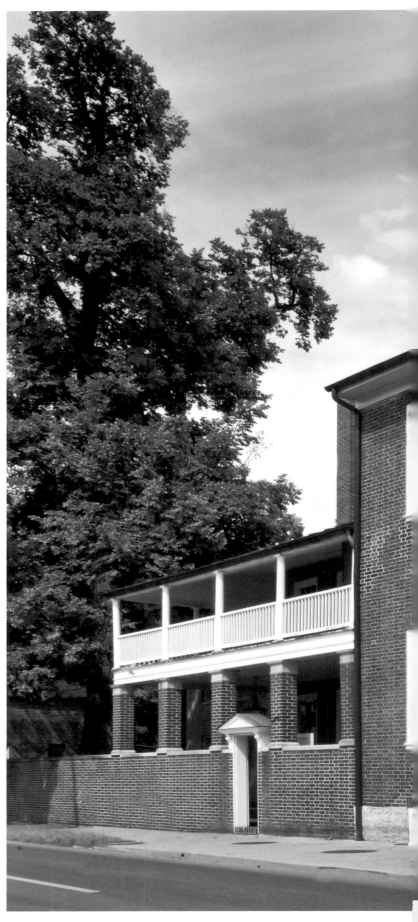

After American independence, Kentucky's population skyrocketed from its pre-Revolutionary tally of two hundred, spurred by an influx of adventuresome Virginians driven westward in search of unclaimed land and opportunity for advancement. In 1792, the United States Congress admitted Kentucky as the fifteenth state. In 1794, twenty-one-year-old merchant John Wesley Hunt emigrated from Trenton, New Jersey, to Lexington. By the time he was forty, he had become the first millionaire west of the Allegheny Mountains.

Hunt made his fortune in diverse ways: trading land grants, banking, horse breeding, agriculture, a hemp factory (for making rope and shipping sacks), and, eventually, railroads. In the 1810s, Lexingtonians like Hunt, Henry Clay, and Senator John Pope began to build houses to represent their wealth, success, and status. By 1820, with help from men like Hunt and by river commerce with the port of New Orleans, Lexington was known as "The Athens of the West," the final bastion of culture before the frontier. By 1828, Frances Trollope reported of Lexington's elite, "with more leisure than is usually enjoyed in America, [they] have its natural accompaniment, more refinement."[10]

Lexingtonians John Pope and Henry Clay both knew the highly sophisticated architectural designs of Benjamin Henry Latrobe, architect

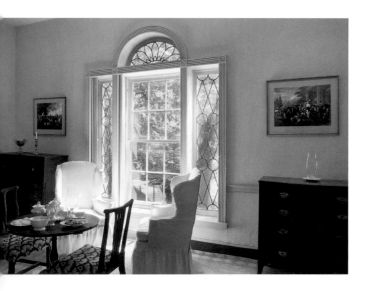

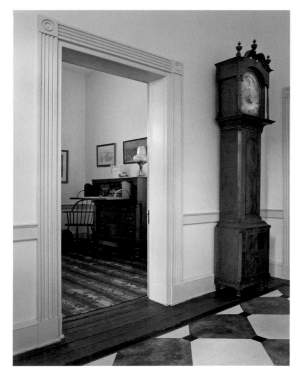

TOP
The Palladian window, embellished with Adamesque tracery, may have been inspired by a similar feature at Henry Clay's Ashland.

ABOVE
The tall-case clock (circa 1800), featuring crotch cherry veneer, is a fine example of Kentucky craftsmanship of the period.

RIGHT
Legend has it that Hunt's grandson General John Hunt Morgan galloped on horseback into the house through this doorway, paused to kiss his mother, and then continued out the back door—with Union troops in hot pursuit.

FOLLOWING PAGES
The dining room was scaled for formal entertaining. The portrait above the mantel is of John Wesley Hunt's wife, Catherine, and is attributed to Matthew Lowry.

of the U.S. Capitol, from their recent terms in the U.S. Senate. Pope commissioned a house from the renowned architect in 1811, and Clay also hired him to expand and remodel his house, Ashland, soon after. Both clients, to Latrobe's consternation, altered the architect's plans during construction to better suit the practical functions of their daily lives and, perhaps, to conform to local builders' habitual practices. In 1812, at Clay's insistence, Latrobe was hired to design the main building of nearby Transylvania University. Significantly, John Wesley Hunt was also a trustee of the university and sided with those who favored a local builder over the prestigious import.[11]

Originally called "Hopemont," the Hunt-Morgan House is a builder's translation of ideas derived from Latrobe, adapted to local skills and sensibilities. The unrelieved geometric simplicity of the building mass marks the Neoclassical influence of nearby works by Latrobe, and the Palladian motif window of the second story may even have been copied from the Latrobe-designed Palladian window surmounting the entryway of Clay's Ashland. The other likely influence at work was the self-empowerment of the owner, armed with one of the newer, user-friendly design manuals that arose to provide upwardly mobile clients with a glossary of classical motifs and technical guidance. The title of the best-known of these guides, *The American Builder's Companion* (first edition, 1806) by Connecticut builder Asher Benjamin, indicates that the audience for architecture books was no longer the British gentleman-amateur but rather a self-styled native class of pragmatic patrons. Builders like Hunt did not embrace the classical theories and proportional systems expounded in the Anglo-Palladian treatises but rather sought to embellish their locally built great houses with select emblems of the gentleman's classical vocabulary. Unlike the architect Latrobe's designs, Hunt's house displayed no technically challenging and costly polygonal or rounded forms and spaces, preferring instead to stick to a more conventional rectangular ground plan. The gable front, facing the street, makes no architectural gesture toward a classical pavilion or portico, and the asymmetrical side elevations are likewise unconventional, suggesting the contingent and functionalist approach of the self-made client and his builder.

Although Kentucky's legislature voted to side with the Union in 1861, John Wesley Hunt's grandson John Hunt Morgan, who had spent much of his childhood in the Hunt house, chose to side with the South. Known as the "Thunderbolt of the Confederacy," Morgan was well known for his 1863 raid, which occurred in defiance of orders from his commanding officer not to cross into Indiana and Ohio; the action resulted in his capture, imprisonment, and subsequent daring escape. Killed in 1864 during a Union raid on Greeneville, Tennessee, Morgan's brash pursuit of the Confederate cause quickly defined him as a legend. In 1866, Hunt's great-grandson, Dr. Thomas Hunt Morgan, was born in the house and in 1933 was awarded the Nobel Prize for his discovery that genes are responsible for the transmission of hereditary traits. He was the first geneticist as well as the first Kentuckian to win a Nobel Prize.

The Hunt-Morgan House was saved from demolition by the Blue Grass Trust for Historic Preservation in 1955 and restored to its circa 1814 appearance. Today it not only presents period rooms, furnished with many Kentucky-made antiques representing the affluent lifestyle of these prominent Lexingtonians, but also houses the Alexander T. Hunt Civil War Museum.

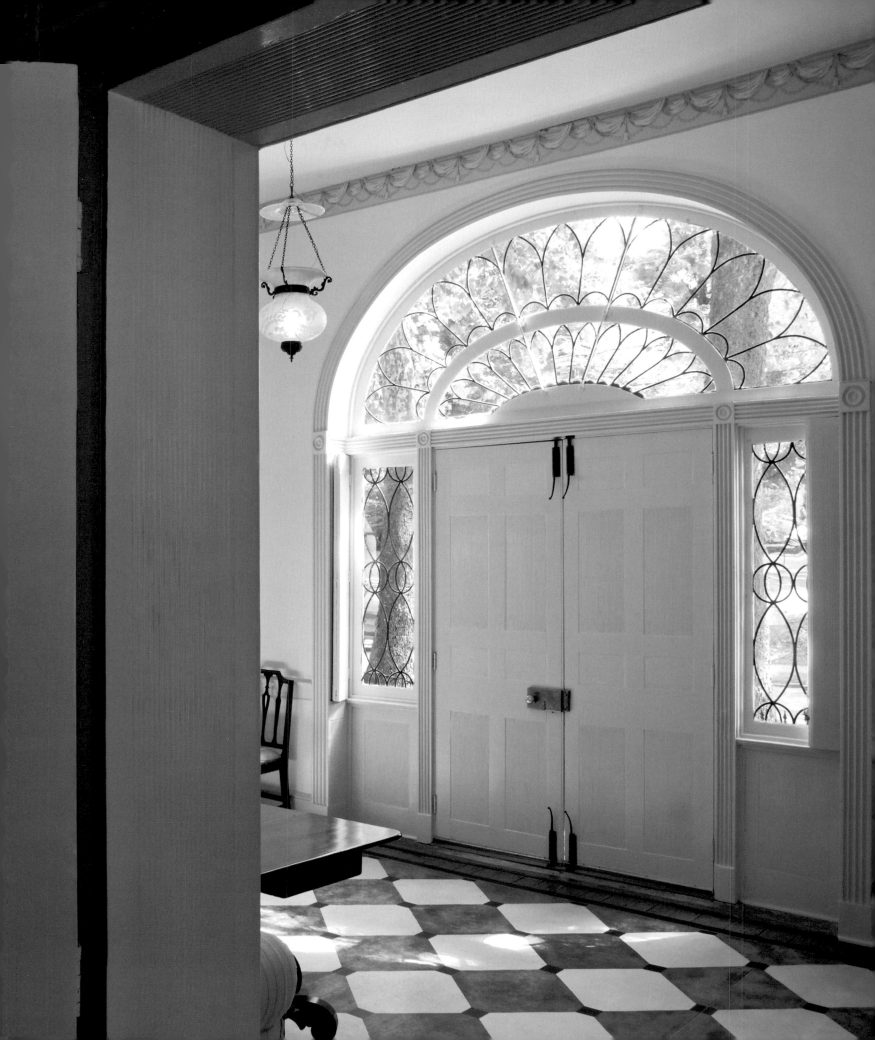

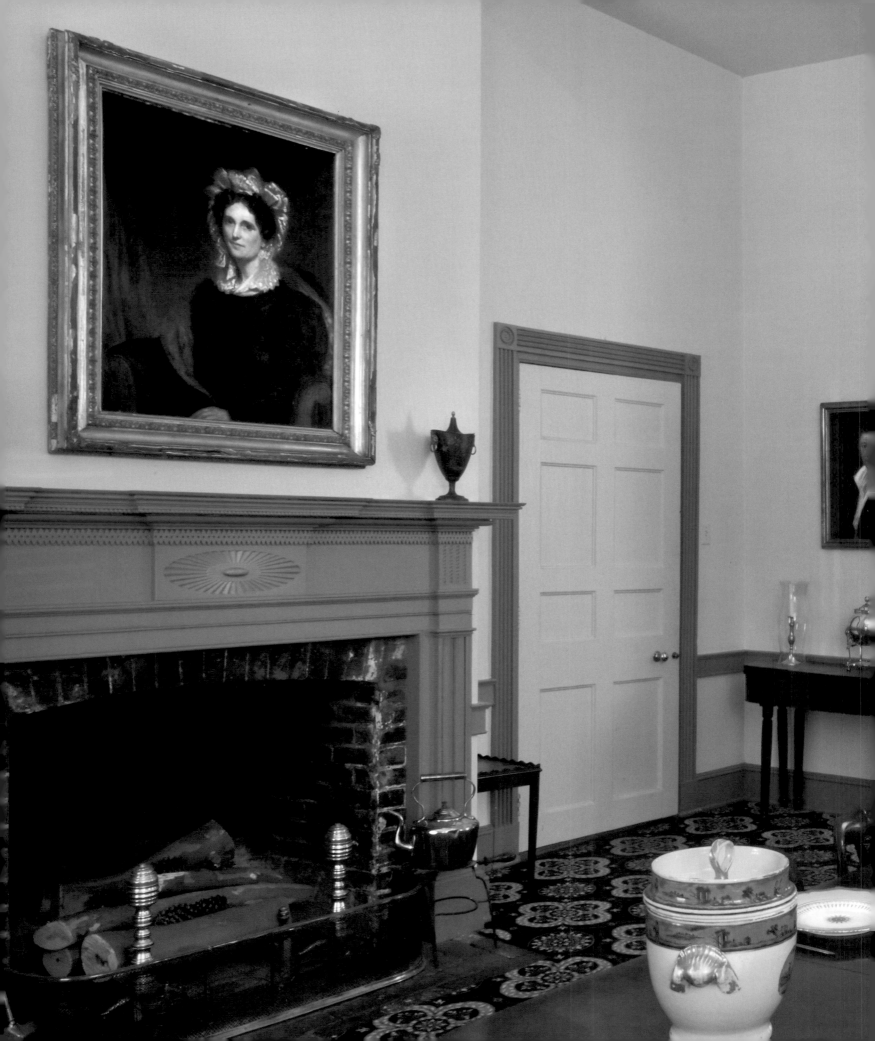

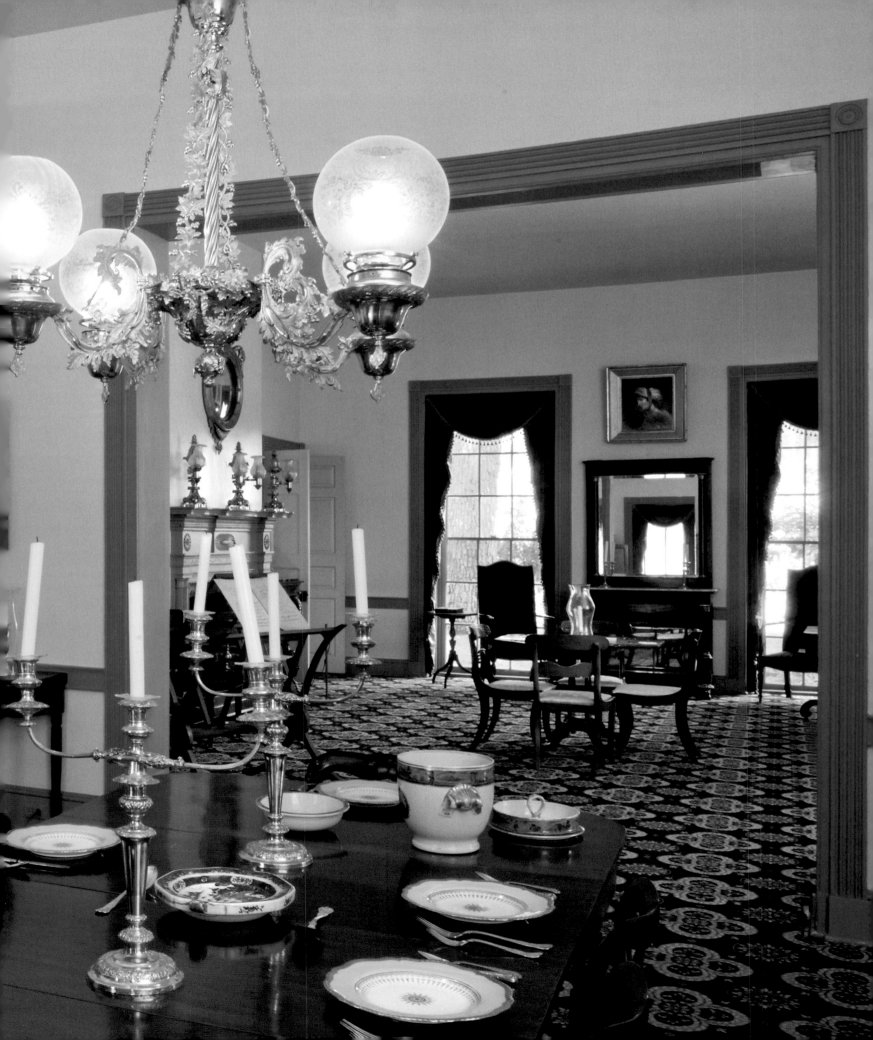

Farmington

Louisville, Kentucky
Built 1815–16
Builder: Paul Skidmore, to designs by Thomas Jefferson
Owned and operated by the Historic Homes Foundation, LLC

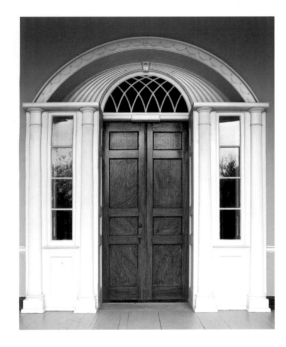

ABOVE
Farmington's elegant Federal doorway stands out against a blue-painted portico wall. This and other painted finishes were restored in 2002, based on documentary research and microscopic paint analysis.

RIGHT
Louisville builder Paul Skidmore translated architectural ideas from Virginia (possibly from Jefferson himself) that were imported to Kentucky by the Speed family and subsequently built by enslaved workers.

John and Lucy Speed, the builders of Farmington, were both born in Virginia (he in 1772, she in 1788) and both moved to Kentucky with their families when they were ten-year-olds. The Virginia connection was especially important for Lucy, Speed's second wife, and definitive for their house. Lucy's maternal grandfather had been one of Thomas Jefferson's guardians following Peter Jefferson's death in 1757, and her aunt and uncle's house in Charlottesville—not coincidentally called Farmington—boasted an 1802 addition designed for them by Jefferson. Owing to the fact that Lucy Gilmer Fry Speed's parents chose to move west to Kentucky, it seems plausible that she, and her husband as well, might have wished to emphasize ancestral status and presidential connections by displaying their ties to Jefferson and to the sophisticated architectural ideas of Virginia.

Architectural drawings and studies by Jefferson in the Coolidge Collection of Thomas Jefferson Manuscripts at the Massachusetts Historical Society strongly resemble the elevation and plan of the Speeds' Farm-

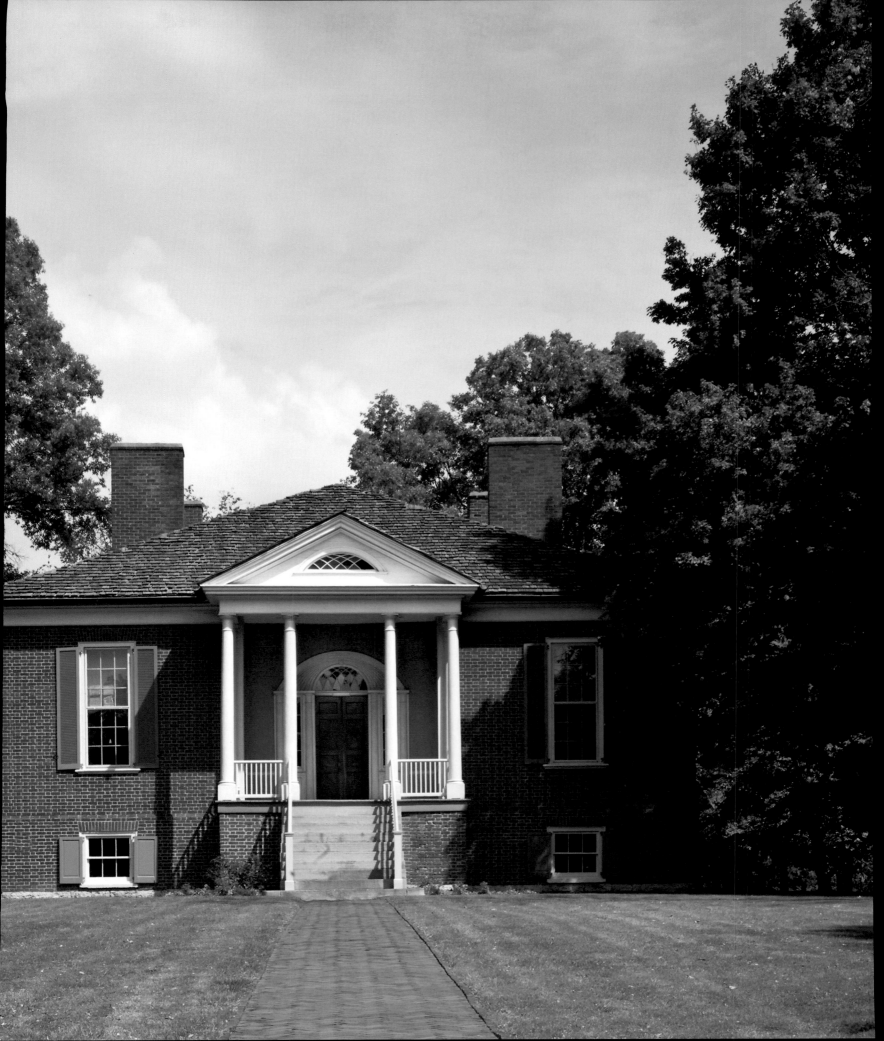

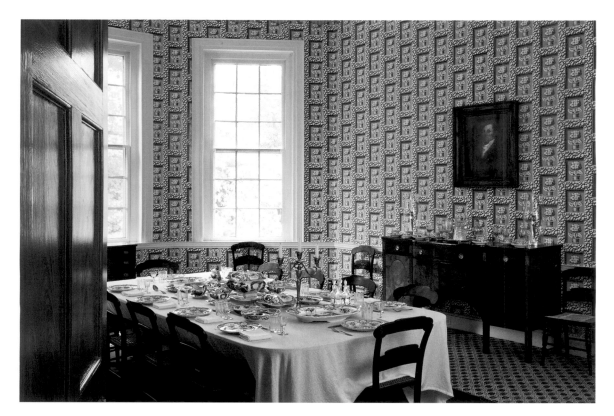

ington, although a contract between John Speed and local builder Paul Skidmore specifies that Skidmore drew the plan.[12] Quite likely, Skidmore needed to turn rough idea sketches (by Jefferson, or someone else) into construction documents, and choices and alterations were made in the process. Nonetheless, Farmington's proportions, concealment of the interior staircases, tetrastyle portico, and octagonal rooms projecting into external bays are elements that so strongly recall characteristic motifs of Jefferson's known designs—including his own houses at Monticello and Poplar Forest—that it seems entirely plausible that his concept guided the execution.[13]

Like Poplar Forest, Farmington achieves the one-story appearance Jefferson preferred by having a half-submerged lower story visually read as a basement. The low-hipped roof at Farmington reinforces the horizontal proportions, balancing the strong vertical thrust of the chimney stacks. Unlike the houses Jefferson supervised himself, the portico columns of Farmington are more attenuated in proportion and do not copy canonic examples of the orders from classical texts. The choice of thinner columns—combined with the extraordinarily delicate, carved tracery of the pediment lunette, fanlight, and the swag-embellished archway above the front door—clearly indicates a conscious preference for the more refined, Adam-influenced taste of the Federal period than for the more assertively bold classicism of Jefferson and Latrobe.

Master carpenter Robert Nicholson is believed to have made extensive use of skilled enslaved artisans owned by Speed in building the house. Records indicate that John Speed, who owned ten slaves in 1810, owned forty-three by 1813. In addition to working the extensive plantation's hemp, corn, hay, apple, wheat, tobacco, and dairy concerns, enslaved people brought valuable skills in building and artisanal trades to the plan-

tation economy. At Farmington, as with many plantation houses in the late eighteenth and early nineteenth centuries, enslaved workers would have been responsible not only for the brickmaking, bricklaying, wall plastering, and framing carpentry of the house but also for the making of nails and hardware, fine millwork, and carved ornament as well as the decorative plasterwork. Jefferson encouraged enslaved workers, including his companion Sally Hemings's half-brother John Hemings, to gain proficiency in the building trades, and planters in general knew that a skilled slave not only produced fine work for his owner's benefit but also could be contracted to work for neighbors or colleagues for a fee. As with most antebellum houses in the South, Farmington was designed to represent the residents' identity in the vocabulary of architecture, but it can also be understood as a record of African-American craftsmanship.

John and Lucy Speed's son Joshua, who grew up at Farmington, left the plantation to seek his fortune in Springfield, Illinois, where he befriended the young lawyer Abraham Lincoln in 1837. Following John Speed's death and Lincoln's broken engagement with Lexington belle Mary Todd, Lincoln spent a month at Farmington in July 1841, nursing a broken heart and debating law with Joshua's brother James. When Lincoln became president, he offered his friend a series of appointments, including secretary of the treasury, which Joshua declined. James Speed became Lincoln's attorney general in 1864. Farmington passed out of the Speed family soon after the end of the Civil War, but it was owned by only two families prior to its purchase in 1958 by the Historic Homes Foundation. In 2002, following extensive archival research and meticulous scholarly investigation, the house was restored and reinterpreted to reflect the appearance and function of its rooms and outdoor spaces in the mid-1830s.

Decatur House

Washington, DC
Built 1818–19; altered 1871–5; restored by Thomas Tileston Waterman, 1944
Architect: Benjamin H. Latrobe
Owned and operated by The National Trust for Historic Preservation

ABOVE

Decatur House faces Lafayette Square, across from the White House.

RIGHT

The exterior's stark simplicity belies the spatial complexity within Decatur House.

Decatur House was the first private residence built on President's Park (now called Lafayette Park), and its proximity to the White House played a large role in its conception and subsequent history. Commodore Stephen Decatur, hero of the Barbary Wars who fought against Ottoman-sponsored pirates, was temporarily flush with prize money he had been awarded for his victories in the War of 1812 when he purchased the northwest corner lot on the square and commissioned a house design from Benjamin Henry Latrobe. Latrobe was not only the country's preeminent architect but also the go-to designer of the prestigious neighborhood, having worked on several projects at the White House, St. John's Church on the park's north side, and the nearby home of the city's wealthiest man, John Peter Van Ness (1813–15, not extant). Decatur's decision to hire Van Ness's architect and establish his own household within the presidential precinct indicates the level of aspiration his house represented.

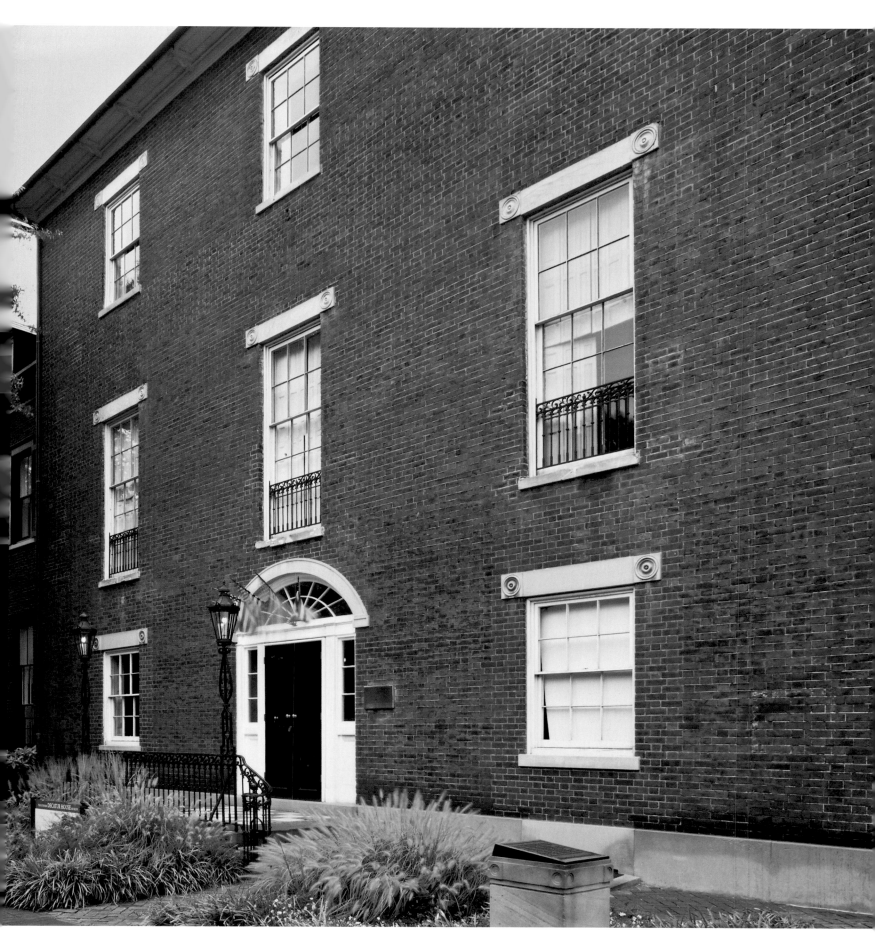

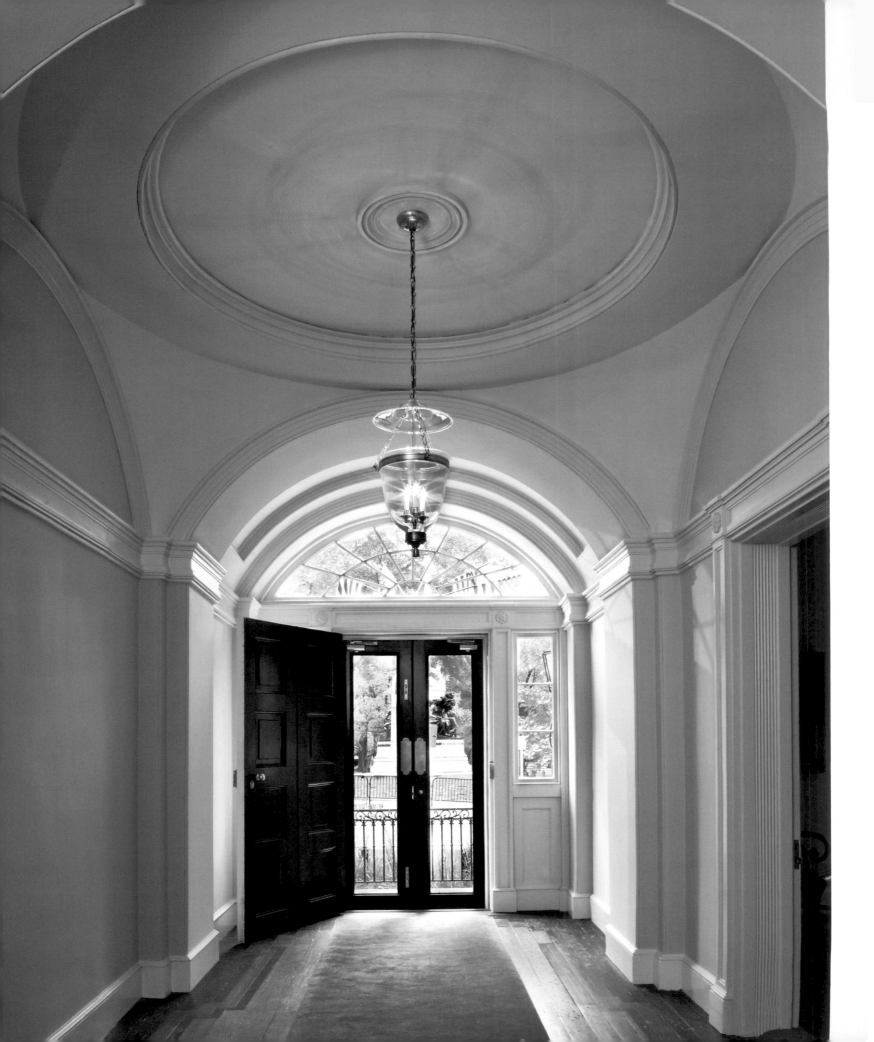

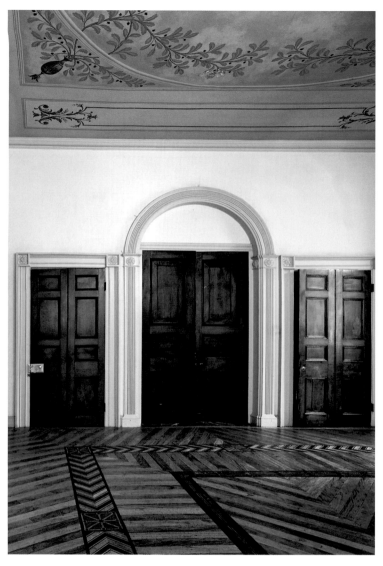

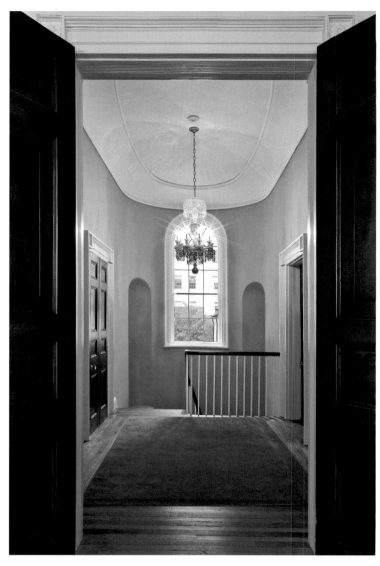

Latrobe's "rotunda" breaks up the length of the central hallway, while simultaneously lending an air of quasi-public monumentality to this private house.

Latrobe chose a Palladian-rhythm configuration for the openings between the second-floor drawing room and formal dining room. Ceiling paintings and parquetry floor date to the Beale family's ownership (1871–1956).

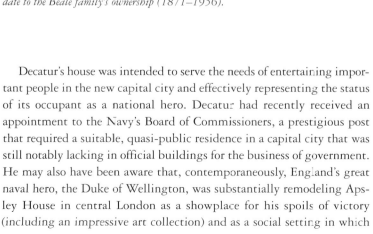

Although Decatur modified some of Latrobe's design during construction, the stair hall retains the architect's signature reiteration of a single geometric shape in plan, two- and three-dimensional forms.

Decatur's house was intended to serve the needs of entertaining important people in the new capital city and effectively representing the status of its occupant as a national hero. Decatur had recently received an appointment to the Navy's Board of Commissioners, a prestigious post that required a suitable, quasi-public residence in a capital city that was still notably lacking in official buildings for the business of government. He may also have been aware that, contemporaneously, England's great naval hero, the Duke of Wellington, was substantially remodeling Apsley House in central London as a showplace for his spoils of victory (including an impressive art collection) and as a social setting in which

to parlay his fame into political influence. The Decaturs were known for their lavish parties, and their choice of location and architect suggests that their house was intended to support an Americanized image of the warrior-turned-statesman.

Latrobe produced a striking, stark facade, rigidly symmetrical with only the faintest concession to ornament in the tracery of the fan and sidelights of the entry door. Three stories in height, the verticality of the simple blocklike brick mass is visually constrained by the low-hipped roof and use of contrasting sandstone trim for the water table, windowsills, and lintels. Whether from inclination or, more likely, budgetary con-

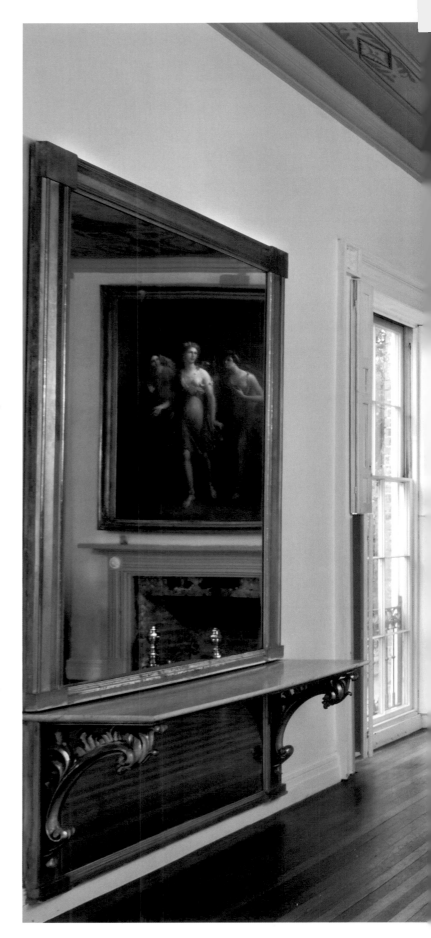

Overlooking Lafayette Square, the drawing room was a social center of official Washington. Owner Edward F. Beale acquired the painting Diana and her Handmaidens *from a hut-dwelling Frenchman who claimed to have salvaged it from the Louvre during the Franco-Prussian War (1870–71).*

straints, Decatur made alterations to Latrobe's design during construction, including changing the floor plans and substituting wood for the stone staircase Latrobe had specified. The most characteristic Latrobe design to survive his client's editing is the spatially complex and subtle entry hall, with its flattened domed ceiling rising from pendentives and an apse-like secondary compartment with niches flanking convex doorways leading to the stair hall beyond; all components are visually unified by a consistent horizontal cornice line, uninterrupted by separate door lintels. The Decaturs moved into the house in 1818, but the parlor and dining room, like the rest of the interiors, remained unpainted for a year to allow the plaster to cure. Ironically, the largest gathering at the house during the Decatur years was a celebration for the marriage of President Monroe's niece Harriet, which proceeded as the host, Decatur, lay dying in an upstairs room, the victim of a duel with a fellow naval officer over a longstanding honor feud. Susan Decatur began leasing the house the following year, and, due to its prestigious location, it housed a number of distinguished occupants over the years, including Martin Van Buren, Henry Clay, and the future Confederate Secretary of War Judah P. Benjamin. In 1836, owner John Gadsby erected a two-story masonry block along H Street that contained, on the first floor, a laundry and kitchen to replace spaces within the main house previously designated for those functions. The wing's second floor housed the King and Williams families as well as other enslaved people who would have previously lived off-site or in the main house. Architecturally, Gadsby's addition created an enclosed working yard with no opportunity for unsupervised access to the park or to other public spaces, perhaps reflecting the increasing nervousness of slaveholders after Nat Turner and forty other escaped slaves massacred at least fifty-five white Virginians in the fall of 1831.

Following the Civil War (during which Decatur House was occupied by the office of the quartermaster general of the Union army), the house was purchased by General Edward F. Beale who remodeled both interior and exterior to suit the more decorative architectural taste of the 1870s. The house became a social center of the presidential administration of Beale's friend, Ulysses S. Grant, and became known as Grant's unofficial Washington residence after he left office. In the 1930s, Beale's heirs hired architect Thomas Tileston Waterman, who had recently worked at Colonial Williamsburg, to undo the Grant-era alterations and to reconstruct the house's Federal-era appearance. By reinstating the building's more prestigious historical association with Decatur, the Beales effectively muted their association with the ethically dubious Grant administration in favor of a more fashionable, indisputably patriotic link to the early days of the American navy (in which one of their ancestors had, indeed, served as an officer). In 1956, Marie Beale gave the property to the National Trust for Historic Preservation, which operates it as an historic house museum.

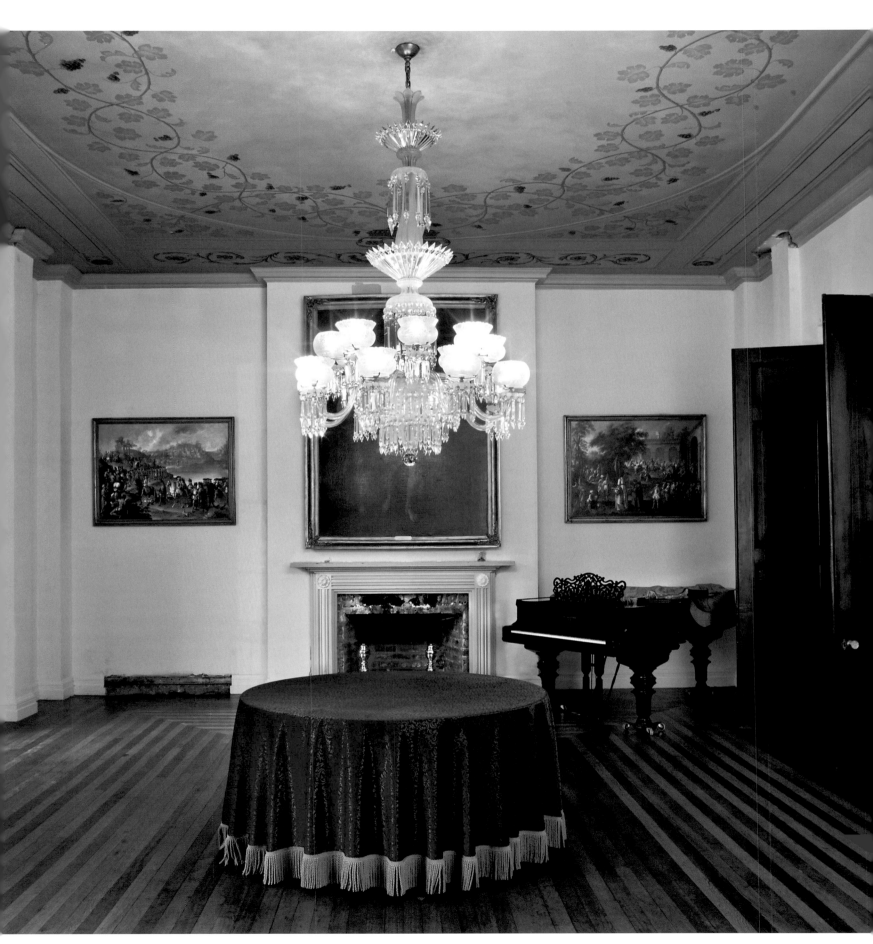

The Isaiah Davenport House

Savannah, Georgia
Built 1819–22
Owner-Builder: Isaiah Davenport
Owned and operated by the Historic Savannah Foundation

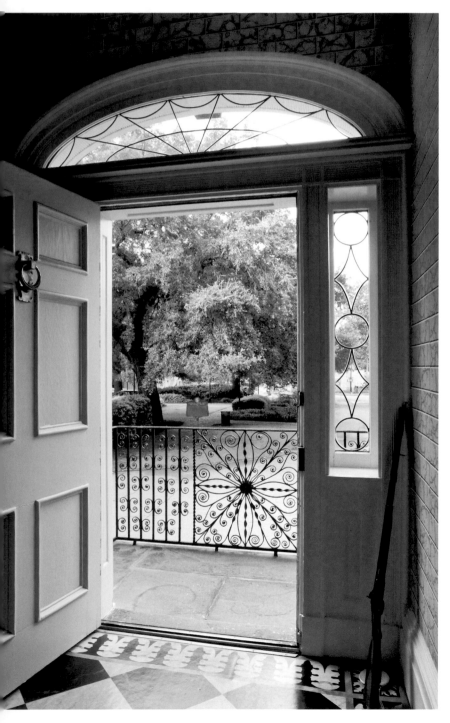

The Davenport House is a textbook example of American Federal architecture, probably designed by Davenport himself using books like Asher Benjamin's ubiquitous *The American Builder's Companion* (in its third edition by 1816). While the Federal style was falling from favor in the Northeast and mid-Atlantic, its popularity lingered in the South, especially amongst the middle to upper sector of merchant class patrons like Davenport and his clientele. Facing Columbia Square in Savannah, Davenport's house served as both a residence and an advertisement of his skills as a builder.

Born in 1784 in Little Compton, Rhode Island, Davenport trained in the family business of carpentry and apprenticed in New Bedford, Massachusetts, the shipbuilding town immortalized a half-century later in Herman Melville's *Moby Dick* (1851). With Savannah producing cotton for Rhode Island textile mills, wealthy planter families were among the first to discover New England's coast as a seasonal retreat from the miasmal Low Country summers. In 1807, perhaps inspired by the spectacle of Southern gentry on holiday, Davenport and two brothers moved to Savannah to start a building business. By 1809, Davenport had prospered enough to purchase a substantial townhouse lot and to marry Sarah Rosamund Clark, of Beaufort. Belying the notion that only Southerners supported slavery, Davenport bought two slaves the following year, and by 1818, he owned six people, at least some of whom were likely skilled craftsmen purchased specifically to work on his house. Construction began in 1819, but 1820 was a bad year for Savannah, starting with a January fire that swept through much of the city, destroying 463 buildings and displacing two-thirds of the residents. This catastrophe was followed by a summertime outbreak of yellow fever that killed one-tenth of the population. Davenport's incomplete house survived the fire, but his brother and business partner fell victim to the epidemic.

The house Davenport designed for himself was a conservative brick block, rising two full stories above a raised basement, with dormers in the roof hinting at the attic beneath. A delicate wrought-iron balustrade and elliptical double stairway gracefully sweep from the sidewalk to the focal entranceway, a gesture of fashionable Regency taste for oval forms and ironwork embellishments. Two rooms deep and five bays wide, the traditional plan features two rooms on either side of a center hall entered via a fanlight- and side-lit doorway. Once inside, the spectacular wooden staircase is framed by an arch supported by Ionic columns. The composition, almost like a billboard, allowed Davenport to show off his joinery and carving skills, while the use of the impost block to fit the room's height indicates the more intuitive, less academic approach that distinguished the builder from the architect. The

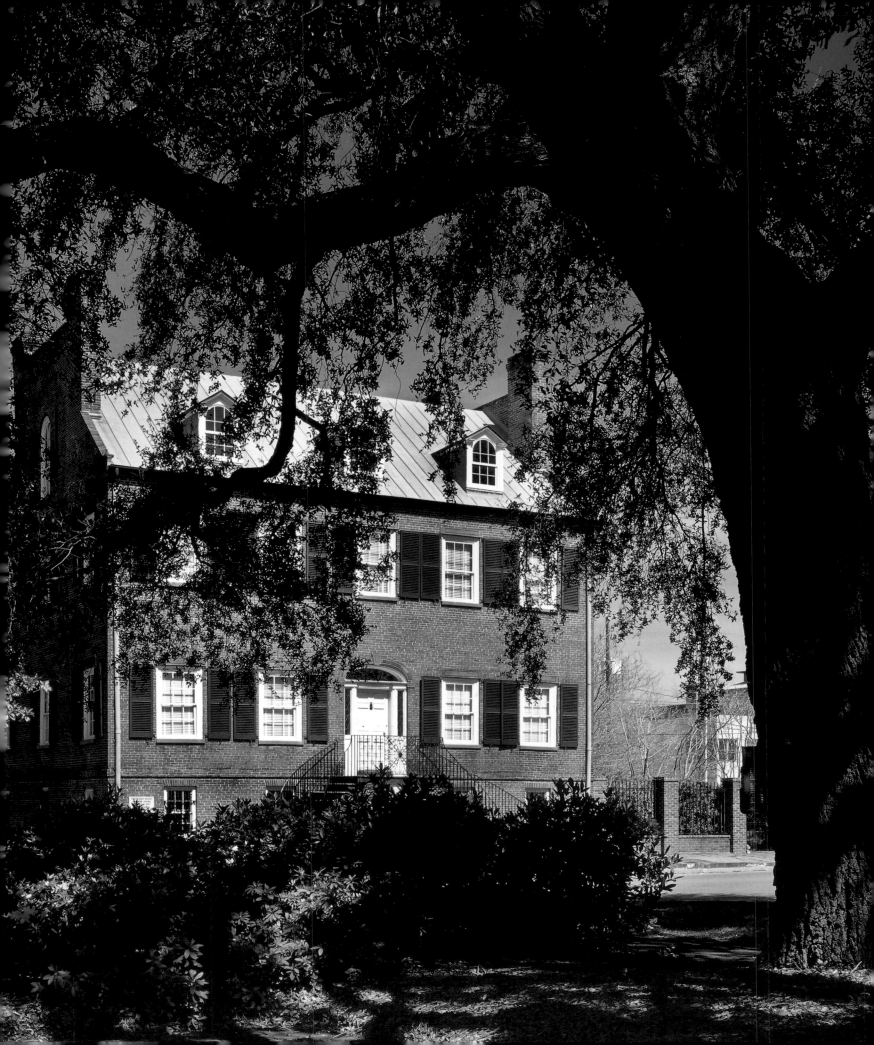

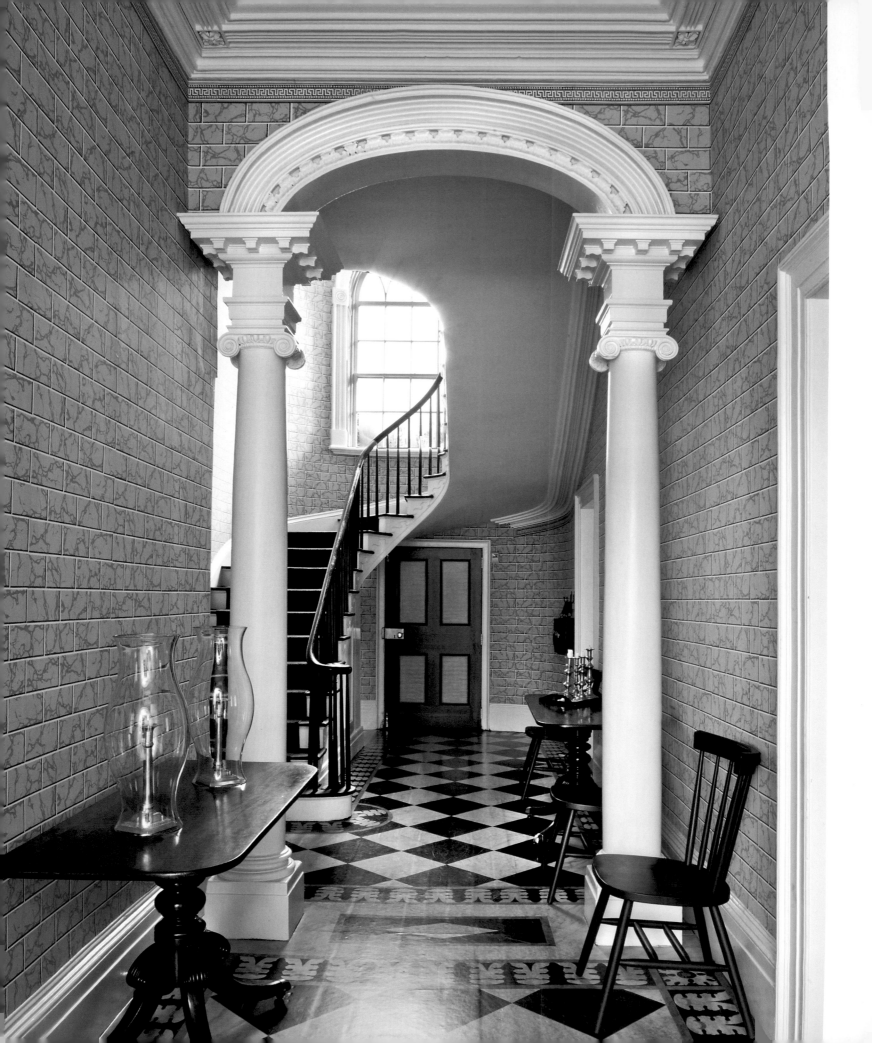

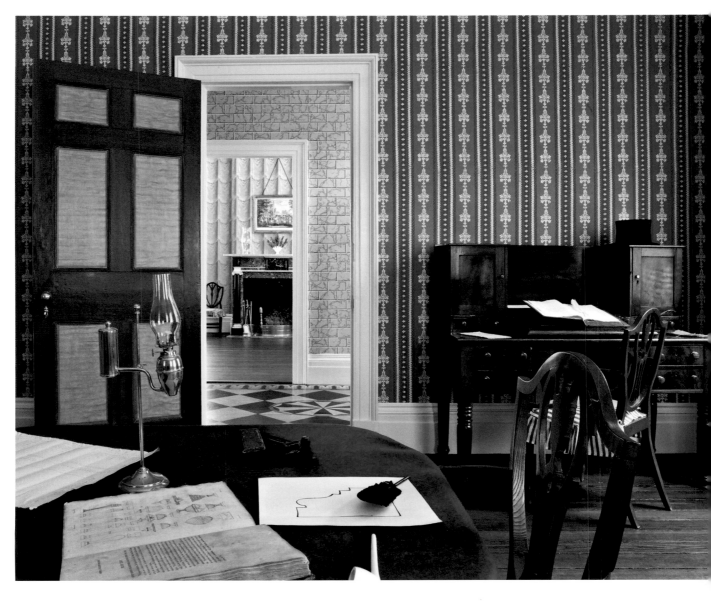

arch motif, with its delicately carved Ionic columns, is repeated in the adjacent parlor, creating a clear sense of hierarchical division between the formal "front" of the house and the more informal, private rooms in the back. The parlor arch is inscribed "George Smith, September 1822," which indicates how long it took to finish the interiors. Riotously patterned wallpaper imitates drapery; the widespread use of wallpaper in the house reveals the increasing availability of block-printed wallpapers, both imported and domestic, in the early nineteenth century. Both the parlor and first-floor study display magnificent carved marble mantels, a display of wealth and expense surely calculated to impress visitors and clients.

Davenport, who served on several civic commissions to study health and sanitation in the fever-plagued city, died of yellow fever in 1827. His widow maintained her residence as a boardinghouse until 1840, at which time she sold it to a family that operated it as rental property until 1920. Badly deteriorated, Davenport's showplace served as a rooming house until 1955. Threatened with demolition for a funeral home parking lot, it was saved by seven ladies who raised $22,500 to buy the property and, in the process, founded the Historic Savannah Foundation. After six years of fundraising, restoration, and collecting, the Davenport House opened to the public in 1963 as a house museum.

By the 1990s, a campaign of scholarly research and material analysis provided new and more accurate information about the house's historic appearance, collections, and social uses during Davenport's lifetime. In 2005, diligent restoration work had resulted in a more accurate depiction of Davenport's domestic environment and earned the Historic Savannah Foundation and the Davenport House staff a Preserve America Presidential Award for Private Restoration.

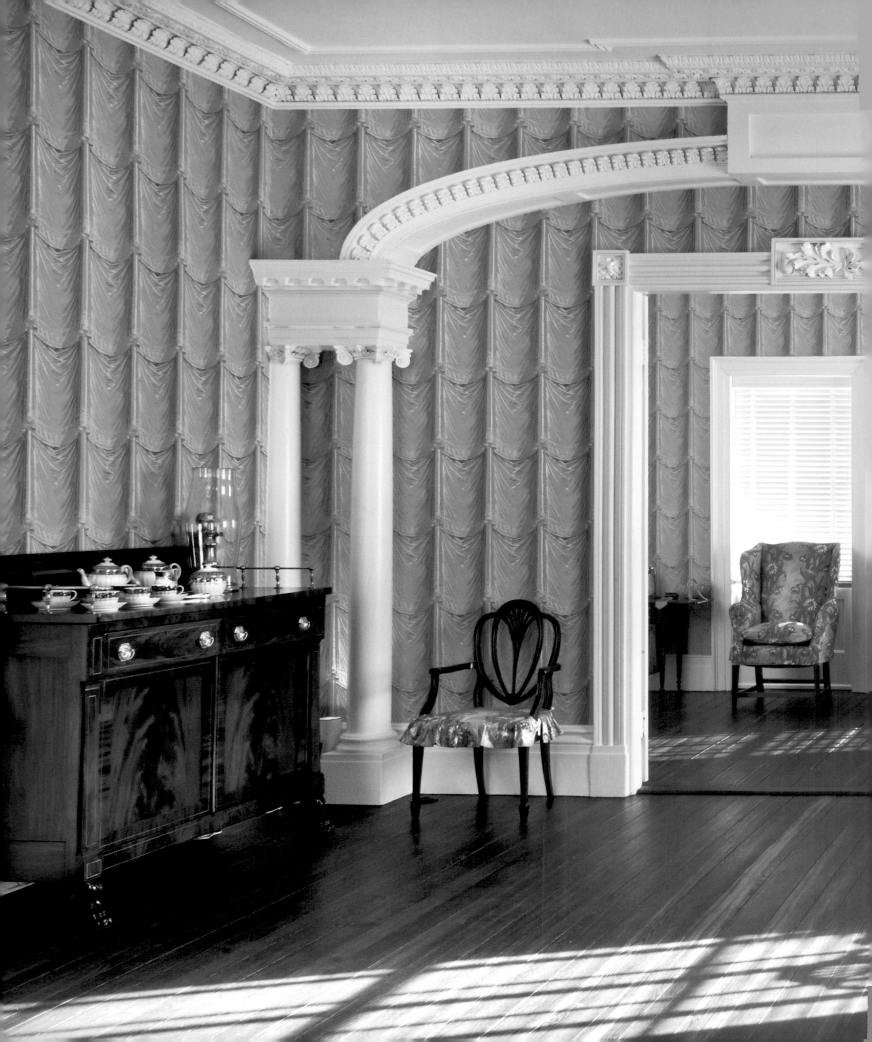

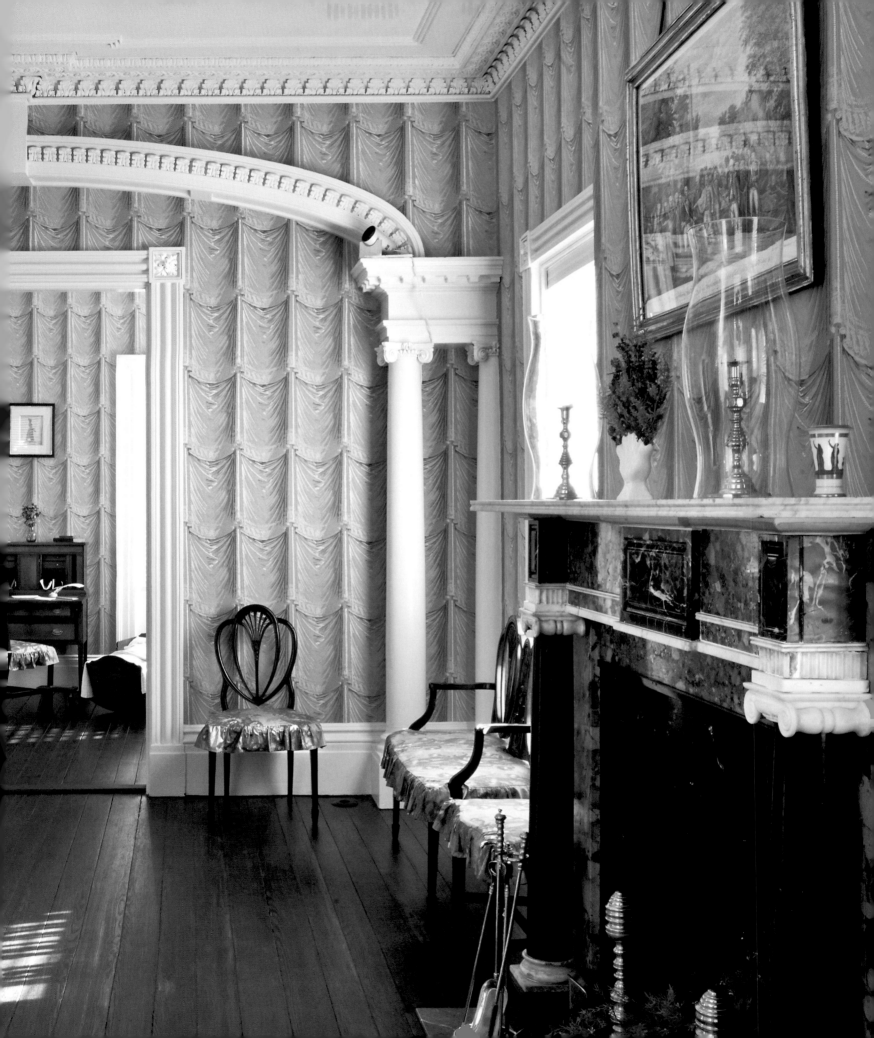

The Owens-Thomas House

Savannah, Georgia
Built 1816–19
Architect: William Jay
Builder: John Retan
Owned and operated by the Telfair Museum of Art

ABOVE
The garden front of the Owens-Thomas House, designed by English architect
William Jay, features distinctive polygonal bows.

RIGHT
The Owens-Thomas House marries imported English Regency style with
locally available materials and a prime location on Oglethorpe Square.

FOLLOWING PAGES
Gilded Composite-order columns in the foyer frame the brass-inlaid staircase.
The unique upstairs hallway "bridge" is just visible above the painting at center.

In contrast to the builder-designed Davenport House, the Owens-Thomas House in Savannah was designed by an architect in the up-to-the-minute English Regency style. For his house, cotton merchant and banker Richard Richardson chose a lot on prestigious Oglethorpe Square, one of the so-called "Trust Lots" designated for trustees of the original royal colony a half-century earlier. Richardson's brother-in-law was married to Ann Jay, whose brother William Jay happened to be an architect in England. Richardson must have commissioned the design by mail, because construction was already underway when Jay arrived in Savannah on December 29, 1817. An inscription under the portico states that the builder was John Retan, and work had begun in 1816.

Jay followed a sophisticated English Regency vocabulary of design. The style is a variant of Neoclassicism that emerged during the reign of King George IV, who ruled as Prince Regent from 1811 to 1820, and is characterized by its use of gracefully curving forms, light proportions, and restrained use of classical ornament. Set in a garden, Jay's design has two main stories rising above a heavy basement level, with a parapet wall

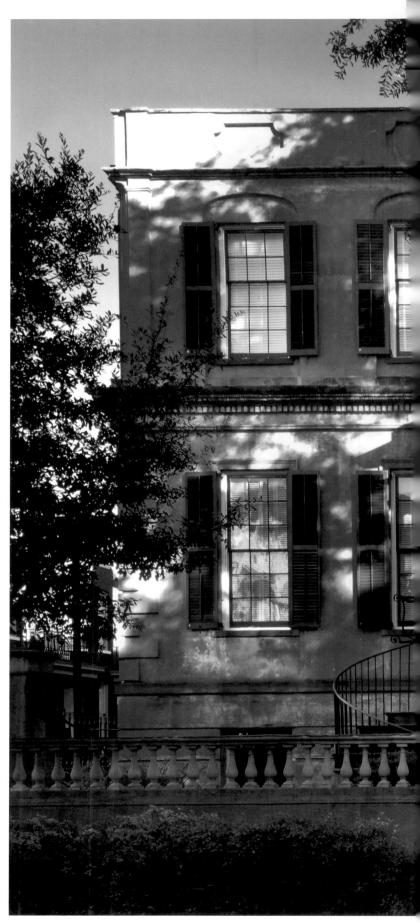

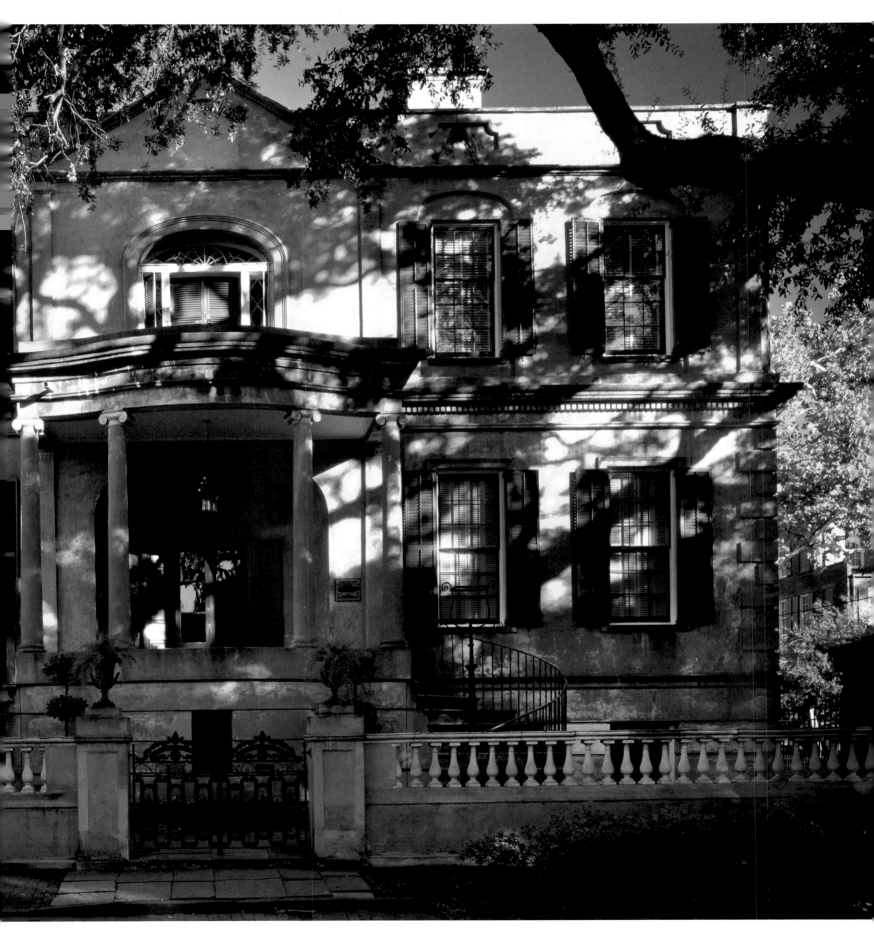

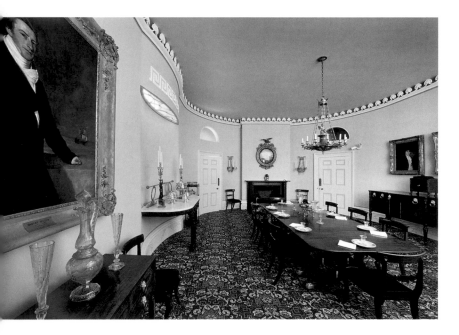

Jay cleverly introduced dramatic lighting into the dining room with the insertion of a projecting top-lit bow, inset with amber glass, into the concave wall over the server (left). The Greek key pattern on the wall surface is illuminated from behind by daylight.

Jay reversed the usual architectural arrangement of open central stairwell with flanking side passages by creating this slightly arched "bridge" across the center of the second floor.

Fan-like plaster pendentives create the illusion of a vaulted ceiling (painted here to resemble open sky) in the drawing room.

at the roofline partially concealing the low-hipped roof. The garden front displays two projecting polygonal bows. Jay—or perhaps his client—made one notable concession of the English designer to local conditions: the materials. The house is constructed largely of "tabby," a mixture of lime, oyster shells, and sand that was an early version of concrete often used in the Caribbean and coastal areas, perhaps introduced by island-trained African-American craftsmen. An amber-tinted stucco, scored to resemble ashlar masonry with red "mortar" lines, produces a smoother textured surface than brick, emphasizing the pure geometry of the massing. The Ionic capitals on both porticoes and the front exterior balustrade are made of an imported ceramic-like material, molded to imitate carved stone ornament. The sweeping serpentine front portico, with its delicate Ionic columns and classical alcove entranceway, announced the Richardson's house as a place of extraordinary refinement.

Jay was not a particularly conventional architect and may have had to adapt certain elements of his original mail-order design during construction. The foyer's Corinthian columns (complete with gilded capitals) frame a brass-inlaid staircase that leads to an unusual bridge-like walkway spanning the stairwell on the second floor. This raised walkway seems like an improvised solution to the problems of allowing adequate headroom below and linking the front and rear portion of the upstairs floor plan. The dining room, rich in classical detail, uses interior framing to define the space as an oval within the rectilinear form of the building shell. Jay's quirkiness can be seen to its best advantage in the concave niche, lit from above through a convex projecting skylight, with a Greek fret-patterned transom, inset with amber glass. The complex play of projecting and receding arcs is one of the most subtle and sophisticated spatial arrangements in nineteenth-century American architecture.

William Jay introduced two practical innovations to Savannah: large-scale cast ironwork and indoor plumbing. The verandah on the south facade (where the Marquis de Lafayette greeted crowds while staying at the house during his 1824–25 tour of the United States) was the first large-scale use of cast iron in the region. Following a devastating citywide fire in January 1820, Jay established a foundry with local ironmonger Henry McAlpin to promote the use of cast iron as a fireproof building material.

Three years after the house's completion, Richardson suffered a financial setback and was forced to sell the property. It operated as an upscale boardinghouse until 1830, when George Welshman Owens—planter, congressman, and, eventually, mayor of the city—purchased it. The house remained in the family until 1951, when George Owens's granddaughter, Margaret Thomas, bequeathed it to the Telfair Museum of Art, which operates it as a house museum. The furnishings on display at the house reflect American and British Neoclassical taste from 1790 to 1840, with a few Richardson pieces and many objects that belonged to the Owens family. An ongoing exhibition in the adjacent carriage house displays the Acacia Collection of African-Americana, showcasing objects that were made and used by slaves.

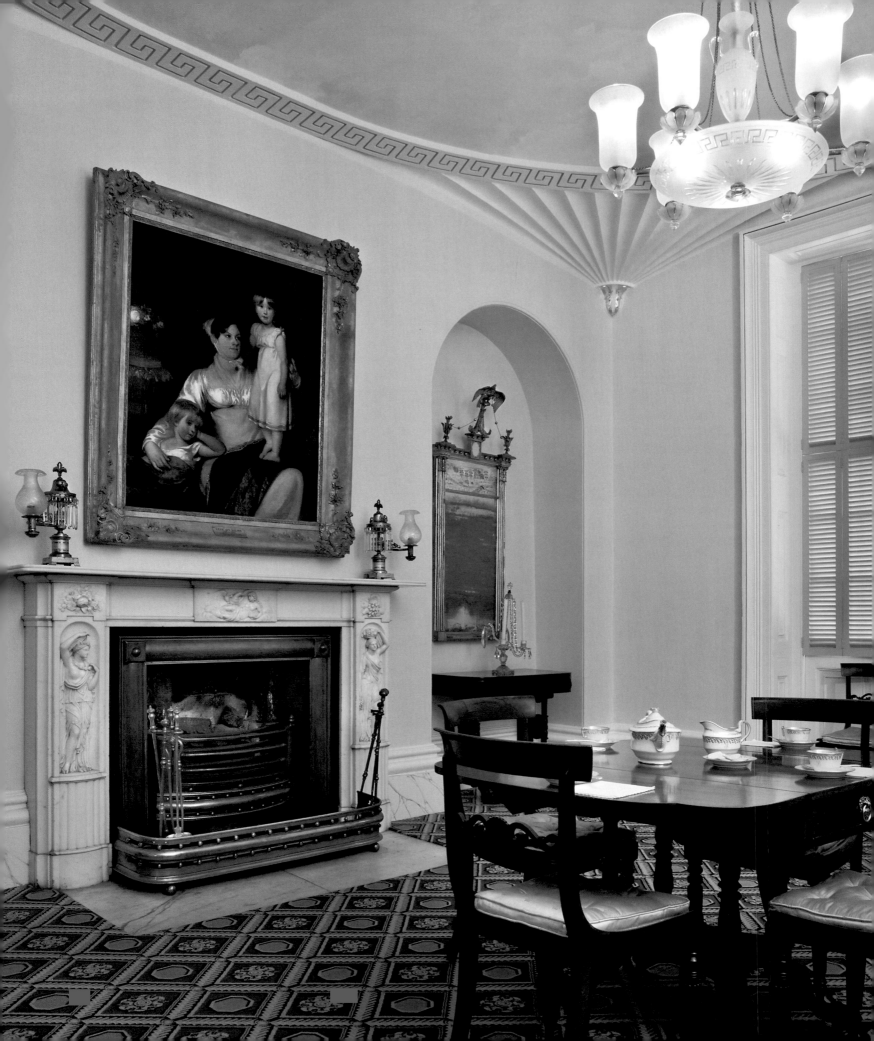

The Hermitage

Nashville, Tennessee
Built 1819–21, 1831, 1834–36
Builder: original, unknown; remodeled by David Morrison (1831);
substantially rebuilt by Joseph Reiff and William C. Hume (1834–36)
Owned and operated by the Ladies' Hermitage Association

ABOVE
*Architect David Morrison designed the Neoclassical tomb for
Jackson and his wife, Rachel, in 1831, during Jackson's first
presidential term.*

RIGHT
*The builders Reiff and Hume took many of the design motifs for
the existing Greek Revival version of the Hermitage mansion
from pattern books by New England architect Asher Benjamin.*

The evolution of the Hermitage from a log cabin to a great estate
mirrors the rise of its owner, Andrew Jackson, from luckless
orphan to the first "outsider" president: the first chief executive
elected from west of the Allegheny Mountains, the first from any state
other than Virginia or Massachusetts, and the first non-oligarch. As Jack-
son suffered ever-greater public scrutiny and weathered the political and
social battles of Washington, DC, the house evolved as a reflection of his
growing mastery of the representational language of architecture and dec-
orative arts to convey his carefully crafted self-image.

Jackson's father died shortly before he was born, and by the end of the
Revolutionary War (in which he served as a messenger and was impris-

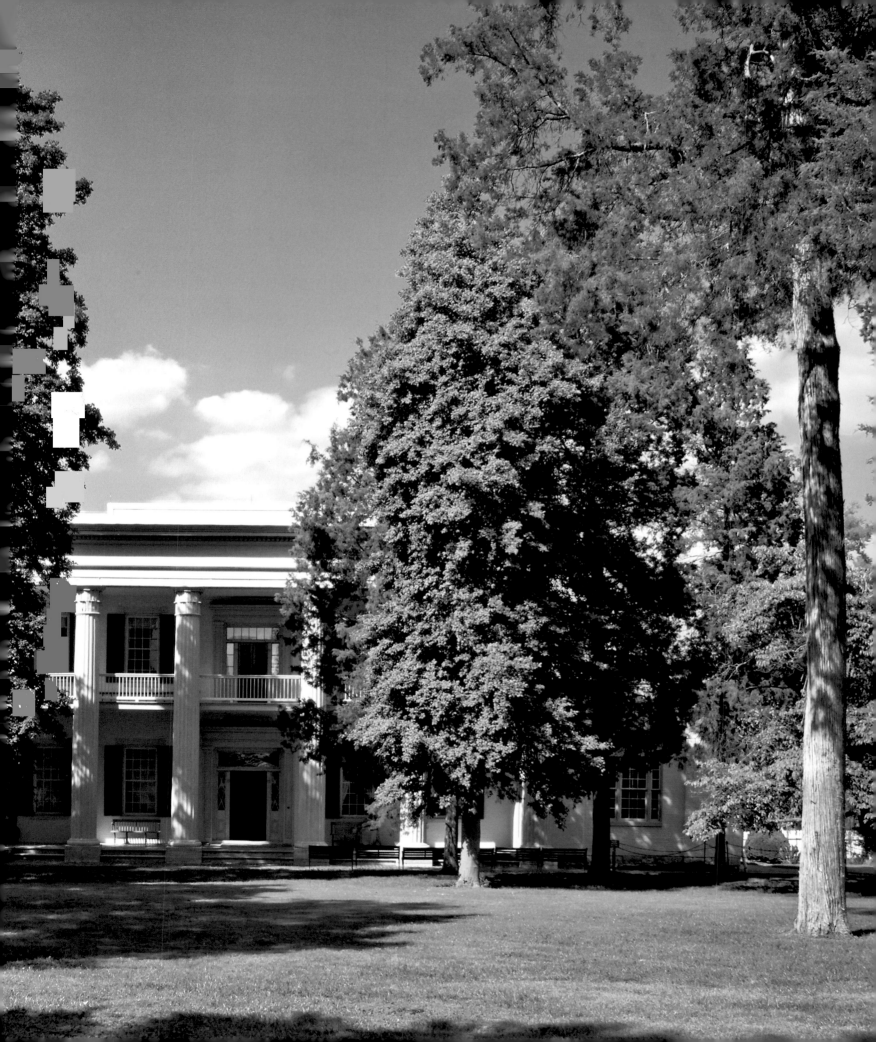

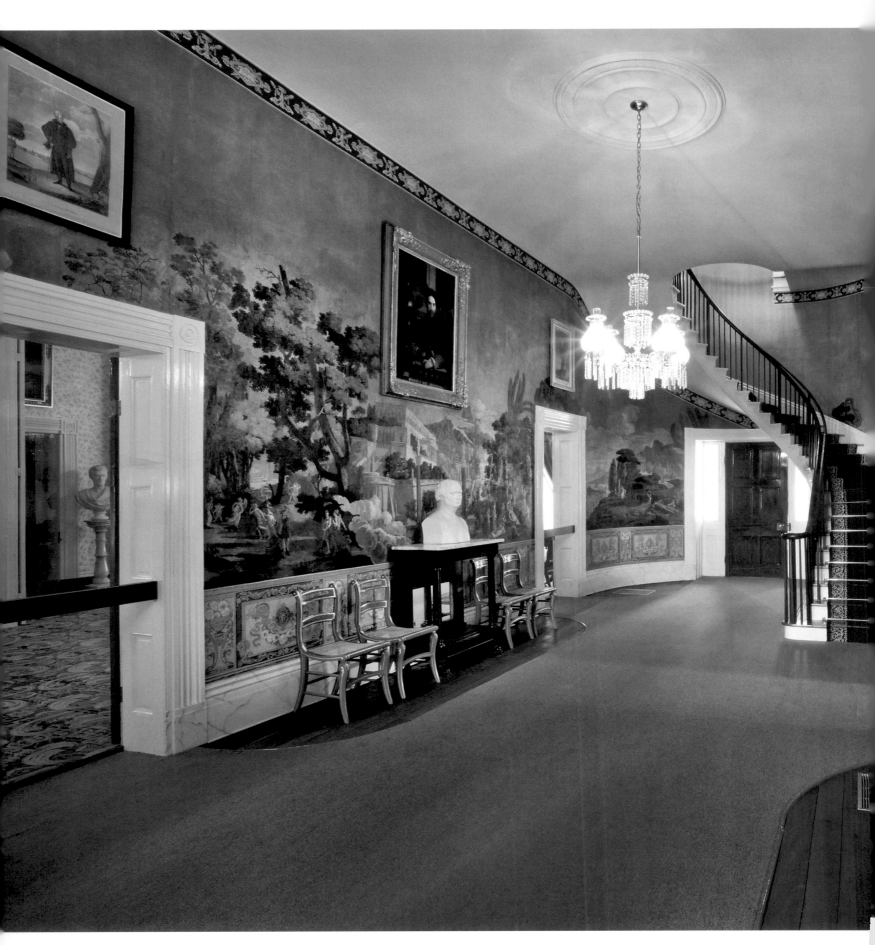

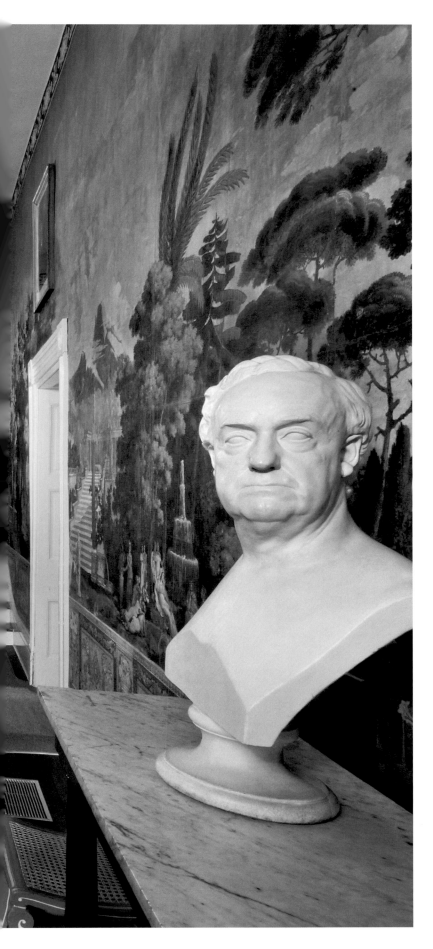

oned), the fourteen-year-old Jackson was left an orphan. At seventeen, he began studying law and by 1788 was the appointed prosecuting attorney for the Western District of North Carolina. When that district became the state of Tennessee in 1796, Jackson became its first congressman and also served a term in the senate. He married divorcée Rachel Robards in 1791, and when the validity of the marriage was contested, they remarried in 1794. Content in his position as state Supreme Court judge, Jackson was called to military service for the first time since the Revolution when he was appointed major general of the Tennessee militia in 1802.

In 1804, the successful state politician Andrew Jackson purchased a 640-acre cotton plantation (later expanded to one thousand acres) that included a recently built two-story log house. Although the log cabin became iconic of humble origins in the twentieth century, a four-room, two-story, well-built log house would have been considered an above-average dwelling, fit for the vast majority of American farmers at the time. With more than a hint of ambition, Jackson chose the name "The Hermitage" and hired a local craftsman to embellish the interior with painted millwork and imported wallpaper. This glorified cabin was Jackson's home when he led American troops against the British in the Battle of New Orleans in 1815, which instantly made him a national hero.

Sometime soon afterward, during the Seminole Wars of 1817–20, Jackson commissioned a new, grander house. Although Jackson's rough-and-tumble image was the basis of his political career, constant contact with elite politicians and power brokers spurred Jackson to adopt some of the architectural and material habits of refinement as a means of asserting his own equality. The desire to project an image of gentility must have been particularly acute for Rachel Jackson, whose controversial divorce was a constant source of scurrilous rumors and character assassination. By the time Jackson returned from a year's service as military governor of Florida, the family's old log house had been converted to slave housing.

The first iteration of the Hermitage as a mansion was a five-bay, eight-room, center-hall brick Federal-style house, built by local craftsmen between 1819 and 1821. While the house marked a definite step up in Jackson's self-image from successful yeoman farmer to landed gentry, stylistically it was a bit *retarditaire* by more fashionable Eastern standards, although Rachel did purchase a set of very trendy hand-printed scenic wallpaper panels by Joseph Dufour of Paris. Jackson hired William Frost, an English-born Philadelphia landscape architect, to design formal gardens on the site, indicating that the land was no longer a purely functional commodity but also a tableau of domestic and personal gentility.

In 1831, President Jackson (now a widower) hired architect David Morrison to oversee a major remodeling of the Hermitage. Morrison dramatically enlarged and updated the house, adding one-story wings, a two-story entrance portico with giant order Doric columns, a rear portico, and copper gutters. The east wing contained a library and farm office while the west wing featured a large dining room and pantry. A new kitchen and smokehouse were also built behind the thirteen-room mansion, suggesting that Jackson may have foreseen some large-scale entertaining in his future.

Fire heavily damaged this version of the house in 1834, and Nashville builders Joseph Reiff and William C. Hume were summoned to the site. Significantly, Jackson did not choose to simply restore but chose to notably aggrandize the house, which he had only completed three years

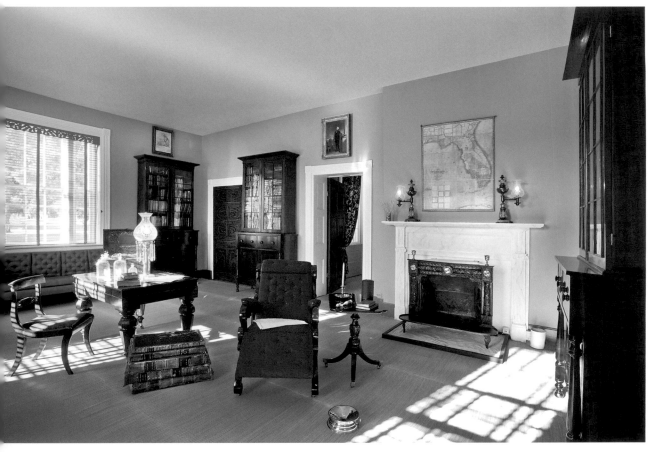

PREVIOUS PAGES
Scenic wallpaper by French manufacturer Joseph Dufour— originally selected by Rachel Jackson for an earlier version of the house— remains in the central hall. Busts of two Jackson cabinet members, Levi Woodbury (left) and Lewis Cass (right), rest on Philadelphia pier tables.

LEFT
Jackson's library houses his personal books and newspapers. His Nashville political friends presented him with the reclining "invalid" chair late in his life.

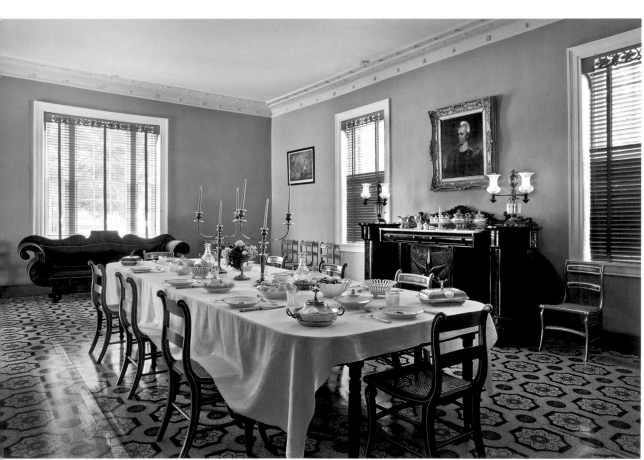

LEFT
The largest room in the Hermitage mansion, the west-facing dining room features Prussian blue walls and a Philadelphia sideboard, possibly the work of Anthony Quervelle.

earlier. The entrance facade was transformed by the addition of a monumental colonnade, perhaps influenced by the White House's north portico, which was rebuilt during Jackson's presidential term of office. At the Hermitage, six giant order Corinthian columns (in contrast to the president's house's hierarchically less elevated Ionic) range across the front under a flat roof, while simpler Doric order columns support the two-story rear porch. While the clear dominance of the temple form over the main block of the residence marks the Hermitage as Greek Revival in stylistic influence, the importance of official Federal Neoclassicism as Jackson would have seen it in the Washington buildings of Latrobe, Strickland, and Mills, made the choice of a monumental portico for his house a statement of his official identity as American president, and no longer merely a statement of his comparative social status in the community.

Inside the house, the interiors demonstrate a mixture of fashionable display and private sentiment. Millwork from the old Federal-style house was salvaged and relocated to the private, family bedrooms, while the more "public" parlors and guest rooms featured newly made Greek Revival–style mantels and woodwork taken from the ubiquitous pattern books of Asher Benjamin, whose *The American Builder's Companion* would have been in its sixth edition by this point. Jackson instructed that the damaged French scenic wallpaper, once chosen by Rachel, should be replaced in kind. Featuring vignettes of the first four books of the *Odyssey*—*The Telemachy*—and handprinted by Joseph Dufour of Paris in 1818–25, these panels were and remain among the finest of their type in the United States. Philadelphia-made furniture, mostly in the classically based Empire style, replaced family pieces destroyed in the fire. Once the renovations were completed in 1837, the Hermitage was an indisputably appropriate presidential house.

A few years after Jackson died in 1845, Andrew Jackson, Jr., ran into financial trouble and began selling off lots. To preserve the property as a "shrine" to Jackson, the state of Tennessee purchased the estate with a proviso that Jackson's son could remain in residence. After the Civil War and following the death of Andrew Jackson, Jr., in 1865, increasing numbers of people from both North and South began to make journeys to the Hermitage, and the image of Jackson and his home emerged as emblematic of the Old South and its supposedly vanquished culture. In 1888, a group of wealthy Nashville women opposed a federal plan to turn the house into a home for indigent veterans and formed the Ladies' Hermitage Association to purchase and operate the house as a public site. Modeled on the Mount Vernon Ladies' Association of the Union, which had purchased George Washington's Mount Vernon estate in 1859, the Ladies' Hermitage Association restored and opened Andrew Jackson's Hermitage as a museum in 1889. This act made the Hermitage the second presidential home in the nation to become a museum and the first to be identified as emblematic of a regionally defined, distinctive culture of the South.

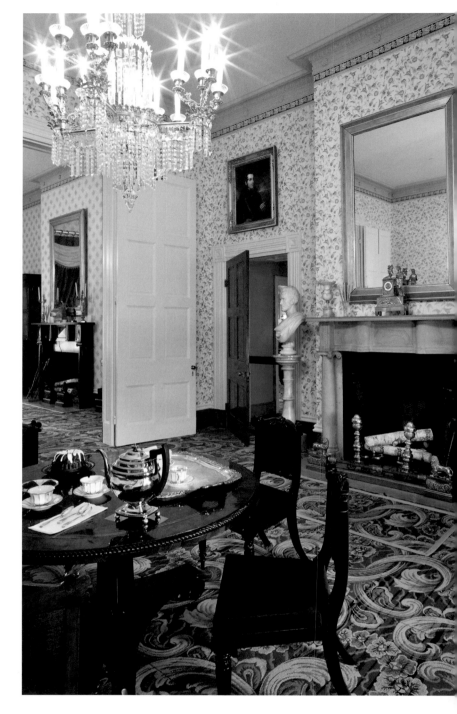

ABOVE
Matching French mirrors and chandeliers, by the Philadelphia design firm Cornelius & Sons, adorn the parlors where the Jacksons entertained. A bust of Jackson by Luigi Persico stands near the mantel.

FOLLOWING PAGES
An imposing archway divides the built-in linen closets from the rest of the upstairs hallway. Guests may have used the hallway as a sitting room during the warmer months.

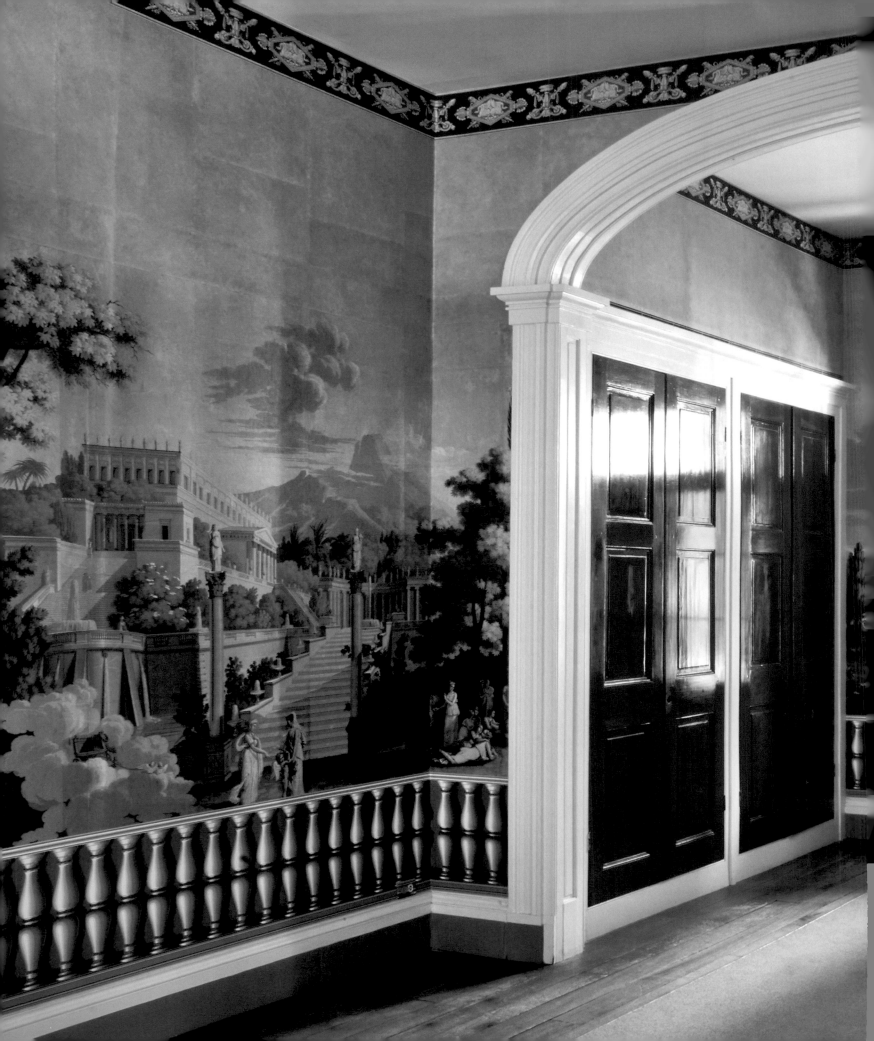

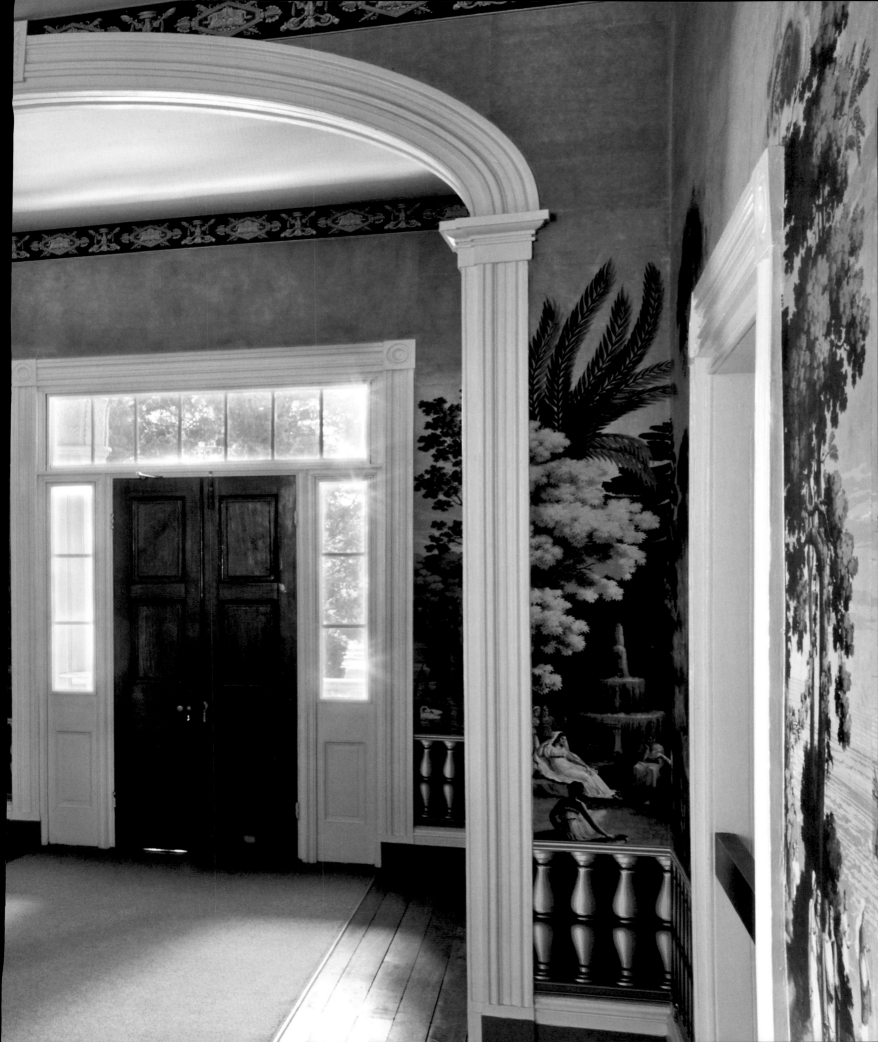

PART III

1820–1861

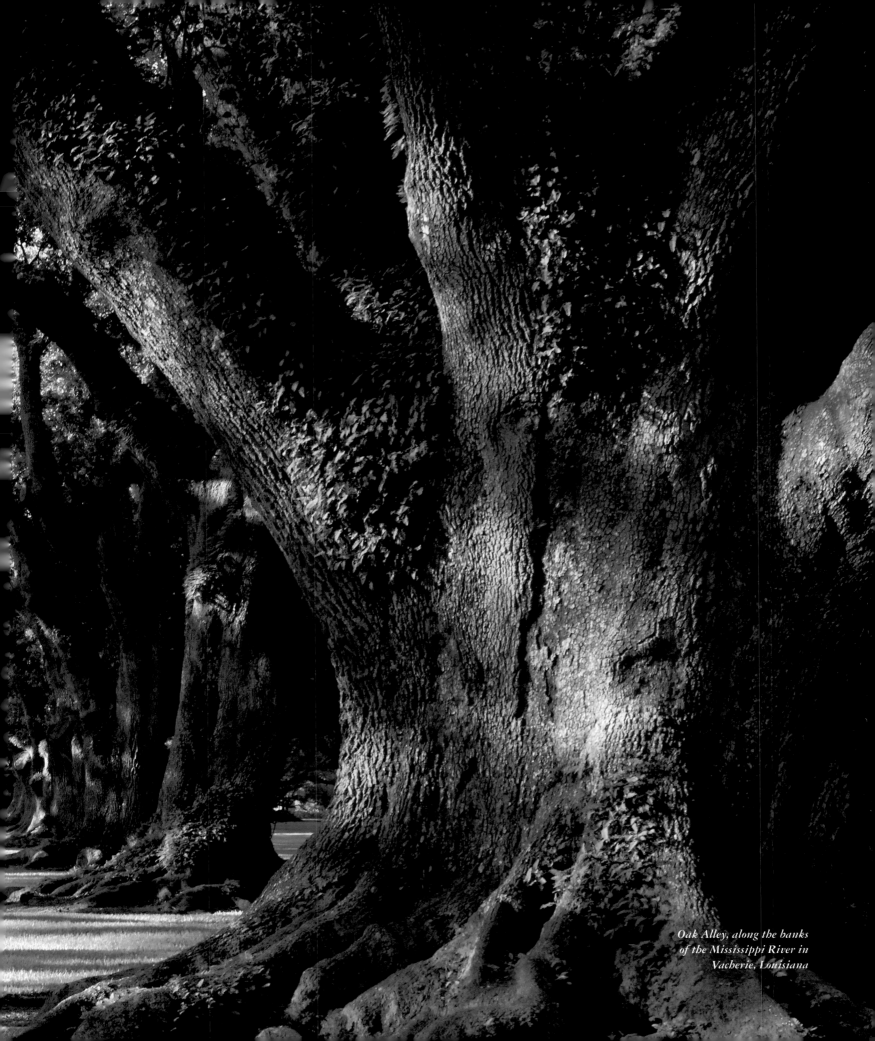

*Oak Alley, along the banks
of the Mississippi River in
Vacherie, Louisiana*

The Hermann-Grima House

New Orleans, Louisiana
Built 1831
Architect-Builder: William Brand
Owned and operated by The Woman's Exchange

ABOVE

The garden-front arcade (originally open) faced both the decoratively planted courtyard and the work wing (left). The work wing contains the kitchen, as well as a laundry, storerooms, and slave quarters.

RIGHT

The elegant Federal-style facade of the Hermann-Grima House, facing Saint Louis Street in New Orleans's Vieux Carré

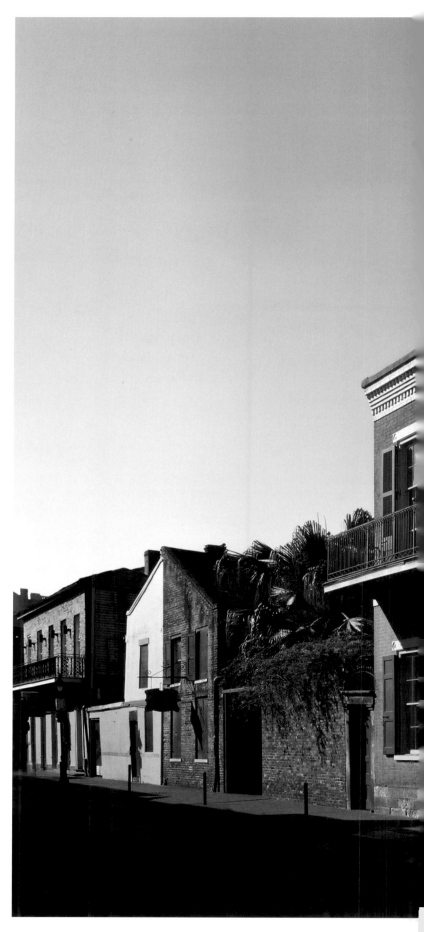

Geographer Peirce Lewis aptly summarized New Orleans as "an inevitable city on an impossible site."[1] The economic advantages of its location at the mouth of the Mississippi River made settlement irresistible to European traders, yet the climate and topography have left its residents subject to a seemingly endless series of catastrophes, including tropical disease epidemics, fires, and, of course, hurricanes. An influx of settlers from the Caribbean, as well as American-born people of French, Spanish, Native American, and/or African descent (Creoles)—in addition to French emigrants from northeastern Canada (Cajuns)—lent the city a distinctly exotic and somewhat more socially elastic cultural flavor compared to the rest of the United States. Architecturally, traditions from New Orleans's French and Spanish colonial past tended to subsume English influences, but prosperous locals filtered a range of European forms through Caribbean practice to create widely legible statements of refinement that still functioned effectively in the tropical climate.

Samuel Hermann, a German-Jewish immigrant merchant and banker, built his French Quarter house in the Anglo-American Federal style in 1831. He chose William Brand, a Virginian by birth and training, to adapt conventional Federal forms and motifs to the local climate and its

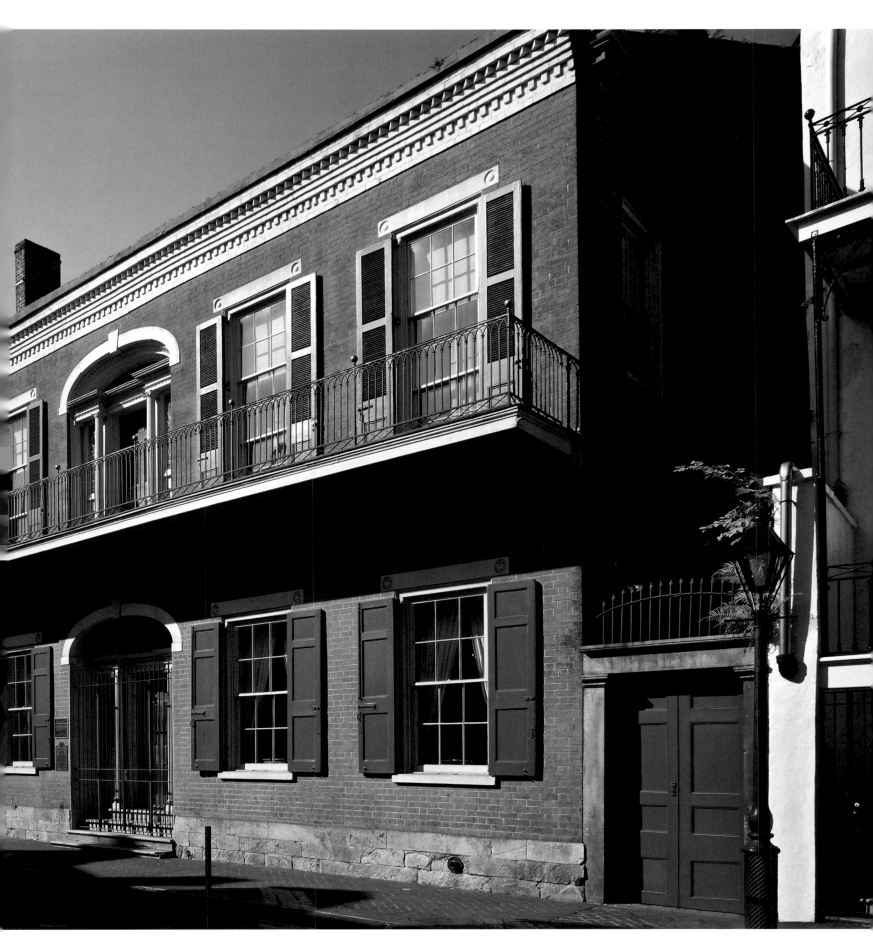

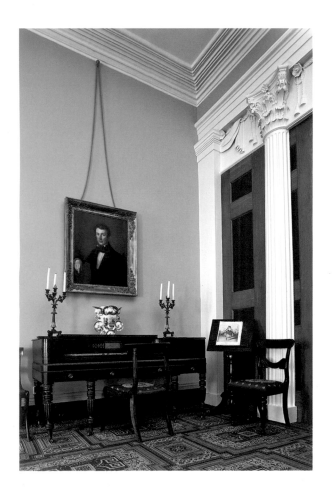

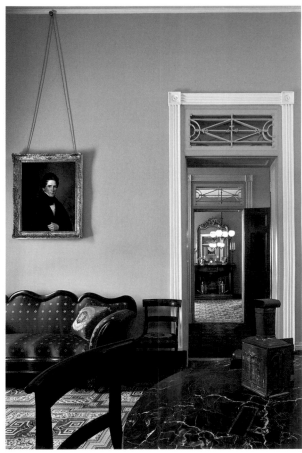

associated building conventions. Those conventions, such as galleries for living as well as for external circulation and enclosed courtyards, were adaptations to climate derived from practices developed in the Caribbean, and possibly derived from African traditions. At the Hermann House, the street facade is calculated to portray a predominantly conventional Anglo-American image, while the private back of the house reveals its local character.

The five-bay Federal plan, with central entrance hall framed by fan- and sidelights, presents a particularly imposing appearance in conjunction with the scale of the streetscape and neighboring buildings in the Vieux Carré. The doorway—framed by finely carved Ionic columns, egg-and-dart, bead-and-reel, and a veritable glossary of classical moldings—is reiterated on the second level, creating a strong central, vertical focus and emphasizing the facade's bilateral symmetry. The impression of imposing scale is heightened by the bold horizontal emphasis of the dentillated, textbook-classical cornice, juxtaposed with the locally inspired ironwork gallery that extends across all five bays of the facade. Hermann imported Philadelphia brick for its durability and had it laid in expensive Flemish bond (alternating headers and stretchers), only to stucco over the material. The brick-colored stucco is scored, and the mortar joints are outlined in white—in stylized imitation of the actual red-brick construction. The slightly raised base-

ment elevates the house, literally and figuratively, above the dirt and traffic of the public street.

The elegant interiors are embellished with marble mantels and, most strikingly, a heavily carved columnar screen between the parlor and dining room, featuring Composite-order capitals and a frieze of classical swags and rosettes embellished with floral sprays. Overlooking the garden courtyard to the rear, the Hermann family would have made ample use of the open gallery on the first floor and a Creole loggia (now enclosed) on the second floor. Colonial cottages in the Caribbean often featured similar wide porches or verandahs, a form possibly adapted from African building types, to create shaded living space with good (or at least tolerable) air circulation. At the Hermann House, as with other more formal residences in the South, the practical gallery form was integrated into fashionable styles, constructed of durable materials such as iron, stone, or brick, and fully furnished for use as family living space. The back of the house opens on to a flagstone courtyard, planted in raised beds with decorative flowers and shady palm trees in the manner of a Spanish patio, but it is also delineated on the long axis by the "working" area of the property, a three-story brick service block that included facilities for cooking, storage, and slave quarters. Outdoor wooden galleries substituted for indoor hallways between rooms. The architectural adaptation to the hot climate and urban environment meant that the courtyard was the real

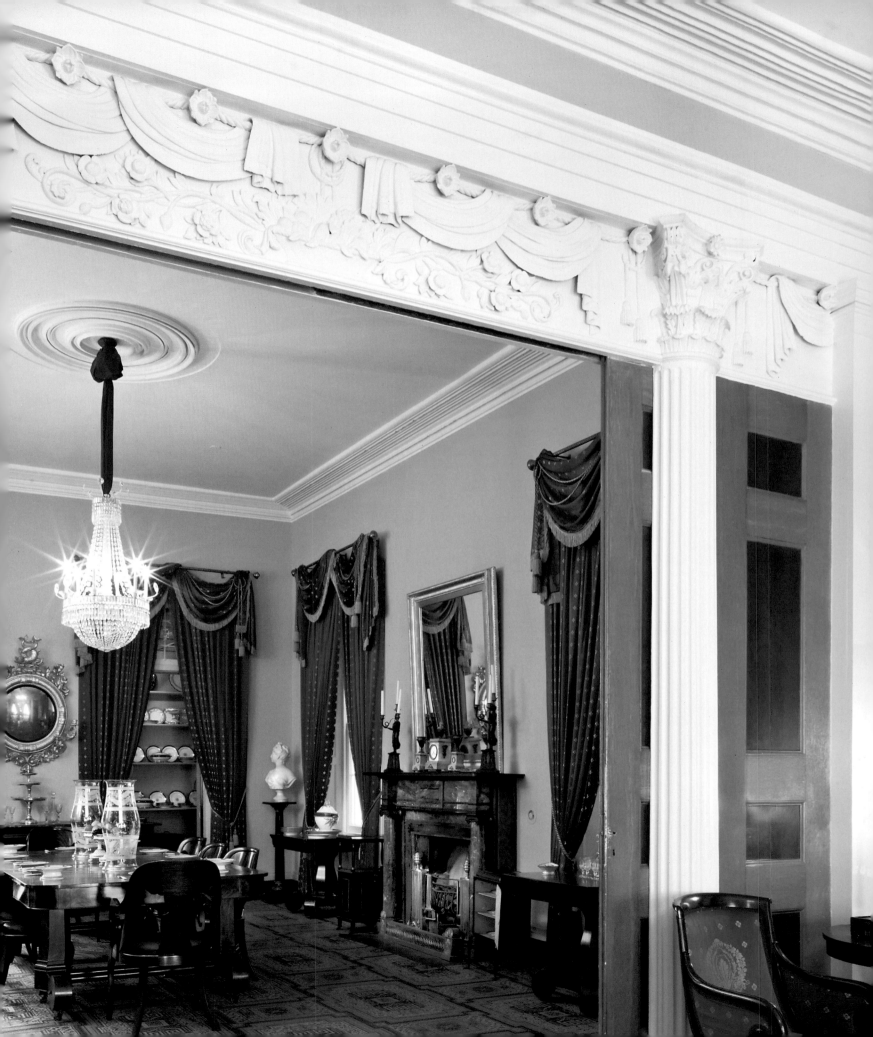

The first-floor child's bedroom opens onto the arcade and courtyard beyond.

Felix Grima, a notary and criminal court judge, used his library both as a public office space to meet with clients and as a room for leisure. The portrait (from the collection of the Louisiana State Museum) depicts Grima's niece Clara Mazereaux.

center of the house, serving as both leisure space for the owner's family and work space for the enslaved residents. The architectural form reveals and also, perhaps, enforced more relaxed notions of privacy and social division of space than was typical for other regions.

In 1844, the house was bought by Judge Felix Grima, who built adjacent stables in 1850. His descendants remained on the property until 1924, when it was purchased by the Christian Woman's Exchange, which operated it as a consignment shop and rooming house for forty years. In 1965, recognizing the importance of preserving the house as an architectural gem and cultural time capsule, the Christian Woman's Exchange began a series of restorations, opening the Hermann-Grima House as a museum in 1971. With new research into social and material culture and refined collections, today the Hermann-Grima House represents the lifestyle of a prosperous Creole family and its enslaved workers in the years from 1830 to 1860.

Oak Alley

Vacherie, Louisiana
Built 1839–41
Architect: Joseph Pilié (attributed)
Builder: George Swainy
Owned and operated by the Oak Alley Foundation, Inc.

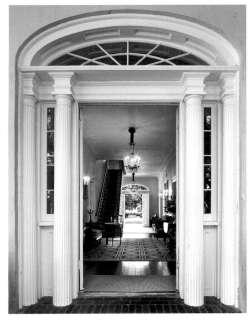

*The front door retains the well-established Federal-style
fan and sidelight form, while the restrained ornament
and bold articulation of the orders reflect then-current
Greek Revival taste.*

*Oak Alley's Greek Revival facade is framed by a
magnificent allée of three-hundred-year-old live oak
trees, which extend from the mansion to the banks
of the Mississippi River.*

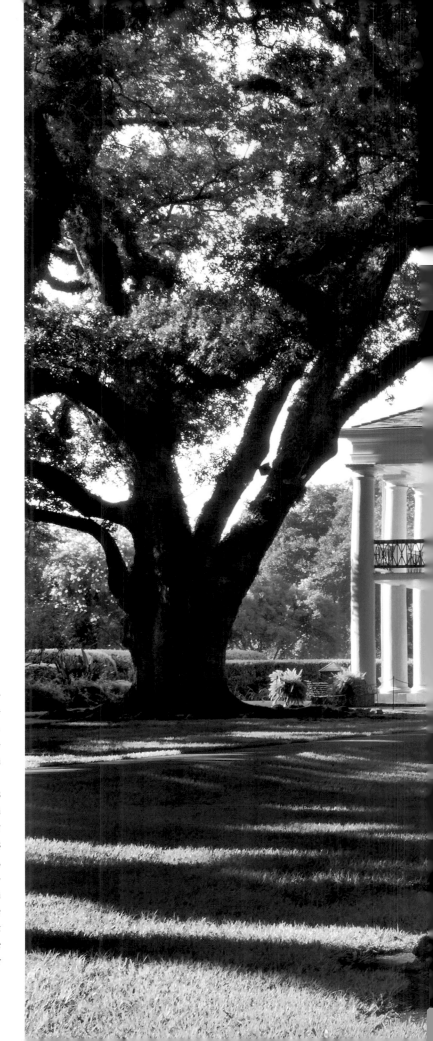

Louisiana's River Road, which runs seventy miles alongside the Mississippi from New Orleans to Baton Rouge, is dotted with distinguished Greek Revival plantation houses of the antebellum era. The allée of twenty-eight live oak trees framing the monumental colonnade of Oak Alley is, however, the iconic architectural image of the region and, indeed, of the antebellum South.

The trees came first. Research indicates that the two rows of live oaks were planted by an ambitious settler in the first quarter of the eighteenth century and were well established when the property was acquired by wealthy Creole sugar planter Jacques Telesphore Roman III from his brother-in-law in 1836. The plantation, named *Bon Séjour* at the time, already had established cane fields, a steam-powered processing mill, outbuildings, and a work force of fifty-seven enslaved people when Roman took over and began to build his house. The logical building site, at the head of the allée, allowed Roman to stand on his balcony and look straight ahead through the shaded tunnel to the river where his products were loaded and shipped to market in New Orleans. In the 1830s, the sugar

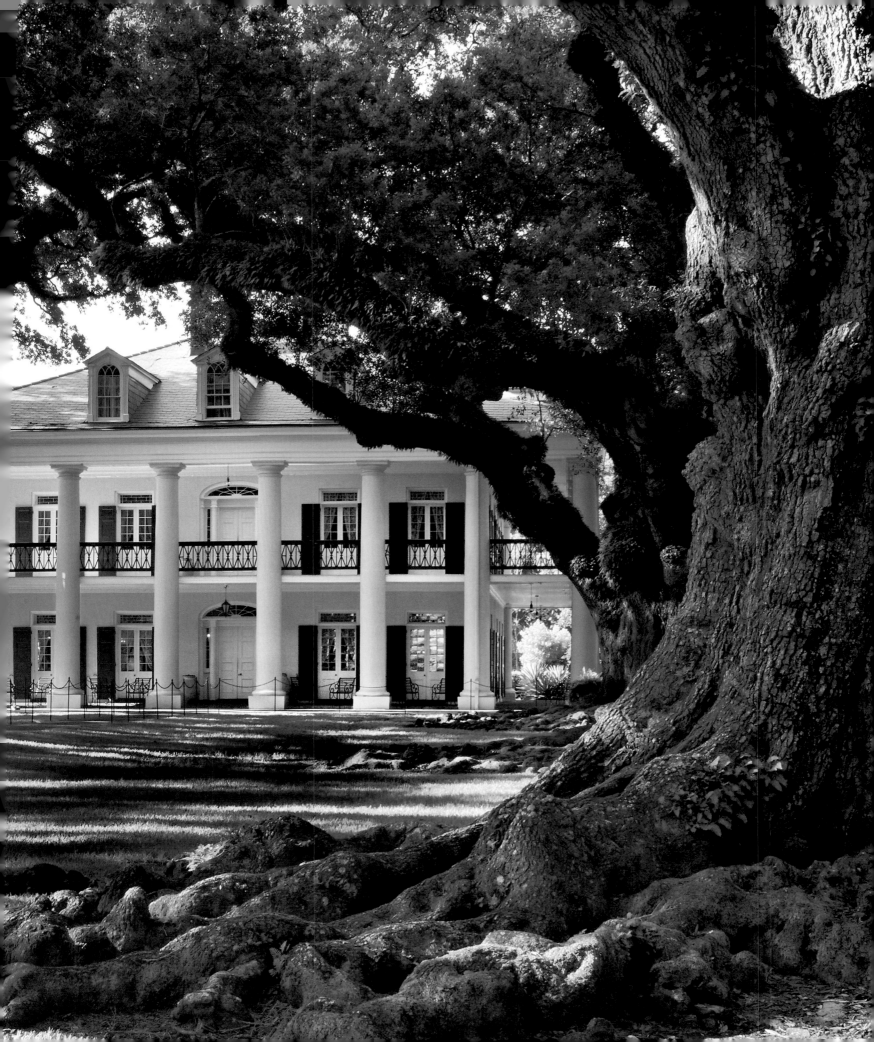

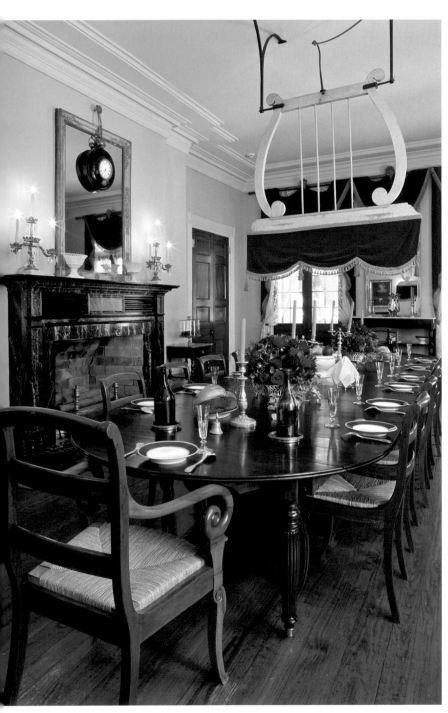

The dining room features a punkah, a type of fan that swung back-and-forth when pulled by a cord, over the Louis-Philippe dining table.

industry was booming in Louisiana, and the River Road was the commodity's highway to market. Roman's father-in-law, Joseph Pilié, an architect and city surveyor for New Orleans, is believed to have designed the plantation's great house. Furnishings and ornaments for the grand mansion arrived by riverboat from shops and importers in New Orleans, all calculated to lure Roman's new bride to the countryside.

The house has twenty-eight Doric columns, one for each tree. Unlike previous classical styles in American architecture, the Greek Revival adopted the peripteral temple form, in which the colonnade completely surrounds the center block. This form particularly caught on in the South, where the shaded verandahs that resulted from the arrangement created ample, useful outdoor living spaces. A wrought-iron balustrade in a simple geometric pattern defines the second-story gallery, which created well-ventilated outdoor living areas adjacent to the family bedrooms. The residential block within, seventy feet square, was not unlike previous Federal houses in plan, with a central hallway or passage (used for living space, as well as for circulation in hot climates) flanked by two large rooms on either side. The fan- and side-lit doorways at either end of the central passage are variations on Federal tradition, ornamentally simplified to emphasize the architectonic qualities of the forms.

Oak Alley was built of brick, which was then stuccoed over, both to protect the clay-based brick from degradation and to create a light, reflective surface. The columns are also stuccoed brick and, like most of the construction, would have been created by enslaved workers. The interiors originally featured marble floors, chosen not only for the material's opulence but also for its resistance to termites and rot (these were later replaced with wooden floors). The dining room features a lyre-shaped punkah, a kind of ceiling fan adopted from British Colonial India, which served to repel flies and circulate air. Here, as at many great antebellum Southern houses, a slave would have stood tableside throughout the family's meals, pulling the ropes that caused the panel to swing back and forth. The house's elaborate decorative plasterwork, most notably a ceiling medallion in a second-floor bedroom, is attributed to enslaved artisans on the plantation, a reminder that slave labor not only created the wealth that built the great houses but also contributed the skilled craftsmanship that made them so beautiful and enduring. In 1846 or 1847, an enslaved gardener at Oak Alley named Antoine successfully grafted pecan trees for propagation, a feat that had defied academic horticulturists for decades. In 1876, Antoine's cultivar was designated the "Centennial" pecan and is still grown today throughout the South.

Jacques Telesphore Roman died of tuberculosis in 1848. The plantation foundered under the management of his widow and son, and could not withstand the trade embargoes and economic devastation of the Civil War. In 1866, the plantation—nicknamed "Oak Alley" by riverboat captains—was sold at auction. The property passed through several owners, eventually falling into grave disrepair by the time of the First World War. From 1917 to 1924, the Hardin family dedicated themselves to restoring the site but ran out of money and luck before the restoration of the main house was complete. Finally, Andrew and Josephine Stewart purchased the property in 1925 and hired architect Richard Koch to conduct an extensive restoration of the mansion. Today the main house and twenty-five remaining acres are owned and operated by the not-for-profit Oak Alley Foundation, founded by Mrs. Stewart before her death in 1972. It is open to the public for daily tours, with an inn and restaurant on the site.

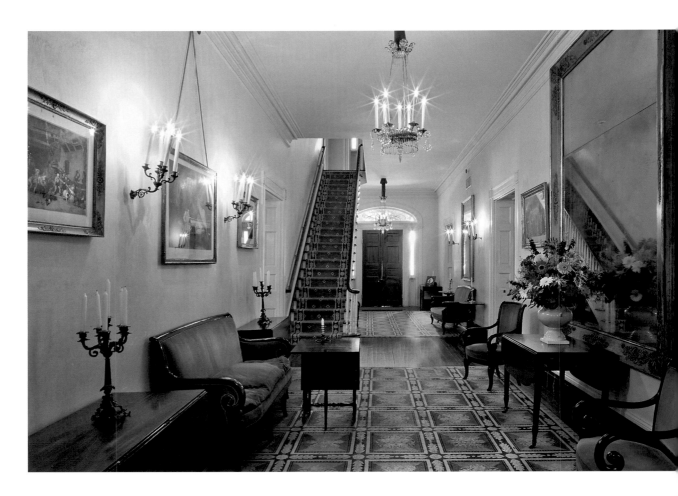

Doors at both ends of the entrance hall, typically used as the summer living room, could be opened to promote cross-ventilation.

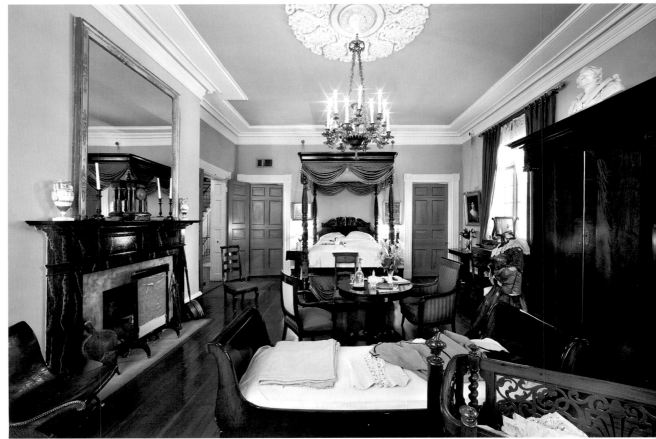

The master bedroom features an elaborate plaster and horsehair ceiling medallion, made by one of the plantation's highly skilled enslaved craftsmen.

FOLLOWING PAGES
The view from the mansion extends to the banks of the Mississippi River.

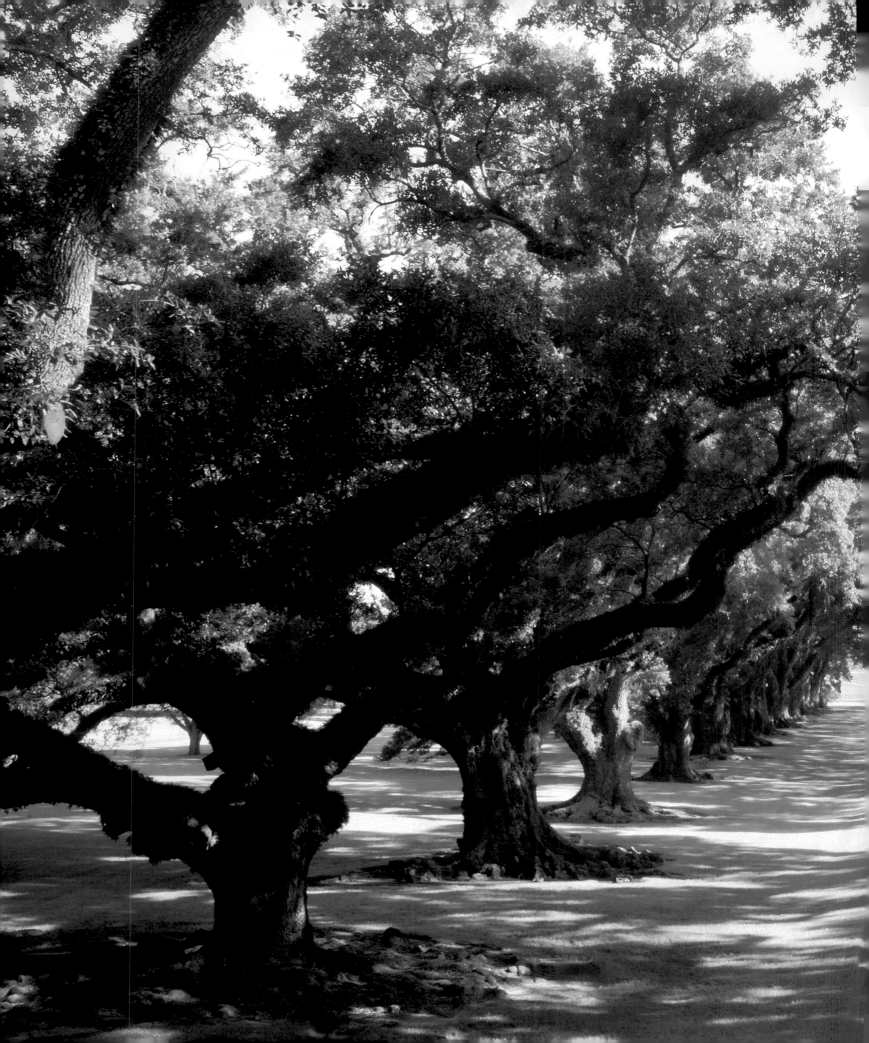

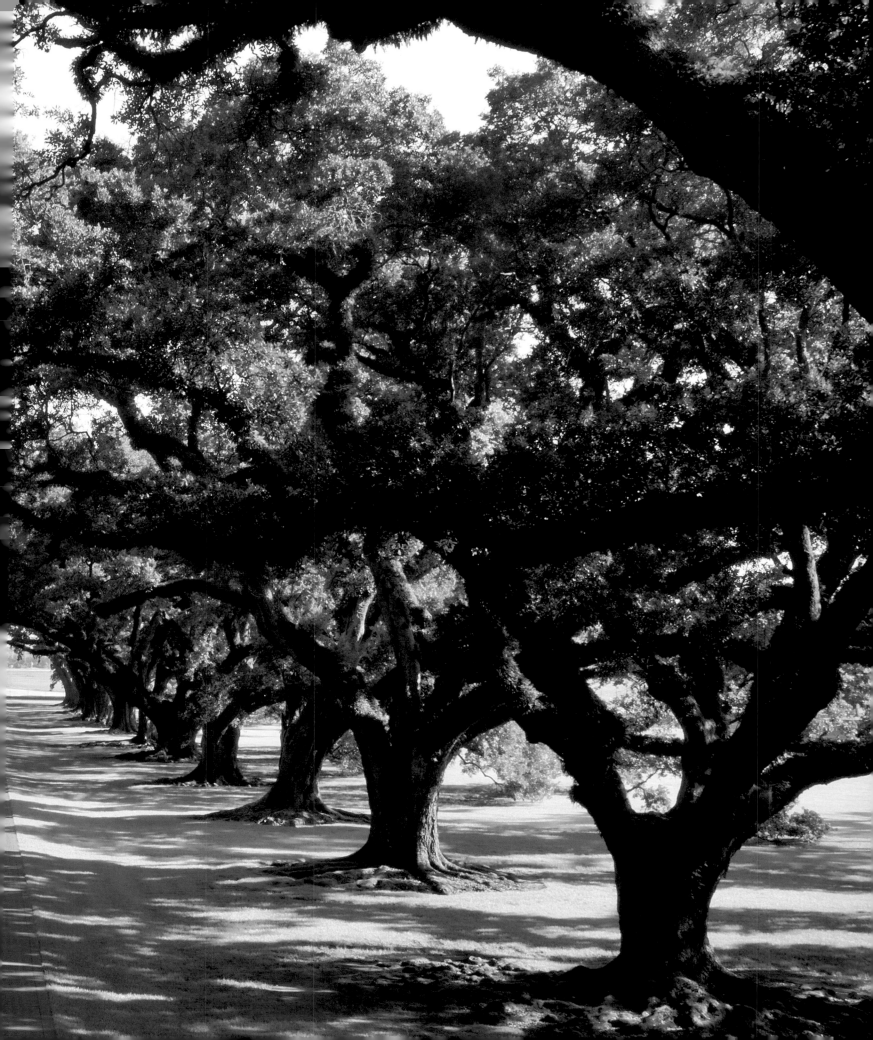

Melrose

Natchez, Mississippi
Built 1841–49
Designer-Builder: Jacob Byers
Owned and operated by the National Park Service, U.S. Department of the Interior

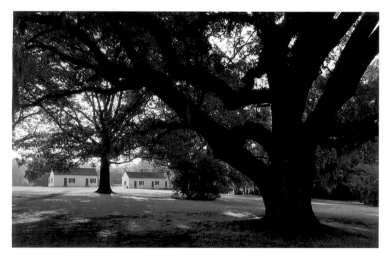

ABOVE

Reconstructed cabins represent where enslaved garden and grounds workers would have lived.

RIGHT

Although it did not function as a commercial plantation, Melrose was designed to resemble one as a statement of social status and regional identity.

Melrose was constructed from 1841 to 1849 for prominent Natchez attorney and planter John McMurran by a Maryland builder. Although the Pennsylvania-born McMurran and his Mississippi-born wife did not operate the estate as a commercial plantation, their house represented their status in the architectural language of the regional planter society, and their refined domestic lifestyle depended on the labor of as many as twenty-five enslaved workers. They named their 133-acre estate Melrose after an abbey described in the second canto of Sir Walter Scott's poem *The Lay of the Last Minstrel*, an elegy for the vanishing values of chivalry. Scott's poems and novels were a popular source of names and inspiration for Southerners, who identified their own lifestyle and mores with those of Scott's heroes.

Stylistically, Melrose is a textbook example of Greek Revival architecture. In contrast to the Roman- and Renaissance-derived basis for earlier versions of American classicism, the Greek Revival was inspired by the temple form associated with the ancient Athenian democracy. The Greek War of Independence from the Ottoman Empire (1821–29) was viewed by the popular press as a validation of the American democratic system of government. The Greek Revival style, popular in the Northeast as well as in the South, coincided in popularity with the economic prosperity of the Deep South through sugar and cotton production. Furthermore, in the increasingly tense decades of regional factionalism over

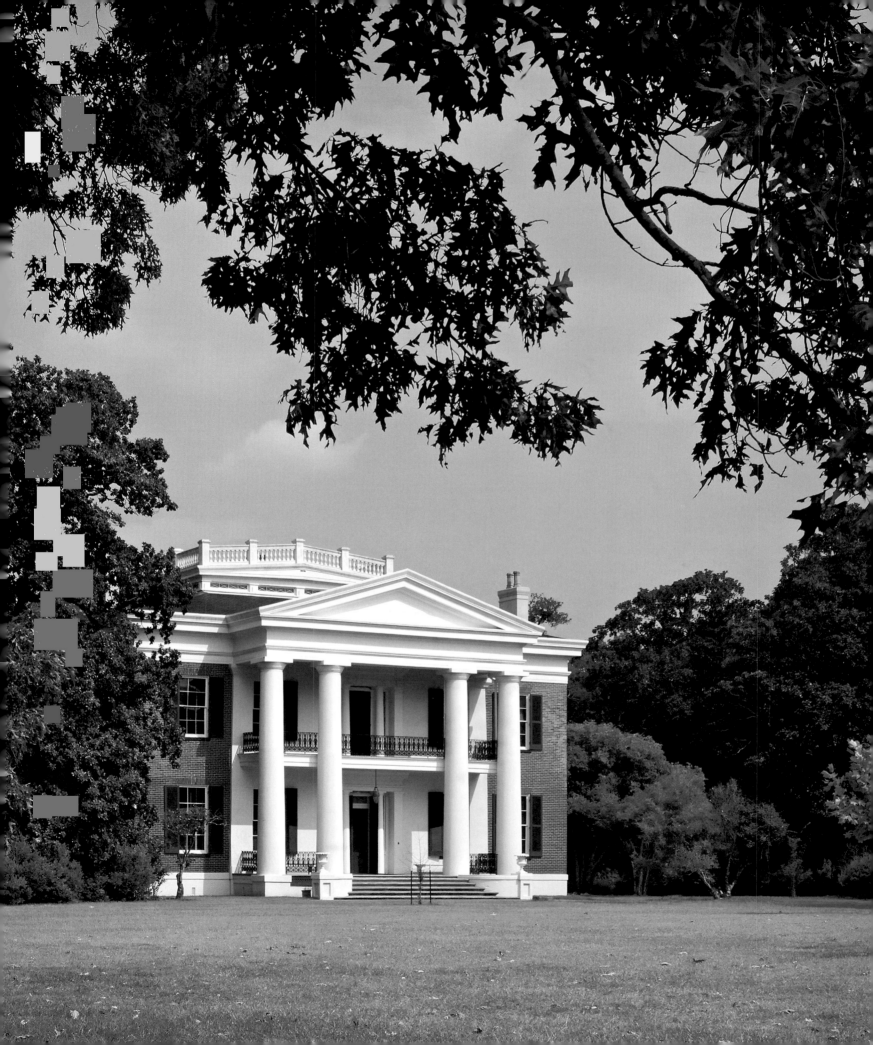

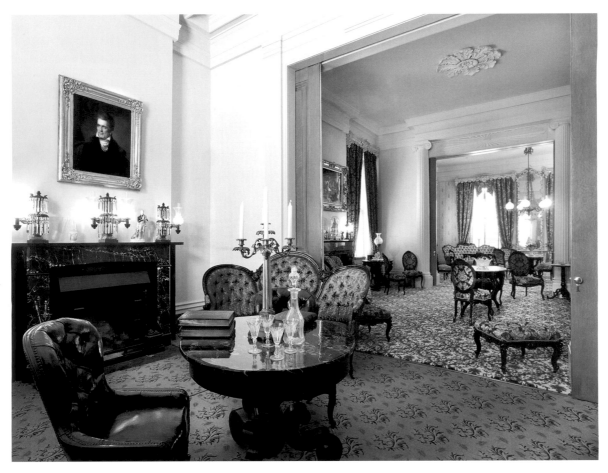

LEFT
The library connects to the parlor and drawing room through broad openings with oak-grained pocket doors. Joseph Meeks's Empire-style mahogany center table features an Egyptian marble top.

RIGHT
The drawing room, library, and parlor form a suite, framed by Ionic columns under a sunburst transom panel, which conceals the mechanical works of the pocket doors.

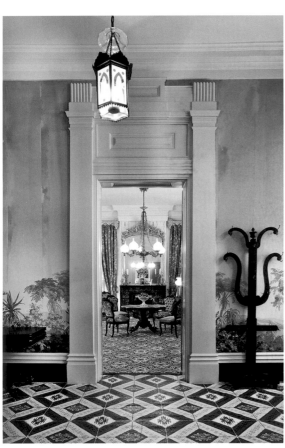

FAR LEFT
The view from the entrance hall into the parlor shows the juxtaposition of staid, classical architectural ornament with fashionably ornate furnishings, fixtures, and surface patterns.

LEFT
Owner John McMurran ordered a pair of walnut bookcases from a local cabinetmaker to showcase his extensive library.

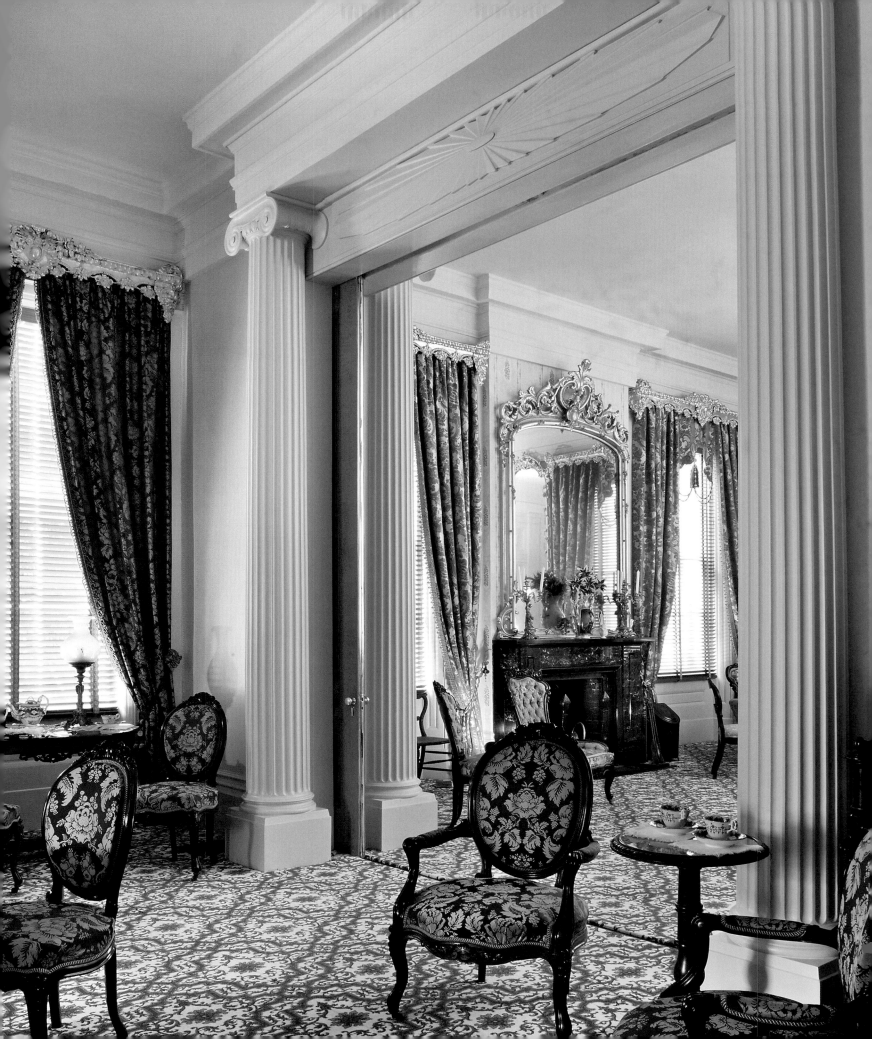

slavery prior to the Civil War, the South could point to the ancient Greeks' habit of taking and keeping slaves as an historical justification for their own institutional reliance on enslaved African people for labor.

Melrose's imposing facade contrasts the five-bay brick block with the boldly contrasting white temple-front portico, rising two stories to a triangular pediment, creating the image of the frontispiece as a Greek temple. Four Doric columns support a simple entablature, with vivid shadow lines substituting for the finely detailed ornamental elements of Federal examples. The effect is monumental and graphically legible from a vast distance across the fields. Inside the fifteen-thousand-square-foot house, engaged Ionic columns frame each first-floor doorway. Two parlors are linked by a wide opening that could be sealed by means of pocket doors. This "double parlor" form was to become the norm for great houses in the decades leading up to the Civil War.

Melrose contains a remarkable number of original furnishings and decorative objects including paintings, glassware, and statues. In contrast to the geometric simplicity of the exterior architecture, the interiors evidence the incipient high-Victorian taste for bold pattern (seen here in the Wilton carpets) and intricate curvilinear carving of the Rococo Revival–style furniture, intermixed with older Empire-style family pieces. While the architecture was calculated to take advantage of whatever breezes and ventilation the climate would allow, the heavy fabrics—used in upholstery and complex, layered window treatments—were thoroughly impractical concessions to fashionable taste. The McMurrans, like other wealthy Southerners, traveled in the summertime to escape the heat and periodic epidemics of tropical disease. On their travels to Europe or to fashionable resorts such as White Sulphur Springs, Virginia (now West Virginia); Niagara Falls; and Newport, Rhode Island, they would have seen and learned of all the latest fashions from a range of places and climates and brought those styles back to Melrose as souvenirs of their travels and talismans of status.

Close to the main house, in the back, two-story brick service buildings with square-pillared colonnades create a formal composition with the main house's rear portico, defining the work yard in the center of the open square as a courtyard opening to formal landscaped gardens and fields beyond. Kitchens, laundries, storerooms, and other workspaces, as well as living spaces for enslaved workers, were located here. On the edge of the fields, small one- or two-room, one-story wooden cabins housed agricultural workers or, in the case of Melrose, gardeners and other slaves whose primary responsibilities lay outside of the main house. Because of the use of inexpensive materials and construction techniques, few original slave dwellings survive, and the small wooden cabins at Melrose today are reconstructions.

In 1865, the McMurrans decided to sell Melrose following the deaths of their daughter and two grandchildren. It was purchased by the Davis family, who opened it to the public for tours during the first Natchez Spring Pilgrimage house and garden tour in 1932; descendants of the Davis family remained in the house until 1976. Since 1990, the property has been owned and operated as an historic site by the National Park Service.

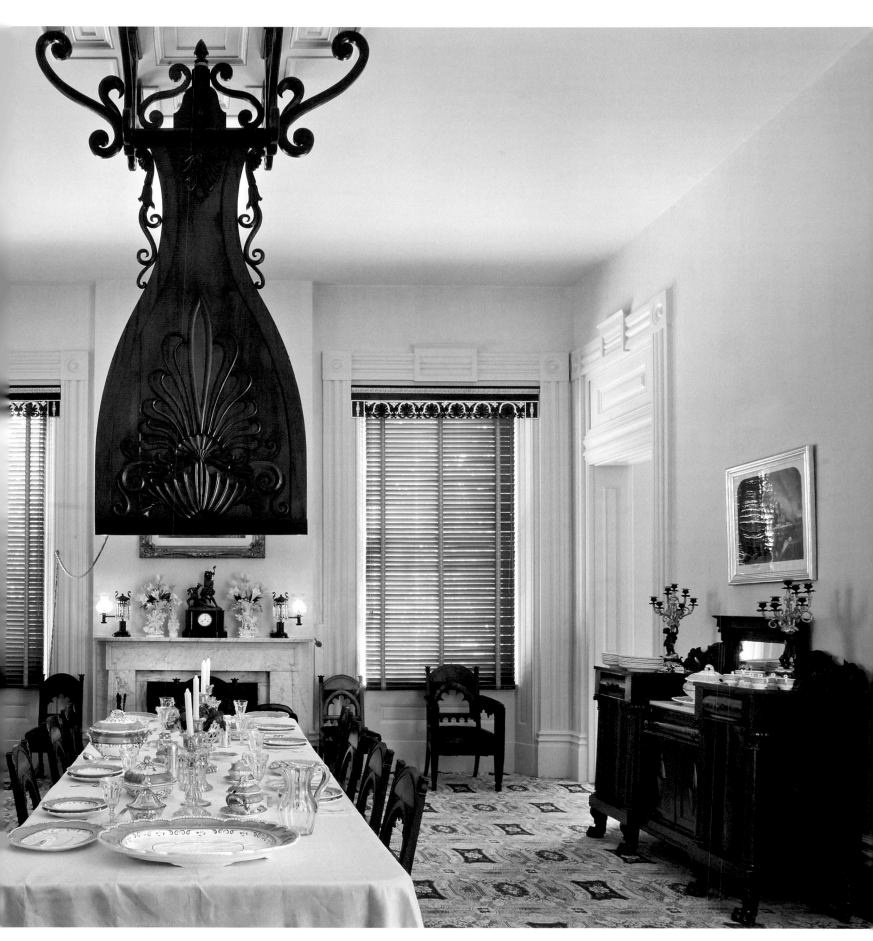

Gaineswood

Demopolis, Alabama
Built 1843–61
Owner-Builder: Nathan Bryan Whitfield
Owned and operated by the Alabama State Historical Commission

*The garden temple at Gaineswood, inspired by
the Temple of the Sybil at Tivoli, served as a
summerhouse and music pavilion for the
Whitfield family.*

*Gaineswood, a Greek Revival masterpiece, was
designed, built, and expanded by Nathan Bryan
Whitfield over the course of two decades.*

If Oak Alley is iconic Southern Greek Revival and Melrose is text-book Greek Revival, then Gaineswood is the *ultimate* Greek Revival. Boldly eccentric and unparalleled in its audacity, Gaineswood has the declarative geometric formalism and meticulous detail of the classical impulse, mixed with the irregular massing of the rising tide of architectural Romanticism. The latter may also reflect the piecemeal series of construction campaigns undertaken by its owner-builder, Nathan Bryan Whitfield (1798–1868). Whitfield's father had identified him as a genius at age seven and thus pursued an eccentric education for his son, which included a deliberate effort to keep the boy from learning to read for fear that books would stunt his aesthetic sensibilities. In spite of this unconventional start, Whitfield graduated from the University of North Carolina at age seventeen and was appointed counselor of state. At twenty-one, he was commissioned a major general in the state militia (to succeed his father) and married his cousin Elizabeth, with whom he eventually had twelve children.

Nathan Bryan Whitfield took his wife, children, and slaves to Ala-

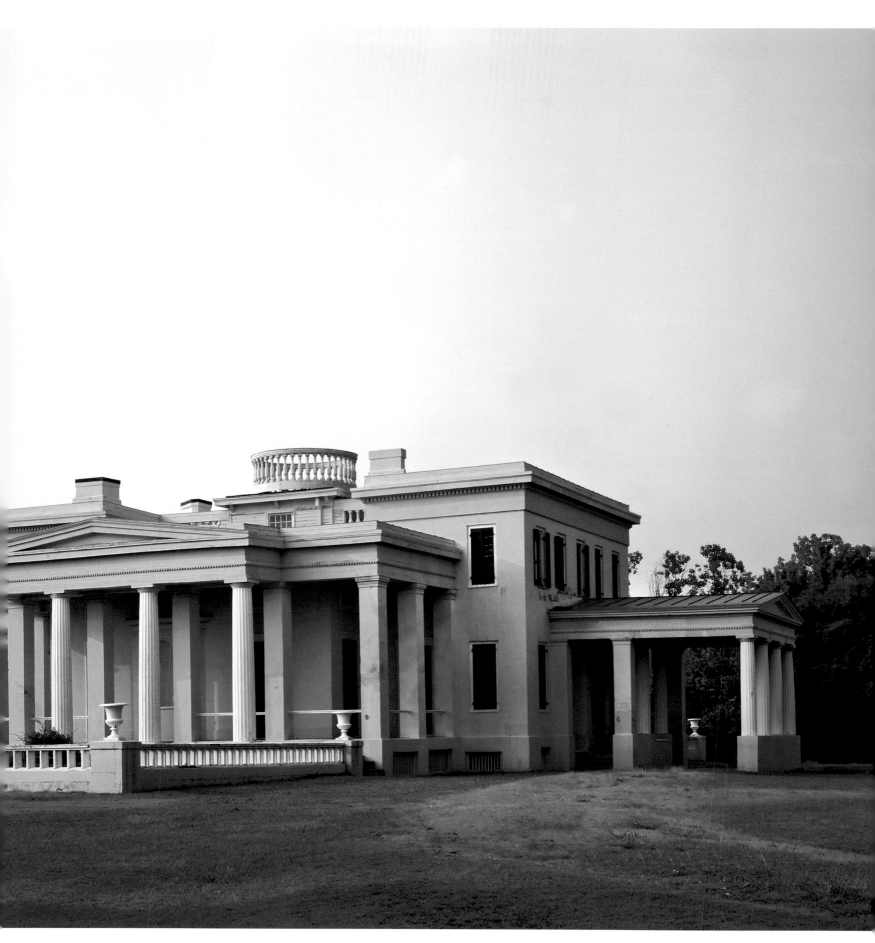

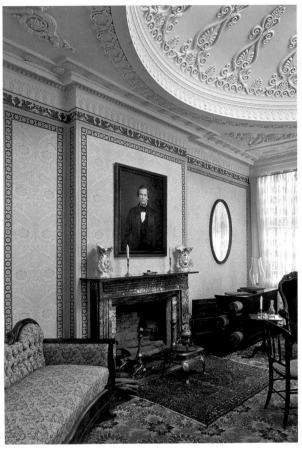

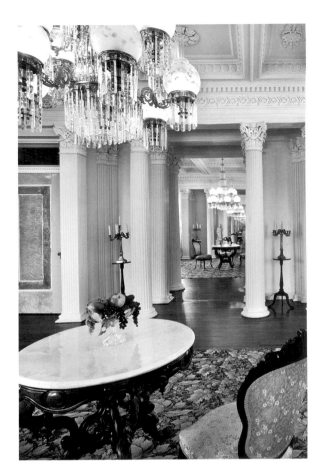

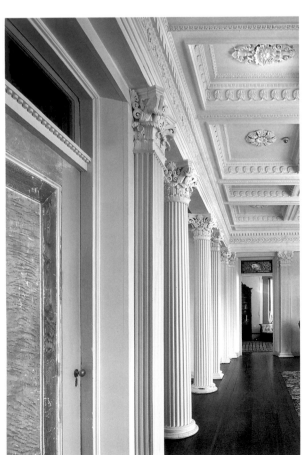

bama in 1834, in the hopes of capitalizing on the boom in the cotton market. He purchased a 480-acre estate near the town of Demopolis from Indian agent George Strother Gaines, in addition to other properties. Gaines left behind a dogtrot cabin he had used as both home and office while negotiating the relocation of the Choctaw people to territory farther west. Whitfield was far from content with the dogtrot and soon set about making the grandest home in the thriving town of Demopolis.[2]

Whitfield relied, in true gentleman-architect tradition, on pattern books for the details of his house, while proceeding to build in sections without much regard for how the whole fit together. Details in Gaineswood have been traced to scholarly studies, including Stuart and Revett's three-volume opus *The Antiquities of Athens and Other Monuments of Greece* (1762–1830, with Whitfield most likely relying on the 1837 omnibus London edition published by Charles Tilt) and Minard Lafever's practical handbooks, *The Modern Builder's Guide* (1833) and, especially, *The Beauties of Modern Architecture* (1835).

Perhaps inadvertently, Whitfield was following Greek planning principles, in which elements of a composition were internally symmetrical and consistent but did not necessarily relate to one another in a unified or logical way. The exterior of Gaineswood presents an almost Cubist series of planes and columnar screens extracted and then superimposed upon a solid central block, as if Whitfield were trying to rebuild the entire acropolis as one building. The temple-front tetrastyle portico is superimposed on a projecting colonnade that screens the solid plane of the building's front. To the west, Whitfield added a rectangular, temple-form porte cochère; while to the east, a semicircular projection for

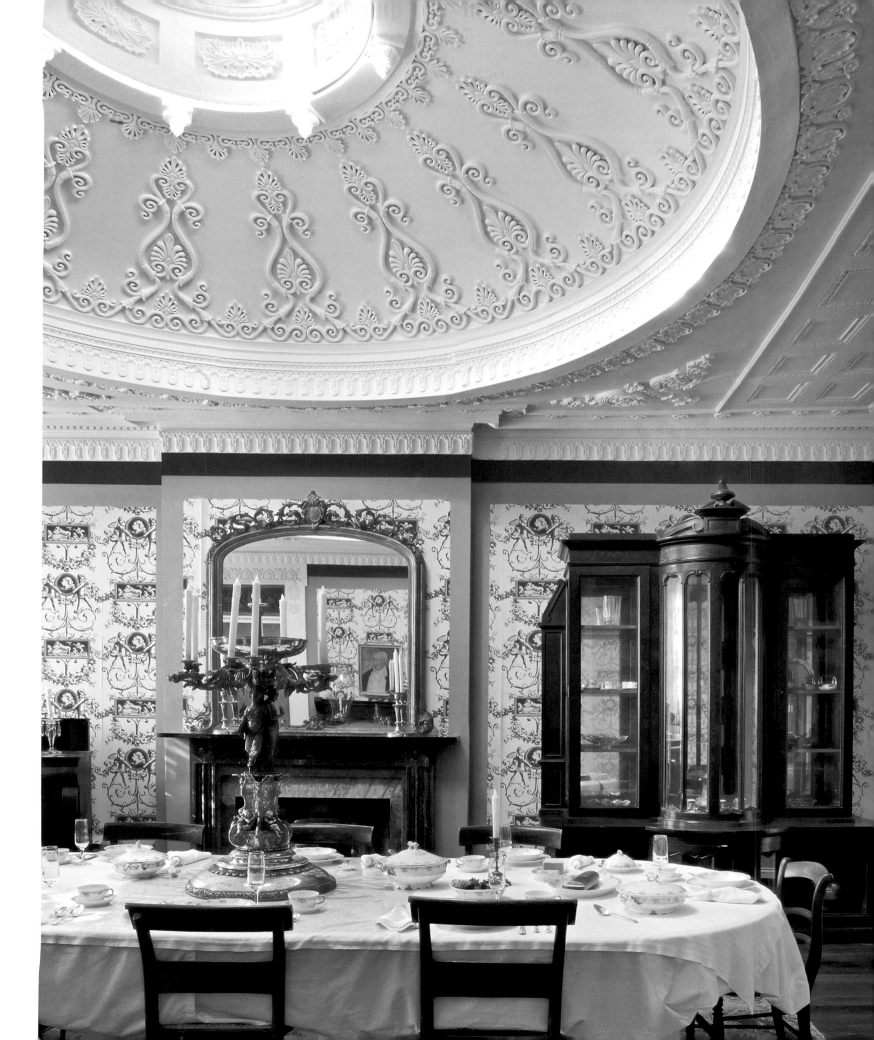

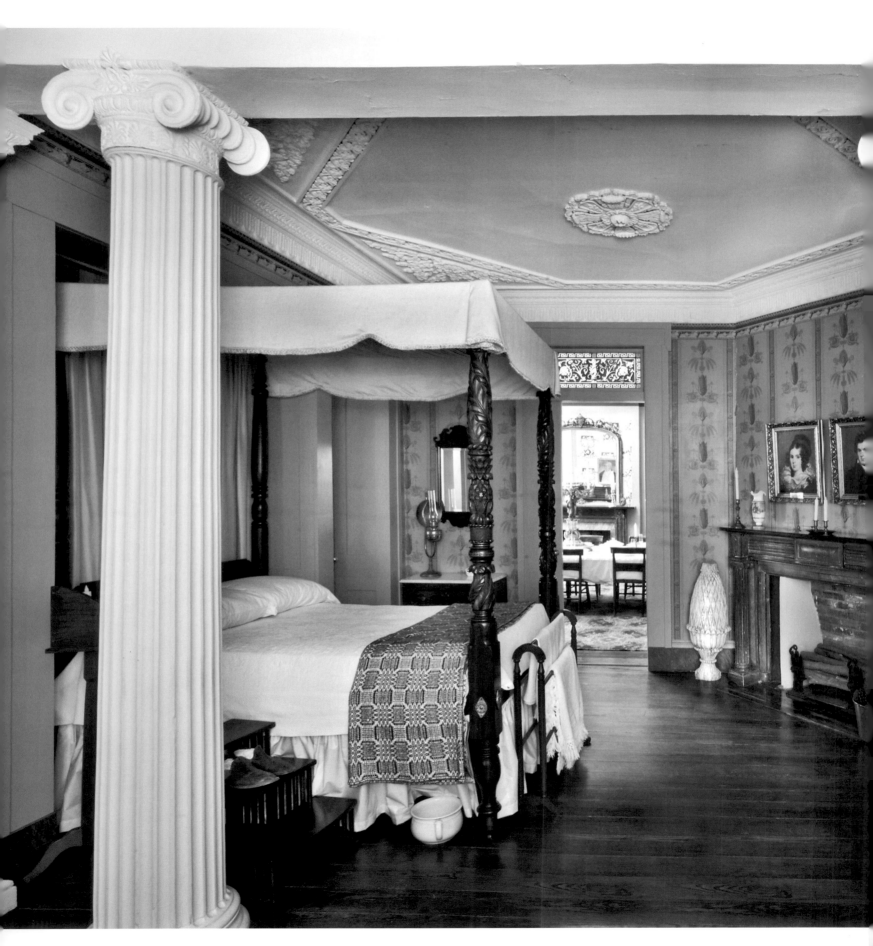

Mrs. Whitfield's room recalls, aptly for the lady of the house, the Temple of Vesta at Tivoli. The house was executed in brick, stuccoed and scored to resemble ashlar masonry.

Ascending from the plain Doric of the exterior (suitable to the outdoors), the entrance hall features the Ionic order. Whitfield added spectacular domed rooms for his library and dining room in the late 1850s. Capped by lanterns, the domes not only aggrandize the impressive spaces but also provide light in the nearly windowless rooms. The shallow, saucer-like forms recall the work of John Soane. Whitfield ordered the boldly scaled and effusive decorative motifs from a London mail-order company that produced papier-mâché ornament (based on Lafever's designs) for interior decoration. The ballroom is defined by Corinthian columns, as befitting the most formal area of the house, and is lined with facing vis-à-vis mirrors to dramatic effect. An elaborate classical scrollwork frieze is layered with egg-and-dart, modillions, anthemia, and other decorative elements in a characteristic illustration of Whitfield's more-is-more brand of classicism. Transom panels in stained glass feature mythological scenes, in this case based on Guido Reni's *Aurora* (1612). Traditional sources state that only the fresco and panel painting in the house were done by outside workmen and brought to Demopolis from Philadelphia. It is believed that the rest of the remarkable decorative work at Gaineswood is, like most of the construction, the product of enslaved artisans' labor. The classical setting extended to the outdoors, with the addition of formal gardens and classical statuary near the house and a round garden pavilion and landscaped lake (now lost) beyond.

Nathan Bryan Whitfield died in 1868, and Whitfield descendants owned the mansion until 1923, at which time the house passed through two other owners. In 1971, the property was placed under the authority of the Alabama Historical Commission, which continues to maintain and operate Gaineswood, furnished with many original Whitfield artifacts, as a house museum.

The Ernest Hemingway House

Key West, Florida
Built 1851; remodeled 1930–31
Builder-Owner: Asa Tift, with William Kerr (1851); remodeled 1930–31
under the direction of Pauline Pfeiffer Hemingway
Owned and operated by the Ernest Hemingway Home and Museum, Inc.

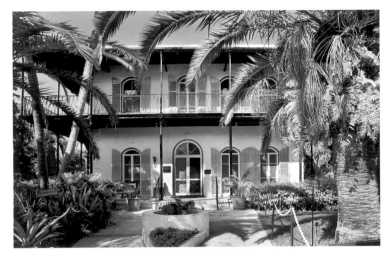

ABOVE
*Key West salvager Asa Tift built his house, later owned and occupied by Ernest
and Pauline Hemingway, of coral rock quarried on-site in 1851.*

RIGHT
*The Hemingway House's sophisticated adaptation of conventional European and
American architectural forms to the tropical climate reflects Key West's definitive
historical, cultural, and economic ties to Cuba.*

Key West, like New Orleans, is a city in which the traditional architecture is far more beholden to the polyglot culture of the colonial Caribbean than to the English-dominated culture of the mainland United States. And the Ernest Hemingway House, generally associated with the life and work of the author, represents the time and culture of its builder, Asa Tift, as much as it does those of Hemingway and his second wife, Pauline. Although Great Britain claimed dominion over Florida for a brief period (1763–83), from its European discovery in 1513 until its acquisition by the United States in 1821, the state's history was one of conflict amongst Spanish authority and native peoples, occasionally contested from the west by the French and from the north by the English. In 1822, Commodore Matthew Perry planted the U.S. flag, symbolically claiming Key West as United States territory once and for all. While fishing and salt production remained viable industries, by the 1850s, Key West's biggest business was salvage. Under the "finder's keepers" principle of traditional maritime law and new arrangements with federal authorities for compensation, local residents benefited from hurricanes and faulty navigation and found themselves, on the eve of the Civil War, the wealthiest (per capita) citizens in the United States.

Fourteen-year-old Asa Tift came to Key West from Groton, Connecticut, in 1826. His father, a sea captain, purchased a warehouse for

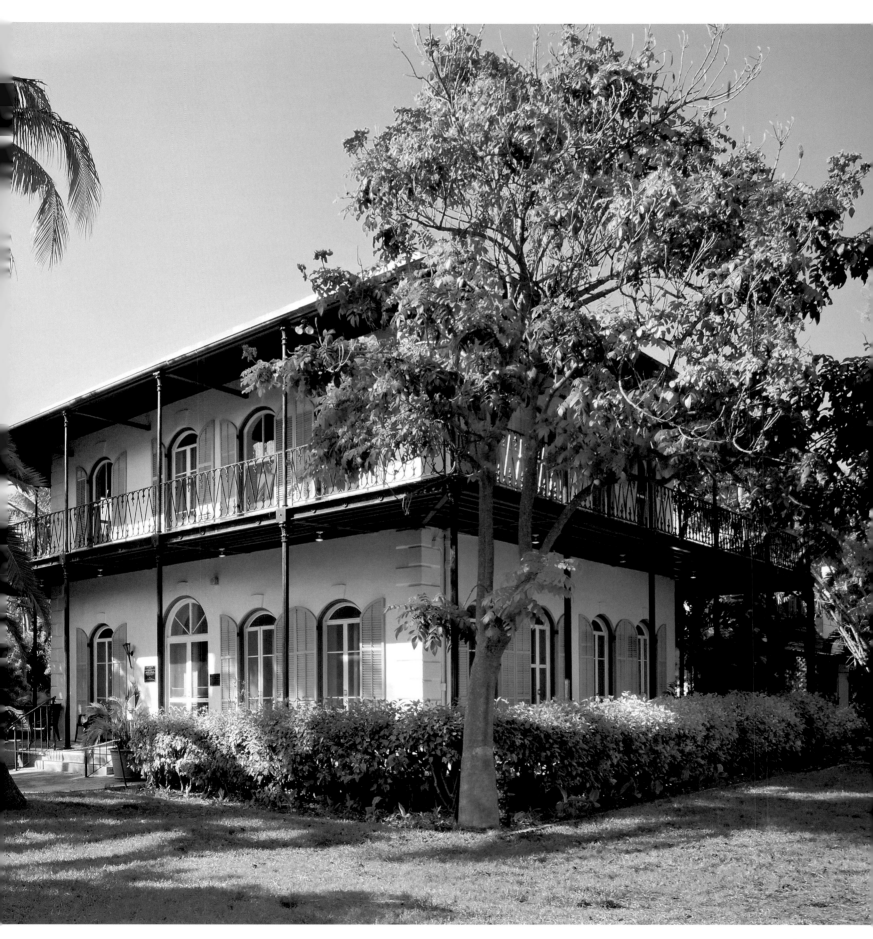

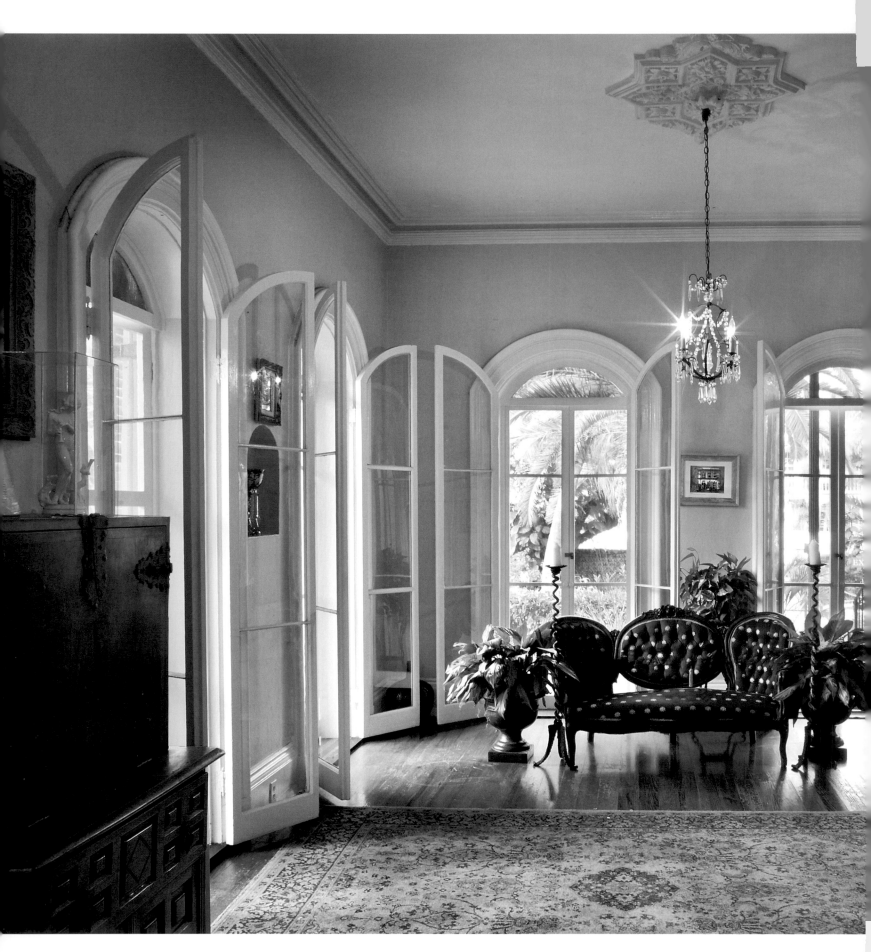

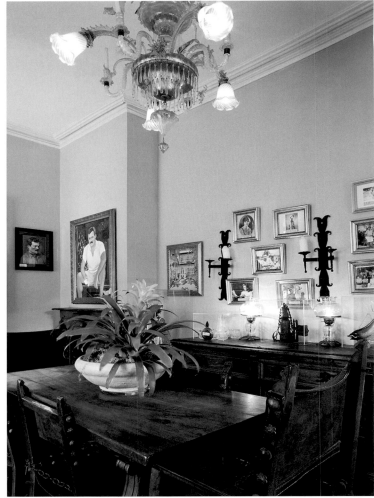

LEFT
The living room, with its elegant proportions and generous windows, is furnished to represent the occupancy by Ernest and Pauline Hemingway.

ABOVE
The dining room includes Pauline's prized Murano glass chandelier and eighteenth-century Spanish dining table. The portrait of Hemingway (second from left) is by contemporary Key West artist Keith Bland (born 1958).

storing salvage on the present-day Mallory Square, and soon the family owned several warehouses, one of which they converted into the town's first icehouse. In 1850, probably on the occasion of his marriage, Tift purchased a relatively high (sixteen feet above sea level) lot on Whitehead Street and hired William Kerr, a local builder, to erect his house.

The center block was built as a simplified Federal plan, featuring a center passage with two rooms on each side. The kitchen was housed in a separate building for fire safety and to isolate heat, while another separate structure on the lot served as a carriage house. Materially and stylistically, however, the house is straight out of Havana, where conventions to adapt European forms to suit the climate had developed throughout the colonial era. The two-story structure uses hurricane- and termite-resistant local stone, rather than wood, and is accented with decorative corner quoins in imitation of classical ashlar masonry. Its porous surface is sealed against the damp and deteriorating salt air with stucco. Arched

Some of Hemingway's best-known works—including Death in the Afternoon, To Have and Have Not, *and* For Whom the Bell Tolls—*were created in this writing studio, originally Asa Tift's carriage house.*

windows and French doors open onto encircling wrought-iron balconies for maximum air circulation and are further shaded and protected against storm winds by louvered shutters. The free connection of indoor spaces with outdoor galleries is typical of Caribbean colonial architecture, which may have been influenced by building practices brought to the islands by enslaved Africans. Wrought-iron balconies, a decorative and durable alternative to wooden galleries, are generally ascribed to New Orleans but may equally have been imported for the Tift house from Havana. Unusually for Florida, and especially for Key West, Tift's house was built with a basement for storage and a chimney for heating and dehumidification. Italian marble fireplaces and crystal chandeliers may have been salvaged from shipwrecks, as many of the accoutrements of Key West's finer homes were alleged to have been.

Indoor plumbing, including an upstairs bathroom fed from a rooftop rain cistern, was a novelty for Key West at the time as well as a display of refinement befitting Tift's status as the new honorary consul to Norway and Sweden, an appointment made by President Millard Fillmore in 1852.

Tift's wife and two children died in a yellow fever epidemic in 1854, and Tift, a Confederate partisan, left Key West (with its Union-held naval station) to design and manufacture warships in New Orleans and Mobile. Unrepentant, Tift returned after the war and created a fountain resembling his own Confederate naval ship design in the front yard of the house. After Tift died in 1889, the house passed through several owners and fell into disrepair.

Ernest Hemingway first visited Key West in 1928 on his way back to the United States from Paris with his bride, the former Pauline Pfeiffer. Having stopped in the glamorous city of Havana en route, as was customary at the time, Hemingway gave in to the nagging of his friend John Dos Passos, who had been urging him since 1924 to visit Key West for its cigars, fishing, and amiably louche atmosphere. The next year, the Hemingways returned and Pauline spotted the Tift house, but they thought it too far gone from water damage to be restored. Optimism gave way to action when her uncle gave the couple the money to buy and renovate the ruinous Tift house in April 1931. Pauline, a former assistant to the editor at Paris *Vogue*, set about restoring and decorating the house to serve the practical needs, personal tastes, and public image of the great writer. On the practical side, she demolished interior partition walls to enlarge the first-floor parlor and master bedroom, and joined the kitchen

The Hemingways displayed art by friends Joan Miró and Pablo Picasso in this room, which opens through French doors onto a shaded outdoor gallery (below).

to the main house. The master bedroom was linked to the carriage house's second floor by a catwalk (destroyed by hurricane in the 1950s). This served both privacy and convenience, as Hemingway was an early riser and wrote (longhand) almost exclusively in the mornings. On the less practical side, the couple added the island's first in-ground swimming pool, alleged to have cost more than the rest of the renovations combined.

The couple's cosmopolitan lifestyle was amply displayed in the decoration, which included French and Italian antiques from their Paris apartment, Spanish colonial antiques from Havana, African hunting trophies, and works of art by friends such as Picasso. Fishing trophies from expeditions in the Keys soon joined the more conventional artwork on the walls. The self-conscious mixture of the urbane and the unpretentious—the cosmopolitan and the local—summed up Hemingway's self-image and came to serve as a metonym for the resort community in the twentieth century. During his time in Key West, Hemingway wrote or worked on some of his best-known works, including *A Farewell to Arms*, *Death in the Afternoon*, *For Whom the Bell Tolls*, and *The Snows of Kilimanjaro*. He also used the town as the locale for his only novel set in the United States, *To Have and Have Not*.

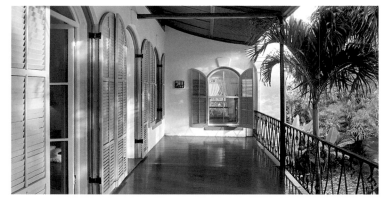

When Key West was repackaged by the New Deal's Federal Emergency Relief Administration as a wholesome Caribbean-flavored tourist destination, Hemingway inadvertently became the town's poster boy. By 1935, a tourist map showed Hemingway's house as an attraction, and the author's evenings at Sloppy Joe's saloon were interrupted by autograph seekers. Following an acrimonious divorce from Pauline in 1940, the author's tropical base became Havana, and he used the Key West house more as a stopover than as a residence. Following his death in 1961, the house was purchased for use as a house museum and has been open to the public since 1964.

Belle Meade

Nashville, Tennessee
Built 1820, enlarged 1845, 1853, 1883, 1892
Builder-Owner: John Harding (1820); William Giles Harding (1845, 1853); William Hicks Jackson (1883, 1892)
Owned and operated by the Association for the Preservation of Tennessee Antiquities

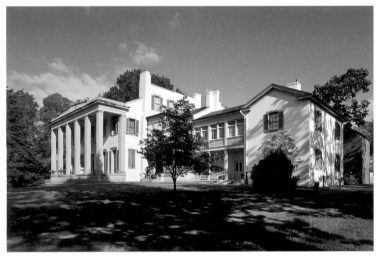

ABOVE
Belle Meade was enlarged and remodeled by successive generations of the Harding and Jackson families throughout the nineteenth century.

RIGHT
Belle Meade's crisply articulated temple portico was built of limestone from builder William Giles Harding's nearby quarry in 1853. The cast-concrete acroteria were added in 1883.

In 1807, Virginia-born John Harding purchased a 250-acre tract of land six miles west of Nashville for the unusual price of a shotgun per acre, plus one Shetland pony. Harding moved his new wife Susanna into a small log home on the property, and, within a decade, the farm grew to encompass more than one thousand acres, its products shipped for sale to New Orleans and Charleston. He supplemented his agricultural enterprise by establishing a blacksmithing service and a lumberyard and, fortuitously, by boarding horses on the property for neighbors such as Andrew Jackson. As racing became an increasingly popular pastime in Nashville and throughout the South, Harding began breeding horses at Belle Meade. By 1820, he was able to build a fine Federal-style brick house for his growing family, and symbolically elevated his profitable farm to the status of a gentlemen's plantation by naming it Belle Meade ("beautiful meadow").

In 1839, John's son, William Giles Harding, assumed control of Belle Meade, expanded the agricultural and stud operations into the first thoroughbred breeding establishment in the nation, and added a limestone quarry. By the 1850s, he was one of Tennessee's wealthiest men and larger landowners, with over three thousand five hundred acres in property worked by 136 enslaved people.

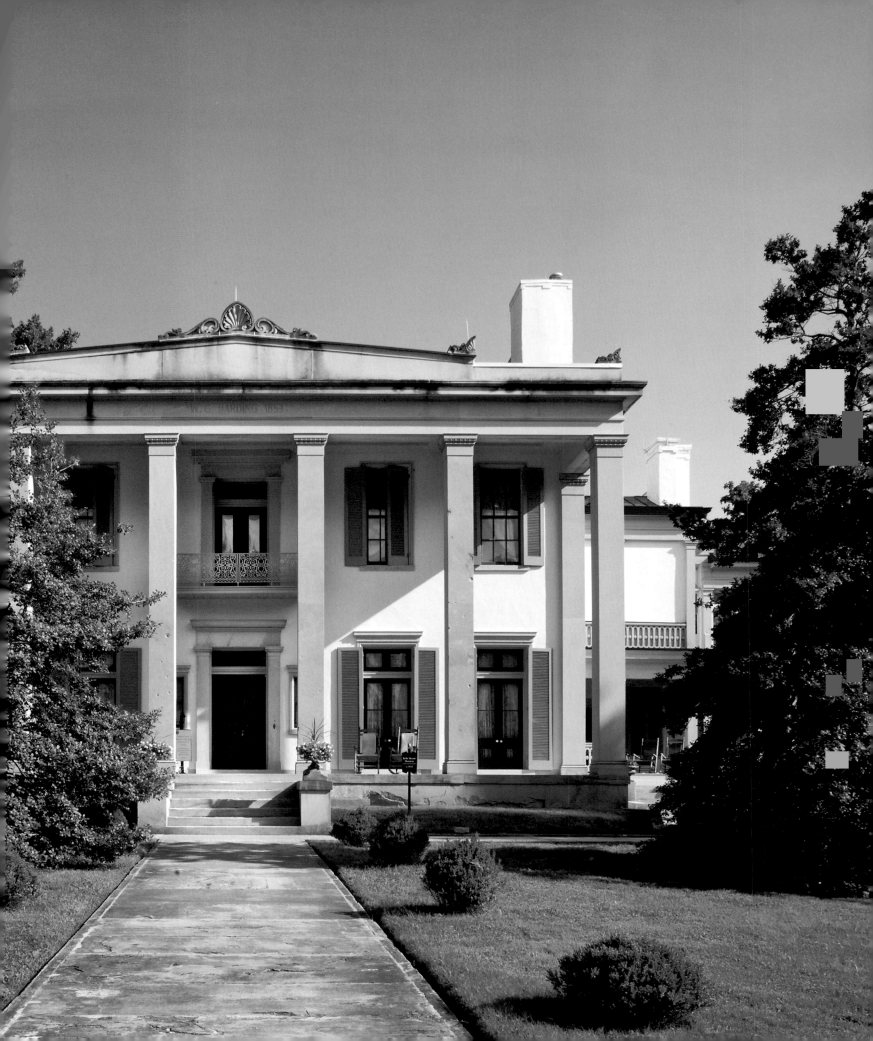

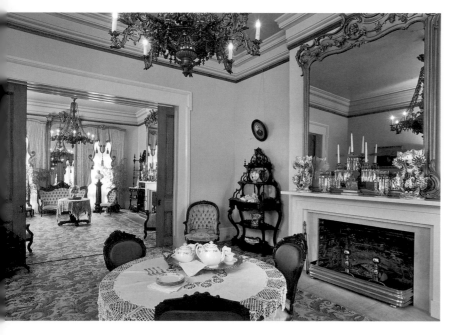

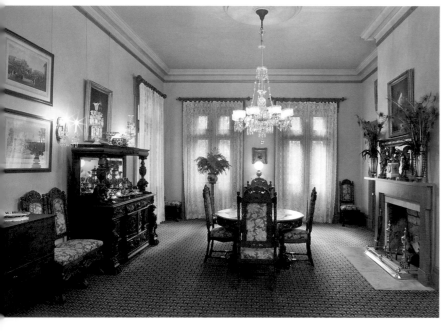

TOP

The parlors were used for entertaining distinguished guests and for important family events. Many interiors today reflect an extensive 1883 remodeling campaign.

ABOVE

The dining room was where William Harding Jackson, with his outgoing personality, easily mixed business interests with social activity.

RIGHT

The hall, lined with portraits of "the heroes and heroines of the turf," serves as an ode to the success of the Belle Meade thoroughbred business. The bust of William Harding Jackson was sculpted by Joseph Zolany in 1897.

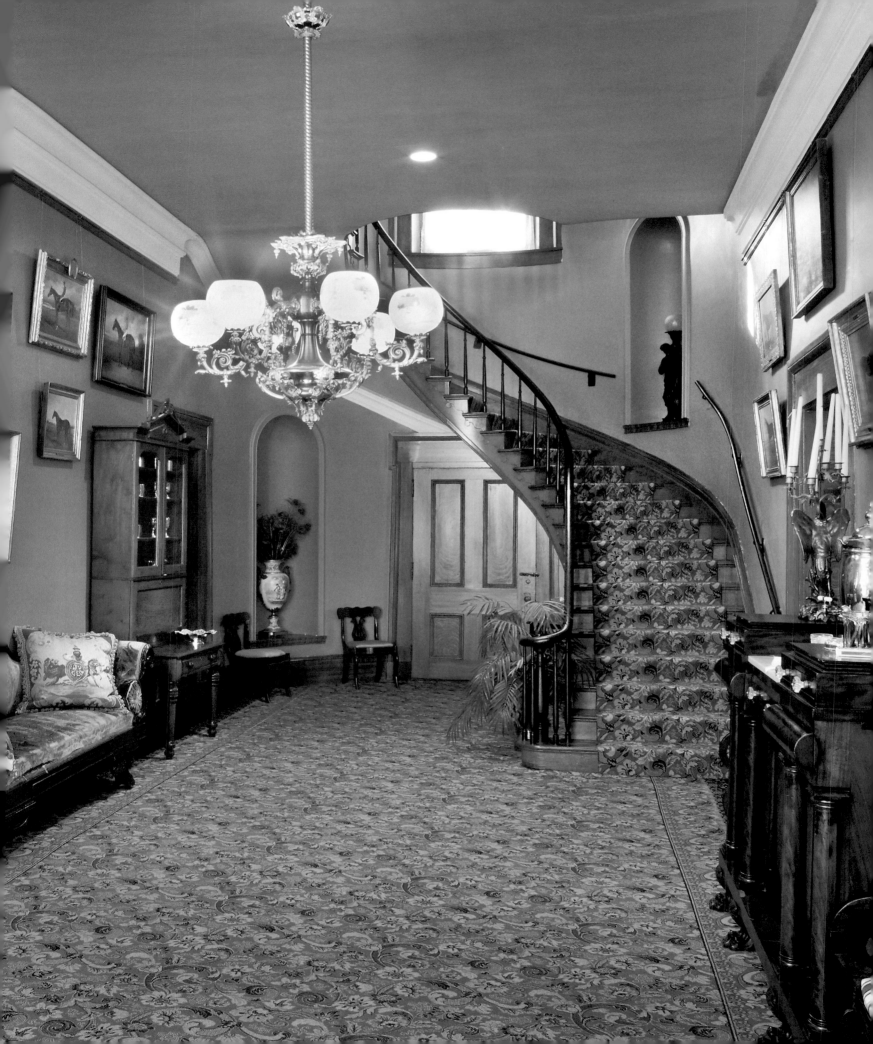

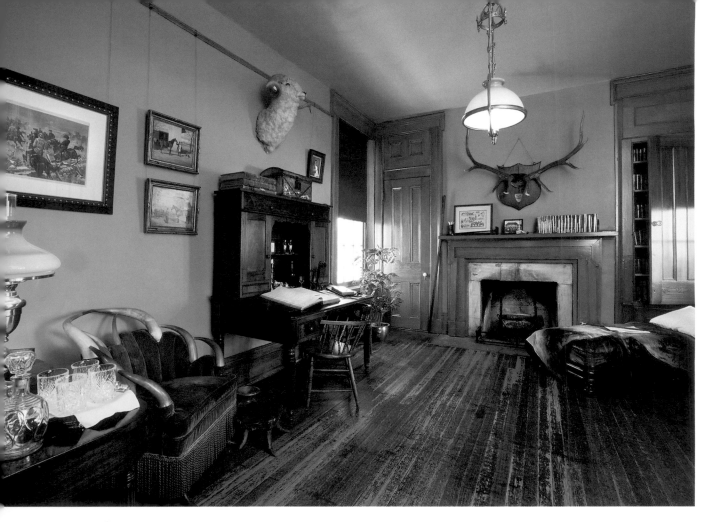

Gentlemen could retire to Jackson's study, the Rustic Room, for brandy and cigars. The elk rack above the fireplace was a hunting trophy from the estate's resident herd.

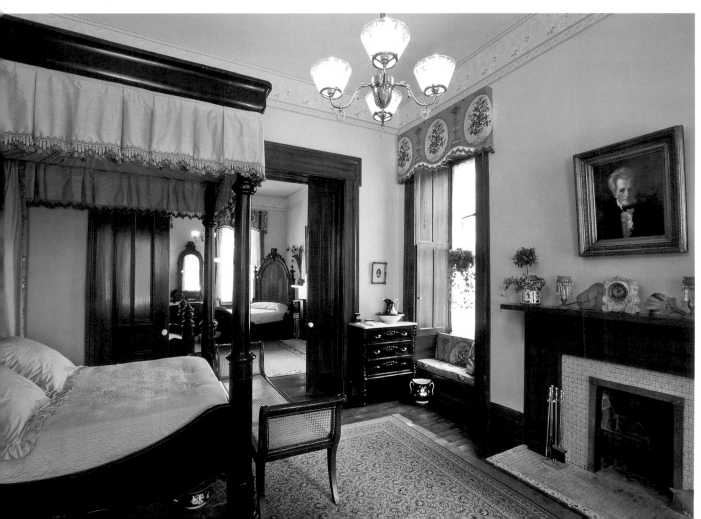

The guest room is furnished to represent its appearance during the 1887 visit of President and Mrs. Grover Cleveland. The portrait of Andrew Jackson hung above the fireplace, facing the four-poster bed (and its occupants).

RIGHT

The master bedroom, used by General and Mrs. William Hicks Jackson (née Harding), includes a sofa from the Harding era.

BOTTOM RIGHT

A ladies' desk and leather portfolio in a guest room

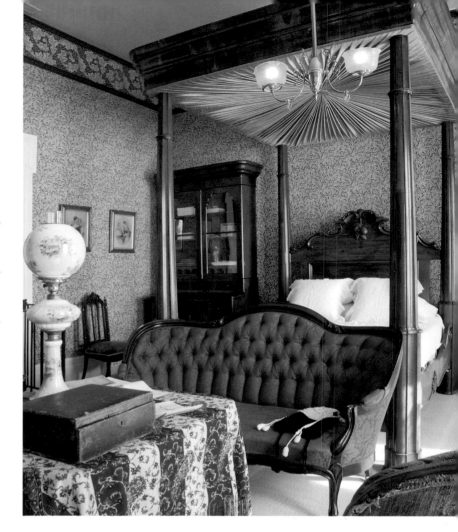

The 1853–54 Greek Revival portico was built as both a statement of success and an advertisement for the limestone quarry. The massive square columns of the portico, each composed of only two sections, were quarried on-site by slaves under Harding's direction. The templelike form of the portico was further conveyed by the low-pitched triangular pediment, accented with acroteria. The main block was built of brick, stuccoed to resemble ashlar masonry, and trimmed with limestone. The starkness of the pilaster-framed entry door is relieved by the intricate decoration of the ironwork balustrade of the opening above. Indoors, the broad center passage, ornamented with a sweeping elliptical staircase, leads to the quasipublic formal double parlor and dining room, each furnished with fashionably ornate Rococo Revival furniture. Patterned carpets, upholstery, and draperies (additionally enhanced with complex lambrequins and cornices) belie the restrained geometric simplicity of the exterior. With the advent of gaslight, additional visual complexity entered the decorative vocabulary of the Southern planter elite in the form of ornate light fixtures embellished with abstracted foliate forms, allegorical figures, and sometimes both. Noted both for its horses and for its hospitality, Belle Meade, over the years, hosted presidential visitors including Andrew Jackson, James K. Polk, William Henry Harrison, William Howard Taft, and Grover Cleveland.

While Tennessee was the last state of the Confederacy to secede and the eastern portion of the state remained largely Union in sympathy, only Virginia endured more battles on its landscape in the course of the Civil War. During the Battle of Nashville, Union and Confederate forces skirmished in the front yard of Belle Meade, and bullet holes remain as visible reminders. Federal authorities arrested Harding, a Confederate supporter, and imprisoned him for six months, but Belle Meade, thanks to the renowned stud operations, recovered quickly from the privations of wartime. In 1881, the Belle Meade stallion Iroquois became the first American winner of the prestigious Epsom Derby, the second leg of the British Triple Crown. Harding died in 1886, but the business flourished under the direction of his son-in-law, ex-Confederate Brigadier General William Hicks Jackson, who established bloodlines that were shared by most of the twentieth-century's Kentucky Derby winners. With Belle Meade visitor Theodore Roosevelt, William Hicks Jackson co-founded the Boone-Crockett Hunt Club, which required that each of its members had bagged at least one example of native big game (bear, elk, or buffalo). The study—with its display of trophies, sporting art, and horn settee—represents these gentlemanly iterations of pioneer pursuits.

Soon after Jackson's death in 1903, Belle Meade passed out of the Harding-Jackson family. In 1953, the state of Tennessee purchased the house, eight outbuildings, and twenty-four acres and deeded the property to the Association for the Preservation of Tennessee Antiquities, which maintains Belle Meade as one of its fourteen historic sites.

The Gallier House

New Orleans, Louisiana
Built 1857–59
Architect-Owner: James Gallier, Jr. (1829–68)
Owned and operated by The Woman's Exchange

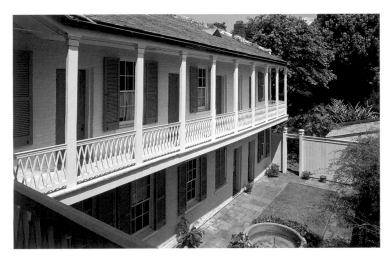

ABOVE
Dependencies in the rear yard of the Gallier House, which include a kitchen, storerooms, and slave quarters, overlook the courtyard garden.

RIGHT
The Gallier House shows architect and owner James Gallier, Jr.'s skillful adaptation of contemporary architectural fashions to the materials, climate, and Creole building traditions of New Orleans.

Upon graduating from the University of North Carolina at Chapel Hill in 1848, James Gallier, Jr., and his father, the Irish-born, New York-trained architect James Gallier, Sr., traveled together to England and France to study cathedrals. Gallier, Sr. (1798–1868) had begun his career in the New York architectural firm of Ithiel Town and A. J. Davis, which specialized in picturesque-style buildings, drawing on historical sources ranging from Greek Revival to "Gothic" cottages and Tuscan villas for inspiration. Gallier had also worked with architect Minard Lafever, whose pattern books helped to popularize the Greek Revival. Gallier's mastery of a catalog of options indicates the rising interest amongst builders and clients in "picturesque" styles, which escalated the challenge to the aristocratic hegemony of academic-based classicism that had begun a generation earlier with the popular builder's guides. The literary associations of the Romantic styles carried with them connotations of contemplative travel and imagery drawn from poetry and novels, rather than mastery of the intellectual rules of orthodox classicism (although classicism remained an option). This new architectural aesthetic mirrored an increased taste for more visually complex forms and decorations in interiors, decorative arts, and even fashion. Facilitated by the rise of manufacturing methods and materials that permitted machine-aided production of intricately detailed furnishings, accessories, and architectural ornament, the Victorian era of *horror vacui* decorating had begun.

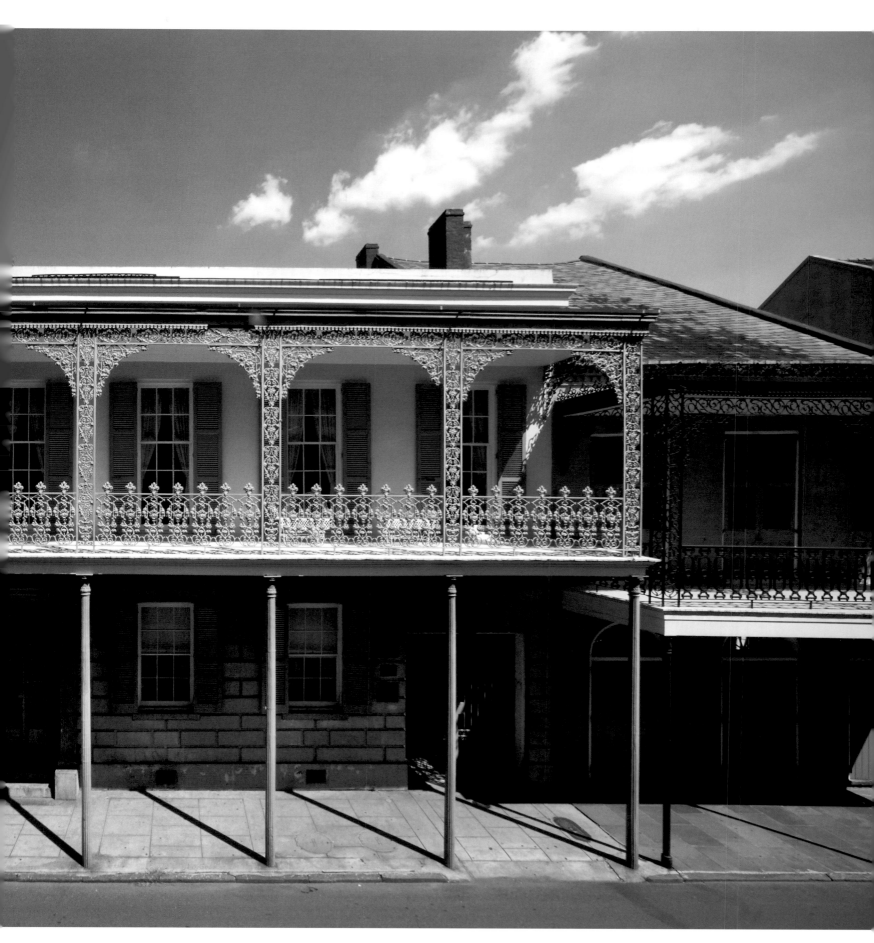

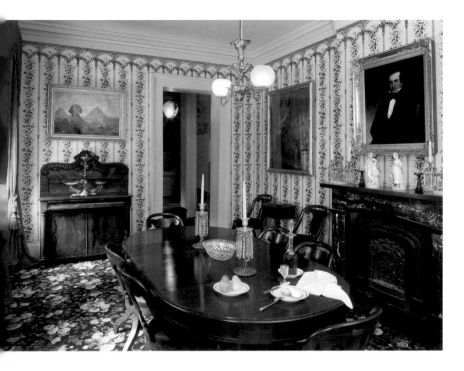

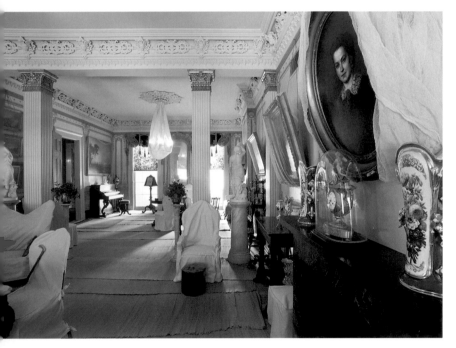

TOP

The dining room features a portrait of the architect's father, James Gallier, Sr., over the mantelpiece.

ABOVE

The double parlors are seen here in "summer dress." Grass matting replaced wool carpets, slipcovers protected upholstery, and paintings (such as the 1869 portrait of Josephine Aglae Villavaso Gallier by François Bernard, at right) were wrapped in netting to discourage insect damage.

To avoid competing with his mentors in New York, James Gallier, Sr., moved to New Orleans in 1834 and soon found great success, designing the original St. Charles Hotel (burned 1851), the Merchants' Exchange, Second Municipality Hall (now called Gallier Hall), and the Pontalba Buildings on Jackson Square. His son, meanwhile, was sent to St. Thomas' Hall boarding school on Long Island and then, when the school relocated, to Mississippi. Mrs. Gallier, who had long resisted moving to the South for fear of illness, finally relocated to New Orleans and shortly died. Gallier, Sr., began planning for retirement soon afterward.

Upon returning from their architectural sightseeing tour in 1849, the elder Gallier married a younger lady from Mobile and promptly turned over his architectural practice to his son. The younger Gallier established his own architectural practice, gaining such prominent commissions as the French Opera House (burned 1919) and Christ Church Cathedral on Canal Street (not extant), but mainly specialized in residential work. In 1853, he married the daughter of a prosperous Creole planter and, by 1857, had purchased a lot on Royal Street in the Vieux Carré to build a townhouse for his family.

In some respects the Gallier House is a typical Creole townhouse, with virtually all the major interior spaces open to porches or galleries. Stylistically, however, it shows the architect's skillful balance of classical forms with picturesque embellishments, adapted to fit the climate, society, and existing architectural traditions of New Orleans.

Gallier's house was built of brick covered with stucco, with the street-level surface heavily scored to look like rusticated ashlar masonry, suitable for the rough-and-tumble public sidewalk. Elegant, fluted Corinthian pilasters frame the formal entrance door, in contrast to the simple, rusticated flat arch of the carriage entrance to the courtyard. The highly complex wrought-iron entrance door not only pointedly excludes the public but also hints at the ornate private spaces within. The cast-iron arcade (supporting the balcony above), as well as the gallery posts facing the courtyard in back, relies on attenuated versions of the simpler Doric order, demonstrating that Gallier knew the hierarchical application of the classical orders and used this knowledge to visually signal the social division between the "working" or public areas and the more elaborate private spaces.

In keeping with contemporary taste for visual profusion, Gallier's house is filled with ornate plasterwork and decorative millwork. The double parlor is the most formal and thus the most elaborate room, the opening (with pocket doors for flexibility) framed by ornate columns, pilasters, and an extraordinary plaster frieze of lions and flowers. Because of its importance as a port and its cosmopolitan culture, New Orleans was the South's major retail market for imported and domestic fine furnishings and household items in the decades preceding the Civil War. The Galliers would have impressed their guests with elaborate Rococo-Revival furnishings, notably the parlor suite by German-born New York cabinetmaker John Henry Belter. Upstairs, the master bedroom boasts a half-tester bed by French-born New Orleans cabinetmaker Prudence Mallard.

For part of each year, Gallier House illustrates the nineteenth-century Southern custom of "summer dress" and particularly shows how it was interpreted by the Creole elite. Heavy velvet and silk upholstery would have been covered with custom-made white linen slipcovers; velvet draperies removed and replaced with linen window shades (sometimes painted with floral or scenic decoration); straw matting laid in place of

James Gallier, Jr., designed this room to act as both a hallway and a library. The skylight could be opened for ventilation.

wool carpeting. Chandeliers were "bagged" with muslin, and even paintings were draped with netting to protect the varnished surfaces and their gilded frames from flies. Such attention to detail not only helped to visually lighten the appearance of the house but also protected the finest possessions from insects, dust, and the effects of heat and humidity during the warm summer months. Since 1996, the Gallier House has been operated by The Woman's Exchange, which has overseen a campaign of meticulous curatorial research and painstaking restoration to enhance the authenticity and educational programming at the site.

Stanton Hall

Natchez, Mississippi
Built 1851–57
Architect: Thomas Rose
Owned and operated by the Pilgrimage Garden Club of Natchez

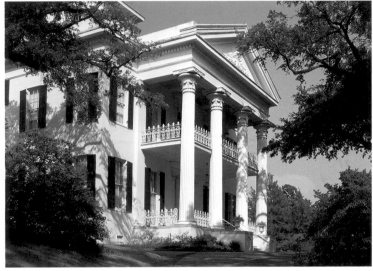

ABOVE
*Stanton Hall transposes the monumental Greek Revival architecture
of the plantation into an urban setting of entertainment and display.*

RIGHT
*During the years of the antebellum cotton boom, the town of Natchez,
Mississippi, boasted the nation's highest concentration of resident millionaires.*

It is said that in 1860 Natchez was home to over one-third of Amer-
ica's thirty-five millionaires. Cotton planters built plantation-scale
houses on relatively small city lots for the social season, each grand
mansion expressing not only wealth but also a typically Southern mix of
fierce conformity and equally fierce competition.

At eleven thousand square feet, Stanton Hall is Natchez's largest ante-
bellum mansion, which once dominated the cityscape from its hilltop
site. Frederick Stanton, an Irish-born cotton merchant who originally
called the house *Belfast*, hired architect Thomas Rose to design the struc-
ture, and then travel for a year in Europe collecting everything from Ital-
ian marble mantels and French mirrors to English sterling silver
doorknobs. Rose's shopping spree reportedly filled an entire sailing ship,
and whether or not it was true, the fact that people said so was what mat-
tered. Stanton also ordered furniture and upholstery from Henry Siebrecht
in New Orleans, whose cost and reputation for exclusivity proved that the
antebellum South had already invented its own version of the status-sym-
bol interior decorator.

Because of Natchez's wealth and investment in building, the town
was rich in skilled artisans, who would have been hired to build the struc-
ture and to bind together the imported decorative elements of Stanton
Hall. Until the 1830s, free craftsmen of color were not unknown in the
South, and some, like cabinetmaker Thomas Day of North Carolina

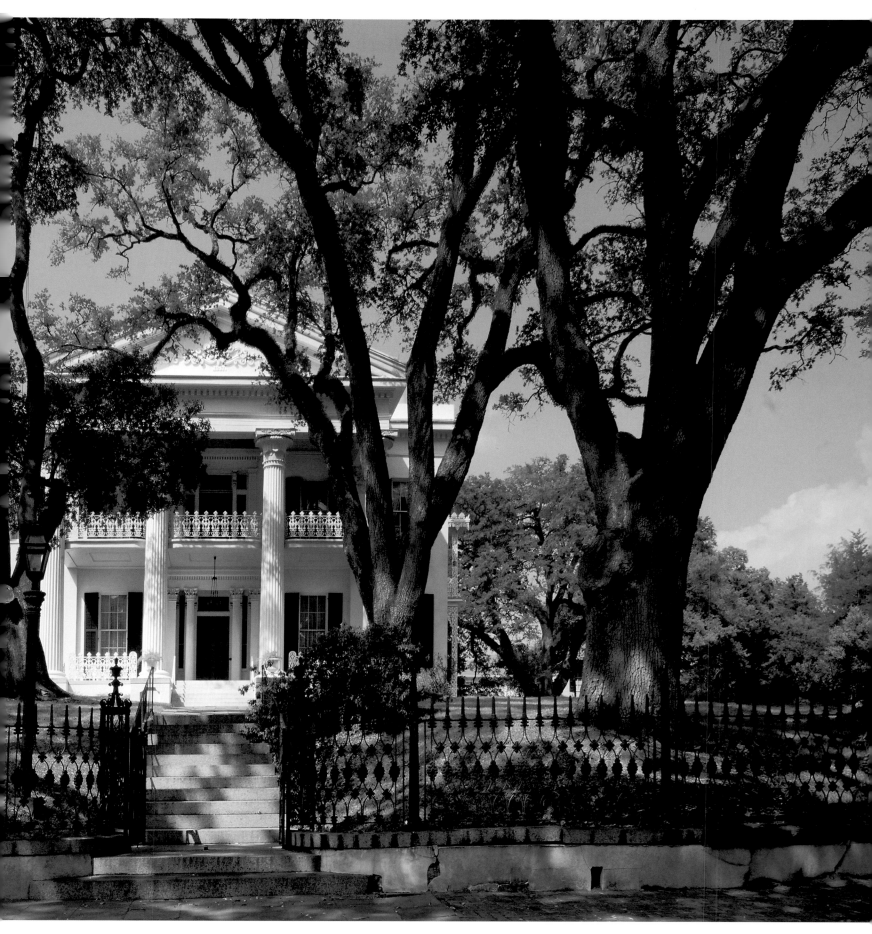

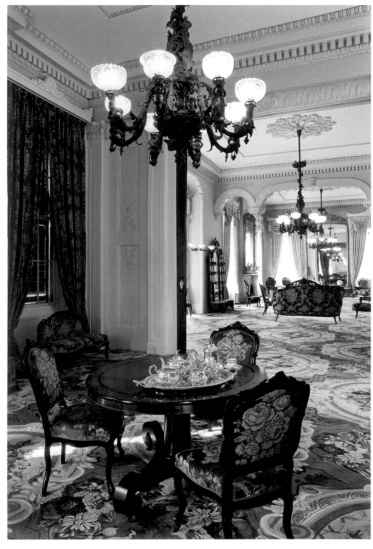

The length of the double parlors is visually extended by gilt-framed pier mirrors placed between the windows at either end.

RIGHT
While the classical architectural vocabulary remained relatively restrained, effusive floral carpeting and intricately carved Rococo Revival–style furniture reveal the contemporary fashion for visual complexity.

(1801–61), were extremely successful. In the eighteenth and first quarter of the nineteenth century, enslaved artisans from nearby plantations were also leased to contractors to earn income for their owners throughout the South. Following a series of violent slave uprisings, most famously the Nat Turner rebellion of 1831, increasingly restrictive laws limited the amount of unsupervised work available to people of color in general and enslaved workers in particular. At precisely the same time, an influx of skilled German and Irish craftsmen began to provide an alternative labor force for building-related trades (such as stone carving, masonry,

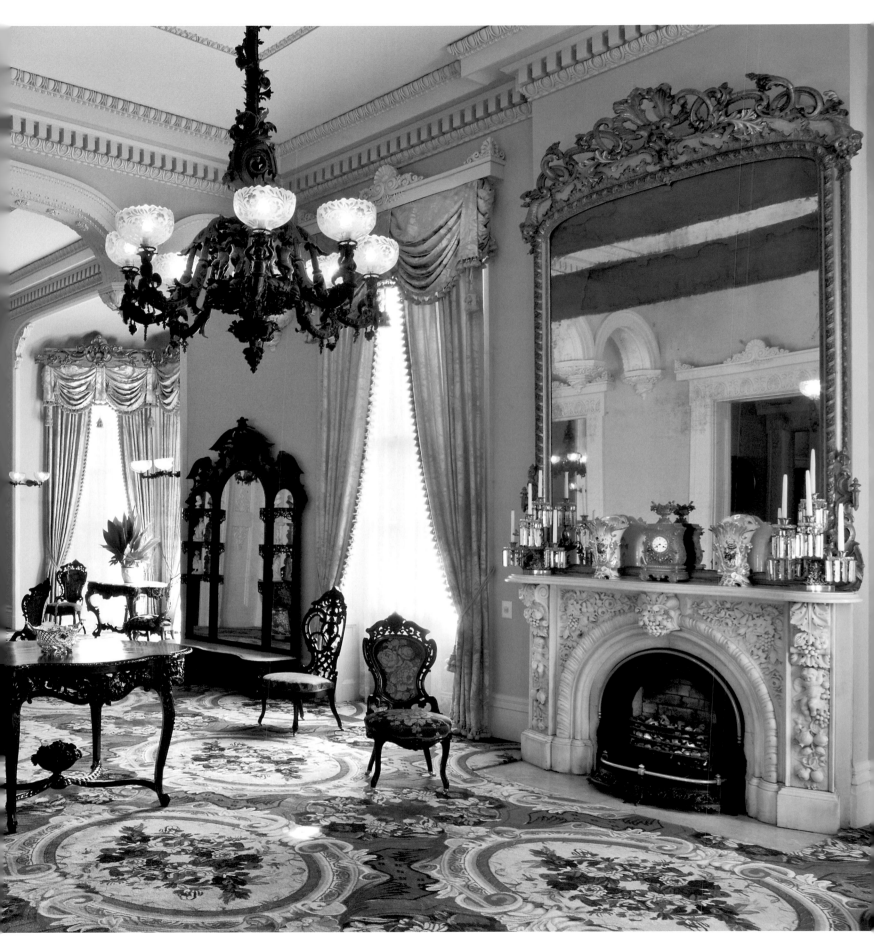

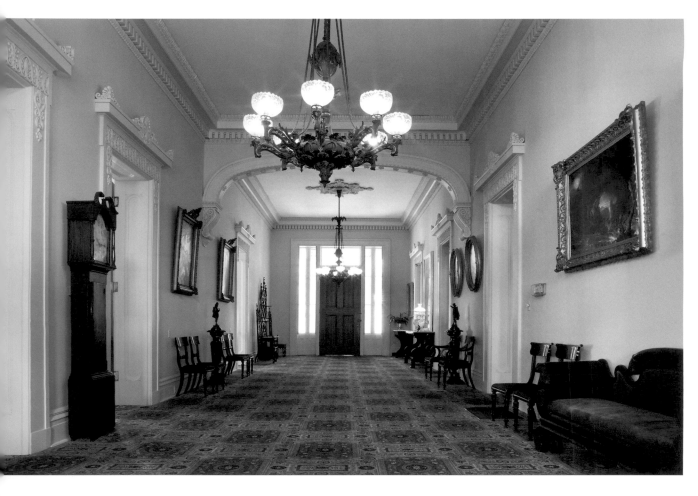

LEFT
Pattern books, such as Minard Lafever's The Modern Builder's Guide, *provided Greek Revival motifs such as those seen on the door surrounds in the capacious entrance hall.*

FACING PAGE
The upstairs hallway features historically appropriate Hindoustan *scenic panels by Zuber et Cie, originally designed by Pierre Mongin in 1807.*

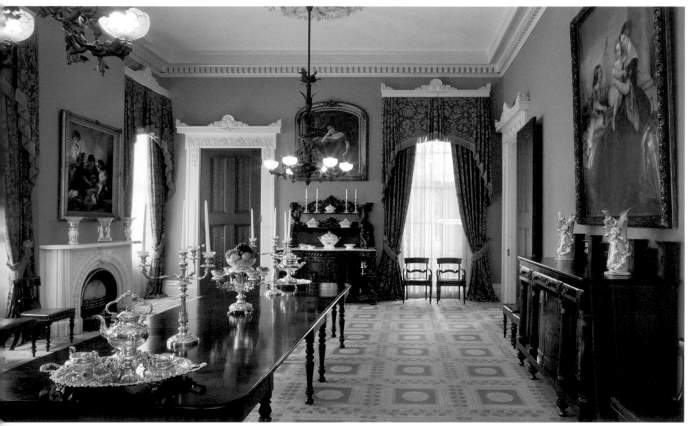

Imported marble mantels and European paintings demonstrated cosmopolitanism, while the frontier-themed Cornelius & Baker chandeliers reflected a pride in American ascendancy.

cabinetmaking, millwork, metalwork, and plasterwork), which eventually drove most African-American artisans out of business.[3] Stanton Hall was most likely constructed by a characteristic regional mixture of Irish, German, and African-American craftsmen.

The primary (southeast) facade of Stanton Hall is most obviously Greek Revival, with the designs of the temple-front portico capitals and entrance doorway derived from designs in Minard Lafever's *Modern Builder's Guide* (1833) and *Beauties of Modern Architecture* (1835). Approached from the north, however, the house presents a distinctly different Italianate style, complete with its towerlike "widow's walk." Both fronts share the use of elaborate ironwork balustrades that refer to Creole traditions, especially those of New Orleans, and provide a decorative embellishment that distinguishes this generation of Greek Revival houses from the more severe, Neoclassical examples prevalent in the 1820s and 1830s. Greek Revival—seen in nearby mansions such as Melrose, Rosalie, Dunleith, Choctaw, Magnolia Hall, Auburn, Monmouth, and others— was the indisputable architectural *lingua franca* of the planter aristocracy, and its forms were legible as emblems of wealth and power. Iterating the style became a pledge of conformity to the values of cotton planter society in the antebellum period. Different versions of the same temple form could be compared for size, setting, materials, and quality of execution, establishing a strong streak of competitive rivalry within the socially accepted limits of style and behavior.

The interior of Stanton Hall immediately impresses with its spacious seventeen-foot ceilings and expansive proportions. The Greek Revival vocabulary of the acroteria-accented doorframes is emboldened with exuberant exaggerations of scale, more plastic articulation, and foliate embellishments. The Carrara marble mantel in the front parlor is carved within an inch of its life, displaying not only the owner's mastery of the rare material but also the expense of its elaborate workmanship. Stanton Hall boasts a remarkable collection of chandeliers by Cornelius & Baker of Philadelphia, a firm that specialized in technology involving metal plating in a variety of colors as well as unbelievably intricate figural compositions illustrating allegorical, historical, and heraldic themes—Anglo-Saxon conquest in the study, American settlement and independence in the dining room. Natchez merchants imported furniture from all the great cabinetmakers of the era including J. W. Meeks and John Henry Belter, and clients could select from their stock or order from catalogs. Patterned textiles—in the carpets, curtains, and upholstery—would have been heightened in effect by the presence of equivalently well-upholstered people of fashion, admiring the Stantons' home and refined entertainments.

Stanton Hall was occupied by Union troops during the Civil War. By 1890, it had become Stanton College for Young Ladies. Rechristened Stanton Hall, the property was saved and restored by the Pilgrimage Garden Club in 1938, which continues to own and operate it as one of the signature house museums of the South.

Ashland

Lexington, Kentucky
Built 1804–09, 1812–15; demolished and rebuilt 1854–56
Builder-Architect: John Fisher (1804–09); Benjamin H. Latrobe (1812–14); Thomas Lewinski (1857)
Owned and operated by the Henry Clay Memorial Foundation

ABOVE
James B. Clay's mid-Victorian interpretation of the Palladian window of the original house built by his father, statesman Henry Clay

RIGHT
Ashland's five-part Palladian articulation recalls the Latrobe design of 1812–14, while the Italianate details reflect current fashions at the time of Ashland's rebuilding in the 1850s.

Restoration and reconstruction are performative gestures that celebrate and, sometimes, redefine the values believed to inhere in the original: by renewing the object, we reaffirm our commitment to the ideals the object represents. Ashland was built by senator and statesman Henry Clay and reconstructed by his son in a gesture that indicates he recognized the importance of the house as a monument that would represent his father and, by association, his family to future generations.

Henry Clay (1777–1852) was born in Virginia and, after a peripatetic childhood, moved to Williamsburg where he studied law with the venerable George Wythe (1726–1806), who also counted Thomas Jefferson, James Monroe, and John Marshall among his protégés. Clay moved to Lexington to practice law in 1797 and married in 1799. By 1804, he was a father, a representative to the state assembly, and ready to move "up" to a more substantial country estate. On an initial 125 acres, Clay hired local builder John Fisher in 1805 to erect a two- or three-room brick dwelling

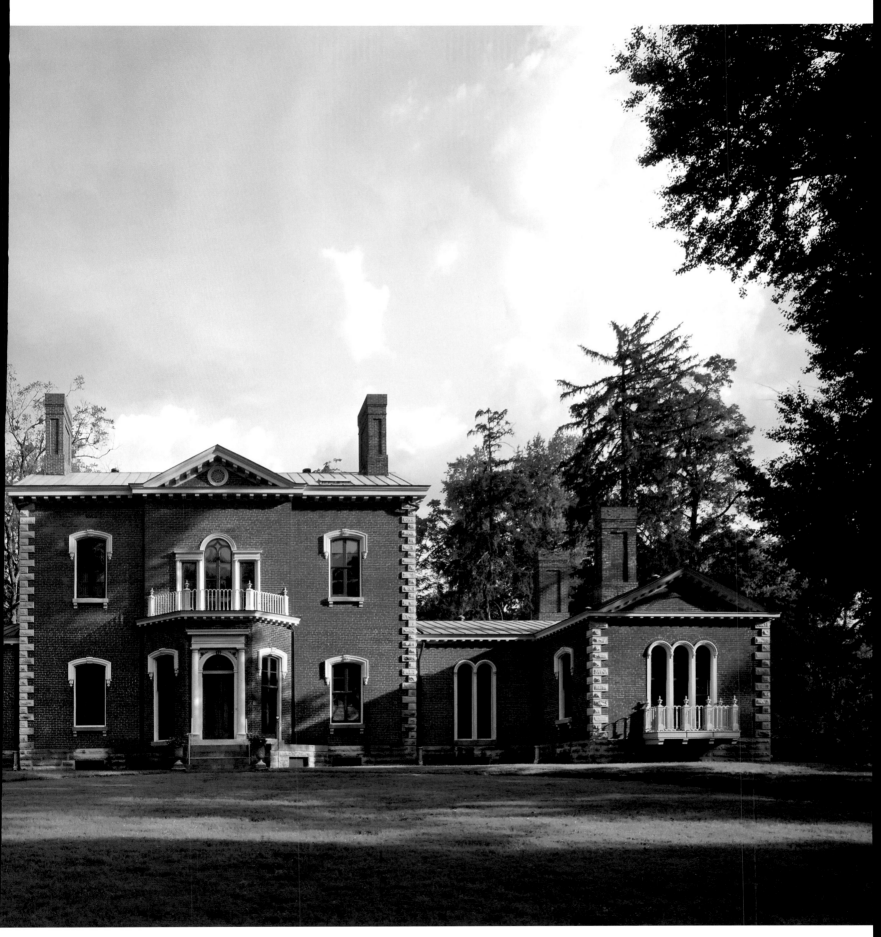

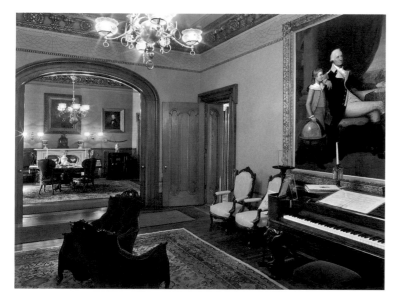

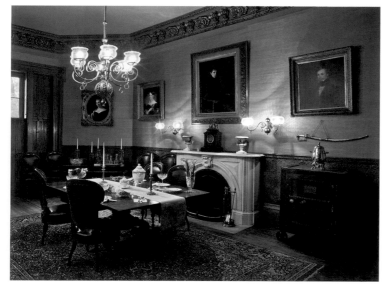

TOP

The drawing room, the most formal room at Ashland, features a copy of Edward Savage's portrait of George Washington and his family; a gift to Clay from Washington.

ABOVE

The dining room at Ashland was designed and furnished to accommodate large formal banquets. Portraits of Henry Clay, Jr.'s family are prominently displayed.

RIGHT

Matthew Harris Jouett's portrait of Henry Clay and Oliver Frazier's of Lucretia Clay preside over the octagonal entrance hall. The Eastlake-style staircase dates from the 1880s.

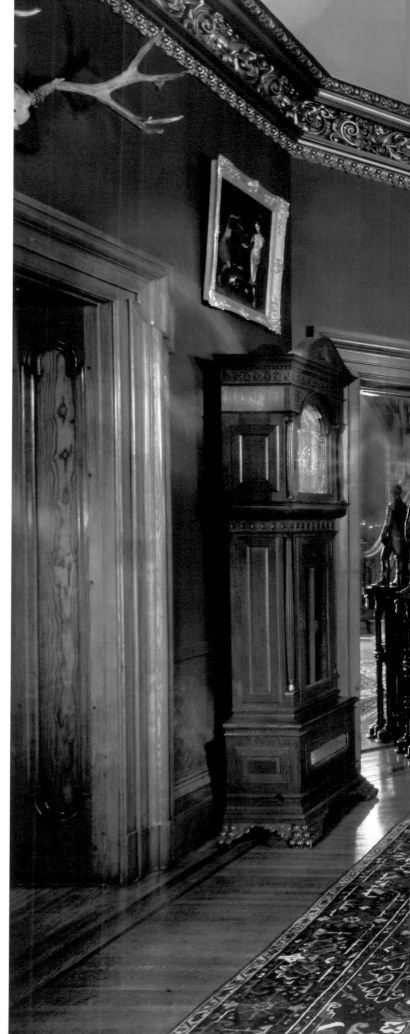

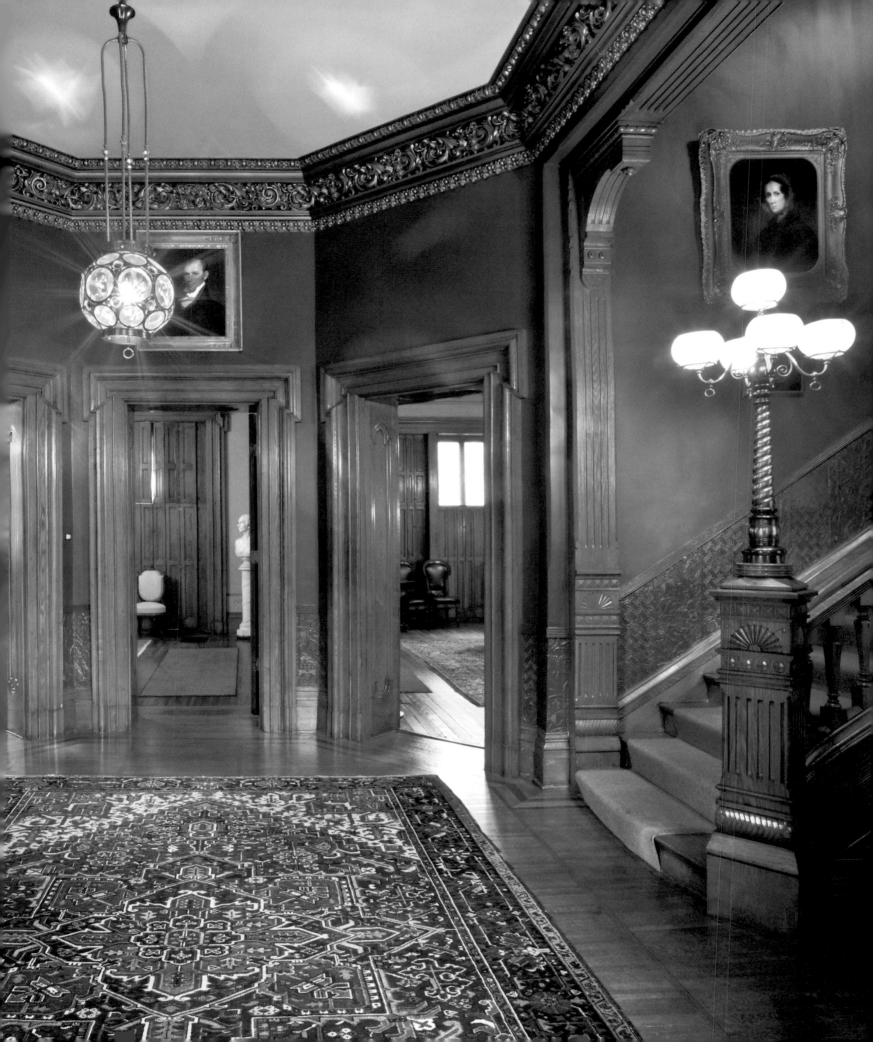

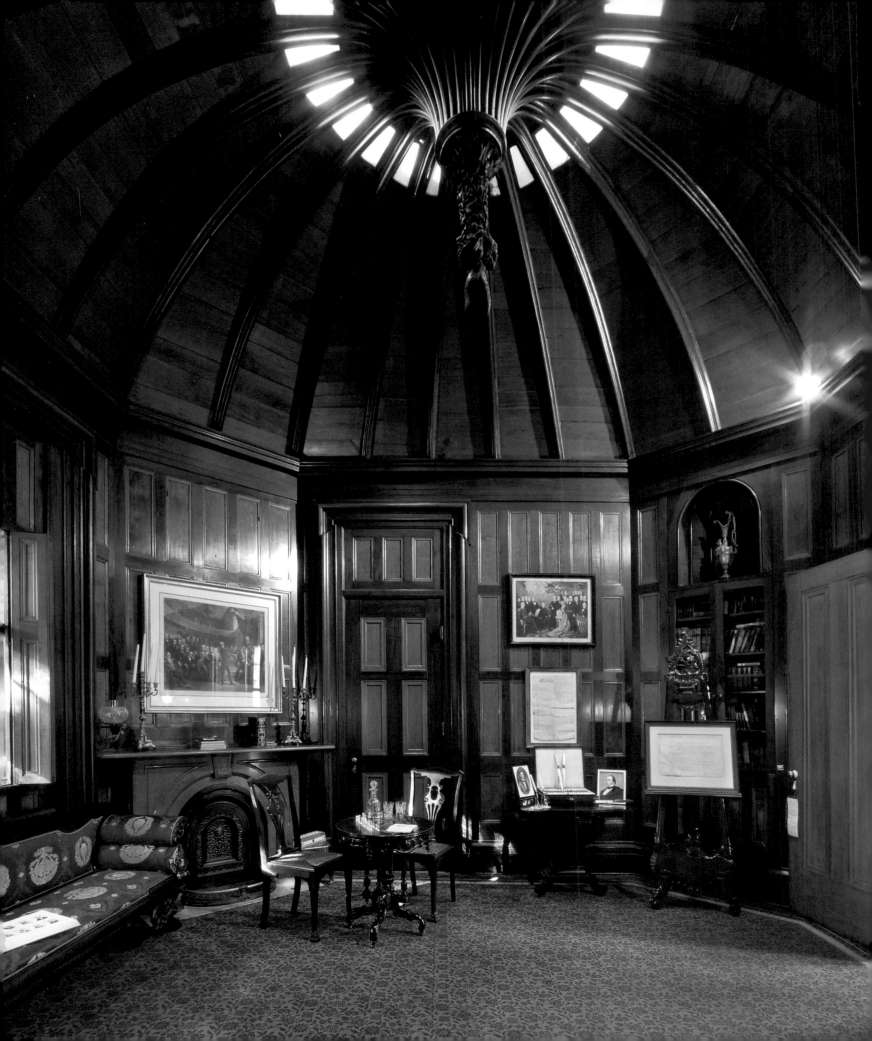

(or possibly an addition to an existing structure), but at some point (possibly when he was elected senator for the first time in 1806), the plans expanded to encompass at least eight rooms. These were probably arrayed within a conventionally symmetrical Federal house, three bays (instead of the more typical five) in width, but overall much like the kind of prosperous planters' houses Clay would have known from his youth in Virginia. By 1809, the center block was finished and, following Clay's election to the U.S. House of Representatives in 1811, the congressman asked the architect of the U.S. Capitol, Benjamin Henry Latrobe, to design the flanking wings, thus creating a typical five-part Anglo-Palladian plantation house. At this time, Latrobe may also have modified (or even rebuilt) the original block, perhaps in response to a series of catastrophic earthquakes that occurred from December 1811 through February 1812, which contained aftershocks believed to have exceeded 8.0 on the Richter scale. Although centered in New Madrid, Missouri, the earthquakes were so severe and intense that the Mississippi River actually shifted course, church bells rang in Boston, and some brick chimneys reportedly were shaken apart in Maine, over one thousand four hundred miles away. Clay's house stood only 335 miles from the epicenter.

Latrobe may have used the opportunity of repairing the earthquake-damaged house to create Ashland's distinctive octagonal entrance hall, with its projecting entrance bow, and dining room.[4] In 1813, Latrobe also supplied designs for the hyphens and flanking structures, which were substantially altered by Clay and his local builder during construction. The exterior was painted a pearl color to unify the various building campaigns, to conceal repairs, or simply to produce a uniform surface preferred by contemporary architects and clients to emphasize Neoclassical formal simplicity. The completed house became the focal point of the six-hundred-acre farm and surely the finest house in the region, as befitting the region's most powerful statesman. Clay became a highly influential figure on the national scene, serving almost continuously in either the House or Senate for over forty years and a term as secretary of state, in addition to being a perennial nominee for the presidency. He died, while in office, in Washington, DC, in 1852.

Although Clay's widow held life interest in the house, she chose not to live at Ashland, and in 1853 the property passed to the Clays' son James. James Clay reportedly found the house in a condition beyond repair, indicating structural problems possibly dating back to damage from the 1811–12 earthquake. James Clay demolished the original structure but made the startling decision to rebuild the house almost exactly as it had been, incorporating the original foundation layout, and replicating the original floor plan. This gesture of filial reverence was tempered by the logically inconsistent decision to stylistically "update" the envelope of the house to reflect current architectural fashion. The resulting building is distinctly a product of the Victorian, romantic imagination, with its colorful contrast of red brick mural surfaces enlivened with textural accents of heavily rusticated stone quoins and bold bracket-like modillions punctuating the eaves. Windows are crowned with carved stone hood molds, and the arched Palladian windows Latrobe specified for the wings were replaced by triple-arched Romanesque windows. Even the once-Palladian rhythm of the window above the entrance bow received a dose of picturesque Gothic tracery. The overall impact of the house recalls the Italianate villa style popularized throughout the United States through the books of A. J. Downing and Samuel Sloan. James

FACING PAGE
The library, with its octagonal plan and stunning vaulted ceiling, is James Clay's reinterpretation of the space designed for his father by Benjamin H. Latrobe.

TOP
Henry Clay's local architect, Thomas Lewinski, designed the keeper's cottage in 1846 to serve as a residence for Ashland's chief gardener.

ABOVE
Henry Clay installed the distinctive conical icehouse and dairy cellar in 1834 to provide state-of-the-art cold food storage in sixteen-foot-deep underground vaults.

Clay's decision to rebuild, but not literally reconstruct, his father's Ashland stands as an illustration of how different Victorian notions of "preservation" were from our own. The idea of the place and the values of its resident—not the literal material accuracy of the house as artifact—were what mattered. When Ashland's interior was remodeled in the 1880s by Anne Clay McDowell, one of Clay's granddaughters, Henry Clay's presence was not de-emphasized, but instead re-presented to suit the new generation's expectations of a statesman's home.

By the turn of the twentieth century, development encroached on Ashland, and by 1926 Clay's descendants sought public support to maintain the property as a house museum. Finally, in 1948, the estate of Clay's great-granddaughter provided for the creation of the Henry Clay Foundation, which continues to ensure that the statesman's home, as preserved and interpreted by his family, remains intact and open to the public as an historic site.

The Aiken-Rhett House

Charleston, South Carolina
Built 1817; enlarged 1833 and 1840s; redecorated 1851; addition 1857
Builder: Unknown
Owned and operated by the Historic Charleston Foundation, Inc.

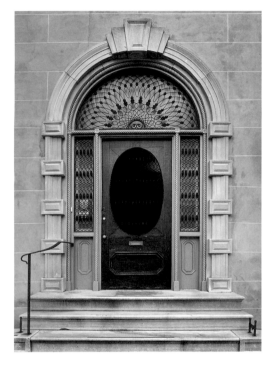

Perhaps more than the residents of any other American city, Charlestonians retained a close sense of cultural allegiance to Western Europe.[5] In the decades preceding the Civil War, the city's elite sent their children to Europe for secondary education, indulged in the yearlong (or longer) Grand Tours of important cultural sites and aristocratic social gatherings, and, significantly, developed their taste in art and architecture. Their purchases of art, personal adornments, furnishings, and portraits of themselves were often installed in existing homes, overlaying the new generation's cultural sophistication upon the framework of the old, representing a sense of continuous and definitive gentility.

The Aiken-Rhett House was built for merchant John Robinson in 1817, with a central hall and two rooms to either side on each floor. The pediment facing over the distinctive double gallery indicates the original orientation of the house facing Judith Street. Financial losses forced Robinson to sell the property in 1827 to William Aiken, Sr., an Irish immigrant and founder of the South Carolina Canal and Rail Road Com-

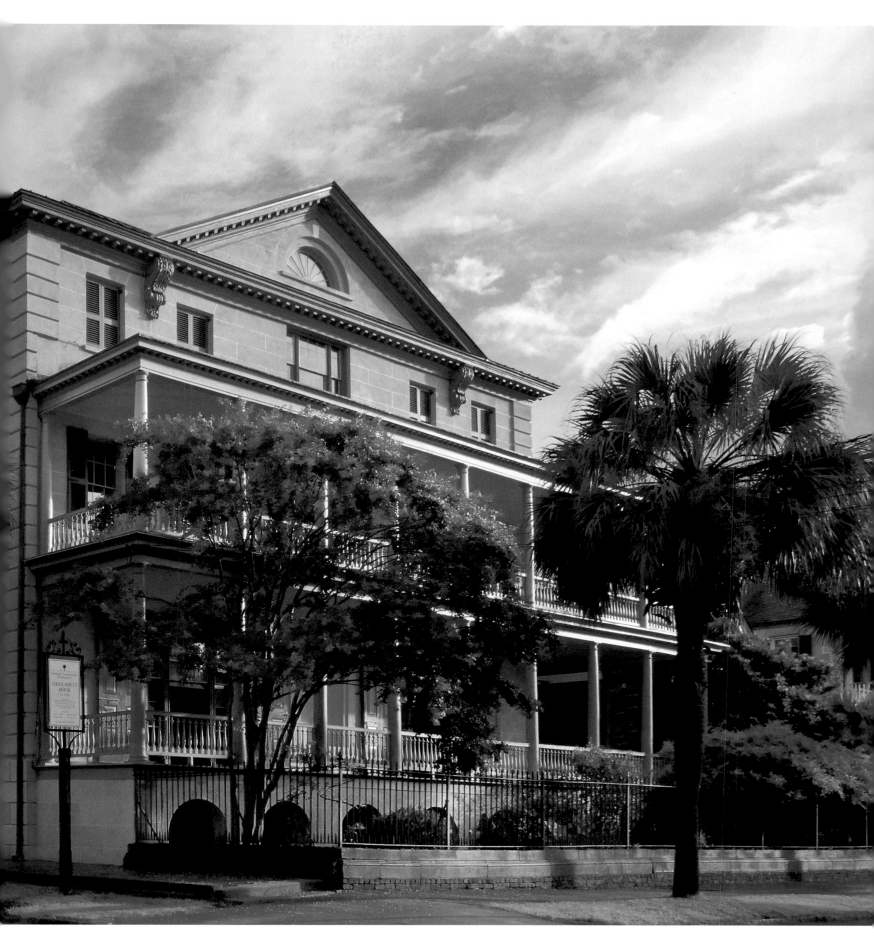

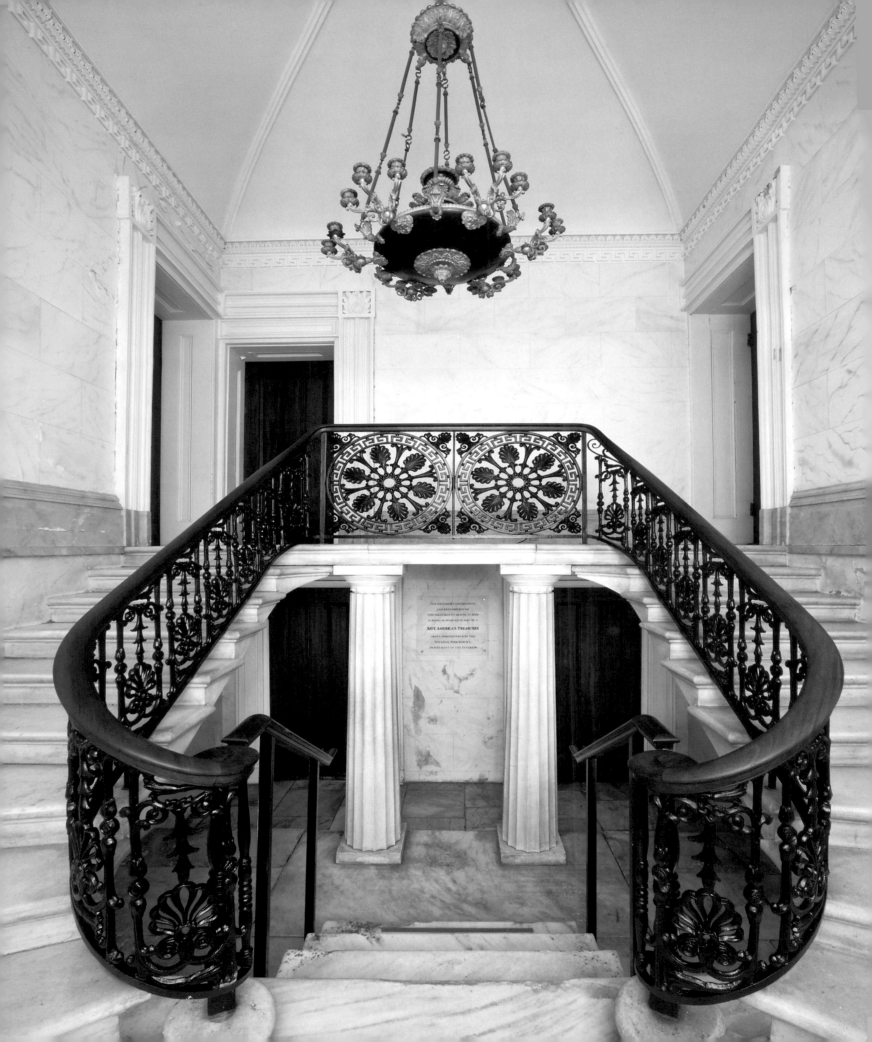

FACING PAGE
When the Aikens reoriented the house in 1833, they created the impressive Greek Revival entrance hall.

RIGHT
The Aikens commissioned an octagonal art gallery addition to be completed upon their return from a European Grand Tour, during which they acquired thirty-eight paintings and statues.

BOTTOM RIGHT
A bronze newel lamp embellishes the stairway to the second floor.

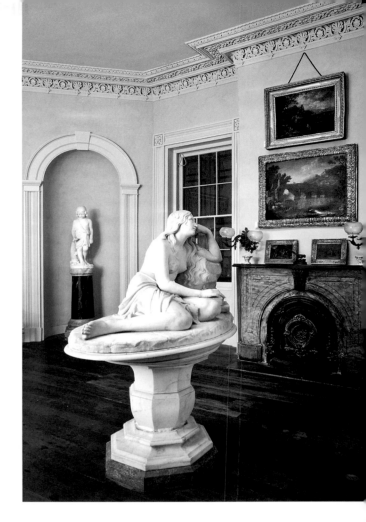

pany, who leased the house to tenants. His son, William Aiken, Jr., inherited the property in 1831 and decided to move into it in 1833. He substantially enlarged the house, notably switching the entrance to the original "side" on Elizabeth Street and embellishing the new entrance hall with an impressive marble staircase in the Greek Revival taste. Aiken was elected governor in 1844 and later served in the U.S. House of Representatives. Perhaps to commemorate his election to Congress in 1851, the house was substantially redecorated in the most fashionable style— with patterned, flocked wallpaper, velvet curtains, and gilded furniture. Remarkably, this decor remains, unrestored and largely unaltered, at the house today. Unlike most historic properties, which strive to represent the property in its heyday, the magnificent impression of the Aiken-Rhett House (like the similarly unrestored Drayton Hall, just outside of town) is that of the passage of time made tangible, and of the unmediated, ghostly presence of the past.

One of the state's wealthiest men, Aiken was also one of its largest slaveholders, with over 875 enslaved people held at his plantation properties. Aiken's townhouse was operated by twelve resident enslaved African-Americans, who slept in a dormitory-type hall located above the carriage house and kitchen/laundry buildings in the rear service yard of the main house. In the 1840s, Aiken remodeled these buildings and added garden follies and other structures to the service yard, all in Gothic Revival manner that suggested a vaguely ecclesiastical basis for the paternalistic social order expressed in the architecture and its hierarchical arrangements. The service yard not only became a decorative adornment to the residents of the main house but also suggested a convent or other Christian institution associated with the Victorian cult of domesticity.[6] Enslaved people—Ann Greggs and her son, Henry; Sambo and Dorcas Richardson and their children, Charles, Rachel, Elizabeth, and Julia; Charles Jackson; Anthony Barnwell; and two carpenters, Will and Jacob—worked and resided within this Gothic stage set, within the inescapable control and view of the masters of Charleston's most luxurious house.

In 1857 and 1858, Aiken and his wife traveled throughout Europe on the Grand Tour (his third, her second), collecting sculpture and paintings for an art gallery addition to their house. Aside from a handful of French and English pieces, the bulk of the collection was assembled in Italy and included works by American artists, such as sculptor Hiram Powers, who lived and worked primarily abroad. In the 1840s and 1850s, the study of art history, focusing on the classical past, as reborn and refined for modern times in the Italian Renaissance, was just starting. Pioneering studies by Franz Kugler (1808–58) and Jacob Burckhardt

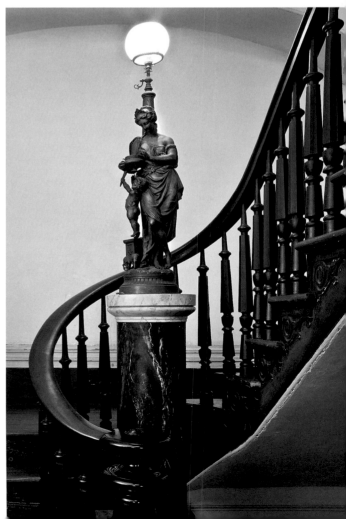

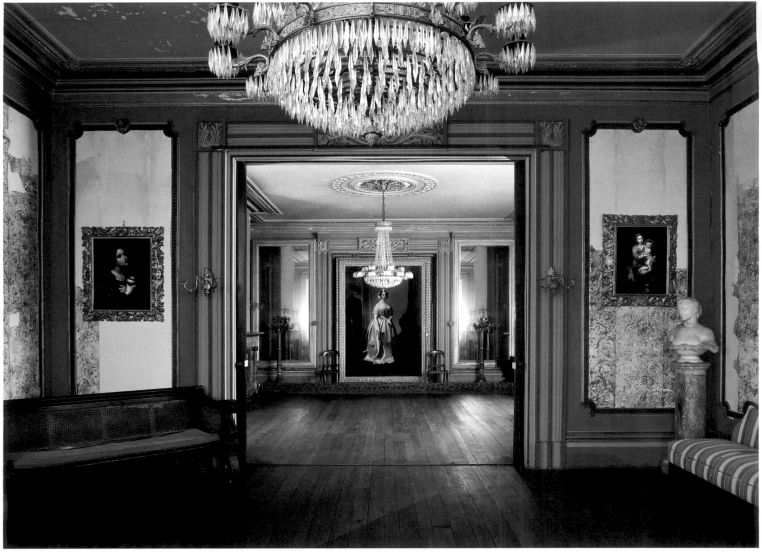

Interiors at the Aiken-Rhett House display a remarkable array of original finishes that remain intact from their heyday in the 1850s. The portrait of Harriet Lowndes Aiken was painted by George Whiting Flagg in 1858.

The ballroom of the Aiken-Rhett House was the site of many of antebellum Charleston's grandest gatherings.

(1818–97) were based on the premise that art reflected the society in which it was created, and that appreciating a past culture's artwork revealed an innate affinity on the part of the contemporary connoisseur or collector. The Italian Renaissance, with its mercantile elite and great patrons of art, became a particularly strong point of self-identification for self-made wealthy Americans. Guidebooks listed not only museums but also shops and commercial galleries that sold skilled copies of the masterpieces on view next door. The Aikens bought a reduced-scale copy of Canova's popular *Venus Italica* (itself a Neoclassical version of a classical statue). Purchasing copies was a not-uncommon practice in an age in which mechanical reproduction of art and published pictorial catalogs were virtually unknown. Artworks might also be bought for their subject (such as Luther Terry's *Romeo and Juliet*, the one original work apart from Mrs. Aiken's portrait known to have been commissioned by the couple while in Europe); for the artist (a scene of musicians was attributed to

Michelangelo when the Aikens purchased it); or, sometimes, for their association with a previous, preferably royal, owner (such as a table that had allegedly belonged to King Louis-Philippe of France, or a genre scene purchased from the Prince Torlonia). These objects served not only as souvenirs of costly travel (itself a status symbol) but also as talismans of aristocratic culture and identity. Correspondence indicates that the Aikens sometimes chose the artworks to fit their gallery addition, which was scheduled for completion by the time they returned from their travels.[7]

The house remained in the family (Rhett was the married surname of William Aiken, Jr.'s daughter) until 1975. Owned and operated today by the Historic Charleston Foundation, this remarkable property retains its convent-like outbuildings, many original finishes, and numerous original artworks from the Aikens' 1857–58 European shopping spree, which provide a unique window into Charlestonian life, art collecting, and identity in the years just before the Civil War.

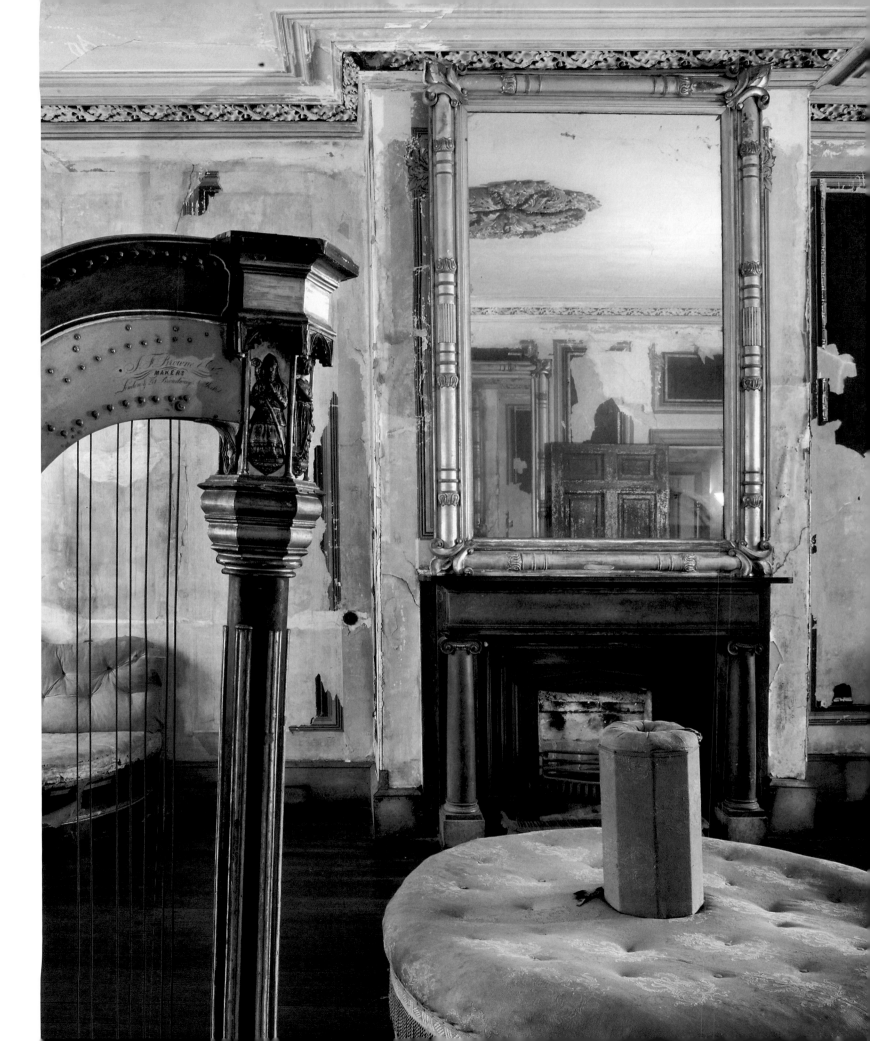

Fendall Hall

Eufaula, Alabama
Built 1859–60
Builder: unkonwn
Owned and operated by the Alabama Historical Commission

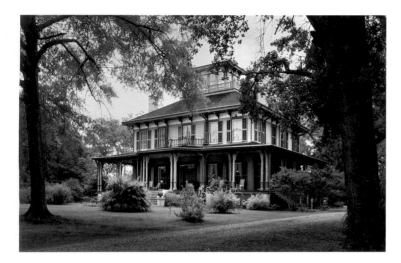

Fendall Hall exemplifies the Italianate villa style, a popular choice for Southern homes in the mid-nineteenth century. The brown exterior paint scheme dates to the 1880s.

While the Greek Revival style is most associated in the popular imagination with the architecture of the Old South, the Italianate style was nearly as prevalent in the generation or two preceding the Civil War. In the Northeast, the design books of A. J. Downing included boxy, porch-encircled houses with wide, overhanging bracketed eaves inspired by the villas of Tuscany, but the similar work of Philadelphia architect Samuel Sloan played the pivotal role in establishing the Italianate style in the South. Sloan included his 1851 design for the villa-inspired Joseph A. Winter House in Montgomery in his two-volume pattern book, *The Model Architect* (1852), which implicitly demonstrated the particular applicability of the Italianate style to the southern climate. Coincidentally, the style's fundamentally simple geometric masses allowed for the retention of traditional room arrangements based in Federal-era classicism, which could then be embellished with the addition of fashionably picturesque cupolas, verandahs, and corbel brackets.

Fendall Hall (originally called Homewood) was built by New York-born cotton trader, banker, and businessman Edward Brown Young on a four-and-a-half-acre site in the small, prosperous river town of Eufaula (then called Irwinton). Young purchased the property in 1856 but waited three years for the lumber (cut from his own land) to cure sufficiently before construction began in 1859. While many of their Eufaula neighbors were still building in the traditional Greek Revival style, the Youngs chose an Italianate design, complete with capacious verandah and a cupola that allowed hot air to rise through the central stairwell and escape through the attic. Deviating from the Italianate style, which tended to favor earthy hues, they chose a white paint scheme with green shutters, perhaps a concession to local taste and the Greek Revival tradition. A

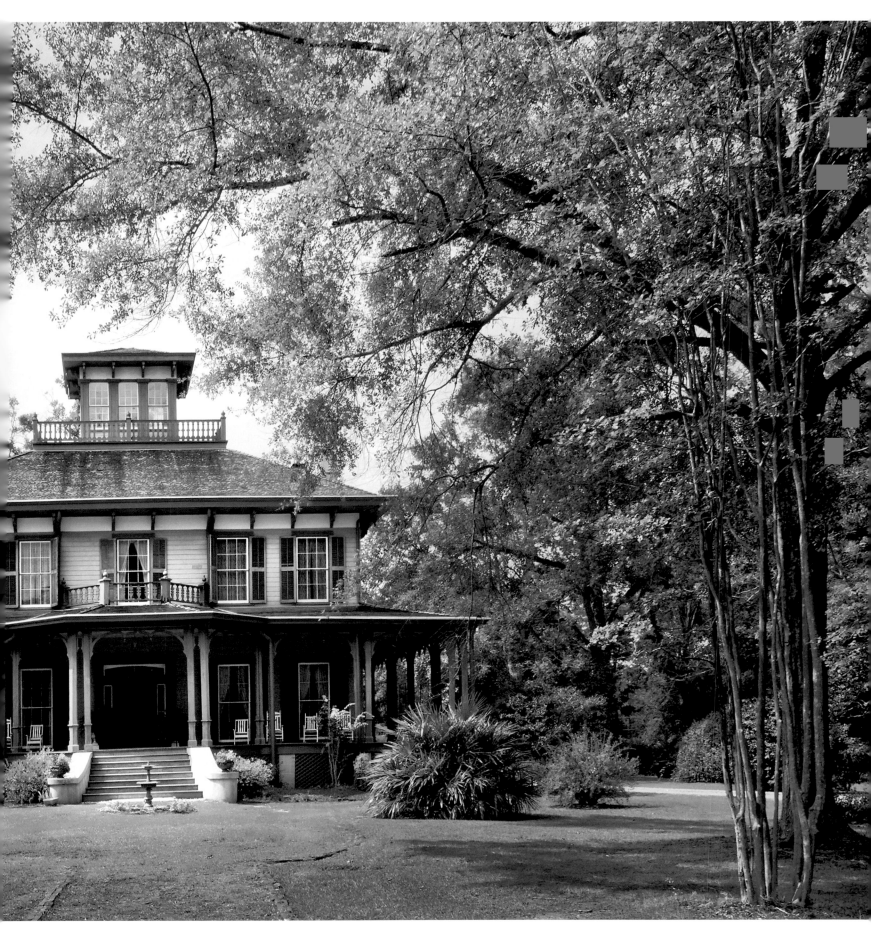

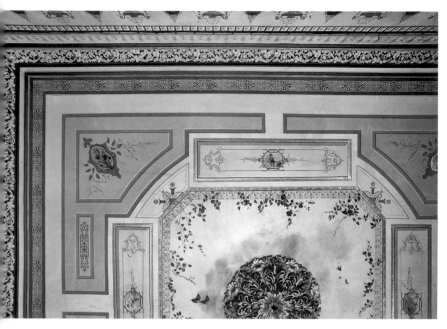

ABOVE
The drawing room ceiling features flowers and foliage, drawn from the gardens at Fendall Hall, and fanciful figures copied from the children's book In Fairyland.

RIGHT
The drawing room features painted decorations by artist D. F. Leifrank, who lived with the Young family for six months in 1884 to complete the work.

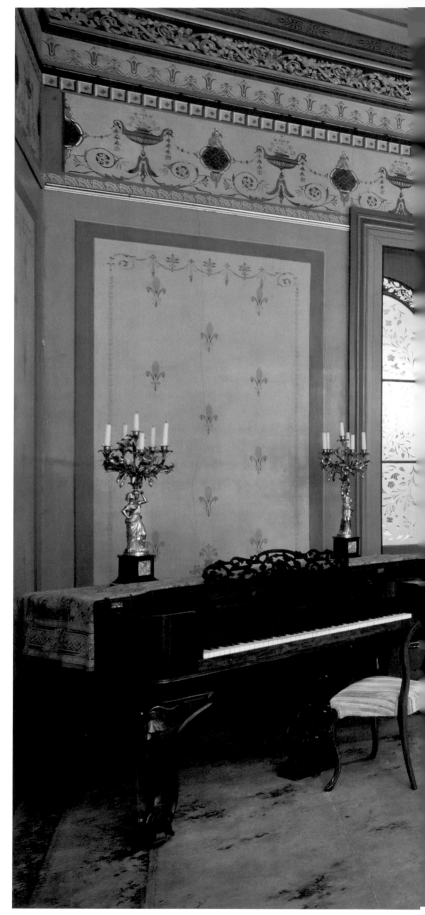

black-and-white marble floor in the entrance hall, marble mantels, and etched Bohemian-glass transom panels displayed imported materials, a sure sign of status and refinement. They did not have long to enjoy their house before the Civil War intervened, but Mrs. Young's supposedly precarious health proved quite sturdy, and she lived in the house until her death in 1876.

Following Edward Young's death in 1879, the property was purchased by their eldest daughter, Anna, and her husband, attorney Stouten Herbert Dent, who was president of the Eufaula National Bank. Whether the old decoration had grown worn or the Dents merely wished to assert their own taste, soon after they purchased Fendall Hall in 1880, they hired artist D.F. Leifrank to decorate the major public spaces of their house. The resulting mural decorations—which mix stenciled border patterns with freehand still-life elements, landscape, and figural vignettes—are among the best surviving examples of Victorian interior painted schemes in the South. They also bear witness to the peculiar cultural institution of the itinerant artist.

In early-nineteenth-century America, portrait painters traveled to wealthy towns, painted the most prominent residents (with varying degrees of fidelity), and, when the supply of subjects ran out, moved on. Political instability in Europe in the 1830s and 1840s drove many artisans (particularly Germans) to America, among them painters specializing in shop signs, church interiors, stage sets, or even carriages. Throughout the country, but especially in the South, they carried on a long-standing tradition of painting murals and ornamental patterns in exchange for room, board, and a fee. Leifrank, who dined with the Dents

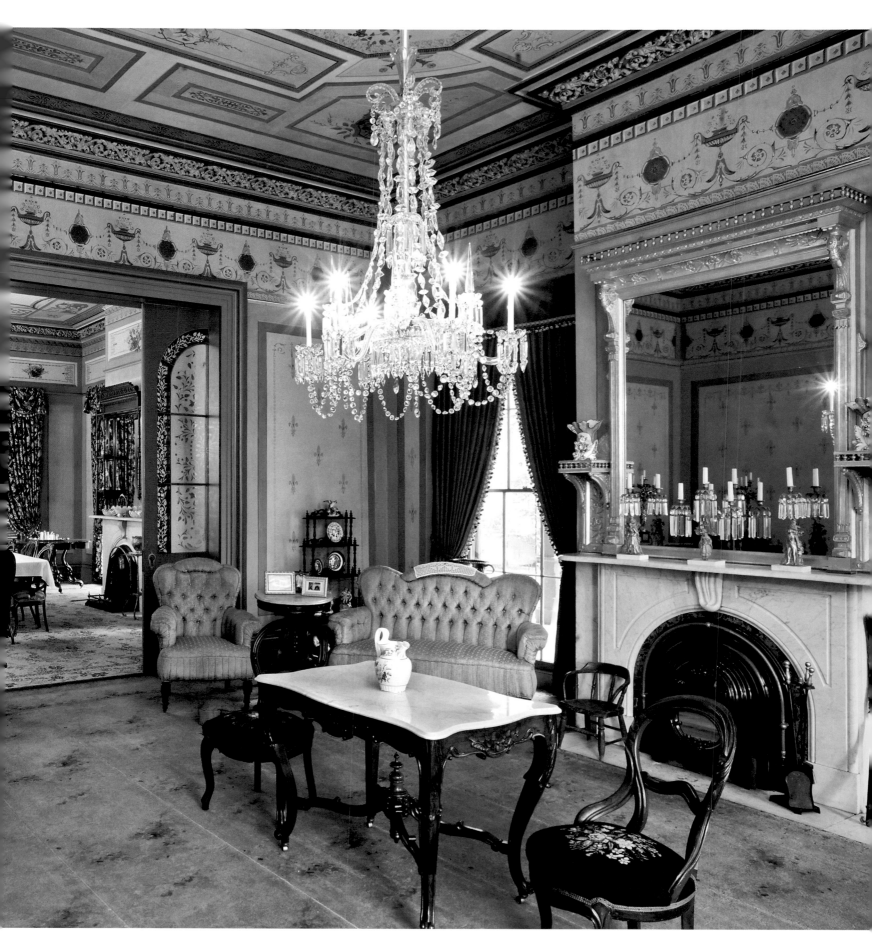

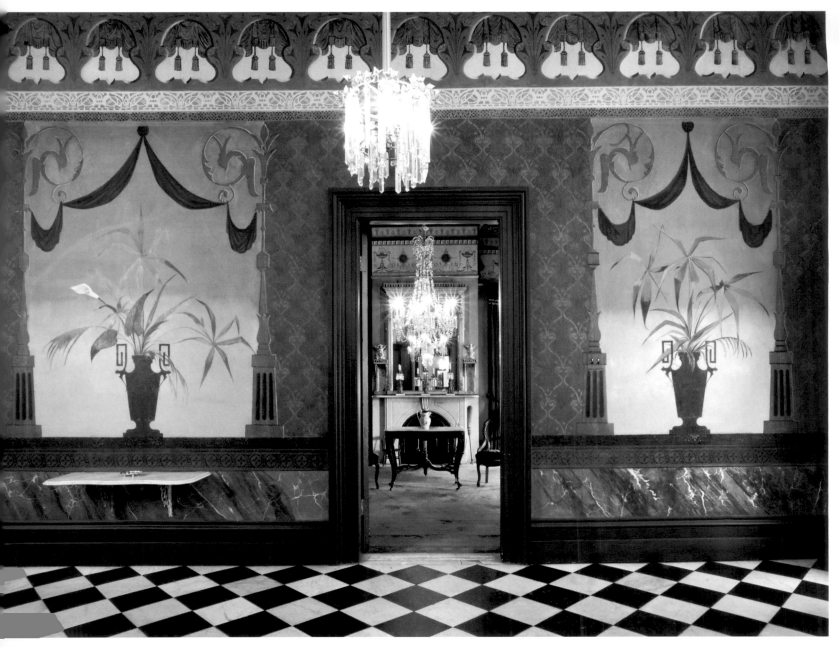

ABOVE
The boldly theatrical treatment of the entry hall creates illusionistic architecture and vistas that visually expand the space.

FACING PAGE
The dining room's decorative scheme incorporates colors and motifs from Mrs. Young's china.

throughout the decoration campaign, executed the entrance hall first, in a flat, theatrical style, with patterned trompe l'oeil curtain panels seemingly pushed aside to reveal urns standing on a fictive parapet, which was painted to resemble marble. In the parlor, he utilized a more layered style, with stenciled wall panels and a Neoclassical Adamesque urn and swag frieze giving way to a Rococo-inspired ceiling, which was divided into compartments featuring allegorical vignettes of the seasons, a swag of morning glories, and an open sky in the center. The door panels, gilded and painted with hollyhocks and other garden plants, suggest the Anglo-Japanese style of the 1870s and 1880s. By the time he got to the dining room, Leifrank knew the family well enough that elements of their china

and silver patterns were incorporated into the decoration. At this stage, the Dents apparently had had enough of their guest artist-in-residence, and the upstairs bedrooms and other more private spaces show no evidence of his work.

The Young House passed through two more generations of the family (one of whom renamed the house "Fendall Hall" in honor of the builder's wife's maiden name) before it was acquired by the Alabama Historical Commission in 1973. In 1982, conservators removed later accretions of wallpaper and, throughout the 1990s, engaged in a series of painstaking restorations to reveal Leifrank's glorious wall paintings once again.

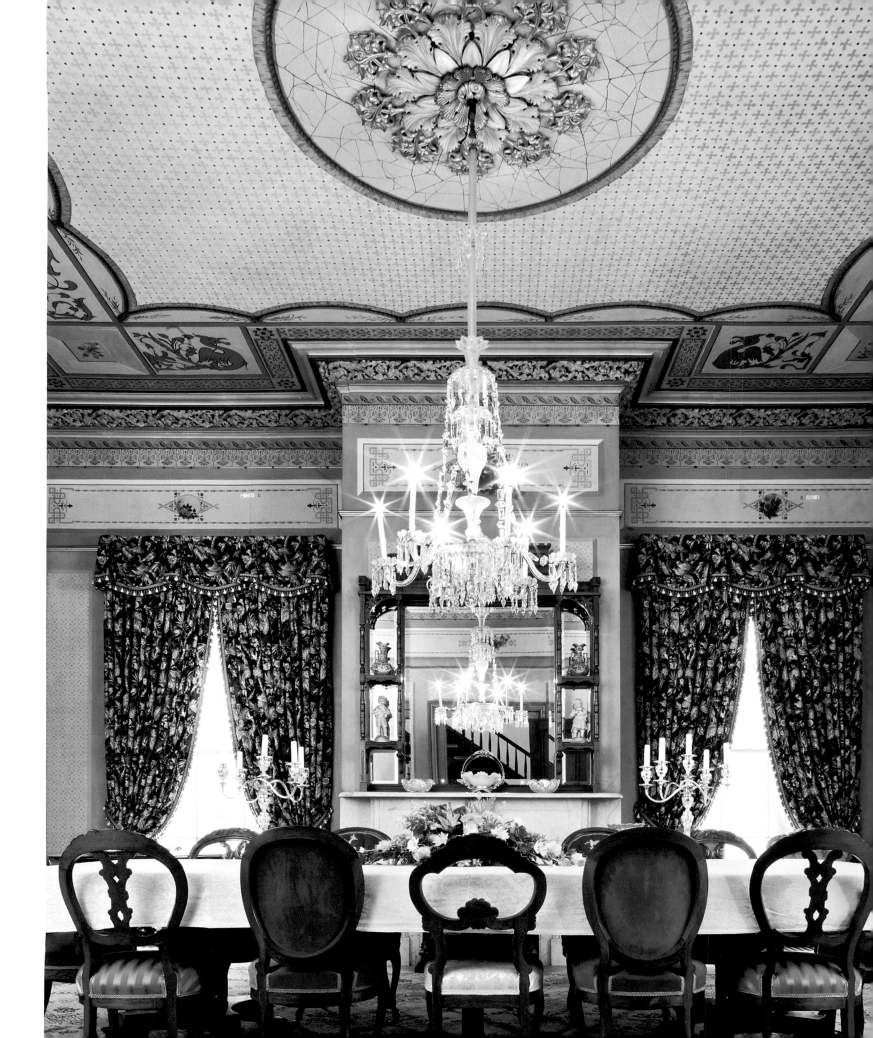

Longwood

Natchez, Mississippi
Built 1860–61
Architect: Samuel Sloan
Owned and operated by the Pilgrimage Garden Club of Natchez

ABOVE
Intricate tracery and horseshoe arches embellish Longwood, one of the few surviving examples of the exotic "Moorish" architectural style.

RIGHT
Octagonal in plan and fancifully "Oriental" in detail, the house has remained unfinished since workmen fled at the outbreak of the Civil War.

For nearly 150 years, Longwood has stood suspended in time—unfinished, with construction tools and supplies scattered where the Yankee workers left them as they fled for safety at the announcement that on January 9, 1861, the Mississippi state convention had voted eighty-three to fifteen to secede from the Union. The unfinished house—peculiarly octagonal, vaguely Islamic, remarkably large—came to embody hubris for North and South alike.

Longwood was built by Dr. Haller Nutt, a Virginia-born physician who developed a profitable strain of cotton that made him a fortune in Mississippi as a planter. In choosing an octagon form for his Natchez mansion, Nutt was almost certainly inspired by the quasi-scientific tract *A Home for All, or A New, Cheap, Convenient, and Superior Mode of Building* by Dr. Orson Squire Fowler. First published in 1848 (and eventually achieving nine editions), Fowler proposed octagon-shaped buildings as (allegedly) cost-effective to build but, perhaps more important for Nutt, better ventilated than conventional rectangular houses and therefore healthier, particularly in hot weather. Fowler was also a respected practitioner of the immensely popular Victorian quasi-science of phrenology, which posited that moral character was revealed in the shape of a person's head.

Nutt and his wife traveled to Philadelphia to meet personally with architect Samuel Sloan, who had included a Fowler-inspired "Oriental" octagon amidst the predominately Italianate villas in his book *The Model Architect* (1852). The "Moorish" or "Oriental" style, made famous by P. T.

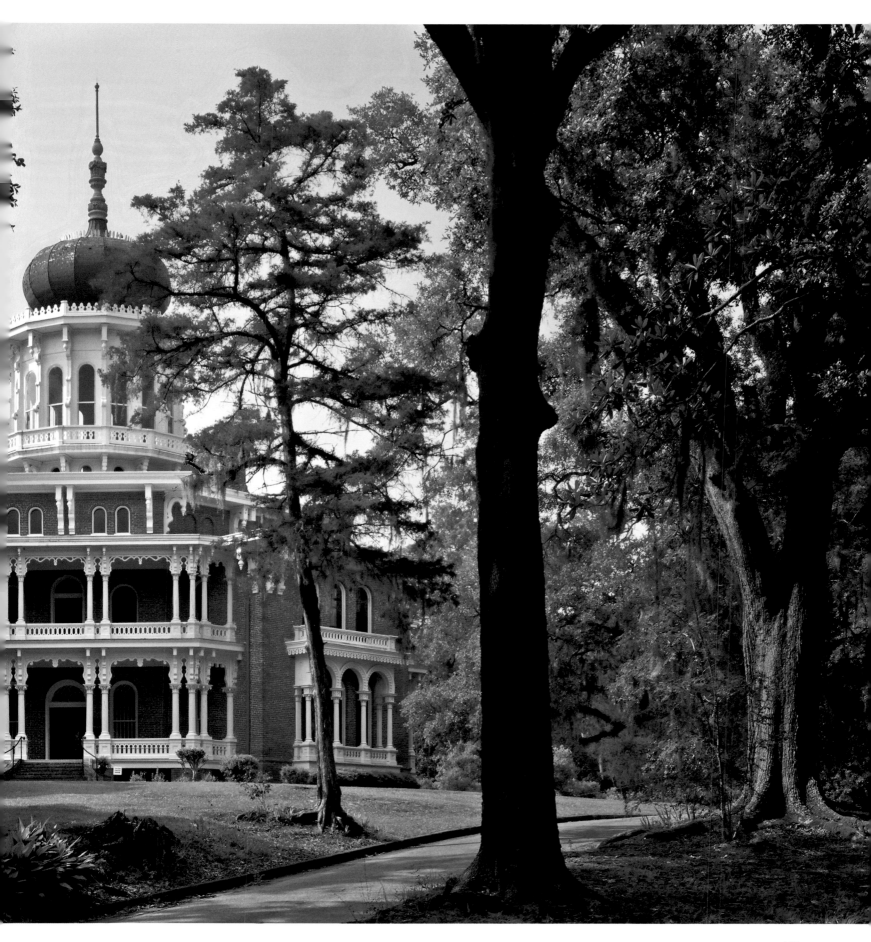

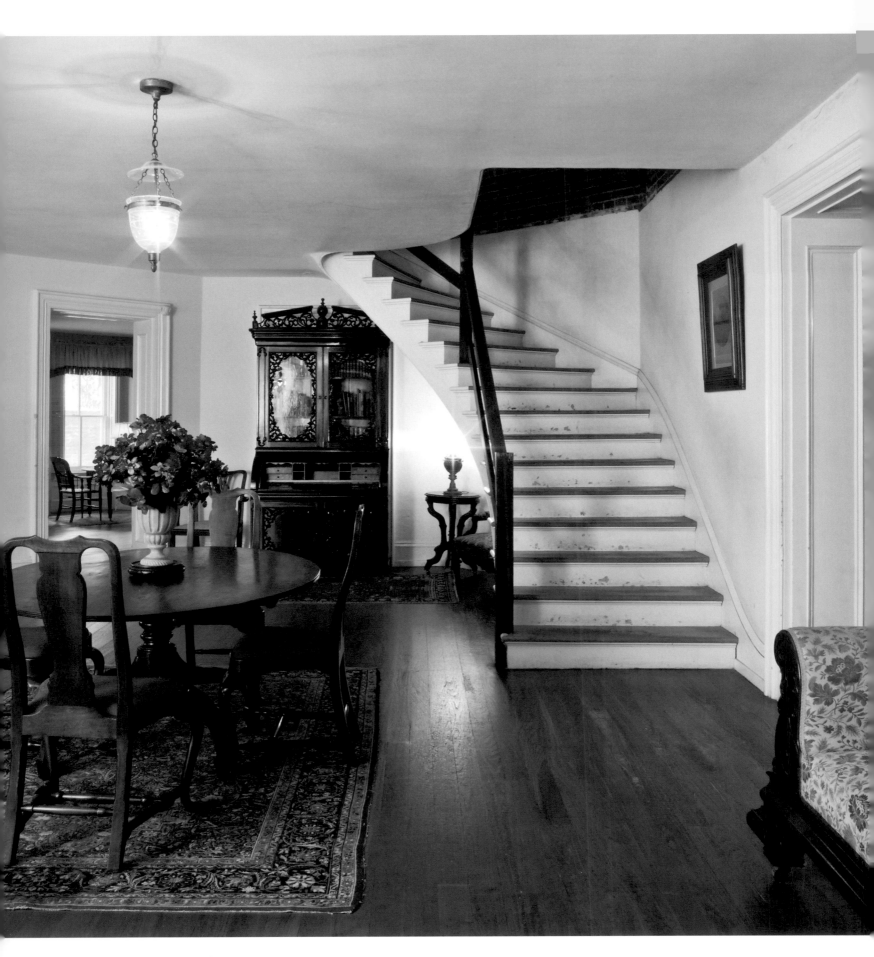

LEFT

The basement-level interiors, finished by enslaved and local craftsmen, served as the family's residence until 1970. The staircase leads to the shell of the unfinished mansion above.

ABOVE

The octagonal plan created unusual room shapes and circulation patterns in the living quarters. The portrait of Haller Nutt (circa 1853) is by Justin Sancan.

Barnum's outrageously ornate house Iranistan in Hartford, Connecticut (1846–48, burned 1857), not only connoted a certain risqué exoticism but also echoed the rise of European colonialism in North Africa and India, which may have appealed to the Southern planter under increasing scrutiny for his own economic reliance on a labor force defined by race. Taken alongside the contemporary taste for decorative complexity and the perpetual search for an architectural manner suited to the hot southern climate, Sloan's "Oriental" style fit the bill. Longwood was designed to have thirty thousand square feet distributed amongst thirty-two rooms, encased in slave-made brick walls twenty-seven inches thick with a five-

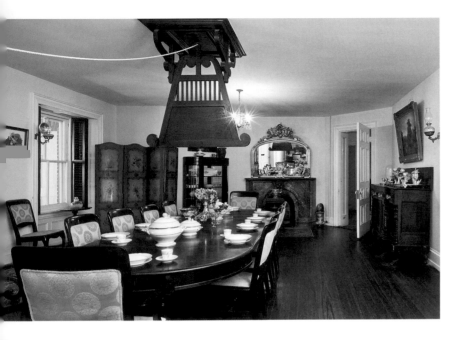

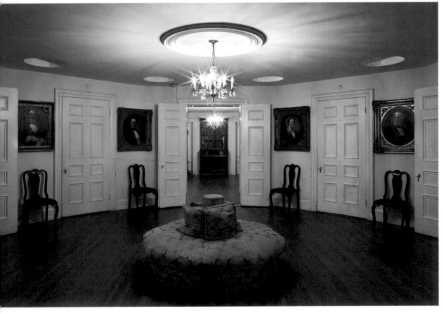

In spite of the unconventional subterranean living arrangements, Longwood's dining room is conventionally furnished for gatherings of the large family, which included eleven children.

ABOVE
Family portraits adorn the windowless room at the house's core. Nutt's widow and children spent decades seeking reparations for the family's losses in the Civil War.

FACING PAGE
The unfinished mansion has been interpreted as an architectural memento mori for the antebellum South.

inch air space between the brick courses for beneficial air circulation (a Fowler theory). Sloan sent Philadelphia masons and roofers to Natchez to help the enslaved and local laborers assemble the unusual building. By Christmas 1860, the exterior shell was complete at a reported cost of $100,000 (at least three million dollars in today's currency) and ready to receive a finishing coat of stucco. The next year was supposed to be dedicated to the completion of the elaborate interiors, for which Nutt had ordered marble flooring, columns, and mantels from merchants in New York and Philadelphia who specialized in European import goods.

Allegedly within hours of the announcement that Mississippi had chosen to secede, Nutt's Northern workers fled Longwood, fearful of mob retribution against themselves and, strangely, against Haller Nutt himself. Nutt, unexpectedly for a slave owner, vocally supported the Union cause in the Civil War, alienating his overwhelmingly pro-Confederate neighbors in the process. Regardless of his political sympathies, Nutt's plantations were fair game for Union troops, who sacked and burned his most valuable properties in Louisiana. The Confederates, on the other hand, seized his cotton stores, valued at over one million dollars at the time. Only a few of the marble mantels and furnishings intended to adorn the grand interiors of Longwood ever arrived, and were installed in the basement level under Nutt's supervision by his enslaved workers and any local craftsmen who would agree to assist. Upstairs, only the essential framing of the interior partition walls stood as a reminder of the extravagant, imaginative "Oriental" villa that Nutt had envisioned. Haller Nutt died at Longwood in 1864, leaving his wife and eleven children with virtually no assets and a massive shell of a house in which only the basement level and slave quarters were inhabitable.

Over time, the house was nicknamed "Nutt's Folly," in derision of its ornate extravagance as well as a play on its owner's name. Longwood's state of incompletion and, over time, decay, gave it a quality of mythic retribution, an emblem of judgment against the Southern society that Nutt's extravagance and slaveholding exemplified. But Southerners, too, found Nutt unsympathetic for his pro-Union politics and, perhaps, for his willful architectural eccentricity. Nutt's descendants lived at Longwood until 1970, at which time they gave the property to the Pilgrimage Garden Club, which has raised funds to preserve Natchez mansions since 1932. Today, it is recognized as the largest surviving octagon house in the United States, the country's best surviving example of a mid-nineteenth-century "Oriental" villa and, perhaps in spite of both distinctions, one of the signature houses of the Old South.

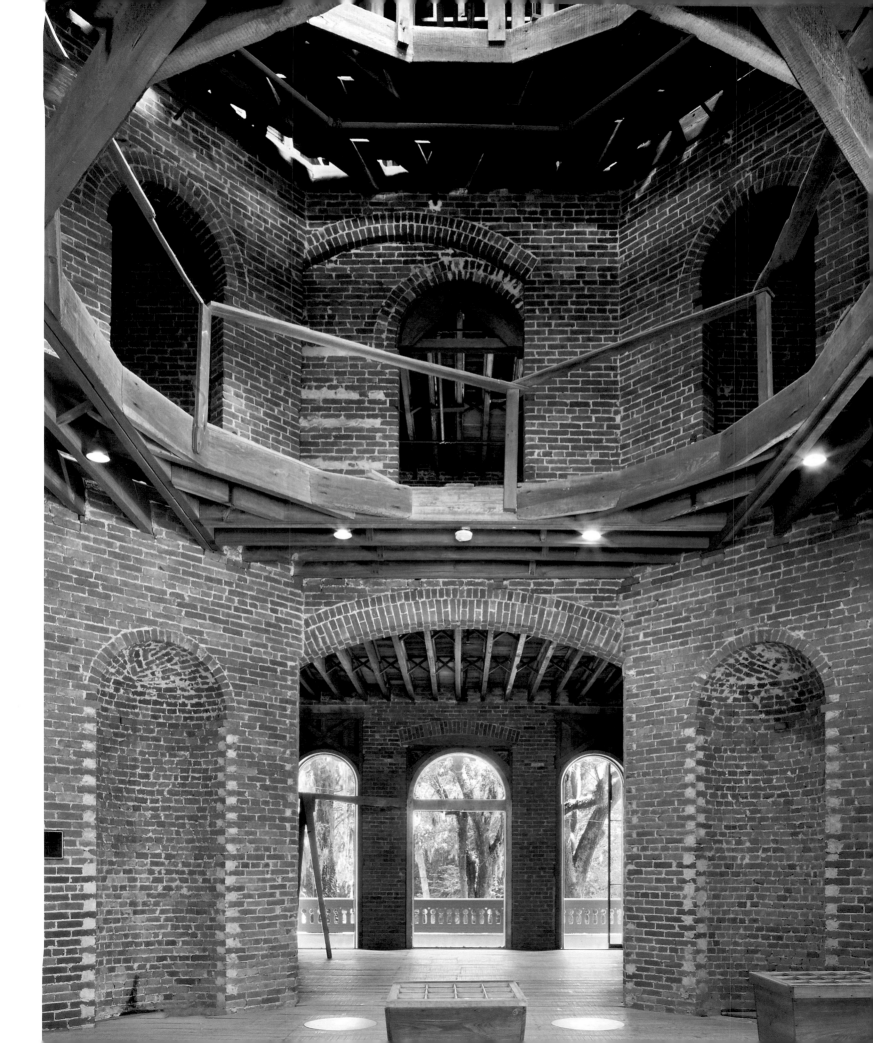

PART IV

1865–1940

The west facade of Biltmore House, seen from the lagoon

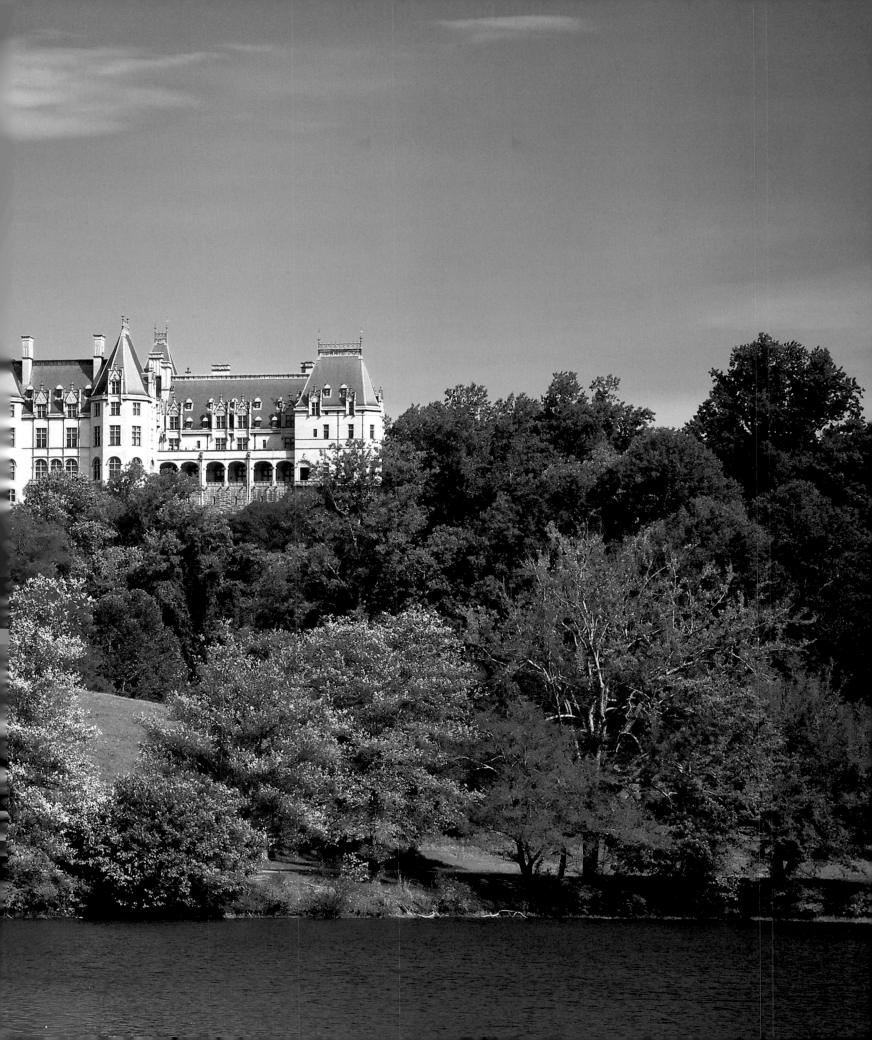

Cedar Hill

Frederick Douglass National Historic Site

Washington, DC
Built 1855–59, with additions and alterations 1877–93
Architect: John Van Hook (1855–59)
Owned and operated by the National Park Service,
U.S. Department of the Interior

RIGHT

Frederick Douglass's Cedar Hill boasts a commanding view of Washington, DC, from its hilltop site in Anacostia. Douglass enlarged the existing house to twenty rooms before occupying the fifteen-acre estate in 1878.

Frederick Douglass well understood the importance of domestic architecture as a representation of personal character and values. In his memoir, *A Narrative on the Life of Frederick Douglass, an American Slave* (1845), he judges the middle-class house of a New England abolitionist superior in all respects to the vast, elite estates of slaveholding Marylanders. Douglass refrains from describing the architecture of elite plantation houses in much detail, lest those descriptions inadvertently inspire admiration. Similarly, he does not detail the conditions of slave dwellings lest the buildings, by association, be interpreted by white readers as a reflection of the inherent characters of the people held against their wills within the unsanitary spaces and ramshackle walls.[1]

The belief that architecture embodied values—and that domestic architecture, specifically, represented the values and moral qualities of the inhabitants—was codified in the mid-nineteenth-century mind through the works of English theorists A. W. N. Pugin, John Ruskin, and, later, Matthew Arnold. This belief took on a particularly acute significance in the decades following the Civil War in the United States, during which time African Americans sought to establish independent households while still subject to pervasive white presumptions of their inferiority. In the nineteenth century (and beyond), white people's domestic architecture was the lingua franca through which the black middle class and elite could represent themselves and, by association, their values as successful, wholesome, and deserving of respect—the equals, if not superiors, of their white neighbors. These are, of course, precisely the same comparative messages that all high-style domestic architecture seeks to convey.

Douglass had been born a slave, probably in 1817 (he himself was uncertain), on Wye plantation on Maryland's Eastern Shore. While in Baltimore as a child, he secretly learned to read and write, and eventually escaped to freedom in Massachusetts, changing his name to Douglass both to throw off bounty hunters and to assert his independence from the circumstances of his birth. A spellbinding lecturer, he gained fame speaking to abolitionist groups in New England and, in 1845, published the first of his three memoirs. While Harriet Beecher Stowe's popular novel *Uncle Tom's Cabin* (1852) is generally credited with bringing the inhumanity of slavery to a wide, international audience, it was Douglass's first hand account, compelling prose style, and personal dignity that summarily shattered societal presumptions of the intellectual or moral inferiority of black people. Forced to flee to England to avoid recapture, Douglass lectured widely, and his British supporters eventually shamed his pursuers into allowing them

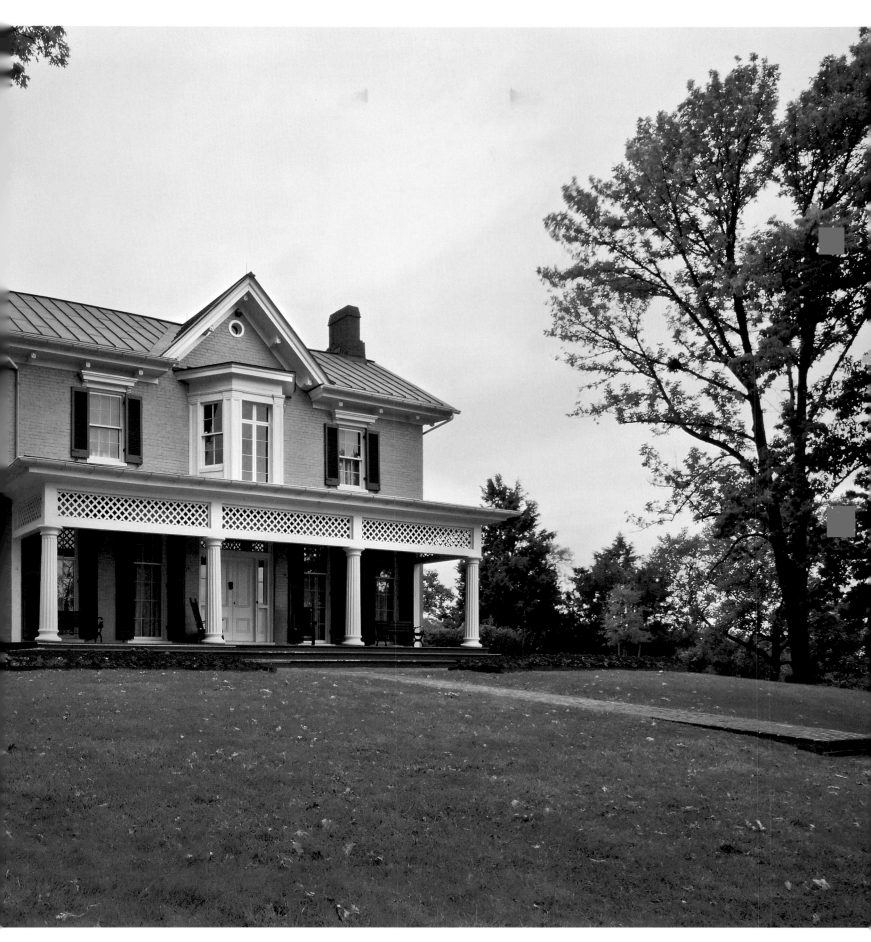

ABOVE
Portrait of Frederick Douglass by Sarah James Eddy, 1883

RIGHT
Abraham Lincoln, who counted Douglass among his most trusted advisors, is given the place of honor over the parlor mantel.

to purchase his freedom so he could safely return. Back in the United States he supported women's rights, became the editor and publisher of an abolitionist newspaper, and led a major Underground Railroad center in Rochester, New York. During the Civil War, Douglass recruited for the Fifty-Fourth Massachusetts Infantry (the first regiment of African-American soldiers, in which two of his own sons served) and, fearing the chance for irrevocable freedom would be lost through hesitation, helped to persuade Lincoln to issue the Emancipation Proclamation in 1863. After the war, Douglass moved to Washington as head of the Freedmen's Bureau and editor of the *New National Era*, a newspaper that reported on the progress (or lack thereof) of Reconstruction civil rights policies. While living at Cedar Hill, he served as U.S. Marshal and recorder of deeds for the District of Columbia, and as U.S. ambassador to Haiti. In the midst of these responsibilities, he found time to write two more memoirs, publish numerous articles, give speeches, and make the literary lecture circuit as a leading scholar of Scandinavian history and the Icelandic sagas.

In 1878, Frederick Douglass was sixty years old and recently appointed U.S. Marshal for the District of Columbia when he purchased a ten-acre estate overlooking Washington, DC, just about at eye level with the dome of the U.S. Capitol on the horizon. The hilltop site, which allowed Douglass to literally look down upon the capital city, was a statement of dominion in itself, while having the added benefits of cooling breezes and healthful air quality in an age still marred by epidemics. The estate had been repossessed by a bank, a legal technicality that allowed Douglass to skirt the capital's discriminatory housing laws and buy the property. The only black

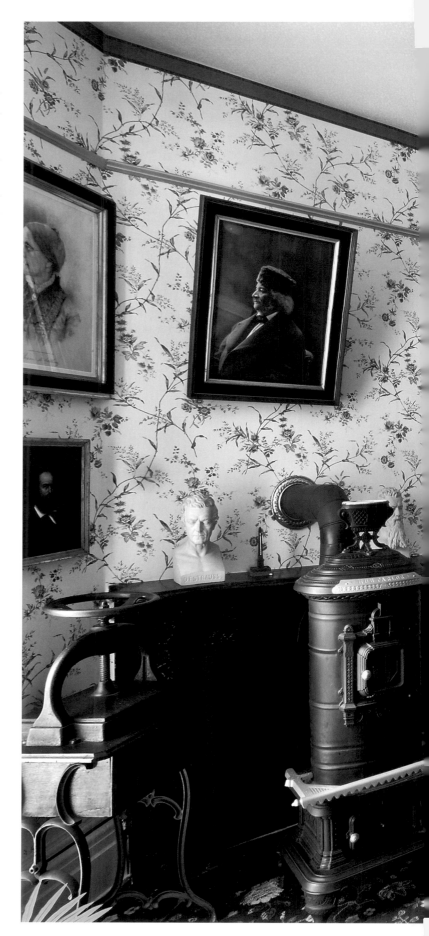

Douglass's library contained over two thousand volumes. His desk chair was originally made for the U.S. House of Representatives. A photograph of longtime friend and fellow activist Susan B. Anthony is visible at far left.

homeowner in the white, wealthy neighborhood, Douglass named his new home Cedar Hill after the stand of cedar trees on the property. Within a year, he purchased an additional five acres and started adding on to the house.

The house Douglass bought was originally built by architect and speculator John Van Hook in the mid-1850s. It was a high-end house from the start, with between eight and ten rooms, incorporating brick construction (painted tan to resemble stone, as was the fashion at the time) and a picturesque mix of Gothic Revival verticality and projections, a Greek Revival Doric colonnade (embellished with latticework), and Italianate stylistic references. Even before he and his first wife, Anna, moved into Cedar Hill in 1878, Douglass had commissioned a two-story wooden addition to the rear of the house, added a partition wall to create an additional second-floor bedroom, and finished the attic to create an additional five bedrooms. By the time the house was ready for the Douglass family, the number of rooms totaled twenty—a substantial house by any standards.

Following Anna's death in 1882, Douglass remarried and, soon afterward, added a library to the house. The addition of a library spoke of literacy (still a notable distinction among whites as well as blacks) and education, qualities inextricably linked with refinement and well suited to Douglass's career as an author and lecturer. By the 1890s, with the addition of another second-story bedroom, he had expanded Cedar Hill to twenty-one rooms, distinguishing it as clearly the best house, with the best view, in one of Washington's best neighborhoods. The scale of Douglass's house spoke of material success, as large houses tend to do, while the fifteen acres of gardens and largely non-working grounds spoke eloquently of the newfound commodity of leisure, where land had, for previous generations of people born into slavery, spoken only of labor. Leisure space, by definition, elevated its owner to the status of an aristocrat.

After Douglass died in 1895, his wife Helen diligently tried to preserve Cedar Hill as a memorial. In 1900, at her urging, Congress chartered the Frederick Douglass Memorial and Historical Association, which inherited the property upon her death in 1903. With no funding and little attention, the property fell into disrepair until 1916, when the National Association of Colored Women's Clubs began to raise funds to preserve Cedar Hill, "with the same veneration as is true of Mount Vernon."[2] Their efforts, which funded a crucial restoration and stabilization of the house in 1922, made an important statement about great houses as emblems of national leadership. By following the path of women's clubs such as the Mount Vernon Ladies' Association of the Union, which had preserved George Washington's house, and the Ladies' Hermitage Association, which had preserved Andrew Jackson's, the National Association of Colored Women clearly asserted the historicity of the black experience, and forced the public at large to accept—or at least to consider—Douglass's contribution to American society in the same terms of architectural representation as Washington's and Jackson's. As Mount Vernon and the Hermitage are considered shrines of American leadership, so must we consider Douglass's Cedar Hill. In 1962, after nearly a decade of resistance by Congress, the care of Cedar Hill was entrusted to the National Park Service, which has undertaken several major restorations both to represent the house accurately as it appeared in Douglass's lifetime and to maintain the property as a national historic site.

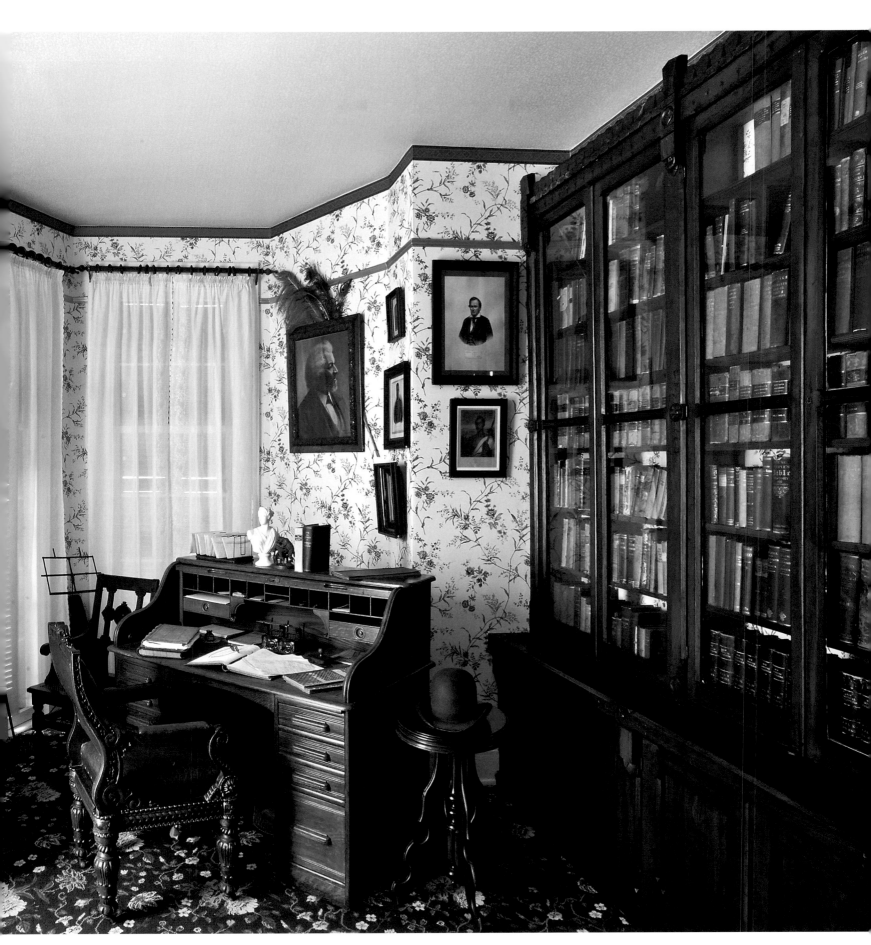

The Wren's Nest

Atlanta, Georgia
Built 1870–84
Builder: George Muse (1870); enlarged and remodeled by Norman and
Humphreys, George P. Humphreys, architect (1884)
Owned and operated by the Joel Chandler Harris Association

In 1921, James Weldon Johnson called Joel Chandler Harris's Uncle
Remus tales, "the greatest body of folklore that America has pro-
duced."[3] Others, beginning with H. L. Mencken, have condemned
Harris (1845–1908) for appropriating black culture and repackaging it
for white audiences, thereby robbing it of its authentic voice. In the his-
torical midst of the reversal of Reconstruction civil rights legislation, the
rising tide of Jim Crow laws, and simmering racial violence in the late
nineteenth century, Harris popularized a standardized version of tradi-
tional African-American folktales, calculated to appeal to white audi-
ences. His multivalent narratives not only documented the racial attitudes
of his own time but also introduced African-American storytelling into
the canon of American popular culture in the twentieth century.

Naturally, the name of Harris's house has a story: in 1900, the Harris
children found a wren's nest in the family mailbox. Rather than disturb
the birds, they simply put up another mailbox. The appearance of the
house, buried in a tangle of ornamental wooden tracery, reinforces the
image of a bird's nest and suggests—perhaps deliberately—that the Har-
ris home itself exists in the realm of folktales.

Joel Chandler Harris's father deserted his mother shortly after the boy's
birth, and they relied on the proverbial kindness of strangers in Eatonton,
Georgia, to get by. At sixteen, Harris was hired by the owner of a nearby
plantation to print the plantation's own newspaper. During this time,
and throughout the Civil War (from which Harris received a medical
exemption from service), Harris worked side-by-side with enslaved peo-
ple. Establishing friendships by proximity, the poor, painfully shy white
teenager began to frequent the slave cabins, where he forged a romanti-
cized image of the plantation as a surrogate family and, not least, enjoyed
the traditional storytelling of his coworkers. Harris pursued a career in
journalism, working his way up to a post at the *Savannah Morning News*
by 1872. To escape one of Savannah's recurrent yellow fever epidemics,
Harris moved his wife and two small children to Atlanta in 1876. Pri-
marily an editorial and political writer, writing often as a proponent of the
"New South" doctrine of social, economic, and racial reconciliation, Har-
ris introduced his Uncle Remus character in a feature in the *Atlanta Con-
stitution* in 1877. By 1880, his versions of African folktales that he had
learned on the plantation were carried in newspapers throughout the
country, and anthologized into a best-selling collection. Improbably, Joel
Chandler Harris had become a national celebrity.

In 1881, Harris began renting a farmhouse that, thanks to the success
of his Uncle Remus tales, he was able to purchase in 1883. By 1884, he

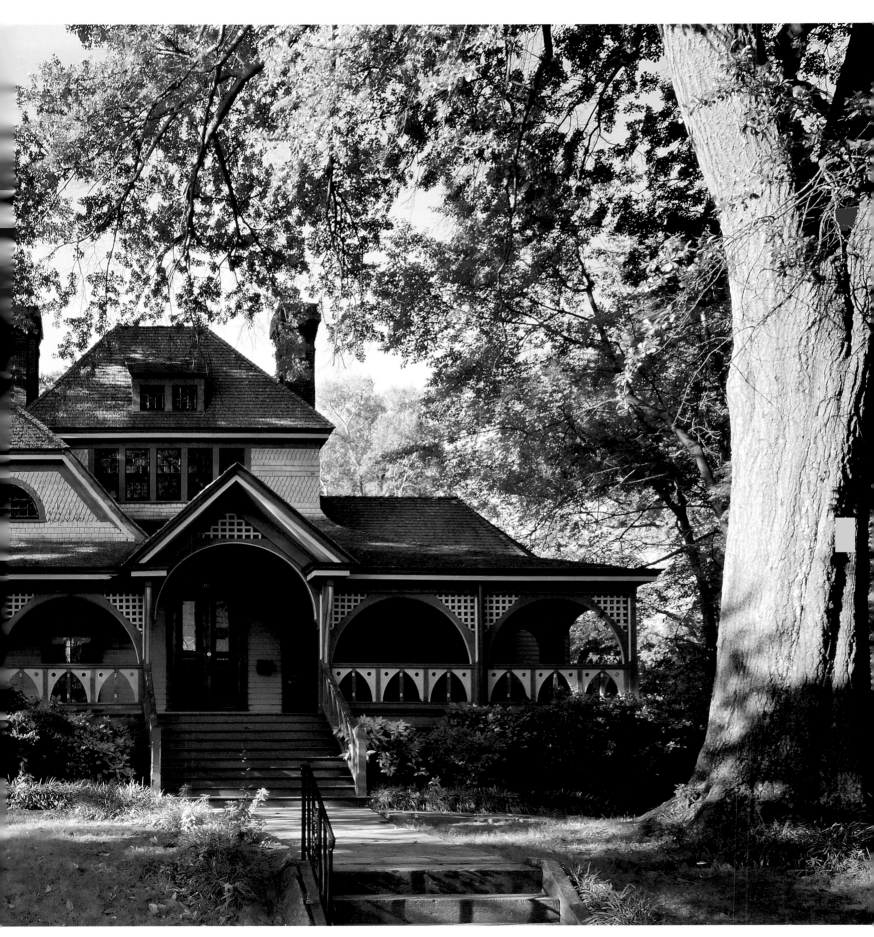

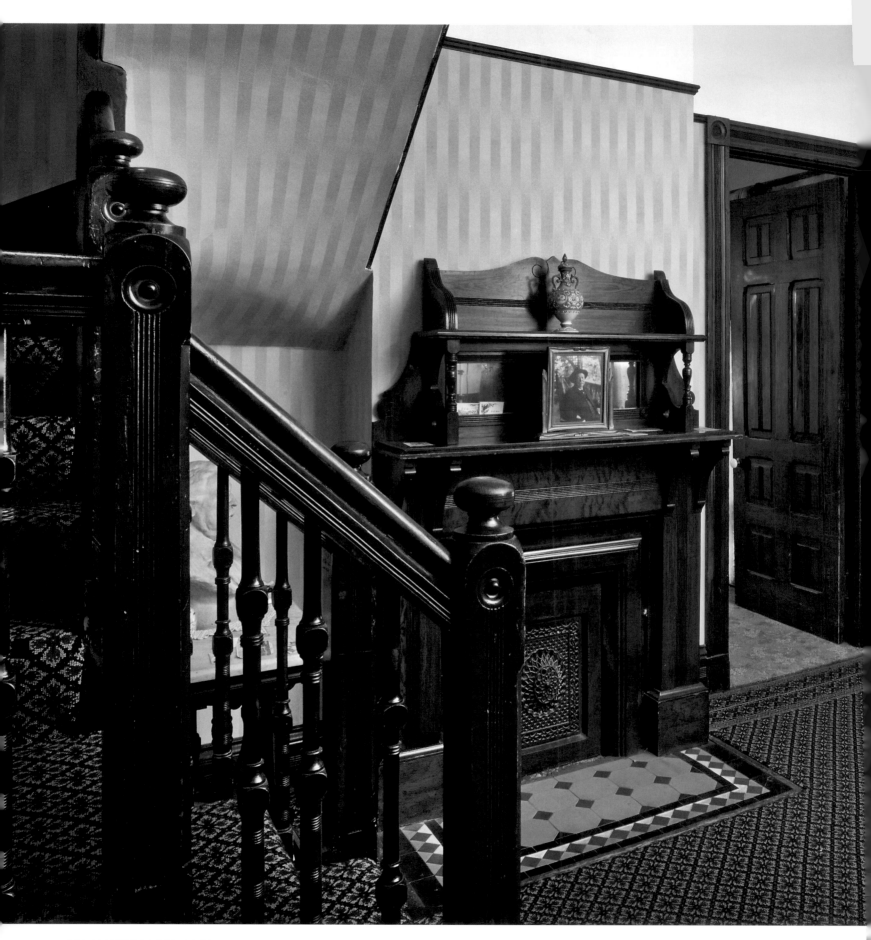

The foyer mantel displays a photograph of Joel Chandler Harris, said to have been the author's favorite image of himself.

The foyer was added to the original house's hallway in 1884. Heavy portières in the doorway helped retain heat in wintertime.

had hired prominent Atlanta architect George P. Humphreys to enlarge and embellish it.

The picturesque tendencies of Italianate house design in the antebellum era exploded into a profusion of visual complexity by the 1880s. Humphreys's renovations at the Wren's Nest followed the postwar Stick and Queen Anne fashion of celebrating the lumber mill, with complex asymmetrical plans, wraparound porches, towers, turrets, patterned bargeboards, balusters, spindles, and a variety of shaped shingles, all in a polychromatic riot of three-dimensional pattern and shadow.

Set back from the street by a series of terraces, the massing of the Wren's Nest continues the terraced rhythm of the site, gradually step-

While Harris was a celebrated figure in his time, he eschewed conventional displays of wealth and fame, opting instead to surround himself with photographs of family and close friends.

ping up in a series of levels defined by arcades and openings to a triangular gable peak. Although Harris had the house enlarged to one-and-a-half stories, the triangular form anchors the structure firmly to the horizon, and its width is further emphasized by the series of arches that defines the deeply shadowed front verandah. The pointed arches of the front balustrade, contrasting with the rounded arcade, embellished with treillage, contribute to the house's vaguely exotic character. Architecturally, the Wren's Nest anticipates the Bungalow Style by at least a generation, and may derive its distinctive character from a combination of Queen Anne style and the Gulf Coast or Creole cottage, a familiar vernacular building type from Harris's youth. In spite of the scale and elaborateness, the overall impression of the Wren's Nest remains unpretentious and approachable.

The interiors are a time capsule of middle-class Victorian domesticity, with plush textures, deep jewel-toned hues, and richly patterned wallpapers contributing to an ambient sense of profusion and enclosure. Amidst period bestsellers and volumes inscribed to Harris by friends and literary colleagues, titles—such as *Happy Thoughts on Home Topics, What Girls Ought to Know*, and *Female Beauty: The Art of Pleasing*—attest to the era's self-consciousness regarding social roles and domestic self-representation. The Victorian notion of family and the domestic environment was the *sine qua non* for Harris, whose youth had been socially determined by his father's abandonment, and whose literary fortunes derived from a romanticized view of the paternalism of antebellum plantation culture. Harris raised a variety of fruits and vegetables, and also built houses for three of his children on the property. The Wren's Nest became an architectural celebration of the intertwined Victorian values of fatherhood, nature, childhood innocence, and social stability.

In addition to his five volumes of folktales, Harris edited the *Atlanta Constitution* for twenty years, published seven collections of short stories and four novels, and maintained a lively correspondence with many notables of the age, including Mark Twain, poet James Whitcomb Riley, and Theodore Roosevelt (who visited the Wren's Nest and deposited a stuffed owl as a gift). First opened to the public as an historic site in 1913, the Wren's Nest was designated a National Historic Landmark in 1962 and remains the oldest house museum in Atlanta. Largely unchanged since Harris's death, the historic residence contains many original Harris family furnishings as well as authentic wallpapers, decorative objects, books, and memorabilia of Harris's wide and often famous circle of acquaintances. The museum's activities focus on storytelling, community, and Southern literary traditions.

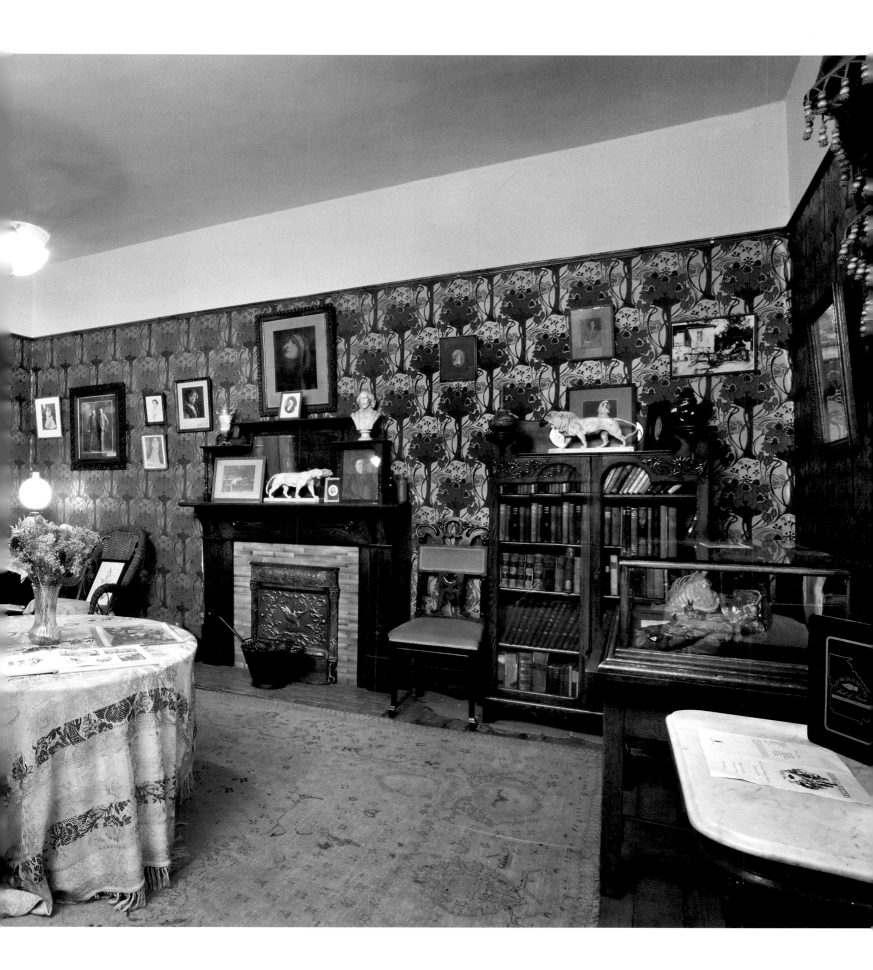

Maymont

Richmond, Virginia
Built 1887–93
Architect: Edgerton Rogers
Owned by the City of Richmond and operated by the Maymont
Foundation, Inc.

*Richmond's Maymont mixes Queen Anne and Chateauesque styles with influences
from the work of architect H. H. Richardson.*

The image of the South's antebellum "Golden Age" has largely, and unjustly, overwhelmed its architectural achievements in the Gilded Age. Not every Southern aristocrat retreated to a dilapidated mansion and into a vanished past after 1865. Some adapted to the new economy and invested in rebuilding, manufacturing, and railroads. Others rose from the working and middle classes on the wave of new opportunities, and a few Northerners, as always, chose to make the South their new home—at least during the winter months. The new money of the South built great estates in imitation of European models, just as their Northern counterparts did in places like Newport, Rhode Island; Long Island's Gold Coast; and the Berkshires of Massachusetts.

Maymont, the estate of James Dooley of Richmond, fits the mold of a Gilded Age estate to a tee. Its builder, Major James Dooley (1841–1922), was born of Irish immigrant parents who had achieved middle-class prosperity as proprietors of a hat factory. Dooley's father served on boards of several charitable institutions and owned three slaves on the eve of the Civil War. James (the third of nine children) received both a bachelor's and, unusually for the time, a Master's degree at Georgetown College (now University) and served in the First Virginia Infantry Regiment during the Civil War, receiving a wound that permanently disabled his right hand. Although there is no evidence that he was ever promoted above the rank of lieutenant, Dooley carried the honorific "Major" throughout his life. By the time his father died in 1868, the family hat factory had been burned, so James Dooley was left with very little money and the responsibility of caring for his mother and younger sisters.

He married Sallie May in 1869, over the objections of her family, who disapproved of Dooley's Catholicism. They moved to Richmond where Dooley established a law practice and soon was elected to three terms (1871–77) in the Virginia House of Delegates during the crucial period of Reconstruction. Dooley and some of his peers in the Richmond business community saw the opportunity to boost the region's (and their own) fortunes by buying small, disconnected railroad lines and uniting them into a network that would facilitate commerce and development. Intertwined with the railroad business were related investments in banking (for financing), steel and iron (for the materials to build the lines), real estate development (of lands newly accessible for settlement or commuting), and warehousing (for goods received at port). Not surprisingly, all of this made Dooley extremely wealthy, and his wife assumed the mantle of social leadership in Richmond.[4]

While the Gilded Age is often tarred with the brush of Thorstein Veblen's term "conspicuous consumption" (coined in 1899), the rich had

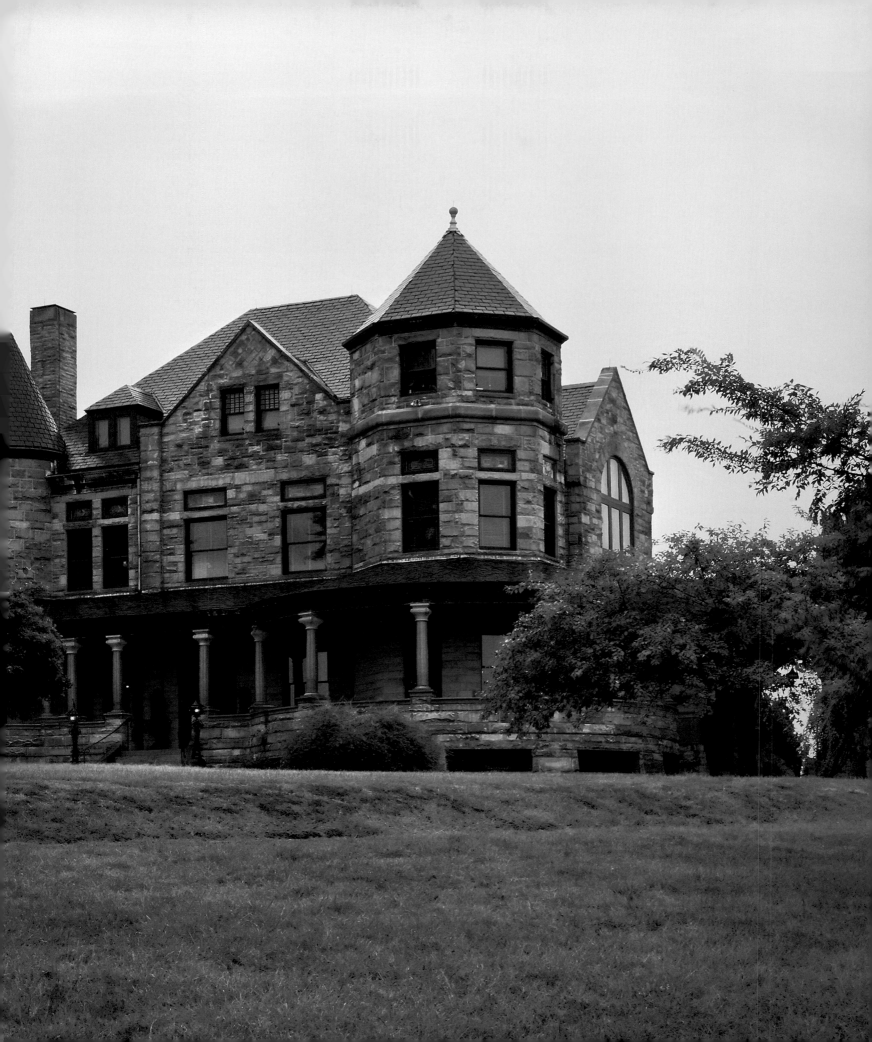

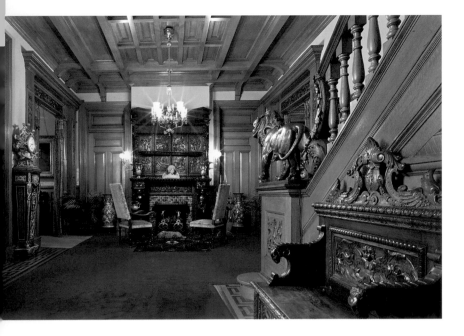

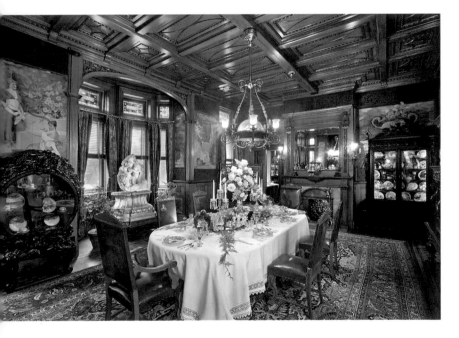

With its imposing mantelpiece, fine woodwork, and staircase embellished with a bronze lion by Louis Amateis (1891), the living hall was calculated to make a dramatic first impression.

ABOVE RIGHT
Original portières frame the view into the dining room. A seventeenth-century allegorical sculpture by Francesco Grassia, Wine, *stands in the bay window.*

ABOVE
The Dooleys had their lavish dinner parties catered by Pompeo Maresi from New York. A Tiffany & Co. commemorative cup stands on the mantel.

FACING PAGE
A Tiffany & Co. annular clock (foreground) is framed by the monumental Tiffany Studios window over the staircase. Local newspapers reported on the window's installation in 1892.

always built showplaces for themselves to represent their elevated social status and cultural values. While eighteenth-century planters built to assert their parity with contemporary English landed gentry, Gilded Age tycoons drew from a broader frame of cultural and historical reference, building in imitation of French, Italian, Spanish, and German royalty as well as English aristocrats of many eras. The ascendancy of the United States on the world economic and political spheres made Americans powerful, and they craved the attributes of social and cultural sophistication to represent their status. Europe, once again, provided the source material.

In 1886, having admired the view overlooking the Henrico River, the Dooleys purchased one hundred acres of farmland on the outskirts of Richmond and began to plan their estate. Sallie Dooley was particularly interested in creating the formal gardens and picturesque landscape setting, while James Dooley was the art collector of the couple. With no children to provide for, the Dooleys made Maymont their shared creative endeavor.

They hired Edgerton Rogers (1860–1901), an American born and trained as an artist in Rome. His mother was a native of Richmond, and his father was Randolph Rogers, a prominent Neoclassical sculptor. Armed with social connections and the cachet of European sophistication, the artist Edgerton Rogers soon received the architectural commission to design Maymont.[5] Oddly, there is little, if anything, Italian about his design.

The Louis XV–style Pink Drawing Room was the most elaborate room in the house. Chandeliers, mantelpiece, and plaster roses on the chimneypiece are gilded with 14-karat gold.

The asymmetrical massing of Maymont suggests the Queen Anne style, with its turret, towers, and wraparound porch, creating a picturesquely irregular silhouette and deep plays of shadow and light. The use of rusticated sandstone for the building, however, recalls the Romanesque-derived style popularized by American architect H. H. Richardson (a native of Louisiana), and hints at perhaps a bit of inspiration from French chateaux. The imposing effect of rough-faced stone was somewhat mitigated through the use of different colors for visual variety: a red slate roof (later replaced with gray); pink granite columns and concrete walkways; and gray and russet-red window trim.[6] Approached by a dramatic winding driveway, the house seems to emerge from its hilltop site in a topographic metaphor for the Dooley's elevated social status.

The interiors of Maymont, among the best examples of Gilded Age décor in the United States, were surely (and successfully) calculated to impress, and to characterize its owners. Unlike the stylistic consistency amongst rooms in antebellum houses, Maymont displays the Gilded Age tendency to incorporate a smorgasbord of historically inspired styles. The choice of style was often conditioned by social use and, thus, gender: the living hall and dining room evoke the Italian Renaissance of great merchant princes, while the two drawing rooms, presumably for Mrs. Dooley to gather with ladies, suggest the sophisticated eighteenth-century French salons of Madame de Pompadour and Marie Antoinette. Mr. Dooley's study showcases an eclectic display of art and furnishings in a setting that suggests the influence of the English Aesthetic movement, appropriate to a connoisseur of art, literature, and music. The bizarre suite of swan furniture in Mrs. Dooley's bedroom, commissioned from Neuman and Company of New York for the Dooleys' villa-style summer retreat Swannanoa,[7] likely reflects the publicity surrounding the 1886 public opening of Ludwig II's Bavarian fantasy palaces Neuschwanstein and Linderhof. Both castles were built in homage to the operas of Richard Wagner, the latter featured a "Grotto of Venus" complete with a mechanical swan-propelled, shell-shaped boat inspired by *Lohengrin*. Mrs. Dooley's bedroom also contained a Tiffany & Company dressing table, chair, and toilette set—all made of silver and narwhal tusk.[8] Narwhals, a sort of arctic whale with a single long tusk, were sometimes believed to have been the inspiration for mythological unicorns, imagery that furthers the theatrical depiction of Mrs. Dooley as a romantic heroine. The house abounded with objects selected not only to showcase wealth, travel, and knowledge but also to provide a series of historical and literary references—clues to the idealized self-images of the residents.

The Dooleys bequeathed their estate to the City of Richmond as a museum and public park, unfortunately failing to leave an endowment for its upkeep. Opened to public in 1926, Maymont became burdensome for the city to maintain. Since 1975, the preservation, care, and public enjoyment of the estate, including outbuildings (notably the carriage house, barn, and water tower designed by Noland and Baskerville in the 1910s), gardens, public programs, and ongoing curatorial research, has been the mission of the Maymont Foundation.

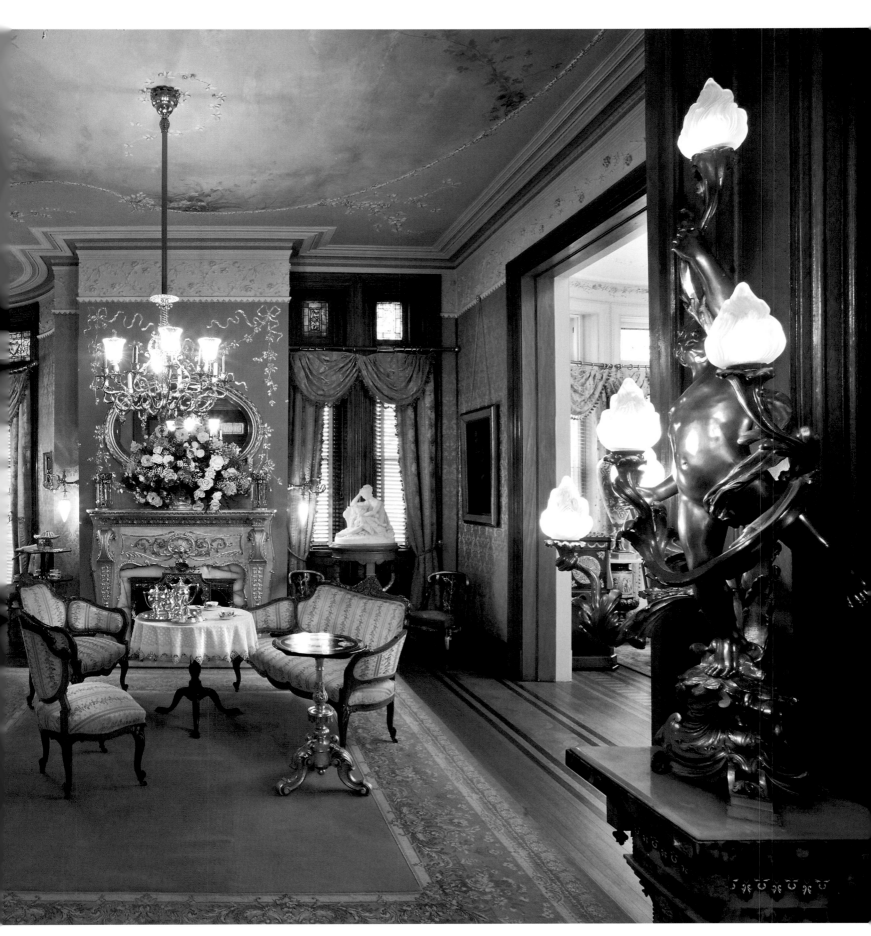

Biltmore

Asheville, North Carolina
Built 1889–95
Architect: Richard Morris Hunt, with landscape and gardens by Frederick Law Olmsted
Owned and operated by the Biltmore Company

The stair tower at Biltmore was inspired by a nearly identical architectural feature at the sixteenth-century Château de Blois.

Designed as the centerpiece of the 125,000-acre estate, Biltmore remains the largest private residence in America.

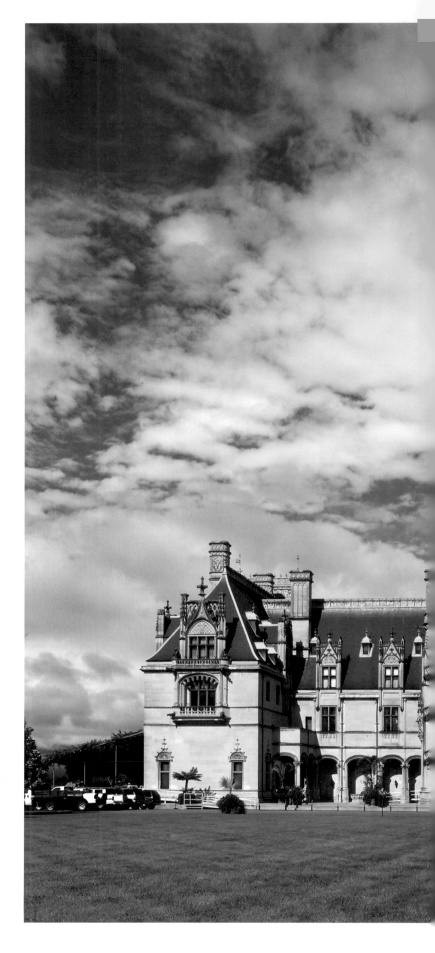

Many Americans tried to build like European royalty, but arguably only George Washington Vanderbilt succeeded. George, the youngest of eight children, was the stealth Vanderbilt: his older brothers—Cornelius, William K., and Frederick—received the more sizeable chunks of their father's estate, ran the family businesses established by their grandfather (The Commodore), and built extravagant and influential European-inspired houses in Manhattan, Long Island, Newport, Hyde Park, and the Adirondacks. George was the bookish, quiet one; fluent in eight languages, it is said that he translated contemporary novels into ancient Greek for the fun of it.

In 1888, George accompanied his mother on a trip to the mountains of North Carolina, a region that was becoming popular as a health retreat.

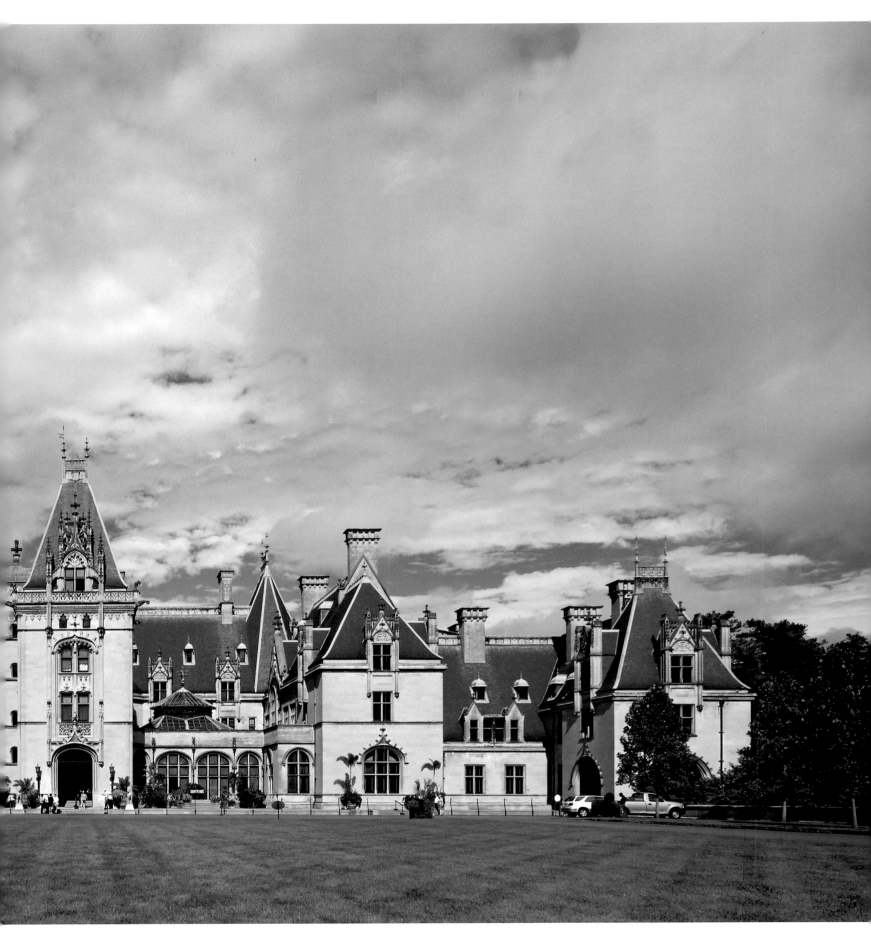

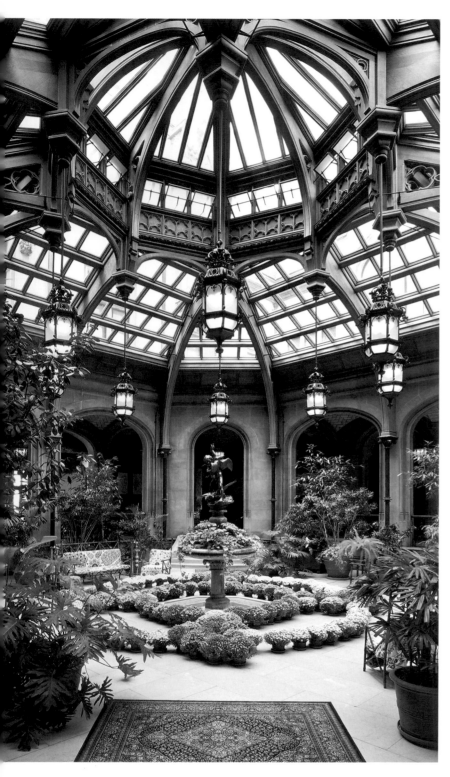

The winter garden was stocked with palms and flowers from the estate's greenhouses. The fountain features a statue by Austrian-born, American sculptor Karl Bitter (1867–1915).

He liked it so much that, the following year, he began acquiring land, which he did through an agent so that the locals did not jack up prices when they heard the name "Vanderbilt." When he had assembled one thousand acres, he consulted Frederick Law Olmsted, who saw forestry as the site's greatest potential. By arguing the scholarly and social benefits of establishing a scientific forestry center, Olmsted convinced Vanderbilt to acquire more land and to think about the estate as a business enterprise and social program as well as a vacation place. Eventually, Vanderbilt's holdings constituted 125,000 acres, incorporating farms, forests, an Arts and Crafts–inspired estate village, and a chunk of the scenic Blue Ridge Mountains.

To design a house to serve as the center of this enterprise, he turned to architect Richard Morris Hunt (1827–95). The first American architect to be trained at the preeminent École des Beaux-Arts in Paris, Hunt had already designed several spectacular houses for members of the Vanderbilt family, and had nurtured George Vanderbilt's interests in architecture since 1885, when George was assigned to oversee construction of the Hunt-designed family mausoleum on Staten Island.[9] Coincidentally, on the same project, Vanderbilt had brokered a rapprochement between Hunt and landscape architect Frederick Law Olmsted, who had been feuding since the 1860s over a gateway design Hunt had submitted for Olmsted and Vaux's Central Park in Manhattan. Hunt took a paternal interest in Vanderbilt, and Vanderbilt ensured Hunt's attention through a series of commissions, such as remodeling his New York townhouse, adding outbuildings to his Long Island estate, and building a small public library on West 13th Street.[10] Putting Olmsted and Hunt together on the Biltmore project guaranteed Vanderbilt not only the best design available but also the company of two artists he revered.

Early sketches suggest that initial discussions for his mountain retreat were along the lines of the Shingle Style houses of Newport and Long Island in scale and style. At some point, perhaps with Hunt's urging, things changed. A lot. By the summer of 1889, Vanderbilt invited Hunt and his wife to join him on a European tour to collect both architectural ideas and actual furnishings and artwork for the North Carolina house. When Vanderbilt purchased three hundred oriental rugs in one morning, the Hunts suddenly had a pretty clear idea of what he had in mind for Biltmore.[11] By 1890, when Hunt finally visited Asheville, Vanderbilt had built a railroad spur to haul trainloads of Indiana limestone to the site, where several hundred workers excavated, placed concrete foundations, and produced thirty-two thousand bricks each day. Eventually encompassing 175,000 square feet distributed amongst 250 rooms, Biltmore was (and remains) the largest privately owned house in the United States. As construction reached the ridgelines of the roof, Hunt was reported to have exclaimed, "The mountains are just the right size and scale for the château!"[12]

Vanderbilt liked to ride and to hunt, appropriately aristocratic interests represented in the chosen style of the French châteaux of the era of François Ier (1494–1547). Perhaps not coincidentally, as a student at the École, Hunt had studied Loire Valley châteaux including Blois, Chambord, and Fontainebleau. The architect, who died five months before the house was completed, seemed to approach Biltmore knowing it was his last chance to build on the monumental scale and in the grand manner of historically based, declarative building for which the French royal academy had trained him. Hunt had spent his entire American career trying

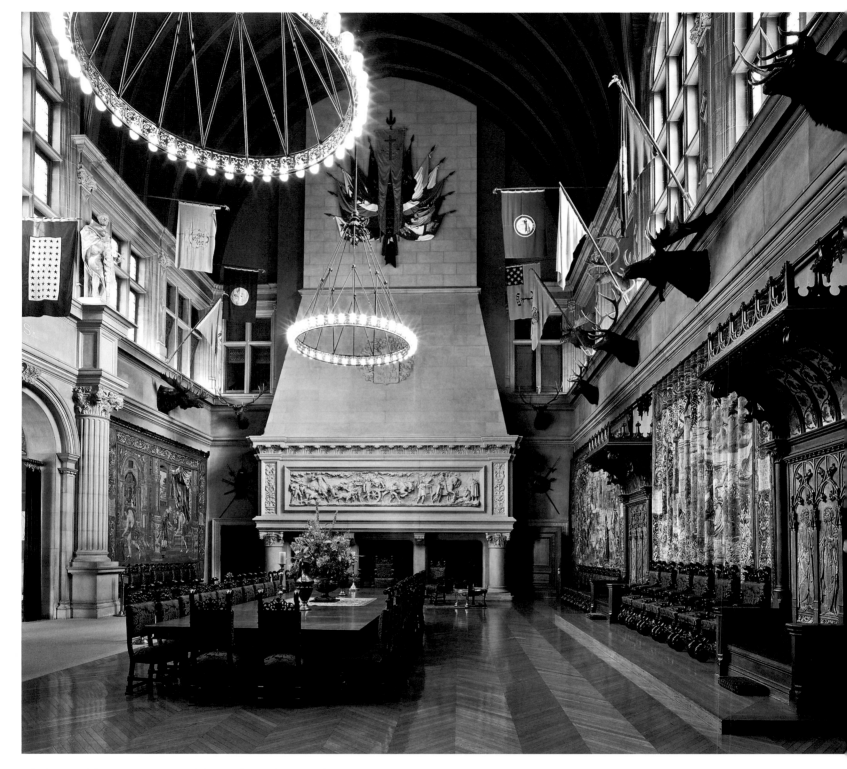

Clearly inspired by Renaissance-era royal hunting lodges, the banquet hall "Americanizes" the historical model by replacing European heraldic banners with replicas of Revolutionary War–era flags of the thirteen original colonies.

to bring European standards of design and professionalism to American architecture. His two final great works, the Metropolitan Museum of Art and Biltmore, embodied ideas and ambitions he had carried with him for forty years.

The interiors at Biltmore are appropriately spectacular. The major first-floor spaces, while displaying a range of references, heel closely to a sixteenth- and seventeenth-century historical reference point which lends them an unusual cohesiveness for Gilded Age houses. (Perhaps there are so few associatively feminine room styles because Vanderbilt did not marry until 1898, after the house was completed). The interiors are, in essence, souvenirs of his travels, representations of the places that held resonance for him, and manifestations of the lifestyle he hoped to create at Biltmore. The tapestry gallery, with its painted beamed ceiling, suggests a fifteenth-century Florentine palace; the library suggests a seventeenth-century Roman palazzo; the oak sitting room recalls Knole, the seventeenth-century English estate he had visited with Hunt. The towering banquet hall, which follows the French Renaissance style of the exterior and appears fit for a visit from Henry VIII, includes flags of the American colonies where heraldic banners might more predictably appear. Amidst the French- and Spanish-inspired bedrooms are Sheraton- and Chippendale-themed rooms, indicative of the American colonial period. Vanderbilt often incorporated specifically American references with the European, casually assuming a cultural continuity that the American elite had, for centuries, so desperately striven to prove.

Vanderbilt foresaw his estate as—more than a fashionable *ferme ornée*— a self-sustaining series of business concerns, incorporating a dairy, agriculture, and forestry as well as a crafts workshop producing furniture from the timber harvested on the estate. There was also a school to teach household management to the locals. In essence, where other Americans had built baronial houses and gardens, George Vanderbilt built an entire fiefdom, with the twist of a thoroughly modern underlying philosophy of social benevolence. It cost him his fortune to maintain. After his death in 1914, his widow was forced to sell land, including the eighty-six thousand-acre tract that became the Pisgah National Forest. Thanks to careful management, the estate today still comprises eight thousand acres and remains privately owned. By establishing the estate as the centerpiece of a series of industries, George Vanderbilt assumed—correctly, as it happened—that he would be providing an economic base for the then-impoverished Asheville region to flourish as a cultural and recreational center in future generations.

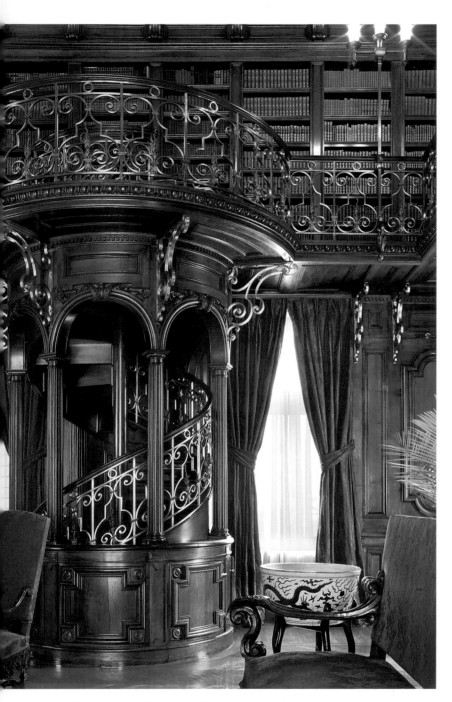

George Vanderbilt's library at Biltmore contained over twenty
thousand volumes.

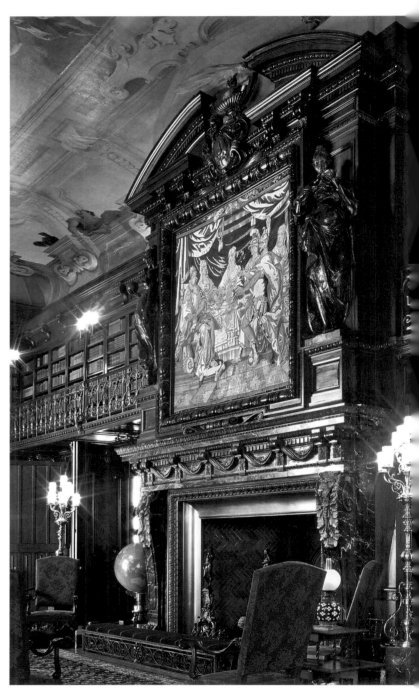

Karl Bitter carved the spectacular overmantel, with its figures
of Hestia (left) and Demeter (right) flanking a seventeenth-
century French tapestry.

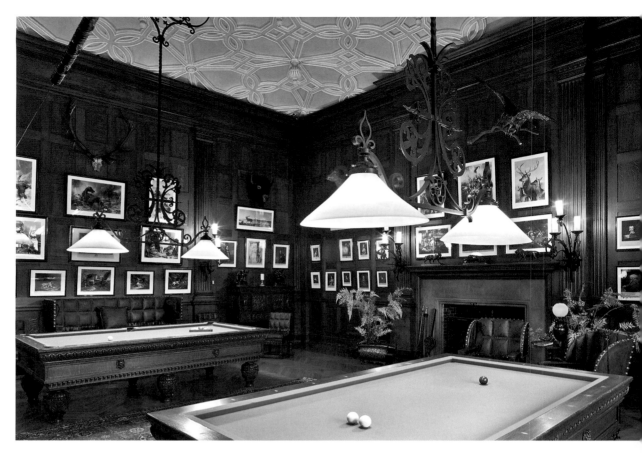

The billiard room, along with the adjacent smoking and gun rooms (accessed by a concealed door in the fireplace wall), formed a gentleman's retreat-within-a-retreat.

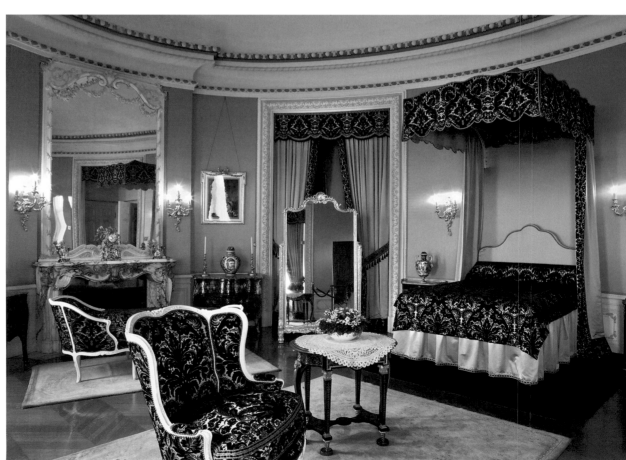

When Biltmore was designed, George Vanderbilt was still a bachelor. This bedroom, in the Louis XV style, was designed for his mother.

Whitehall

Palm Beach, Florida
Built 1900–02
Architects: Carrère & Hastings
Owned and operated by the Henry Morrison Flagler Museum

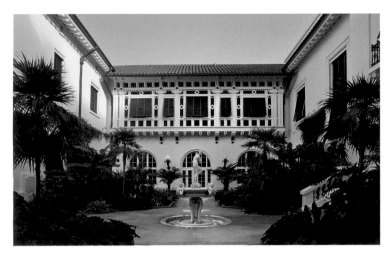

ABOVE
Whitehall's courtyard features a fountain, lush plantings, ground-level arcades, and shaded open galleries above—an arrangement modeled on aristocratic palaces and luxury hotels in Cuba.

RIGHT
Henry Flagler's Whitehall brought the Beaux-Arts classicism of the "White City" to early-twentieth-century Florida.

After cofounding the Standard Oil Corporation and becoming one of America's wealthiest men, most people would have rested on their laurels, but Henry Flagler (1830–1913) decided, as a retirement project, to invest in creating a railroad and hotel network that would establish the infrastructure for modern Florida. In many ways the epitome of the Gilded Age businessman, Flagler understood that railroads were not enough to create a truly thriving place and that a modern society of any value required the arts and culture. Flagler's Palm Beach house, Whitehall, served not only as his home but also as a manifesto of his belief in the significance of classical culture as a fundamental ingredient of the ascendant American empire.

Henry Morrison Flagler was born in Hopewell, New York, moved to the Midwest as a teenager, and, by the Civil War, had established himself in the grain and salt mining businesses. In 1867, an acquaintance from his grain-trading operations, John D. Rockefeller, approached Flagler for investment capital for a new oil refinery he was starting. By 1870, the partnership of Rockefeller, Flagler, and Andrews had been restructured as a joint stock corporation called Standard Oil. By 1872, it was the United States' leading oil refinery. As part of the Standard Oil ground-to-market business model, the company bought and operated railroads. Flagler witnessed how this mobility created markets and towns. By 1885, Flagler was ready to step back from day-to-day operations.

Around the same time, Flagler's wife became ill, and the couple vis-

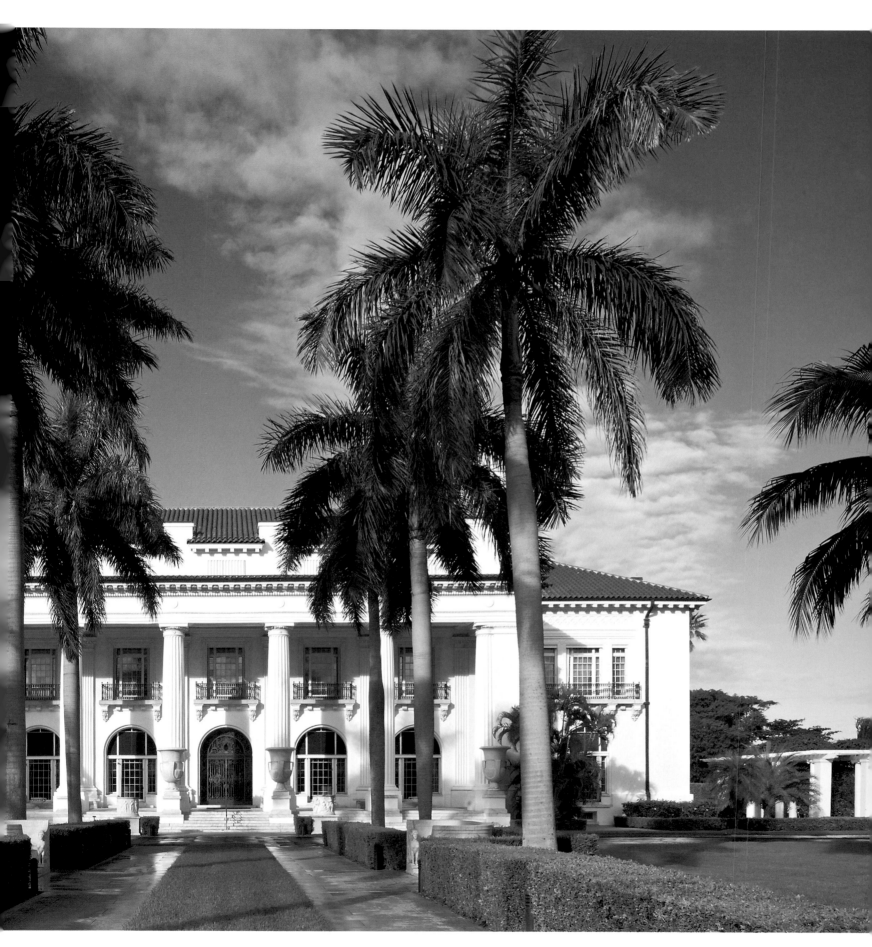

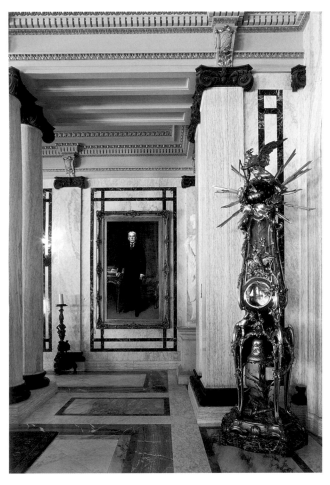

ABOVE
The portrait of Henry Flagler (1899) is by Raimundo de Madrazo y Garreta. Books, antiques, and ledgers characterize the subject as a man of both business and culture. The tall-case clock is by François Linke.

RIGHT
Flagler asked architects Carrère & Hastings to lower the original ceiling height to give the 4,400-square-foot grand hall a greater sense of intimacy.

ited St. Augustine, Florida, for her health. In the sixteenth-century Spanish town, with its picturesque old buildings, balmy climate, and undeveloped beachfront, Flagler was struck by the potential for the tropical Florida coast to develop into an American Riviera. He simultaneously began building a luxury hotel complex in St. Augustine and purchasing regional rail lines to combine into an efficient coastal transportation network to bring goods and, not coincidentally, wealthy vacationers to his new resort. To design the Hotel Ponce de León, Flagler hired his minister's son, Thomas Hastings. Hastings had studied at the prestigious École des Beaux-Arts in Paris and served an apprenticeship in the office of McKim, Mead & White before forming a partnership with his colleague and fellow École alumnus, John Merven Carrère. By giving the pair their first major commission (and a million-dollar budget), Flagler struck a quintessential win-win deal: he got the best design talent in the country,

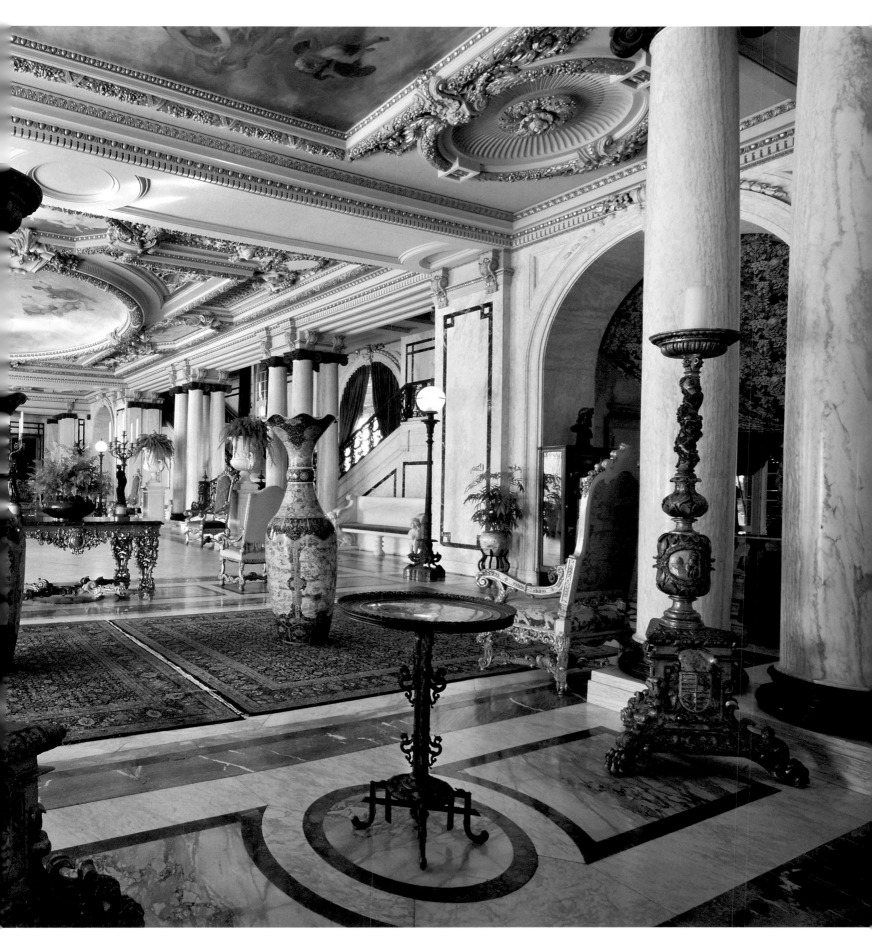

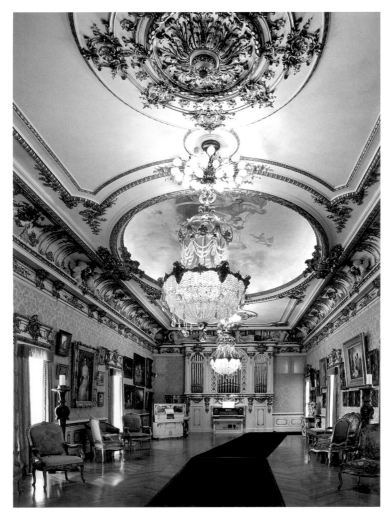

ABOVE
The Baroque-style music room doubled as an art gallery and today retains many paintings from Flagler's collection.

RIGHT
The Louis XVI–style drawing room's architectural details are highlighted with aluminum leaf, which was more costly than gold at the time.

the architects got the break they needed to propel themselves into the forefront of American design, and Florida got a Spanish-influenced architectural identity that remains definitive today.

Soon after the Ponce de León was completed, however, Flagler grew restless and determined to push his Florida East Coast Railway and its associated hotel network further south. By 1894, the railroad had gone as far as West Palm Beach, and, in 1896, he managed to pry enough land away from flinty local landowner Julia Tuttle to establish the city of Miami. Wealthy vacationers still tended to see Florida as a way station en route to Havana, which combined all the aristocratic lineage and glamour of Europe with the exoticism (and proximity) of the Caribbean. On the island of Palm Beach, Flagler was determined to establish an American resort that could provide an alternative to Havana's European sophistication. Once again, he turned to Carrère & Hastings, who had made good on Flagler's initial support and recently won the prestigious com-

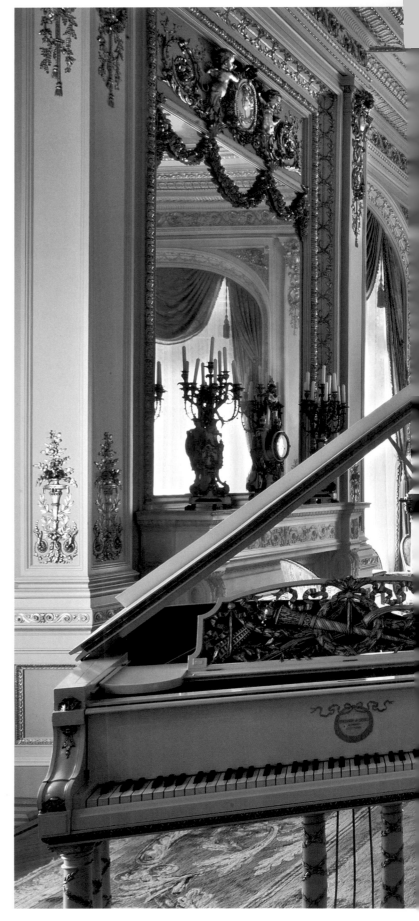

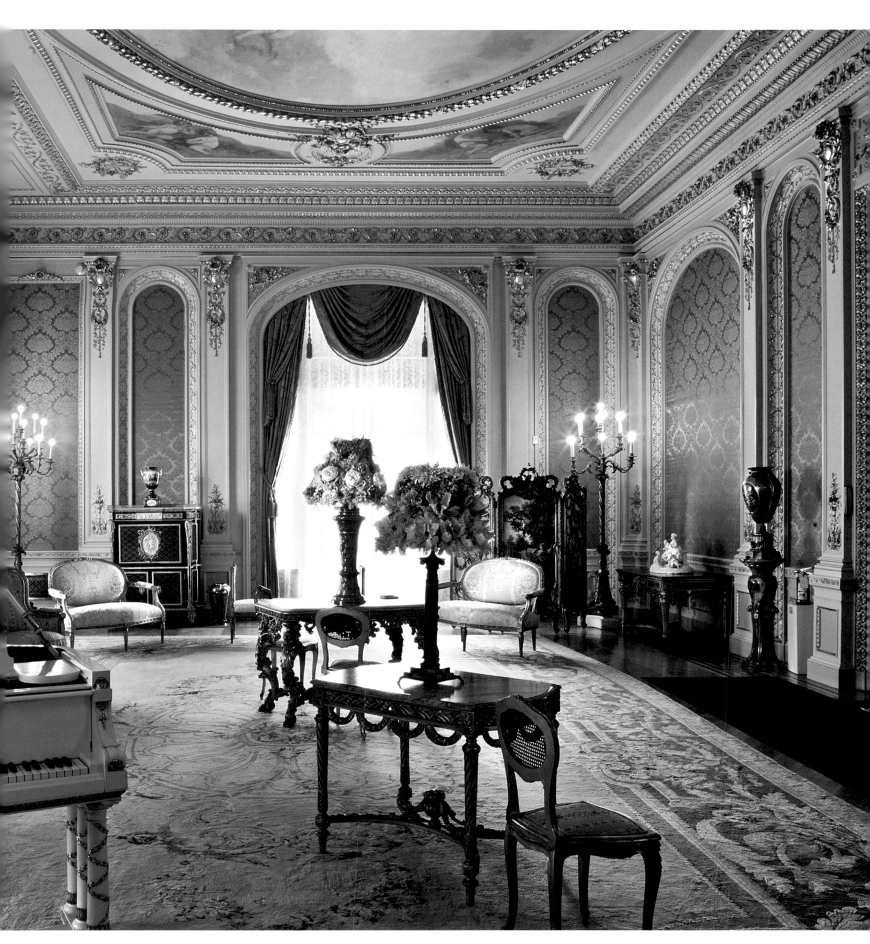

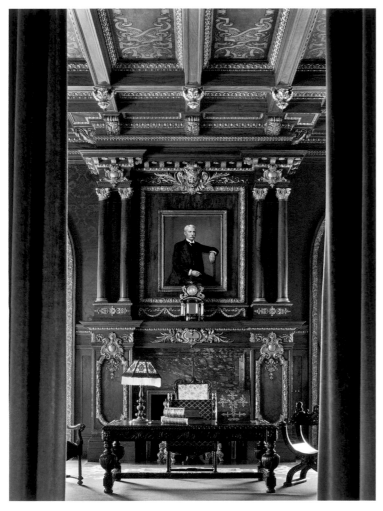

Concealed behind its classical portico, within its hollow, square-shaped plan, Whitehall did contain a courtyard with first-floor loggias surmounted by louver-shuttered galleries. This central garden patio, with adjacent shaded loggias, was not only a concession to the tropical climate but also a direct derivation of the Caribbean side of the Spanish-Cuban building tradition. Whereas Flagler's St. Augustine estate was calculated to evoke a romanticized vision of the age of Spanish empire beginning in the reign of Ferdinand and Isabella, Flagler's Palm Beach home was an oasis of classical refinement calculated to recall ancient Rome, by way of Paris, Havana, and Chicago's White City.

The 4,400-square-foot grand hall—with its bust of Augustus (the emperor who famously found Rome a city of brick and left it one of marble) and ceiling painting of the *Oracle of Delphi*, representing artistic inspiration—makes it clear that Flagler's Palm Beach was conceived as more than your average beach resort. It was also clear that his house was more than a private residence. The manifesto of Whitehall was one of patronage and leadership of the arts, thus defining Flagler's house as the centerpiece of a place in which American ascendancy to the mantle of the Western cultural tradition was fulfilled, and that the arts, music, history, travel, and classical learning would be prerequisites for belonging here. Whitehall was, in effect, a house for the Muses.

The interiors, by the decorating firm of Pottier & Stymus of New York, followed the Gilded Age practice of assigning each room an historically based style seen as befitting its social function. Flagler's study is Italian Renaissance, a period associated with classical learning and patronage of art; the billiard room is a Pre-Raphaelite variation on the chivalric great hall; and the dining room represents the French Renaissance hunting lodge. Mary Lily's spaces were variations of a theme of ancien régime France; the music room/picture gallery was executed in a French Baroque style; the ballroom is Louis XV, while the drawing room is Louis XVI, right down to the custom-made, art-case Steinway grand piano. Whitehall's rooms, exemplars of Gilded Age style, are stage sets for characterizing the activities and occupants in the visual terms of historical times, historical people, and the values they represented.

Whitehall officially opened as the center of Palm Beach society on March 7, 1903, when the Flaglers hosted an eighteenth-century costume ball in honor of George Washington's birthday. The roster of A-list guests (with requisite Astors and Vanderbilts, a few European nobles, and the architect Thomas Hastings's bride-to-be, Helen Benedict) apparently saw no irony in the thematic conflation of the decadent extravagance of the ancien régime with American revolutionary ideals.[14]

Flagler's restless determination to extend civilization led to his creation of the legendary Florida Over-Sea Railroad, which ultimately reached Key West, the southernmost point of the United States, in 1912. Exhausted at last, Henry Flagler died at Whitehall in 1913 and was buried in St. Augustine, following his wishes. After the property passed to Mary Lily, and then to a niece, it was used for several decades as a hotel, and the great house was subjected to a massive tower addition. Whitehall was saved from demolition in 1959 by Flagler's granddaughter, Jean Flagler Matthews, who restored the great house and created the not-for-profit Flagler Museum to preserve it as a tribute to Henry Flagler's life, achievements, and related aspects of the American Gilded Age culture in which he played such an integral part.

mission to design the New York Public Library.

The house they designed for Flagler and his new bride, Mary Lily Kenan, began as a Spanish-style structure but grew more classical during construction, with the addition of a giant order hexastyle Doric portico to the landside entrance facade in 1901. In contrast to the earthy materials and colorations of the Mediterranean style they had established in St. Augustine, Flagler's Palm Beach house looked like it was lifted from the "White City" at Chicago's World's Columbian Exposition of 1893. *The New York Times* called the house "Colonial" in one paragraph and "Spanish" in the next.[13] The Flaglers called it "Whitehall." Perhaps the fashionable academic classicism of the Beaux-Arts recalled the Greek Revival mansions of the upstate New York landscape of Flagler's youth, or even the massive, single-story columned entrance of Mary Lily Kenan's ancestral plantation home, Liberty Hall, in North Carolina (1833).

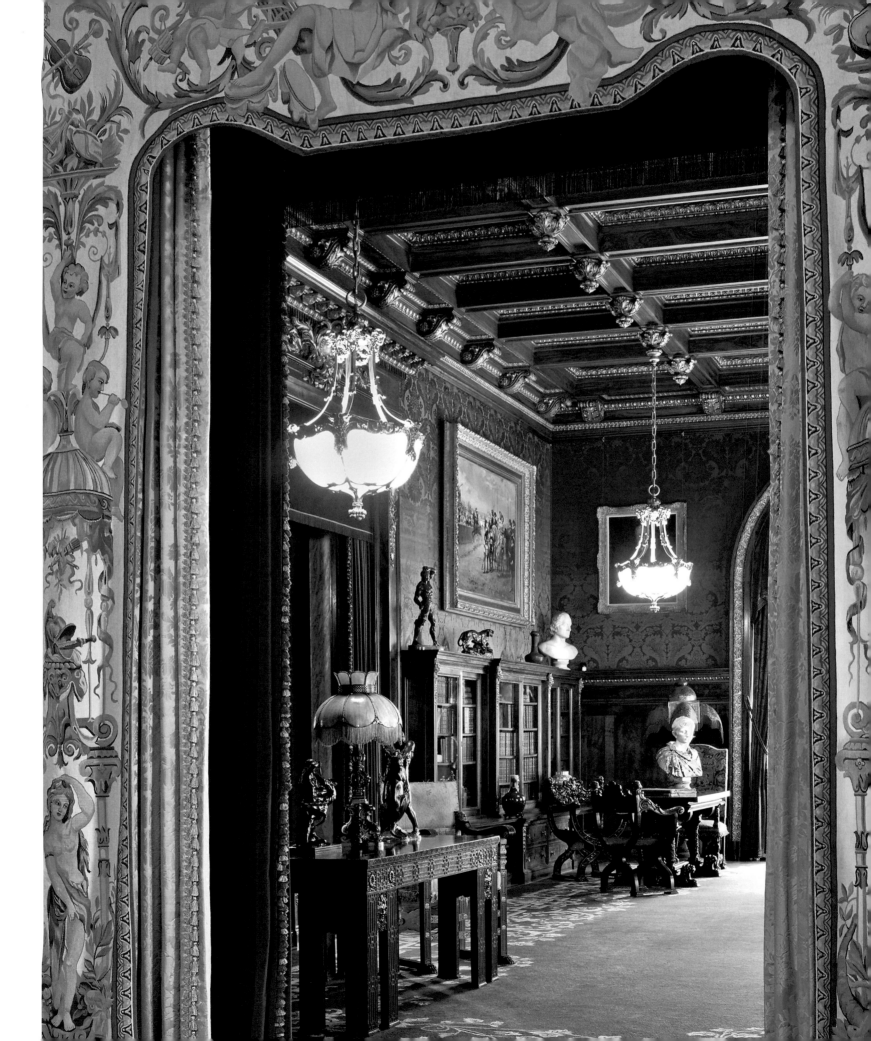

Vizcaya

Miami, Florida
Built 1914–16, gardens 1914–22
Architects: F. Burrall Hoffman, Jr., and Paul Chalfin,
with Diego Suarez, gardens
Owned and operated by Miami-Dade County

ABOVE
*A carefully constructed arrival sequence dramatizes the contrast between
the surrounding hammock (native subtropical forest) and Vizcaya's
highly refined architecture and formal gardens.*

FACING PAGE
*Vizcaya, the winter home of International Harvester vice president
James Deering, overlooks Biscayne Bay in Miami.*

James Deering, vice president of the Deering Harvester Company
(later International Harvester), was an unlikely patron of one of the
Gilded Age's greatest estates. While his older half-brother, Charles,
studied painting in Paris and befriended artists like Gari Melchers, John
Singer Sargent, and Anders Zorn, James studied engineering at M.I.T.
and Northwestern, and appears to have been the family's designated prag-
matist. Fortunately, since the 1880s, wealthy Americans had relied on
advisors to help them build their art collections, which were then dis-
played in picture galleries or period-style interiors. As European aristoc-
racies tumbled in the political turmoil of the late nineteenth century, a
new breed of dealers stood poised to gather up the relics of the past—not
just paintings, but furniture, garden sculpture, architectural fragments,
and even entire rooms—to market them to wealthy Americans in a kind
of transatlantic primogeniture.

Vizcaya arose from the felicitous confluence of James Deering's unex-
pected cultural ambition; the availability of quality artifacts in the years
immediately preceding the First World War; and the creative genius of
his design advisor, Paul Chalfin.

Vizcaya is also the happy result of Elsie de Wolfe's snobbery. Hired by
James Deering to redecorate some rooms in his Chicago house in 1911,
the pioneering interior decorator sent her assistant, Paul Chalfin, instead.
Deering confessed to Chalfin that his art and antiques did not inspire the

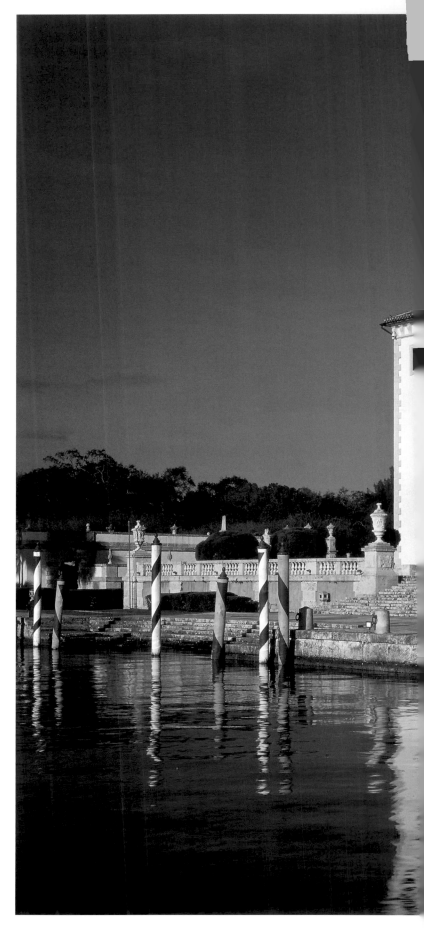

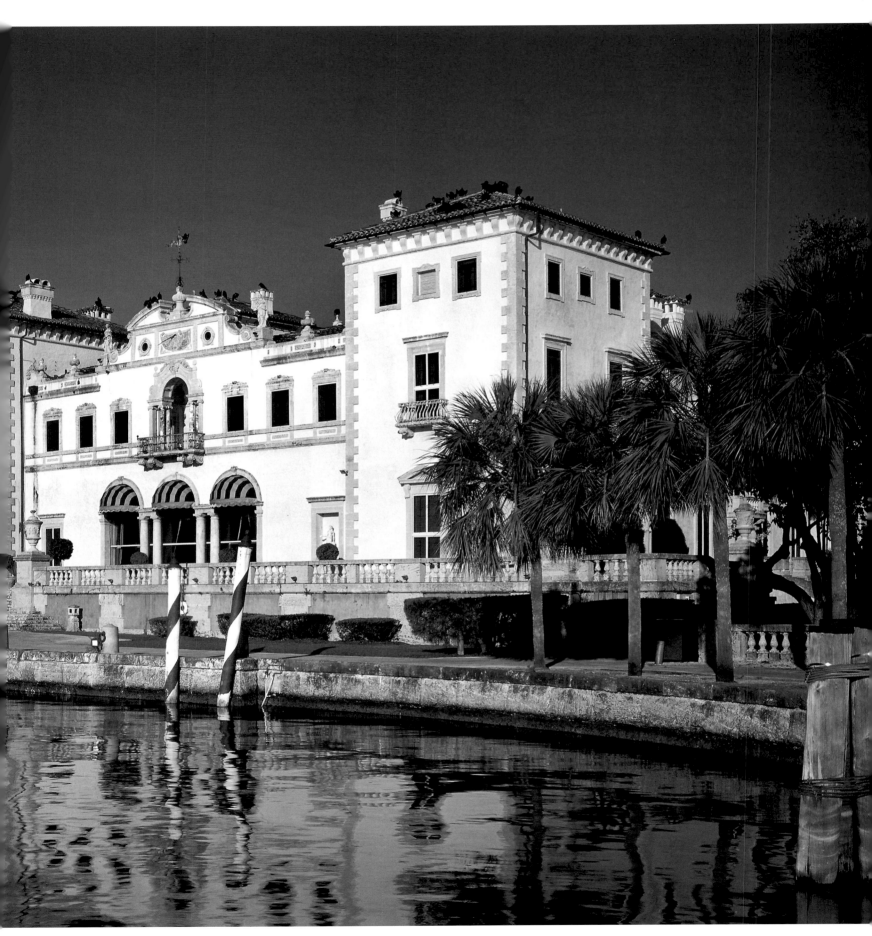

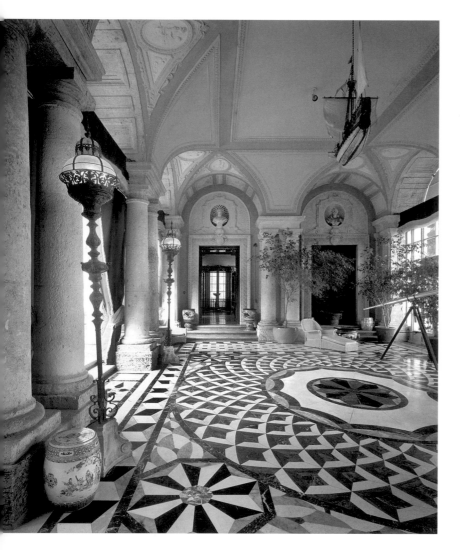

kind of admiration from his guests that he intended.[15] Chalfin, who had trained as a painter in Paris and Rome and advised Isabella Stewart Gardner on her Asian art purchases, offered to tutor the businessman in the finer points of self-representation through collecting. Still, when Deering decided, in 1913, to build a house near his parents in Coconut Grove, Florida, he offered the now-famous de Wolfe the commission first. De Wolfe dismissed the opportunity as too distant from New York to do her career any good and, once again, passed the job on to Chalfin.

Chalfin's design process began with collecting; the architecture would follow. He set an itinerary for Deering of Italian villas and gardens to visit and artifacts to purchase from dealers in Paris, Venice, Rome, and Florence. While staying at Villa La Pietra near Florence with Sir Arthur Acton, they met a young Colombian-born architecture student, Diego Suarez. Armed with Edith Wharton's *Italian Villas and Their Gardens* as their guidebook, Chalfin and Suarez gave Deering a crash course in formal garden design. Needing an architect to tie together all the rooms he intended to assemble from their European purchases, Chalfin recommended to Deering the young F. Burrall Hoffman, Jr., who had recently left the studio of Carrère & Hastings to establish his own practice in New York. Hoffman undertook the unique challenge of having to design a shell to hold Deering's collection of mismatched architectural elements and artifacts, which ranged from ancient Roman columns to Renaissance doorways and gates to early-nineteenth-century Neoclassical mantelpieces. The square villa plan with central courtyard was an established form for the Gilded Age great house, and had been tried in Florida by Hoffman's mentors Carrère and Hastings at Henry Flagler's Whitehall. Whereas Whitehall's patio was distinctly regional and Caribbean in articulation, the courtyard at Vizcaya was more fully integrated with the Italian style and materials of the rest of the house.

To unite the assemblage thematically, Chalfin hit upon the conceit of an ancestral villa, built in the age of Exploration and remodeled by succeeding generations. Deering chose the name "Vizcaya," because he wanted to perpetuate a local myth that a Spanish explorer named "Viscaino" had discovered Miami in the sixteenth century.[16] Stylistically, Deering may have been influenced by Villa Turicum, the immense Italian villa–style estate (chosen in preference to an alternate design by Frank

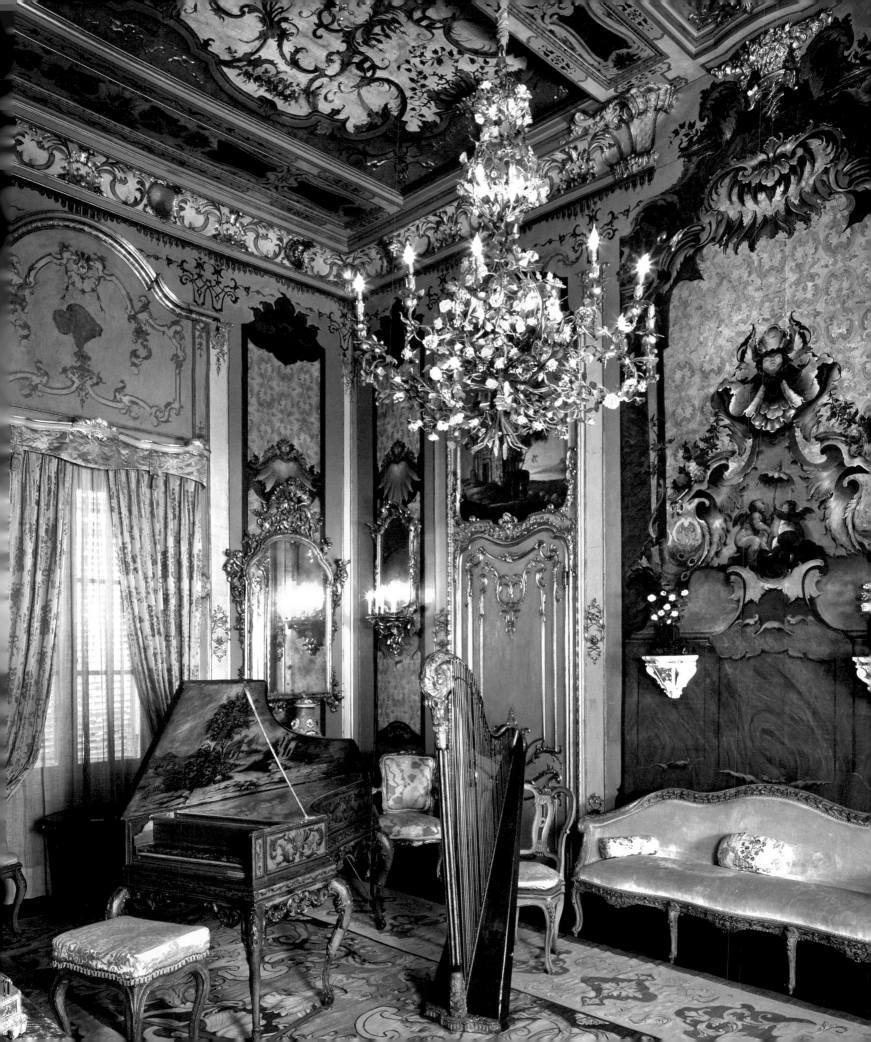

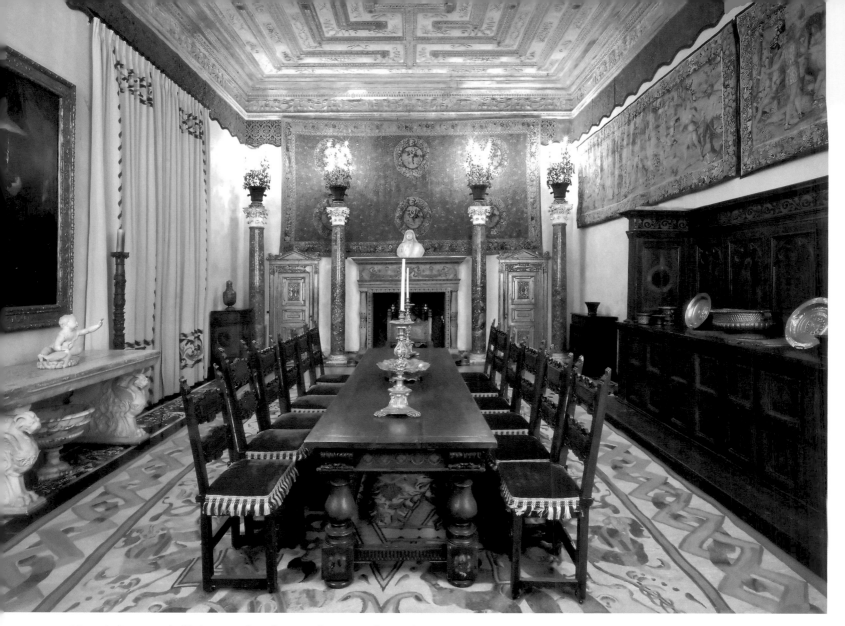

Vizcaya's dining room highlights sixteenth- and seventeenth-century architectural fragments, furnishings, and textiles. The plaster ceiling was made for the residence and painted to look like wood.

Lloyd Wright) of fellow International Harvester executive (and relative by marriage) Harold McCormick and his wife Edith Rockefeller McCormick, built in 1908–12 in Lake Forest, Illinois. Chalfin noted that each of the four facades of Vizcaya, in fact, displays a slightly different version of Italian Renaissance and Baroque architecture, each one serving as a souvenir "snapshot" of a moment in the European past.[17] Chalfin wrote Acton of the arduous enterprise and its visual impact on the rugged landscape of Biscayne Bay, "it is almost as imposing as the Palazzo Pitti, if you can imagine the Palazzo Pitti standing on a lagoon in Africa."[18]

Formally uniting the collections was Chalfin's genius: too sophisticated for a literal, homogenous "period room" approach, he skillfully mixed visually compatible elements from various periods to create a plausible impression of historical and aesthetic cohesiveness. From the banquet hall, recalling late-fifteenth-century Florentine palazzi, and the Renaissance hall, with its references to the sixteenth-century Age of Euro-

pean Exploration, through the Baroque, Rococo, Chinoiserie, Adamesque, French Empire, Biedermeier, and Italian Neoclassicism, Vizcaya is a visually stunning, conceptually erudite series of historicist tableaux of the classical tradition and its various stylistic permutations. The implication was that Deering's collections and activities in present-day America formed the newest chapter of this implied narrative of wealth, patronage, and cultural hegemony.

The final, crowning piece of the ensemble was the landscape design, which Suarez (stranded in the United States at the outbreak of World War I) assembled as a series of "greatest hits" from their Italian travels. Eventually, the property extended over 180 acres, and the gardens displayed a variety of cultural references, ranging from the formal French parterres adjacent to the main house, to the Italian-inspired grottos, sculpture allées, and fountain garden, to the outer lagoon island gardens (now lost), which Chalfin probably modeled on Chinese examples such as

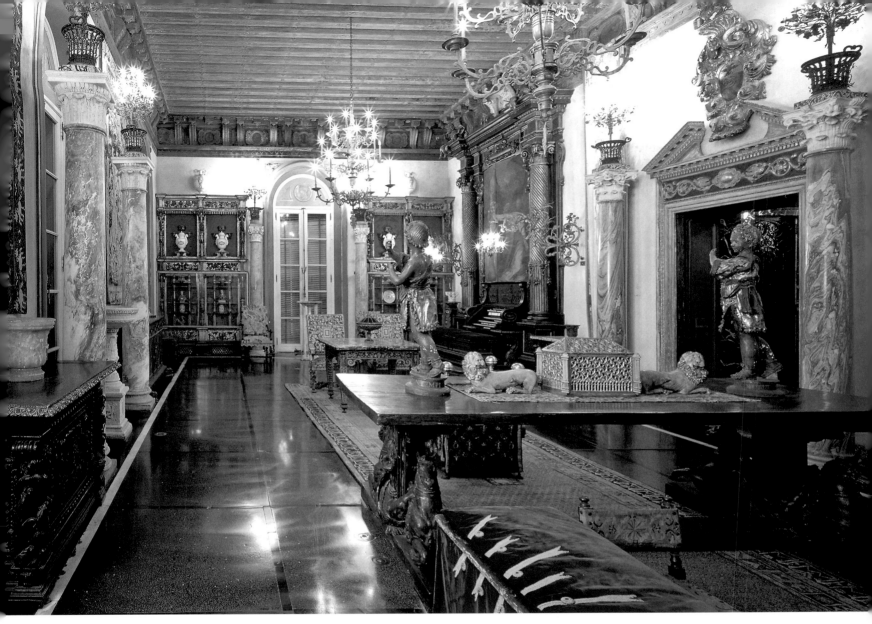

The Renaissance hall includes a number of fifteenth- and sixteenth-century objects, including two particularly fine Spanish carpets.

the Summer Palace at Beijing, which he would have known from his earlier career as a curator of Asian art in Boston.

In addition to summarizing the past, Chalfin also incorporated the present into his conception of Vizcaya. Three American artists featured in the watershed 1913 International Exhibition of Modern Art (better known as the Armory Show) created works for Vizcaya: Robert Chanler painted a folding screen and the vault of the swimming pool; Charles Cary Rumsey sculpted the frog and lizard figures on the south terrace fountain; and Gaston Lachaise modeled peacocks and columns for the Marine Garden bridge. Chalfin, Suarez, and Hoffman all bickered later over who deserved credit for the design of the stunning water-folly in Biscayne Bay known as "The Barge," but the execution by A. Stirling Calder (whose son, the sculptor Alexander Calder, visited the site during the project) is well established. John Singer Sargent also visited Vizcaya in 1917, and made numerous watercolors of the gardens and architecture.

Vizcaya officially "opened" at Christmas 1916, with a grand ball orchestrated by Chalfin, to which Deering arrived by boat to the sound of miniature cannon fire, and was greeted on the terrace by local socialites costumed as Italian peasants. Construction of the outer gardens and the pastoral farm village across the street from the main house dragged on into 1922, to Deering's consternation. His heath was failing, and his last few years at Vizcaya were spent as a partial invalid. He died in 1925, onboard a ship returning to the United States from Europe. Vizcaya passed to his nieces who, in 1952, conveyed ownership of the property to Dade (now Miami-Dade) County as the city's first art museum. Today, Vizcaya serves the local community through a variety of programs and events, and fulfills James Deering's ambition to be remembered as more than a mere businessman or even as a philanthropist, but as one of the American Gilded Age's last and greatest collectors and patrons of the arts.

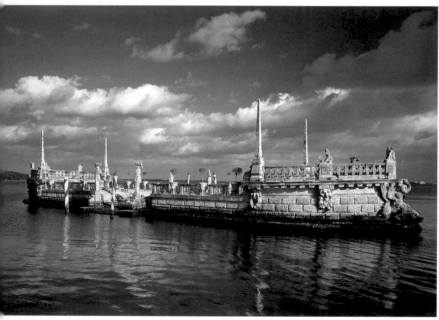

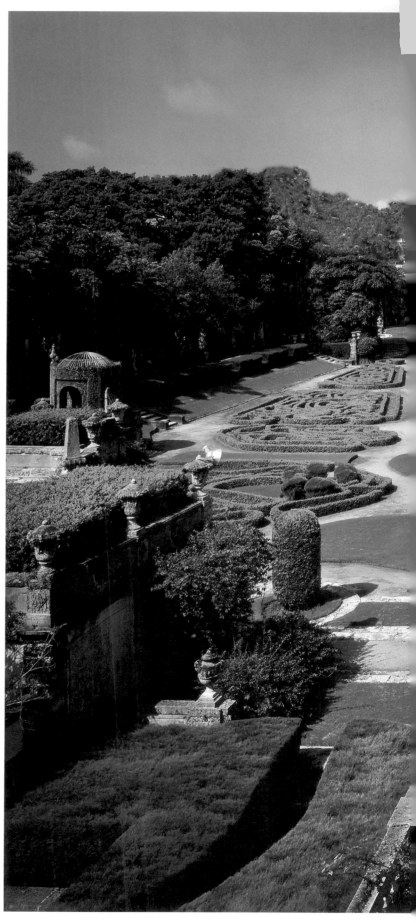

TOP
The tea house, at the southern end of the lower terrace, provides a shady respite from the subtropical sun.

ABOVE
The Barge features allegorical embellishments carved from local oolitic limestone by sculptor A. Stirling Calder (1870–1945).

RIGHT
Viewed from the south terrace, formal parterres at the center give way to a series of "outdoor rooms" representing different historical periods and gardening styles.

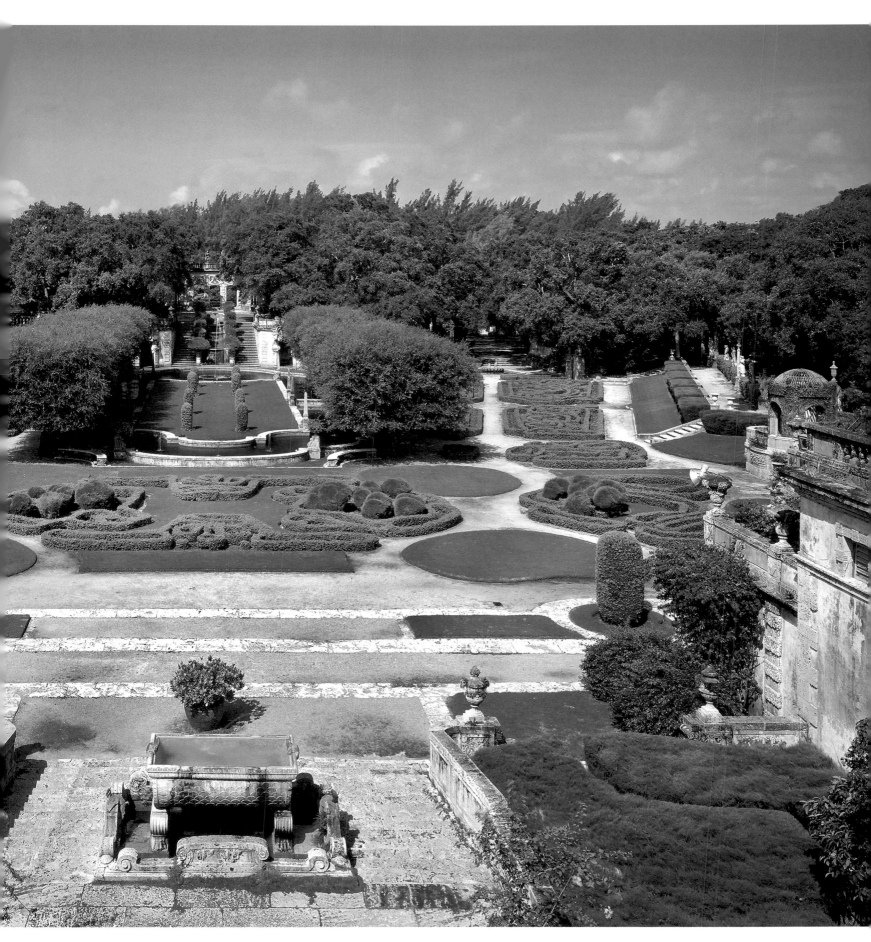

Reynolda

Winston-Salem, North Carolina
Built 1912–17
Architect: Charles Barton Keen
Affiliated with Wake Forest University

The former residence of Katharine and R. J. Reynolds originally served as the center of a model agricultural estate.

Built in 1912–1917 for native North Carolinian Katharine Smith Reynolds and her husband R. J. Reynolds (founder of the eponymous tobacco company), Reynolda marks a decisive conceptual shift away from the declaratively Eurocentric Gilded Age great house. Incorporating elements of Arts and Crafts philosophy and Colonial Revival style, Reynolda presents an image of understated pastoral refinement, befitting a 64-room mansion that happened to serve as the center of a 1,067-acre model estate.

In reaction to the Gilded Age's yawning gulf between the "robber baron" economic elite and the interests of the working poor, the Progressive Era, (circa 1900–1918) was characterized by the widespread belief that government-sponsored social and economic programs were necessary to improve the standard of living for the poor. Led by President Theodore Roosevelt, Progressive Era plutocrats took the Gilded Age notion of noblesse oblige and translated it into moral outrage and public policy. While spurred by muckraking exposés of urban poverty (especially the appalling living conditions of many of the 8.8 million immigrants who had arrived in the United States between 1900 and 1910) and inhumane industrial practices, Progressive Era policy also had a rural subset, sometimes called The Country Life Movement, which derived from the English Arts and Crafts philosophy which linked social reform to nostalgia for the now-threatened rural lifestyle. The contrast between pastoral ideal and rural misery was particularly acute in the South, where lagging technology and agricultural practices meant many real-life farmers struggled for subsistence.

Likely inspired by widely published model estates such as fellow tobacco baron James Buchanan Duke's 2,700 acre Duke Farms in Hillsborough, New Jersey (1893–1925) and, closer to home, George Vanderbilt's Biltmore (1889–95), around 1912, Katharine Reynolds hit upon the idea of creating a model farm in Winston-Salem at which modern agricultural techniques would be demonstrated for the benefit of local farmers. To accommodate the farm workers, there would be model housing: estate workers, both black and white, would live in quaint cottages in the village, while others lived in the all-black Five Row settlement or in cottages and boarding houses scattered across the property. To spare workers an arduous commute, there would also be a model village, including a dairy, smokehouse, blacksmith shop, barns, greenhouses, gardens, schools, churches, and a post office. In addition to the luxurious modern amenities of electricity and running water, there was also a central heating plant for the village. Night classes were offered to promote literacy among adults, while the community's children attended the

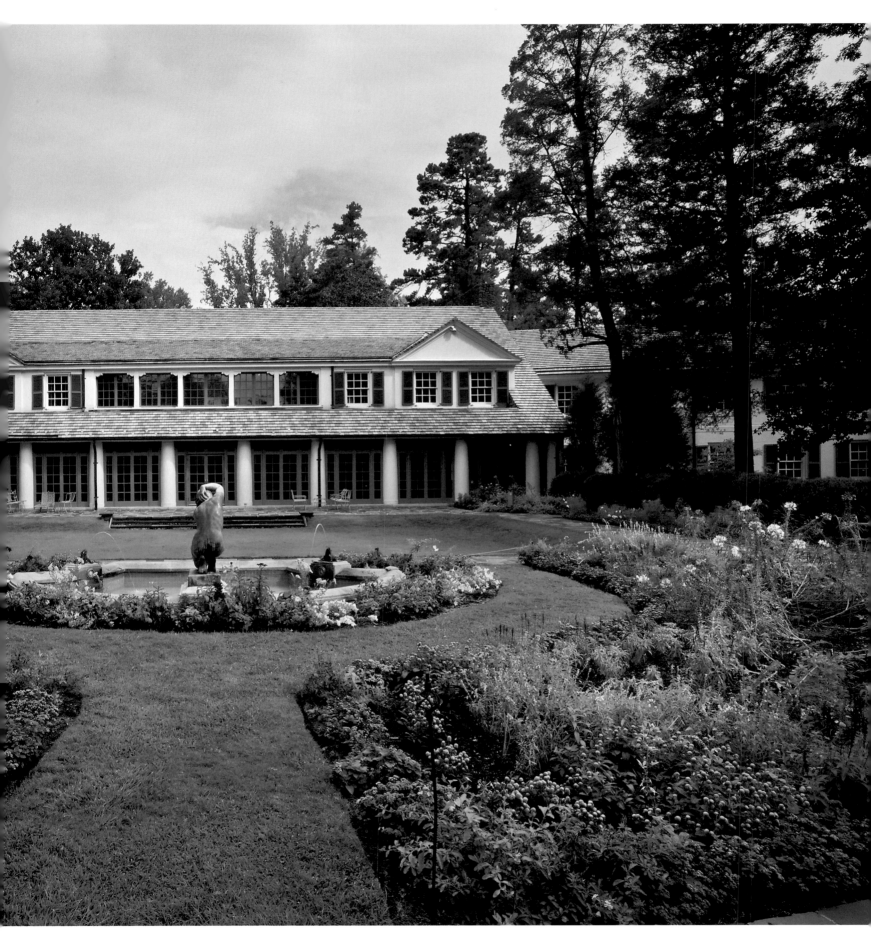

PREVIOUS PAGES
In the reception hall, an impressive divided staircase overarches a fireplace inglenook. The hand-forged wrought-iron railings are by Samuel Yellin.

ABOVE

The Streamline Modern–style bar was added circa 1937.

RIGHT

The study features portraits of R. J. and Katharine Reynolds that were painted in 1905 by Eugène Pirou. Mr. Reynolds's walnut desk has Jacobean-style linenfold panels and a thoroughly modern typewriter shelf.

racially segregated Reynolda School (white) or Five Row School (black).

Katharine Reynolds hired Buchenham and Miller, the landscape engineers of Duke Farms, to lay out the estate and Thomas Sears, an alumnus of the Olmsted Brothers landscape firm (whose founder had so artfully meshed working farm, pastoral village, and formal estate at Biltmore, twenty years earlier), to design the formal gardens. But while the estate and village at Reynolda were conceptually indebted to the example of Biltmore, the great house reflected a modern, distinctly American, curiously un-Southern version of idealized country life.

Reynolda's main house stands at the center of the estate, separated from the working farms by the formal gardens and picturesque 16-acre lake. Perhaps because Philadelphia's Main Line suburbs stood at the forefront of the Country Life Movement, Mrs. Reynolds chose Philadelphia sources almost exclusively for Reynolda. Architect Charles Barton Keen, well-known for large estates along the Main Line and in suburban New Jersey, designed the farm and village buildings, as well as the main house. None evince the slightest interest in the regional past, but instead define the ideal present as a dialogue between the Arts and Crafts rusticity of the farm and the genteel refinement of the main house.

A sconce designed by E. F. Caldwell & Co. hangs above a tapestry chair in the reception hall.

The library also served as the music room. Thomas Doughty's In the Catskills *(circa 1835) hangs above the piano.*

Reynolda's exterior deliberately averts the use of classical proportions, ornate orders, and elevated siting that generally characterized high-end interpretations of the Colonial Revival style. Instead, the exaggerated horizontality of the angled wings and open porches deemphasize the monumentality of the structure in measured deference to the surrounding landscape. The interiors are less reticent than the exterior, although strikingly unpretentious in comparison to the contemporary estates at Vizcaya in Miami or Swan House in Atlanta. Apparently uninterested in gathering antiques or fine art in Europe, Mrs. Reynolds ordered most of the furnishings for Reynolda from John Wanamaker's department store. Although Wanamaker's interiors department had been established by legendary decorator and American antiques doyenne Nancy McClelland in 1913, Mrs. Reynolds chose decorator E.A. Belmont from the flagship Philadelphia store rather than the New York-based McClelland.

On first glance, the stylistic anchor of Anglo-American Colonial classicism is somewhat obscured by the sprawling proportions of the 1,786-square foot, two-story Reception Hall. The staircase features carved wood paneling by Irving and Casson-A.H. Davenport, a Boston firm that had worked on the remodeling of The White House during Theodore Roosevelt's administration.[19] However, in most of the house, including the adjacent dining room and library, compo (chalk bonded with linseed oil, glue and resin) or cast plaster imitates hand-carved eighteenth-century moldings and millwork. Although several notable Arts and Crafts–affil-

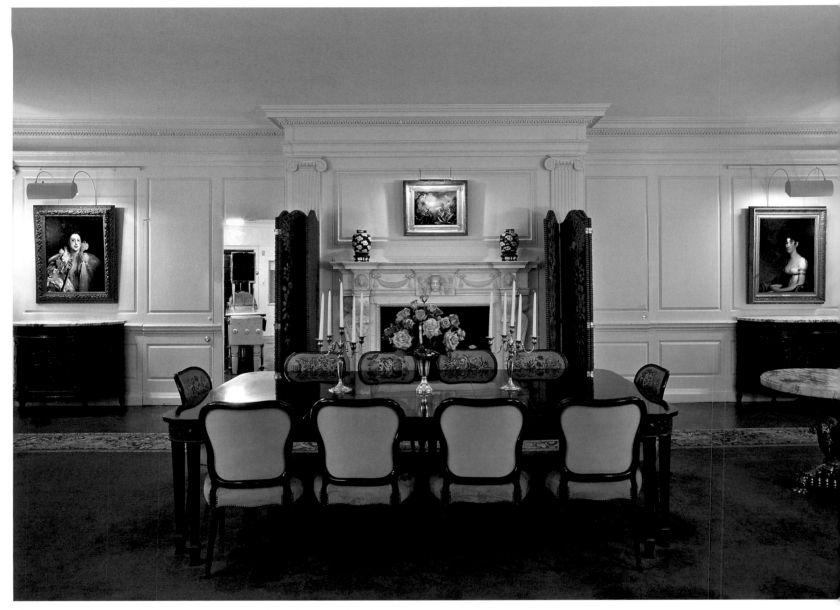

The dining room showcases John Singer Sargent's portrait of Marchesa Laura Spinola Núñez del Castillo (1903) and Martin Johnson Heade's Orchid with Two Hummingbirds *(1871) over the mantel.*

iated artisans supplied elements for the main house, any "rustic" inclinations were resolutely contained. The reception hall gallery, for example, is embellished with an elegant wrought-iron balustrade by Philadelphia artist Samuel Yellin. Yellin's work is typically associated with an Arts and Crafts aesthetic of handcrafted irregularities and medieval stylistic references—not so at Reynolda. Enfield Pottery and Tile Works, another Philadelphia Arts and Crafts firm, supplied floor tiles, but these are confined to the expansive porches that link three sides of the house to the surrounding gardens. A highly refined, Philadelphia-centered Colonial Revivalism establishes the main house as a distinct precinct of understated refinement in the midst of the estate's overall Arts and Crafts–derived rusticity.

In 1935, heir and eldest daughter Mary Reynolds Babcock and her husband Charles assumed full ownership of the estate. The Babcocks sold off unproductive land and streamlined operations. They added a swimming pool, a game room, a mirrored Art Deco bar, and hired the New York decorating firm of McMillen to update the interiors. After fifty years in the Reynolds family, the main house and 19.1 acres were endowed for public use in 1965 and opened as a museum in 1967. Decades of fundraising and skillful collecting established the American painting collection as one of the strongest in the South. In 2002, Reynolda House Museum of American Art entered into a formal affiliation with Wake Forest University (which was built on land donated for that purpose by Mary and Charles Babcock) and today offers a full complement of exhibitions and programs.

Cà d'Zan

Sarasota, Florida
Built 1924–25
Architect: Dwight James Baum
Owned by the State of Florida and operated by Florida State University as
part of the John and Mable Ringling Museum of Art

By the early 1920s, driven by railroads and real estate speculation, Florida was in the midst of the first of its periodic boom economies. Circus magnate John Ringling parlayed his lucrative show business earnings into a fortune through shrewd investment in Western land, oil fields, and railways. He bought land in Sarasota and the adjacent keys with the goal of creating a Gulf Coast alternative to Palm Beach and Miami on the Atlantic Coast. While Ringling's colorful and eclectic Sarasota mansion is often seen as the architectural manifestation of a man whose taste was formed by circus wagons, Cà d'Zan ("House of John" in Venetian dialect) manifests the same Jazz Age theatricality and iconoclastic opulence that characterizes Marjorie Merriweather Post's contemporary extravaganza, Mar-A-Lago, in Palm Beach (1923–27).

John Ringling (1866–1936) was an archetypal American success story: born into a farming family in Iowa, he and his five brothers banded together and started a circus in 1884. By 1907, when they merged with the Barnum & Bailey Circus, the Ringlings were acknowledged powerhouses in the entertainment industry and, with that success, became accepted by New York's artier aristocrats and social organizations. In 1905, John married Mable Burton, who shared his Midwestern farming background. Together, they began to collect art and antiques to fill their Fifth Avenue apartment and country place in Alpine, New Jersey. Although both Ringlings were

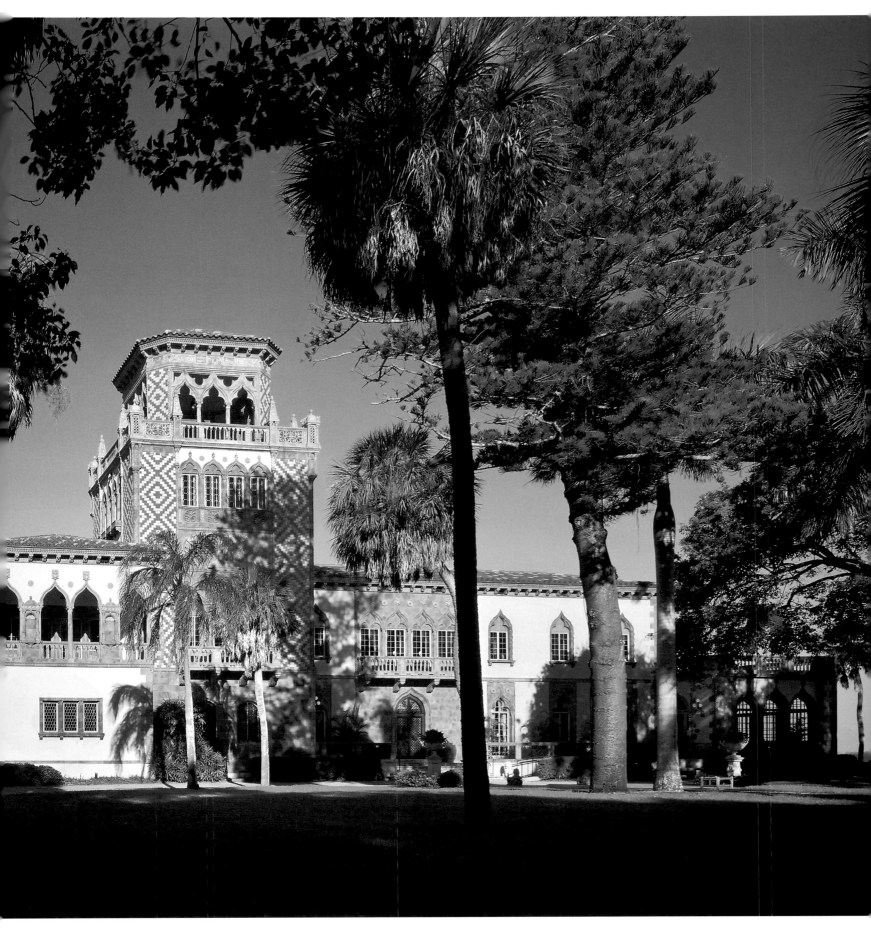

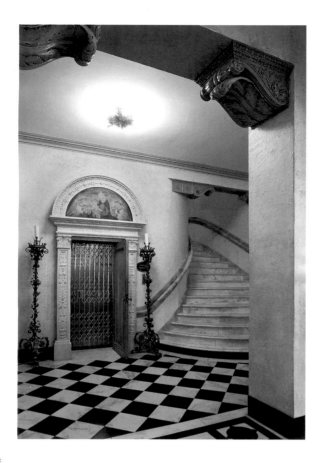

noted as soft-spoken by contemporaries, their purchasing habits were notably ostentatious. At New York auctions, they purchased entire rooms from the Richard Morris Hunt–designed mansion of Mrs. Astor and furnishings from the William K. Vanderbilt estate. In Europe, they purchased Old Master paintings from dealers such as Julius Böhler, known as the official art purveyor to the Imperial Court of Germany, who guided them to spectacular purchases from the aristocratic estates of the Duke of Westminster and Sir George Lindsay Holford.[20]

Like Henry Flagler, John Ringling recognized that he needed to build a house to establish the image of his planned resort, to demonstrate confidence, and to set a standard for potential investors. While his older brother Charles built a more conventional Beaux-Arts palazzo on the adjacent property in 1925–26, John Ringling was inspired by the exuberant architecture of McKim, Mead & White's Madison Square Garden (of which he was a trustee), Venice, and the arcaded waterfront buildings along El Malecón in Havana. What each of these apparently disjunctive architectural inspirations shared was an association with leisure and entertainment, the commodities in which John Ringling excelled, and which he hoped to elevate to a lifestyle choice in Sarasota.

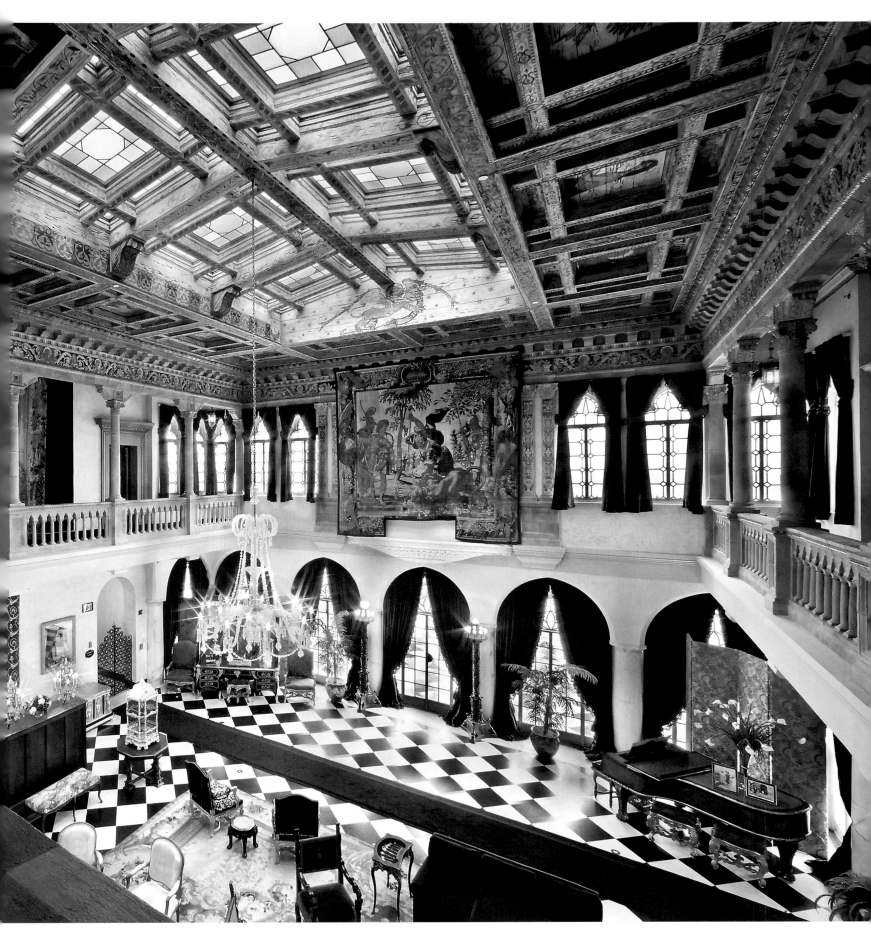

The game room features whimsical representations by illustrator Willy Pogany (1882–1955) of the Ringlings and their friends mingling with fairy-tale and Venetian carnival characters.

For their architect, the Ringlings chose Dwight James Baum (1886–1939). It is not clear how the Ringlings met Baum, who trained in Beaux-Arts architectural methods at Syracuse University, and quickly established himself after graduation as the go-to architect for the developing community of Riverdale-on-Hudson (eventually building 140 houses), and obtained commissions for country places in Westchester and Long Island. In 1923, he became the youngest designer ever to win the Architectural League of New York's Gold Medal. The Ringlings, perhaps impressed by his ability to manage a community development like Riverdale, invited the architect to Sarasota in 1924. He eventually designed the county courthouse, the *Sarasota Times* Building, the El Vernona Hotel (not extant), an apartment building, and several commercial structures that established Mediterranean Revival–style architecture as the signature image of the resort community of Sarasota.

The exterior of the Cà d'Zan emerges from the dense tangle of tropical foliage that frames both the driveway and pedestrian approach path. Clad in glazed terra cotta, the exterior blazes against the blue Florida sky. The yellow and red diaper-pattern tiles and Gothic tracery, reminiscent of the Doge's Palace, are artfully combined with polychrome bas-relief ornament that translates Renaissance grotesquerie panels into an unexpected third dimension. An inset panel depicts Adam and Eve, allegedly a wry reference to the Ringlings themselves but equally apt as a reference to the paradise Florida (and Ringling) promised to potential investors. The squat tower, often spuriously linked to that of Madison Square Garden, provided a rooftop belvedere from which to enjoy the breeze and spectacular views of Sarasota Bay. A swirling spiral stair enlivens the otherwise rectilinear geometry of the wildly asymmetrical massing. The overall effect, as Ringling surely intended, is an unlikely mixture of monumentality and whimsicality.

In contrast to the raucous impression of the exterior, Baum's plan for Cà d'Zan was surprisingly lucid. Baum followed the now-canonic Floridian version of the Renaissance palazzo form, with rooms arrayed around a central courtyard. Unlike its predecessors Whitehall and Vizcaya, however, the two-story courtyard at the Cà d'Zan was roofed over with a skylit, pecky cypress–beamed ceiling. The onyx-clad columnar arcades overlooking the herringbone-patterned, marble-paved waterfront terrace are glazed with the same tinted glass panes that were used at Vizcaya's tea room a decade earlier—a material used for centuries in Venice on the theory that the tint cut down on glare. Red velvet panels framed the view. Rare tapestries hung on the walls above (at least one covering the pipes of the Aeolian Duo Art organ), and some of Mable Ringling's collection of lavishly embroidered antique vestments were displayed with apparent carelessness over the gallery balustrade. The ballroom's gilded coffered panels featured painted scenes of dancers by illustrator and set designer Willy Pogany, whom the Ringlings had met through their close friend, impresario Florenz Ziegfeld. The dining room and taproom feature the kind of dark, paneled interior that the pre–air conditioned Floridian elite seemed to favor. On the second floor, John Ringling's bedroom abounds with Napoleonic references from the Empire-style bedroom suite to the risqué painting of Paulina Borghese that faces the beds. The third floor contains the real surprise of the house: a vaulted "game room" with near-life-sized painted figures of the Ringlings and their pets (the former in Venetian carnival costume) surrounded by monstrous creatures and figures that suggest they may be caricatures of the couple's friends—or enemies. Due to the low ceiling height, the effect is vertiginous and more than slightly menacing. The artist, Pogany (who later decorated the fairy-tale village at William Randolph Hearst's Wyntoon), depicted himself in the midst of the menagerie, skipping away toward the doorway.

The land bubble burst in 1926; Ringling's investments collapsed; and his half-finished Ritz-Carlton resort on Longboat Key languished in an unfinished state, a premature ruin visible from the belvedere of the Cà d'Zan. Mable Ringling died in 1929. After a disastrous remarriage, Ringling finally succumbed to disappointment and heart disease in 1936. He bequeathed his Sarasota estate, including the house, art gallery, and collection of Old Master paintings, for public education and benefit. In 1946, the state of Florida officially opened Cà d'Zan as a house museum, part of the larger institutional campus known as the John and Mable Ringling Museum of Art.

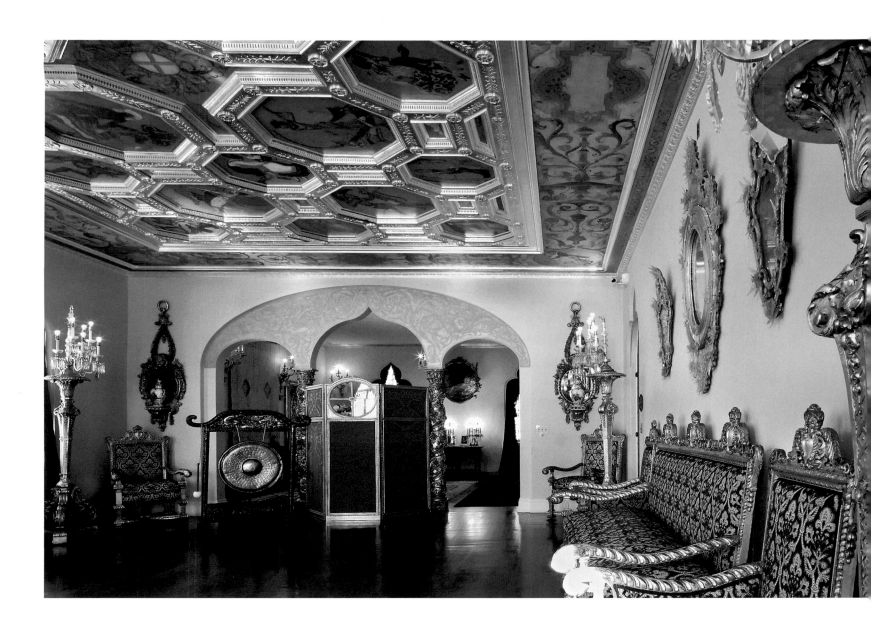

ABOVE

The ballroom's gilt-wood torchères and furnishings were reflected in a series of Venetian glass mirrors. The coffered ceiling was also gilded.

LEFT

On the ballroom's ceiling, Pogany painted Dances of the World. *He also designed sets for Broadway impresario Florenz Ziegfeld, a close friend of the Ringlings.*

Swan House

Atlanta, Georgia
Built 1926–28
Architect: Philip Trammell Shutze
Owned and operated by the Atlanta History Center

ABOVE
The entrance of Swan House references the work of English architect William Kent and his circle, particularly the Temple of Flora at Stourhead (1744) by Henry Flitcroft.

RIGHT
Shutze sought a more Italian-influenced appearance for the garden front to reflect the origins of English (and, by extension, American) classicism.

On the eve of the Great Depression, the Georgia-born, Italian-trained architect Philip Trammell Shutze built estates that paid homage to the Old South in the language of European classicism. Stylistically, Swan House, in Atlanta's tony Buckhead suburb, would not have appeared out of place on Long Island's Gold Coast, on Philadelphia's Main Line, or in Lake Forest, Illinois. But the fact that the house, its patron, and its designers were all products of a context in which the collective identity of the Southern past was being honed into a distinctive cultural mythology provides a presumptive regional subtext to its Beaux-Arts classicism.

The Colonial Revival in the South rarely hewed to pre-1776 architecture (of which states like Georgia and Alabama had little to show), but instead relied on the antebellum era's Federal and, especially, Greek Revival plantation houses. Richard Guy Wilson has noted the irony that Reconstruction-era Northerners initially embraced and promoted the romanticized plantation in literature and architecture with particular gusto.[21] "The Lost Cause" was rewritten as a battle purely over states' rights, not slavery, which was depicted as a benignant paternalism that even Yankees viewed with pernicious nostalgia. The national thirst for a heroic image of the antebellum past was made manifest in a monumen-

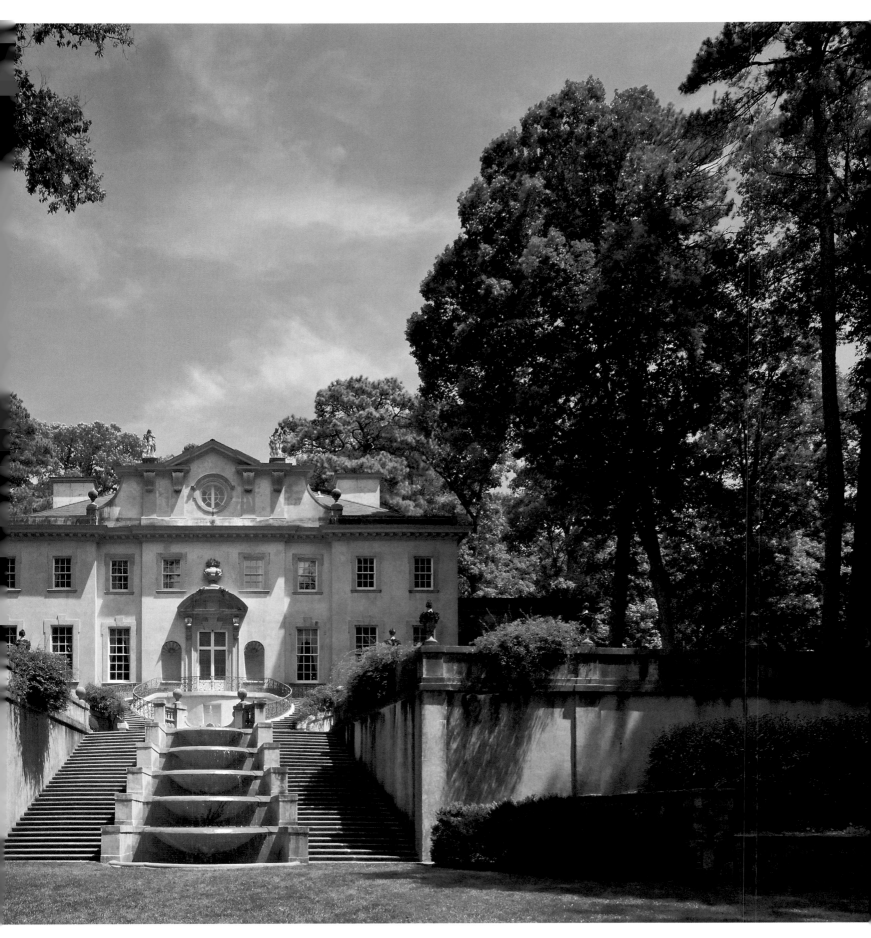

*From the Doric entrance portico, the Inmans' visitors entered an Ionic-order
"circular temple" foyer that projects into the entrance hall.*

*The view through one of the entrance hall's magnificently carved Anglo-Palladian
doorways into the dining room, with its Chinoiserie wall covering and gilded
Chippendale consoles.*

tal "cyclorama" painting (four stories tall and 358 feet in circumference)
of the Battle of Atlanta, which toured Northern cities for several years
before being installed in Atlanta's Grant Park in 1893. By the turn of
the century, Confederate monuments and memorials had sprung up in
towns and cities throughout the region, reminders not of defeat and
shame but as talismans of the enduring self-image of defiant pride in the
past that had become so inextricably associated with the regional cul-
tural identity of the South.

The Swan House was built for Edward Hamilton Inman (1881–
1931), whose fortune began with his cotton brokerage inheritance and
grew through investments in transportation, banking, and real estate.
Inman belonged to a plethora of social clubs and civic groups, served sev-
eral terms on the city council, and ran (unsuccessfully) for mayor. After
their house in the Olmsted-influenced garden suburb of Ansley Park
burned in 1924, the Inmans commissioned the preeminent Atlanta archi-

tectural firm of Hentz, Reid & Adler to design a new house on twenty-
eight acres in the up-and-coming north Atlanta suburb of Buckhead.
While principal designer Neel Reid tended to favor iconically American
inspirations such as Mount Vernon or the Hammond-Harwood House
for his Colonial Revival designs, there was also a tendency to step back
one generation further (and one step higher in the ancestral social ladder),
to the English palaces to which the elite colonial builders aspired. Some
patrons and designers went a chronological step beyond, to the styles of
Tudor and Elizabethan England, historically rationalized insofar as they
represented the age in which the British first settled in America. The
firm's rising star, Philip Trammell Shutze, brought the classical tradition
in the South full circle, to the same mix of Italian Renaissance and Anglo-
Palladian inspirations as the gentleman-architects of eighteenth-century
Virginia and South Carolina had done. Unlike Washington, Jefferson, or
Drayton, however, Shutze had extensive direct knowledge of classical
buildings and, more importantly, access to the materials and craftsman-
ship to pull off a convincingly English great house in America.

Philip Trammell Shutze (1890–1982), arguably the postbellum
South's greatest classicist, was born in Columbus, Georgia. He attended
architecture school at Georgia Institute of Technology and Columbia Uni-
versity and, in 1915, was awarded the prestigious Rome Prize, to study
architecture at the American Academy in Rome (founded 1894). While
World War I interrupted his studies, Shutze found time in between stints
as a Red Cross volunteer to fulfill the Academy's purpose, namely, to
measure, draw, and absorb firsthand the architectural remains of antiquity
at the wellspring. Back in the United States, Shutze worked in New York
for Mott Schmidt and F. Burrall Hoffman, Jr., who had already completed
his designs for James Deering's Vizcaya. Learning of the fatal illness of his
mentor, Neel Reid, in 1923, Shutze returned to Atlanta and took up the
mantle of the leadership of the classical tradition in the new South.

In true Beaux-Arts fashion, Shutze's design for the Inmans' house can
be endlessly picked apart as a series of identifiable (if arcane) historical ref-
erences. Like Chalfin at Vizcaya, Shutze resisted attempts to pinpoint
precise models, instead favoring the more sweeping assignment of inspi-
ration to the circle of Anglo-Palladian architects that centered around
Richard Boyle, Lord Burlington, in the first half of the eighteenth cen-
tury. The house filters its Italian Renaissance classicism through the pedi-
greed Anglo-American line, especially the works of William Kent, as
specified by Mrs. Inman.[22] With its Tuscan-order portico, the driveway
entrance clearly represents English Neoclassicism, but also may nod gen-
tly toward Greek Revivalism in a fluid allusion to the regional past.

The interiors draw from a range of sources found not only directly
within Burlington's English circle but also in the great houses built in the
period of Anglo-American Colonialism up to the early nineteenth cen-
tury, thus representing the historical and social milieu with which the
Southern aristocracy traditionally chose to be associated. Shutze parsed his
designs as beholden to Wren (in the library) and Kent (in the dining
room), but with clever interpolations of originality, such as the swan-
form volutes that embellish the capitals in the morning room.[23] The inte-
riors pointedly draw on the same eighteenth-century pattern books that
John Drayton or Thomas Jefferson would have known, but Shutze exe-
cutes the ideas with a pointedly high degree of fidelity and finesse. The
shared source material not only associates the Inmans as individuals with
the eighteenth-century British aristocracy but also links the capital of

ABOVE

Shutze described the library as inspired by the work of Christopher Wren. The line between English inspiration and colonial American style is a matter of degrees.

RIGHT

The morning room's engaged Corinthian column capitals incorporate a swan, Mrs. Inman's choice for the emblem of the house. Shutze chose the distinctive blue-green color.

the New South to the cultural tradition of the Old South.

Shutze often assisted his patrons in selecting antiques for their homes and took an active interest in gardening and horticulture. Shutze chose the Italian garden as the setting for the house, but more specifically, "the Italian garden in England . . . [b]efore the advent of Capability Brown."[24] In an even more direct Anglo-Italian connection, Shutze, like Chalfin and Suarez at Vizcaya, cited Arthur Acton's villa La Pietra near Florence as a source of inspiration for the gardens and their ornaments.[25] The garden front at Swan House links the architecture firmly to the setting. The water cascade was adapted from that of Villa Corsini in Rome (not far from Shutze's former home at the American Academy), and uses exaggerated perspective to dramatize the grandeur of the composition. The Inman House took two years to build and reportedly cost $106,000—about fifty times the national average for a single-family house at that time—an amount which Inman allegedly paid for in cash.

Mr. Inman died only three years after Swan House was completed, and before Shutze's complete landscape scheme could be implemented. Mrs. Inman continued to live there with family until her death in 1965. By prior agreement, the Atlanta History Center purchased the house, its furnishings, and twenty acres for $500,000 and converted the property to public use. Today, Swan House is part of a thirty-three-acre campus that includes one of the Southeast's largest history museums, the Tullie Smith farm, the Centennial Olympic Games Museum, the Kenan Research Center, and offers programs and exhibitions on a range of topics related to local and regional history.

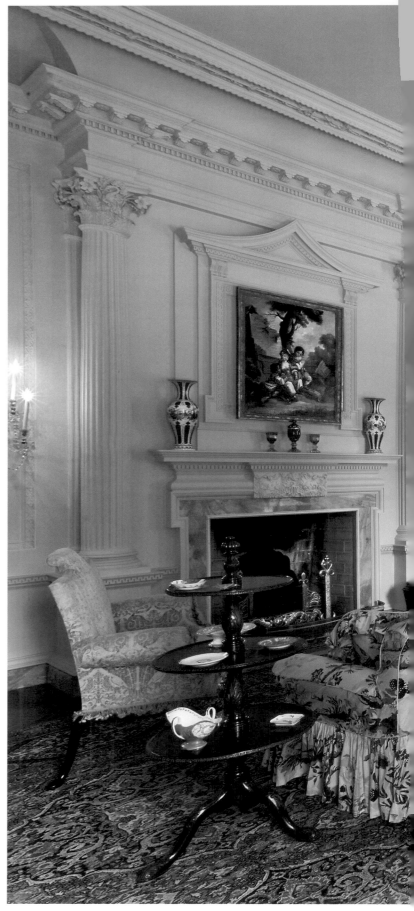

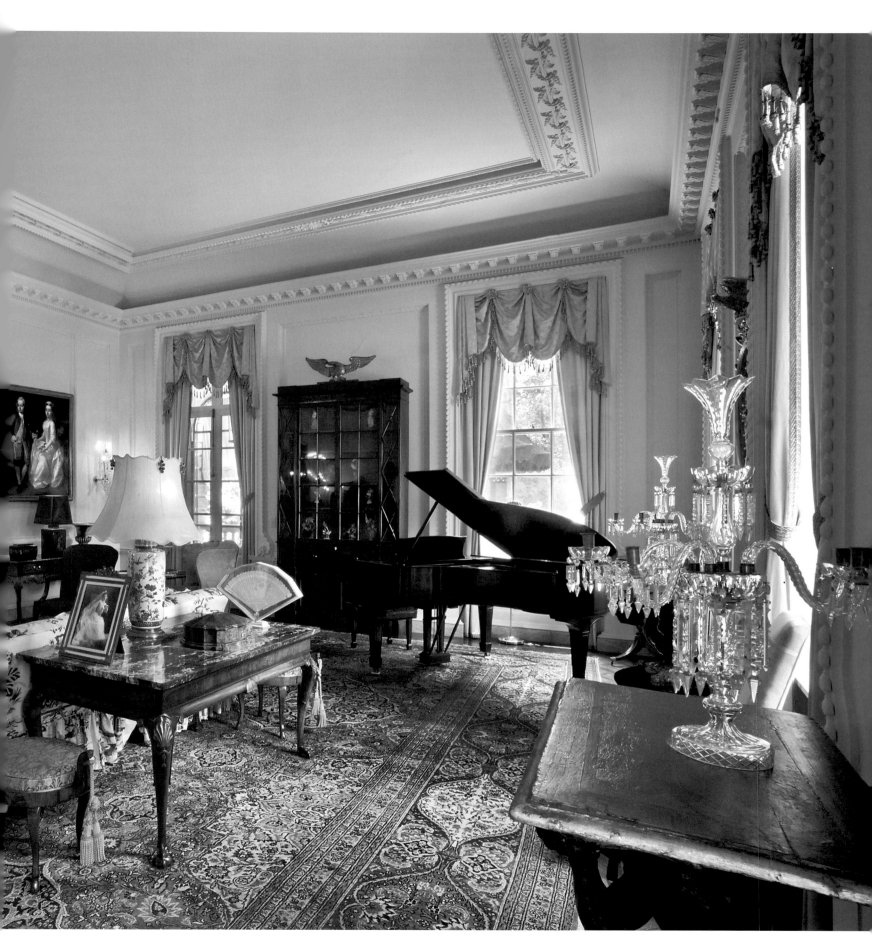

Longue Vue

New Orleans, Louisiana
Built 1939–42
Architects: William and Geoffrey Platt, with Ellen Biddle Shipman, landscape designer
Owned and operated by Longue Vue House and Gardens Foundation Corporation

ABOVE
Longue Vue mixes the Beaux-Arts inclinations of the architects, William and Geoffrey Platt, with the owners' interest in honoring the South's Greek Revival tradition.

RIGHT
Longue Vue's Spanish court, inspired by the Generalife Gardens in the Alhambra, was designed by William Platt and Edith Stern in the 1960s.

Longue Vue, completed just as the United States entered World War II, marks the end of the era during which the architectural identity of the South remained focused on its past, with little reference to the future represented by European Modernism. It has often been called the last of its kind. While its immediate impression is that of Beaux-Arts classicism, Longue Vue's conception, like that of Swan House, interweaves the landscape with the architecture, and the European classical tradition with regional precedent.

Longue Vue was built for Edgar and Edith Rosenwald Stern, prominent local philanthropists. New Orleans–born Edgar Bloom Stern (1886–1959) attended Tulane and graduated from Harvard before joining his father's cotton brokerage business. He parlayed his inherited fortune into a larger one by diverse investments in banking, lumber, oil, publishing, real estate, and early telecommunications. His wife, Edith Rosenwald Stern (1895–1980), had grown up in Chicago, where her father was an early partner and eventually chief executive officer and principal shareholder of Sears, Roebuck and Company. Edith Stern had grown up in a household in which "giving back" was expected, as her father—the son of a German-Jewish immigrant who arrived in the United States penniless, in 1854—supported Jane Addams at Hull House and established hundreds of schools throughout the rural South for African-Americans. Together the Sterns

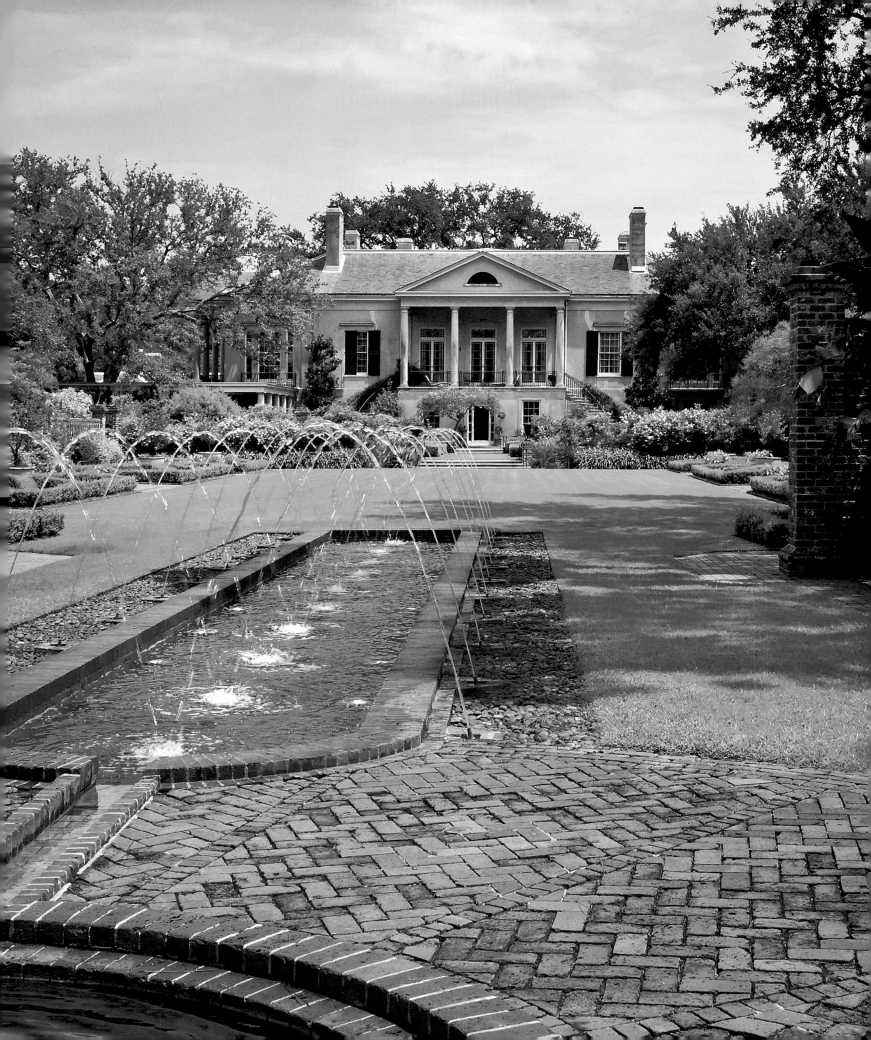

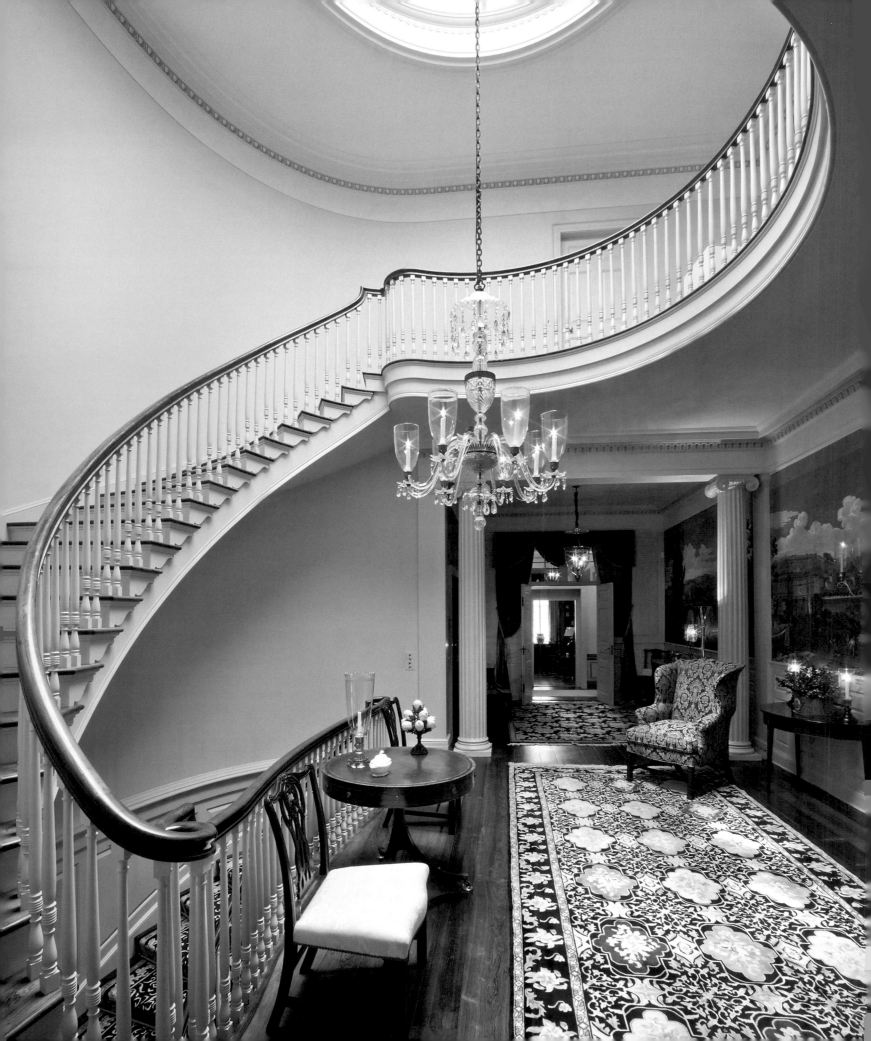

took a particularly active role in the philanthropic community in New Orleans, including support of the arts, health care, and education.

Longue Vue was designed to fit preexisting gardens on the site. The Sterns had built a Greek Revival–inspired house to designs by local architect Moise Goldstein in 1921–23, on a lot adjacent to the New Orleans Country Club. The couple acquired additional lots, and, in 1935, Mrs. Stern engaged noted landscape architect Ellen Biddle Shipman (1869–1950) to design eight acres of formal gardens near the house. Shipman had stumbled into a career in garden design following a divorce, when she was approached by prominent architect (and neighbor) Charles Adams Platt to devise planting schemes to populate his trademark Italianate landscape designs. Shipman's gardens, when completed, outshone the house in Mrs. Stern's opinion, and so she decided to build a house to suit the gardens. (The old house was laboriously moved down the street and later sold). Shipman recommended William and Geoffrey Platt, sons of her now-deceased mentor, to design the perfect house to suit the gardens at Longue Vue.

The Sterns piled the Platt brothers into their car to visit a series of Greek Revival houses, such as Shadows-on-the-Teche (1831–34) in New Iberia and the Beauregard-Keyes House (1826) in New Orleans. The Platts filtered the local inspiration through the Beaux-Arts classicism of their father, reinforced by their shared training at Harvard and, especially, Columbia University. A live oak allée, which is surely inspired by that of Oak Alley, lines the entrance drive and frames the portico and entrance court fountain. The impression, derived from Italian gardens but expanded by the Beaux-Arts influence into a richer variety, was that each garden constituted an outdoor room and evoked a different historical style. The facades of the house, as at Vizcaya, act as backdrops to support the historical allusions of the foreground garden spaces. From the south, the primary facade's portico serves as a backdrop for Shipman's formal English garden and camellia allée (later altered by Mrs. Stern and William Platt, and now known as the Spanish Court). The east terrace features roses and a sweeping lawn, overlooking the adjacent golf course. The portico form is more graphically expressed here, as a series of engaged columns set against contrasting red-brick fill in the center three bays, an effect that claims its inspiration from Shadows-on-the-Teche but is visually more akin to Wren's work at Hampton Court—an appropriately Georgian pedigree, in any case.

The interior's forty-five rooms, distributed over three stories (with an additional basement), were largely Colonial Revival in taste. Millwork in mahogany, birch, and rosewood, as well as ornate plaster cornices and ceiling medallions, were made in New York to Platt's specifications and installed on-site. Even the first-floor brick pavers in the hallway were produced in New York.

Oddly, the landscape designer Shipman was entrusted by the Sterns with all of the interior decoration—selecting furniture and decorative objects, as well as designing, purchasing, and installing carpets, window treatments, and wall coverings. While twentieth-century decorating clients have almost unanimously proclaimed their desire to "bring the outdoors in," the Sterns acted on this theoretical proclamation and entrusted the garden designer with the oversight of the entire project, from planting beds to selecting lampshades. The interiors are accomplished exercises in Colonial Revival style, with the abundant use of patterned textiles, including floral chintzes, silk damasks, and tapestries as well as the rich wall coverings that distinguish the luxurious twentieth-century "Colonial" from the sometimes dreary historical reality.

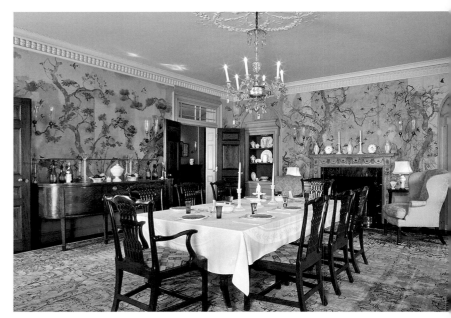

FACING PAGE
The elliptical stairwell rises three stories to a glass dome.

TOP
The drawing room was designed by Ellen Biddle Shipman around the circa 1800 mantelpiece, carved as a memorial to George Washington by Robert Wellford of Philadelphia.

ABOVE
Shipman contributed a set of real Chinese screens from her own house to cover the walls of the Sterns' "Chinoiserie" dining room.

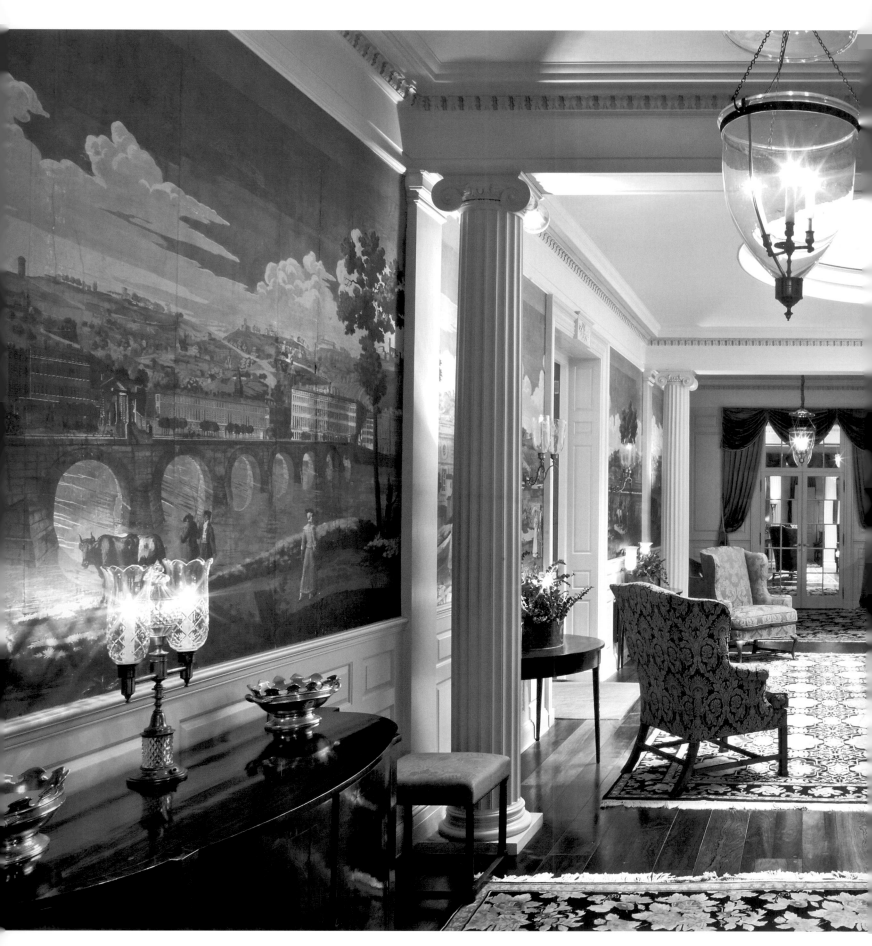

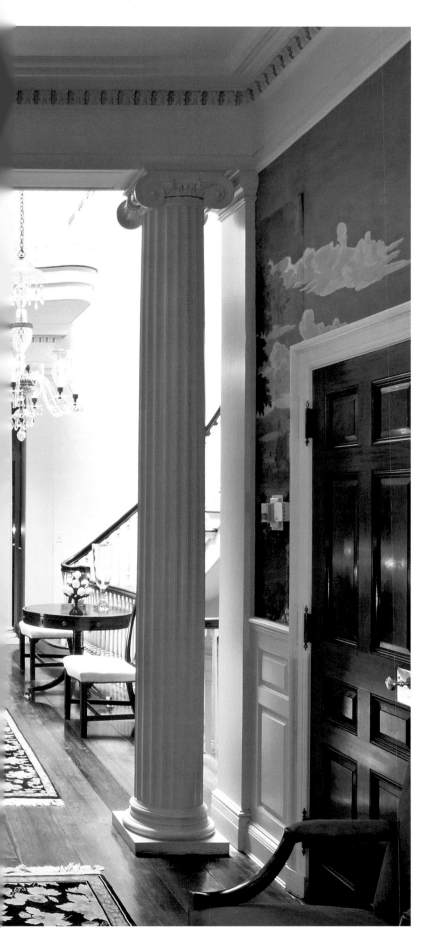

LEFT
The upper hall is divided into three bays by Ionic columns. Mirrored French doors could be closed to shut off the bedroom wings and redefine the center bay as a sitting room.

ABOVE
The Blue Room was designed as a conventional colonial "period" interior, but Mrs. Stern added contemporary seating and Wassily Kandinsky's 1926 Sketch for "Several Circles" *(the original now replaced with a copy).*

What further animates Longue Vue is the interpolation of modern art from the Sterns' collection into the period interiors, an unexpected nod to the present-day in the midst of the carefully crafted historicist ensemble. The slate-blue paneled sitting room features a striking Kandinsky, and by the 1960s, Mrs. Stern brought back William Platt to convert the solarium into a gallery to house works by Vasarely, Picasso, Arp, and Kasuba. In the gallery, the modern art is displayed alongside eighteenth-century Venetian painted side chairs, a pair of Edwardian tête-à-têtes, and some early American pewter pieces. The house was no longer an emblem of the vanished past and a stubborn adherence to its social codes but rather a respectful foundation upon which the New South would embrace the future.

Even before Longue Vue was completed, the Sterns planned to create a foundation to support it for public use after their lifetimes, a subtle but significant shift from the dynastic subtext of antebellum estates. In 2005, Longue Vue's gardens suffered extensive damage from Hurricane Katrina, both from high winds that damaged or toppled three hundred trees as well as from flooding that followed the breach in a levee on the 17th Street canal. With the assistance of both grant-supported professional advisors and volunteers, the disaster was used as an opportunity to restore parts of Shipman's original planting schemes that had been gradually replaced over the years. Today, in addition to the gardens, Longue Vue serves as an historic site, museum, and host to many community programs.

Notes

Introduction

1 Richard Bushman, *The Refinement of America: Persons, Houses, Cities.* Paperback ed. (New York: Vintage Books, 1993), 390.

2 James C. Cobb, *Away Down South: A History of Southern Identity* (New York: Oxford University Press, 2005), 42–3.

3 Thomas Jefferson to the Marquis de Chastellux, "Climate and American Character," September 2, 1785, and Chastellux, *Voyages de M. le Marquis de Chastellux dans l'Amerique Septentrionale: dans les Années 1780, 1781 et 1782,* as cited in Cobb, 10–11.

4 John Beck, Wendy Frandsen, and Aaron Randall, *Southern Culture: An Introduction* (Durham, NC: Carolina Academic Press, 2007), 52.

5 Cobb, 6.

Part I: 1700–1800

1 William S. Rasmussen, "Drafting the Plans," *The Making of Virginia Architecture* (Charlottesville and London: University of Virginia Press, 1992): 13; William S. Rasmussen, Charles E. Brownell, and Richard Guy Wilson, "Idea, Tool, Evidence," *The Making of Virginia Architecture* (Charlottesville and London: University of Virginia Press, 1992): 138–9.

2 "Governor's Palace," *The Official Site of Colonial Williamsburg,* http://www.history.org/Almanack/places/hb/hbpal.cfm, retrieved January 18, 2009.

3 Rasmussen, "Drafting the Plans," 16–17.

4 "The Origins of Drayton Hall, from Andrea Palladio to William Kent," Drayton Hall Web site, http://www.draytonhall.org/research/architecture/.

5 Mills Lane, *Architecture of the Old South* (New York: Beehive Press, 1993), 39.

6 William M. S. Rasmussen and Robert S. Tilton, *George Washington, The Man Behind the Myths.* paperback ed. (Charlottesville: University of Virginia Press, 1999), 117.

7 Lane, 69.

8 "William Buckland's Library," Gunston Hall Web site, http://www.gunstonhall.org/houseandgrounds/buckland_master.html, retrieved January 6, 2009; Luke Beckerdite, "Architect-Designed Furniture in Eighteenth-Century Virginia: The Work of William Buckland and William Bernard Sears." *American Furniture* (Milwaukee, WI: Chipstone Foundation, 1994), 29–48. http://www.chipstone.org/publications/1994AF/index1994Beck.html. "Architecture," Web site of The Hammond-Harwood House, http://www.hammondharwoodhouse.org/History.htm#Architecture, retrieved January 6, 2009.

9 Calder Loth, "Palladio's Influence in America" (Baltimore: Homewood Museum/The Johns Hopkins University, 2008), 2. https://jscholarship.library.jhu.edu/bitstream/handle/1774.2/32824/PalladioAmerica_FINAL.pdf?sequence=1.

10 Frederick Doveton Nichols, *Thomas Jefferson's Architectural Drawings,* 1961, rev. ed. The Thomas Jefferson Memorial Foundation (Chapel Hill: University of North Carolina Press, 1995), 3.

11 Annette Gordon-Reed, *The Hemingses of Monticello, An American Family* (New York: W. W. Norton, 2008), 113–5. The chronology of occupancy is based on "South Pavilion with Kitchen," Monticello Web site, http://explorer.monticello.org/text/index.php?sect=plantation&sub=buildings&lid=18, retrieved January 14, 2009.

12 Jack McLaughlin, *Jefferson and Monticello: The Biography of a Builder,* rev. ed. (New York: Owl Books, 1990), 258.

13 Marie Goebel Kimball, *Jefferson, The Scene of Europe, 1784 to 1789* (New York: Coward-McCann, 1950), 142.

14 Howard C. Rice, *Thomas Jefferson's Paris* (Princeton, NJ: Princeton University Press, 1991), 98.

15 Charles E. Brownell, "Cat. 12: Monticello, Second House, West Elevation," *The Making of Virginia Architecture* (Charlottesville and London: University of Virginia Press, 1992), 220.

16 Richard Rush, as quoted in Merrill D. Peterson, *Visitors to Monticello,* paperback ed. (Charlottesville and London: University of Virginia Press, 1989), 72 ff. and passim.

17 Catherine W. Bishir, *North Carolina Architecture* (Chapel Hill: University of North Carolina Press, 1990), 45.

Part II: 1800–1820

1 Catherine Rogers Arthur and Cindy Kelly, *Homewood House* (Baltimore: The Johns Hopkins University Press, 2004), 22.

2 William Thornton, *The Papers of William Thornton,* vol. I, Charles M. Harris and Daniel Preston, eds. (Charlottesville: University of Virginia Press, 1995), 528.

3 Charles Harris, "William Thornton (1759–1828)," rev. 2001, Biographies and Essays, Prints and Photographs Reading Room, Library of Congress Web site. http://www.loc.gov/rr/print/adecenter/essays/B-Thornton.html, accessed December 27, 2008.

4 Daniel D. Reiff, *Houses from Books: The Influence of Treatises, Pattern Books, and Catalogs in American Architecture, 1738–1950* (University Park, PA: Pennsylvania State University Press, 2000), 42 identifies Sydney Lodge (Hampshire) of 1789, published in George Richardson's *New Vitruvius Britannicus* (vol. 1, 1802–03; vol. 2, 1808) as the specific model.

5 Douglas Harper, "Slavery in Rhode Island," Web site *Slavery in the North,* http://www.slavenorth.com/rhodeisland.htm, accessed January 10, 2009.

6 J. Thomas Savage, "Cat. 138, Watch," in Maurie D. McInnis and Angela D. Mack, *In Pursuit of Refinement: Charlestonians Abroad, 1740–1860.* Exhibition Catalog. (Charleston, SC: Gibbes Museum of Art/Historic Charleston Foundation. Columbia, SC: University of South Carolina Press, 1999), 323.

7 William Way, *History of the New England Society of Charleston, South Carolina, for One Hundred Years, 18191919* (Charleston: The New England Society, 1920), 3, 17. http://books.google.com/books?id=JzqAffB6UpAC.

8 Jane Webb Smith, "The Wickham House in Richmond: Neoclassical Splendor Restored." *The Magazine Antiques.* Brant Publications, Inc. 1999. HighBeam Research, accessed 22 January 2008.

http://www.highbeam.com.

9 Benjamin H. Latrobe to John Wickham, April 26, 1811, as cited in Edward Francis Zimmer and Pamela J. Scott, "Alexander Parris, B. Henry Latrobe, and the John Wickham House in Richmond, Virginia," *Journal of the Society of Architectural Historians* 41 (Oct. 1982): 207. http://www.jstor.org/stable/989874.

10 Frances Trollope, *Domestic Manners of the Americans.* 1839. (London: Century Publishing, 1984), 28.

11 Michael Fazio and Patrick Snadon, *The Domestic Architecture of Benjamin Henry Latrobe* (Baltimore: The Johns Hopkins University Press, 2006), 663, 665, n.7.

12 Thomas Jefferson, architectural drawings, "Louisville: house (study plan)," *Thomas Jefferson Papers: An Electronic Archive,* Web site of the Massachusetts Historical Society. http://www.masshist.org/thomasjeffersonpapers/cfm/search.cfm?archive=arch&tag=front&query=%22Louisville%22&hi=off, accessed February 11, 2009.

13 Fiske Kimball, "Jefferson's Designs for Two Kentucky Houses," *The Journal of the Society of Architectural Historians* 9.3 (Oct. 1950): 14–16. http://www.jstor.org/stable/987456.

Part III: 1820–1861

1 Peirce F. Lewis, *New Orleans: The Making of an Urban Landscape,* 2nd ed. (Charlottesville: University of Virginia Press, 2003).

2 Mills Lane, *Architecture of the Old South* (New York: Beehive Press, 1993), 252.

3 Sharon F. Patton, *African-American Art* (New York: Oxford University Press, 1998), 40–41.

4 Fazio and Snadon, 660–61 note that the room shapes and arrangement are unprecedented in the region but consistent with Latrobe's other domestic work.

5 McInnis and Mack, 10.

6 Maurie D. McInnis, *The Politics of Taste in Antebellum Charleston* (Chapel Hill and London: University of North Carolina Press, 2005), 209. McInnis notes that the Aikens made their slaves go to church on Sunday.

7 McInnis and Mack, 49–50.

Part IV: 1865–1940

1 Barbara Burlison Mooney, "The Comfortable Tasty Framed Cottage: An African American Architectural Iconography," *The Journal of the Society of Architectural Historians* 61 (March 2002): 48–67. http://www.jstor.org/stable/991811.

2 Patricia West, *Domesticating History: The Political Origins of America's House Museums* (Washington, DC, and London: Smithsonian Institution Press, 1999), 47.

3 James Weldon Johnson, *The Book of American Negro Poetry* (New York: Harcourt Brace & Company, 1922): viii.

4 Dale Wheary, "James and Sallie Dooley of Maymont," Richmond: Maymont Foundation Curatorial Document, 2000.

5 Dale Wheary, "Edgerton Rogers, Architect of Maymont House," Richmond: Maymont Foundation Curatorial Document, 2000.

6 Dale Wheary, "Edgerton Rogers."

7 Dale Wheary, "Maymont House Museum Collection

Overview," Richmond: Maymont Foundation Curatorial Document, 2000.

8 Dale Wheary, "Maymont House Museum Collection Overview."

9 Percy Preston, Jr. "The Vanderbilt Mausoleum on Staten Island, New York City," *The Magazine Antiques*, Brant Publications, Inc. (2005). HighBeam Research, http://www.highbeam.com.

10 Paul R. Baker, *Richard Morris Hunt* (Cambridge, MA and London: The MIT Press, 1980), 291.

11 Baker, 332.

12 Baker, 414.

13 "Palm Beach Gayeties," *New York Times*, March 8, 1903, 8. http://www.nytimes.com.

14 "Palm Beach Gayeties," *New York Times*, March 8, 1903, 8. http://www.nytimes.com.

15 Paul Chalfin, interview by Robert Tyler Davis, transcript, May 1956. Robert Tyler Davis Papers, Smithsonian Institution Archives, RU 7439, box 4, folder 20.

16 James Deering, letter to Paul Chalfin, July 6, 1915, box "Metals" folder "Silver," Vizcaya Museum and Gardens Archives, as cited in Joel M. Hoffman, "Director's Foreword," *Visions of Vizcaya* (Miami: Vizcaya Museum and Gardens, 2006): 3.

17 Witold Rybczynski, "Hoffman's Plan," *Vizcaya: An American Villa and Its Makers* (Philadelphia: University of Pennsylvania Press, 2007), 54–55 cautions that Chalfin's assertion of the different facade styles should not be taken too literally, but rather as an affirmation of the notion that the house was intended to represent the passage of time

18 Paul Chalfin, letter to Arthur Acton, partial transcript, February 23, 1915, box "Personnel," folder "Acton," Vizcaya Museum and Gardens Archives, as cited in Laurie Ossman, "The Construction of Vizcaya," *Visions of Vizcaya* (Miami: Vizcaya Museum and Gardens, 2006), 31.

19 Barbara Mayer, *Reynolda: A History of an American Country House* (Winston-Salem. NC: John F. Blair, 1997), 65–70.

20 Mitchell Merling, *Ringling: The Art Museum* (Sarasota: The John and Mable Ringling Museum of Art, 2002), 9–12.

21 Richard Guy Wilson, "Building on the Foundations," *The Making of Virginia Architecture* (Richmond: Virginia Museum of Fine Arts. Charlottesville: University of Virginia Press, 1992), 83–131.

22 Elizabeth Meredith Dowling, *American Classicist: The Architecture of Philip Trammell Shutze* (New York: Rizzoli International Publications, 2001), 90.

23 Dowling, 98.

24 Philip Trammell Shutze, "Inman description, 14 pages," as cited in Dowling, 107.

25 Dowling, 107.

Acknowledgments

Our journey began in Louisiana, and so do our thanks: to John McLaughlin, our charming host in New Orleans, for getting us off to a good start; Director of Development Lisa Samuels, Executive Director Mamie Gasperecz, and Deputy Director Carolyn Bercier at the Hermann-Grima and Gallier Houses; Debra Mayhew and Zeb Mayhew, the owners and generous good spirit of Oak Alley; Executive Director Bonnie Goldblum and Lenora Costa of the Collections staff at Longue Vue. In Natchez, thanks to Mimi Miller of the Historic Natchez Foundation; Ruthie Coy of the Natchez Pilgrimage Garden Club; Gayle Ferrell at Stanton Hall; Kenny at Longwood (who let us in) and Curator Cheryl Munyer of Melrose, who stayed well past closing time to help us get "the shot." At the Alabama Historical Commission, thanks to Senior Architectural Historian Robert Gamble, who will hopefully forgive our choices; Ellen Mertins for the introductions; Executive Director Eleanor Cunningham, Curator Bruce Lipscombe, and Rick Rand, all of whom made Gaineswood even better than we expected. Thanks to Deborah Casey, Site Director of Fendall Hall, for her hospitality.

In Florida, thanks to John Blades, Executive Director, and David Carson, Public Affairs Director, of Whitehall, The Henry Morrison Flagler Museum; and, as ever, thanks to Executive Director Joel M. Hoffman of Vizcaya Museum and Gardens, and, in Sarasota, to independent curator and scholar Mark Ormond. At the Atlanta History Center, thanks to Lea Massey and to Hilary Hardwick, Director of Media Relations; at the Wren's Nest, thanks to Program Director Amelia Lerner for not hanging up on us and to Executive Director Lain Shakespeare. In Savannah, special thanks to Curator Tania Sammons of the Owens-Thomas House for her insight and assistance; to Executive Director Jamie Credle and to Raleigh at the Davenport House for being so accommodating. In Charleston, thanks to architect Joseph K. Oppermann for his mastery of the fine art of opening doors; Executive Director of the Historic Charleston Foundation Kitty Robinson for access and Media Relations Coordinator to the stars, Caroll Ann Bowers, for coffee and great good humor. At Drayton Hall, our special thanks to Director George McDaniel; Director of Interpretation Craig Tuminaro; Visitor Services Manager Sheila Harrell-Roye; and Marketing Coordinator Natalie Baker.

In North Carolina, we owe a debt of gratitude to Nancy Hawley and Curator Nancy Richards of Tryon Palace for coming in on a Sunday morning and sweltering because of us. Thanks to Media Coordinator Sharyn Turner at Reynolda House Museum of American Art for arranging access. At Biltmore, thanks to William Cecil, not only for sharing his house with yet another visitor but also for having such a terrific professional staff, especially the dauntless, patient, and altogether wondrous Kathleen Mosher, Director of Communications; Conservation Manager Nancy Rosebrock; and producer Lori Garst.

We appreciate the generous and courteous support of Liesel Nowak at Monticello and Janie Berkheimer. At the Richmond History Center, thanks to Lesley Bruno for her patience with the phone tag and to Suzanne T. Savery for her time and knowledge. Dale Wheary, Director of Historical Collections and Programs at Maymont, proved herself, once again, to be Maymont's professional treasure; and our thanks to Executive Director Norman O. Burns II for his support of this project. At Shirley, particular thanks to Mr. Randy Carter, as well as to Director Janet Appel and Collections Supervisor Kim Adkins for their time, good humor, and professionalism. And deepest thanks to our at-large supporters and advisors in Virginia: Professor Richard Guy Wilson of the University of Virginia, architectural historian Debra McClane, and architect Pat McClane in Richmond, and Dr. Mitchell Merling, Paul Mellon Curator and Head of the Department of European Art at the Virginia Museum of Fine Arts.

Professor John Alexander of the University of Texas, San Antonio, gave important editorial suggestions; Dr. Ware Petznick provided helpful introductions and guidance in several states. For flexibility and grace under pressure, our thanks to Alton Kelley, Director, and John Lamb, Curator, of Belle Mead and Marsha Mullin, Vice President of Museum Services and Chief Curator at the Hermitage. In Kentucky, our work was made not only possible but enjoyable, thanks to Eric Brooks, Curator of Ashland, and Assistant Director Amanda Caffee at Farmington. Thanks to David Mohney, who brought us the Hunt-Morgan House, and served as host and guide to Lexington.

In Washington, DC, thanks to Director Cynthia Malinick and Mame Croze, Public Relations and Marketing Manager at Decatur House and to Executive Director Leslie Buhler and Heather A. Bartlow, Director of Communications and Development at Tudor Place. In the fine state of Maryland, we are especially appreciative of the generous support of Executive Director Carter Lively of the Hammond-Harwood House, and for the wit and scholarly wisdom of Catherine Rogers Arthur, Curator of Homewood.

Thanks to Patty Fisher for keeping Steven's affairs in order while we were on the road. Thanks to Jim Vaughan, Vice President of Stewardship Sites at the National Trust for Historic Preservation, for the time to complete this project and to Stacey Hawkins, Duane Hill, and Karen Sherwood, who kept the (purely metaphorical) home fires burning at Woodlawn and Pope-Leighey.

Special and boundless thanks to John F. W. Rogers for over four decades of faith and support.

Bibliography

Adams, William Howard. *Jefferson's Monticello*. New York: Abbeville Press, 1988.

Akin, Edward N. *Flagler: Rockefeller Partner and Florida Baron*. Gainesville: University of Florida Press, 1991.

Amort, Joanne, et al. *Oak Alley Plantation*. Vacherie: Oak Alley Plantation Foundation, 2000.

Anderson, Heather R., and Latasia D. Brown. *The Davenport House Museum*. Screven, GA: Papyrus Tree Publishing, 2007.

Arthur, Catherine Rogers, and Cindy Kelly. *Homewood House*. Baltimore: The Johns Hopkins University Press, 2004.

Aslet, Clive. *The American Country House*. New Haven and London: Yale University Press, 1990.

Axelrod, Alan, ed. *The Colonial Revival in America*. New York: W. W. Norton for The H. D. Winterthur Museum, 1985.

Ayers, Edward L. *The Promise of the New South: Life After Reconstruction*. 15th anniv. ed. New York: Oxford University Press, 2007.

Ayers, Edward L. *What Caused the Civil War? Reflections on the South and Southern History*. New York: W. W. Norton and Company, 2005.

Baker, Paul R. *Richard Morris Hunt*. Cambridge, MA, and London: The MIT Press, 1980.

Banks, William Nathaniel. "The Galliers, New Orleans Architects." *The Magazine Antiques*. Brant Publications, Inc. (1997). HighBeam Research. http://www.highbeam.com.

Beck, John, Wendy Frandsen, and Aaron Randall. *Southern Culture: An Introduction*. Durham: Carolina Academic Press, 2007.

Beckerdite, Luke. "Architect-Designed Furniture in Eighteenth-Century Virginia: The Work of William Buckland and William Bernard Sears." *American Furniture*. Milwaukee, WI: Chipstone Foundation, 1994: 29–48. http://www.chipstone.org/publications/1994 AF/index1994Beck.html.

Beiswanger, William L., Peter J. Hatch, Lucia Stanton, and Susan R. Stein. *Thomas Jefferson's Monticello*. Chapel Hill: University of North Carolina Press, 2001.

Benjamin, Asher. *The American Builder's Companion*. Reprint of 6th ed. New York: Dover, 1969.

Berlin, Ira. *Many Thousands Gone: The First Two Centuries of Slavery in North America*. Cambridge, MA: Belknap Press of Harvard University Press, 2000.

Bishir, Catherine W. *North Carolina Architecture*. Chapel Hill: University of North Carolina Press, 1990.

Bishir, Catherine W. *Southern Built: American Architecture, Regional Practice*. Charlottesville: University of Virginia Press, 2006.

Brooke, Steven. *The Majesty of Natchez*. 2nd Pelican ed. Gretna, LA: Pelican, 1999.

Brooks, Eric. *Ashland: The Henry Clay Estate*. Charleston, Chicago, Portsmouth, and San Francisco: Arcadia Publishing, 2007.

Brown, Elizabeth Via. "Fendall Hall's Murals." *Alabama Heritage* 51 (1999): 18-24.

Brownell, Charles E., Calder Loth, William S. Rasmussen, and Richard Guy Wilson. *The Making of Virginia Architecture*. Richmond: Virginia Museum of Fine Arts. Charlottesville: University of Virginia Press, 1992.

Burckhardt, R. Walter. "HABS AL-211: Gaineswood, The Whitfield Home." Historic American Buildings Survey/Historic American Engineering Record, National Park Service, U.S. Department of the Interior (1936). http://memory.loc.gov/ammem/collections/habs_haer/.

Busch, Jason T. "Furniture Patronage in Antebellum Natchez." *The Magazine Antiques*. Brant Publications, Inc. (2000). HighBeam Research. http://www.highbeam.com.

Bushman, Richard L. *The Refinement of America: Persons, Houses, Cities*. New York: Vintage, 1993.

Casper, Scott E. *Sarah Johnson's Mount Vernon: The Forgotten History of An American Shrine*. New York: Hill & Wang, 2008.

Cobb, James C. *Away Down South: A History of Southern Identity*. New York: Oxford University Press, 2005.

Dowling, Elizabeth Meredith. *American Classicist: The Architecture of Philip Trammell Shutze*. New York: Rizzoli International Publications, 2001.

Edwards, Jay D. "The Origins of Creole Architecture." *Winterthur Portfolio* 29.2/3 (1994): 155-89.

Fazio, Michael, and Patrick Snadon. *The Domestic Architecture of Benjamin Henry Latrobe*. Baltimore: The Johns Hopkins University Press, 2006.

Fischer, David Hackett. *Albion's Seed: Four British Folkways in America*. New York: Oxford University Press, 1989.

Fischer, David Hackett, and James C. Kelly. *Bound Away: Virginia and the Westward Movement*. Charlottesville and London: University of Virginia Press, 2000.

Friedman, Alice T. "The Way You Do The Things You Do: Writing the History of Houses and Housing." *The Journal of the Society of Architectural Historians* 58.3 (September 1999): 406–13. http://www.jstor.org/stable/991534.

Galloway, Regina Ulmer. *Gaineswood and the Whitfields of Demopolis*. Montgomery, AL: Skinner Printing, 1994.

Gamble, Robert. *Historic Architecture in Alabama: A Primer of Styles and Types, 1810–1930*. Tuscaloosa and London: University of Alabama Press, 1990.

Gamble, Robert. "Victorian Chic." *Alabama Heritage* 51 (1999): 25.

Giordano, Ralph. "Thomas Jefferson: The Education of an Architect." *The Early America Review* 3.4 (2001). www.earlyamerica.com/review/2001_summer_fall/architect.html.

Goldstein, Erik, interviewed by Lloyd Dobyns. "A New Look at The Governor's Palace." Podcast, April 3, 2006. Transcript. http://www.history.org/media/podcasts_transcripts/NewLookatGovernorsPalace.cfm.

Gordon-Reed, Annette. *The Hemingses of Monticello: An American Family*. New York: W. W. Norton, 2008.

Greenberg, Allan. *George Washington, Architect*. London: Papadakis Publisher, 1999.

Harris, Charles M. "William Thornton (1759–1828)." Library of Congress, Prints and Photographs Reading Room. 2001. http://www.loc.gov/rr/print/adecenter/essays/B-Thornton.html.

Harrison, Stephen G. "The Nineteenth-century Furniture Trade in New Orleans." *The Magazine Antiques*. Brant Publications, Inc. (1997). HighBeam research. http://www.highbeam.com.

Hewitt, Mark Alan. *The Architect and The American Country House*. New Haven and London: Yale University Press, 1990.

Horton, Frank L., and Sally Gant. "An Eighteenth-century Sideboard Table." *The Magazine Antiques*. Brant Publications, Inc. (1997). HighBeam Research. http://www.highbeam.com.

Howett, Catherine. *A World of Her Own Making: Katharine Smith Reynolds and the Landscape of Reynolda*. Amherst: University of Massachusetts Press, 2007.

Johnson, James Weldon, ed. *The Book of American Negro Poetry*. New York: Harcourt Brace & Company, 1922.

Johnson, Walter. *Soul by Soul: Life Inside the Antebellum Slave Market*. Cambridge: Harvard University Press, 2000.

Kennedy, Roger G., John M. Hall, and Jack Kotz. *Greek Revival America*. New York: Stewart, Tabori & Chang, 1989.

Kerr, Charles, William Elsey Connelley, and Ellis Merton Coulter, eds. *History of Kentucky*. Chicago and New York: The American Historical Society, 1922. http://books.google.com/books?id=YHQUAAAAY AAJ.

Kimball, Fiske. "Jefferson's Designs for Two Kentucky Houses." *The Journal of the Society of Architectural Historians* 9.3 (October 1950): 14–16. http://www.jstor.org/stable/987456.

Kimball, Marie Goebel. *Jefferson, The Scene of Europe, 1784 to 1789*. New York: Coward-McCann, 1950.

Kingsley, Karen. *Buildings of Louisiana*. Society of Architectural Historians, Buildings of the United States series. New York: Oxford University Press, 2003.

Kopper, Philip. *Colonial Williamsburg*. rev. ed. New York: Harry N. Abrams, 2001.

Lane, Mills. *Architecture of the Old South*. New York: Beehive Press, 1993.

Lewis, Peirce F. *New Orleans: The Making of an Urban Landscape*. 2nd ed. Charlottesville: University of Virginia Press, 2003.

Longue Vue Museum and Gardens. *Longue Vue*. New Orleans: Longue Vue House and Gardens Foundation, n.d.

Loth, Calder. "Palladio's Influence in America." Homewood Museum, The Johns Hopkins University, 2008. https://jscholarship.library.jhu.edu/bitstream/handle/1774.2/32824/PalladioAmerica_FINAL.pdf?sequence=1.

Lounsbury, Carl R. "Beaux-Arts Ideals and Colonial Reality: The Reconstruction of Williamsburg's Capitol, 1928–1934." *The Journal of the Society of Architectural Historians* 49. 4 (December 1990): 373–89. http://www.jstor.org/stable/990566.

Mayer, Barbara. *Reynolda: A History of an American Country House*. Winston-Salem, NC: John F. Blair, 1997.

McInnis, Maurie D. *The Politics of Taste in Antebellum Charleston*. Chapel Hill and London: University of North Carolina Press, 2005.

McInnis, Maurie D., with Angela D. Mack. *In Pursuit of Refinement: Charlestonians Abroad, 1740–1860*. Charleston, SC: Gibbes Museum of Art/Historic Charleston Foundation. Columbia, SC: University of South Carolina Press, 1999.

McKee, Pamela, et al. *Hammond-Harwood House 1774*. Annapolis: Hammond-Harwood House Association, 2004.

McLaughlin, Jack. *Jefferson and Monticello: The Biography of a Builder*. revised edition. New York: Owl Books, 1990.

Merling, Mitchell. *Ringling: The Art Museum*. Sarasota: The John and Mable Ringling Museum of Art, 2002.

Mixon, Wayne. "Joel Chandler Harris: An Annotated Bibliography of Criticism, 1977–1996, with Supplement, 1892–1976 (Review)." *The Mississippi Quarterly*. Mississippi State University (1998). HighBeam Research. http://www.highbeam.com.

Mooney, Barbara Burlison. "The Comfortable Tasty Framed Cottage: An African American Architectural Iconography." *The Journal of the Society of Architectural Historians* 61 (March 2002): 48–67. http://www.jstor.org/stable/991811.

Moscou, Margo Preston. "New Orleans's Freemen of Color: A Forgotten Generation of Cabinetmakers Rediscovered," *The Magazine Antiques*. Brant Publications, Inc. (2007). HighBeam Research. http://www.highbeam.com.

Nichols, Frederick Doveton. *Thomas Jefferson's Architectural Drawings*, 1961, revised edition. The Thomas Jefferson Memorial Foundation. Chapel Hill: University of North Carolina Press, 1995.

"Palm Beach Gayeties." *New York Times* (March 8, 1903): 8. http://www.nytimes.com.

Patton, Sharon F. *African-American Art*. New York: Oxford University Press, 1998.

Perlman, Bennard B. "Baltimore Mansion, 1801–03." *The Journal of the Society of Architectural Historians* 14.1 (March 1955): 26–28. http://www.jstor.org/stable/987719.

Peterson, Merrill D. *Visitors to Monticello*. paperback ed. Charlottesville and London: University of Virginia Press, 1989.

Pitts, Carolyn. "Owens-Thomas House." National Register of Historic Places Inventory—Nomination Form. National Park Service, U.S. Department of The Interior (1976). http://pdfhost.focus.nps.gov/docs/NHLS/Text/76000611.pdf

Poppeliers, John C. "HABS LA-1122: Hermann-Grima House." Historic American Buildings Survey/Historic American Engineering Record, National Park Service, U.S. Department of the Interior (1952). http://memory.loc.gov/ammem/collections/habs_haer/

Poston, Jonathan H. for Historic Charleston Foundation. *The Buildings of Charleston: A Guide to The City's Architecture*. Columbia: University of South Carolina Press, 1997.

Preston, Percy, Jr. "The Vanderbilt Mausoleum on Staten Island, New York City." *The Magazine Antiques*. Brant Publications, Inc. (2005). HighBeam Research. http://www.highbeam.com.

Rappleye, Charles. *Sons of Providence: The Brown Brothers, The Slave Trade and The American Revolution*. New York: Simon & Schuster, 2006.

Rasmussen, William M. S., and Robert S. Tilton. *George Washington, The Man Behind the Myths*. paperback ed. Charlottesville: University of Virginia Press, 1999.

Rasmussen, William M. S., and Robert S. Tilton. *Old Virginia: The Pursuit of a Pastoral Ideal*. Charlottesville: University of Virginia Press, 2003.

Ravenel, Beatrice St. J. "HABS SC-269: The Robinson-Aiken House." Historic American Buildings Survey/Historic American Engineering Record, National Park Service, U.S. Department of the Interior (1958). http://memory.loc.gov/ammem/collections/habs_haer/.

Reeves, F. Blair. "HABS FL-179: Tift-Hemingway House." Historic American Buildings Survey/Historic American Engineering Record, National Park Service, U.S. Department of the Interior (1967). http://memory.loc.gov/ammem/collections/habs_haer/.

Reiff, Daniel D. *Houses from Books: The Influence of Treatises, Pattern Books, and Catalogs in American Architecture, 1738–1950*. University Park, PA: Pennsylvania State University Press, 2000.

Rice, Howard C. *Thomas Jefferson's Paris*. Princeton, NJ: Princeton University Press, 1991.

Rousey, Dennis C. "Friends and Foes of Slavery: Foreigners and Northerners in the Old South." *Journal of Social History* (2001). HighBeam Research. http://www.highbeam.com.

Rybczynski, Witold, and Laurie Olin. *Vizcaya: An American Villa and Its Makers*. Philadelphia: University of Pennsylvania Press, 2007.

Sarles, Frank B., W. B. Morton, Polly M. Rettig, and Cecil McKithan. "The Hermitage: Home of Andrew Jackson." National Register of Historic Places Inventory—Nomination Form. National Park Service, U.S. Department of the Interior (1978). http://www.nps.gov/history/nhl/Themes/Scanned%20Nominations/1812/The%20Hermitage.pdf.

Scarborough, William Kauffman. *Masters of the Big House: Elite Slaveholders of the Mid-Nineteenth Century South*. Baton Rouge: Louisiana State University Press, 2003.

Smith, Jane Webb. "The Wickham House in Richmond: Neoclassical Splendor Restored." *The Magazine Antiques*. Brant Publications, Inc. (1999). HighBeam Research. http://www.highbeam.com.

Stein, Susan R. *The Architecture of Richard Morris Hunt*. Chicago: University of Chicago Press, 1986.

Stein, Susan R., Peter J. Hatch, Lucia C. Stanton, and Merrill D. Peterson. *Monticello: A Guidebook*. Charlottesville: The Thomas Jefferson Memorial Foundation, 2002.

Thornton, William, Charles M. Harris, and Daniel Preston, eds. *The Papers of William Thornton, 1781–1802*. Charlottesville: University of Virginia Press, 1995.

Trollope, Frances. *Domestic Manners of the Americans*. 1839. London: Century Publishing, 1984.

Vizcaya Museum and Gardens. *Visions of Vizcaya*. Miami: Vizcaya Museum and Gardens, 2006.

Vlach, John Michael. *The Planter's Prospect: Privilege & Slavery in Plantation Paintings*. Chapel Hill: University of North Carolina Press, 2002.

Way, William. *History of the New England Society of Charleston, South Carolina for One Hundred Years, 1819–1919*. Charleston: The New England Society, 1920. http://books.google.com/books?id=JzqAffB6UpAC.

Wells, Camille. "Virginia by Design: The Making of Tuckahoe and the Remaking of Monticello." *ARRIS: The Journal of the Southeast Chapter of the Society of Architectural Historians* 12 (2002): 44–73.

West, Patricia. *Domesticating History: The Political Origins of America's House Museums*. Washington, DC, and London: Smithsonian Institution Press, 1999.

Wheary, Dale. "Edgerton Rogers, Architect of Maymont House." Richmond: Maymont Foundation Curatorial Document, 2000.

Wheary, Dale. "James and Sallie Dooley of Maymont." Richmond: Maymont Foundation Curatorial Document, 2000.

Wheary, Dale. "Maymont, Gilded Age Estate." Richmond: Maymont Foundation Curatorial Document, 2000.

Wheary, Dale. "Maymont House Museum Collection Overview." Richmond: Maymont Foundation Curatorial Document, 2000.

Willis, John C. "Where These Memories Grow: History, Memory, and Southern Identity." *The Mississippi Quarterly*. Mississippi State University (2001). HighBeam Research. http://www.highbeam.com.

Wills, Ridley. *The History of Belle Meade: Mansion, Plantation, and Stud*. Nashville: Vanderbilt University Press, 1991.

Wilson, Richard Guy, ed. *The Buildings of Virginia: Tidewater and Piedmont*. Society of Architectural Historians Buildings of the United States series. New York: Oxford University Press, 2002.

Wilson, Richard Guy. *The Colonial Revival House*. New York: Harry N. Abrams, 2004.

Wilson, Richard Guy, Shaun Eyring, and Kenny Marotta, eds. *Re-Creating the American Past: Essays on The Colonial Revival*. Charlottesville: University of Virginia Press, 2006.

Wyatt-Brown, Bertram. *Southern Honor: Ethics and Behavior in the Old South*. 25th anniversary ed. New York: Oxford University Press, 2007.

Young, Joanne. *Shirley Plantation: A Personal Adventure for Ten Generations*. Charles City County: Shirley Plantation, Inc., 1981.

Zimmer, Edward Francis, and Pamela J. Scott. "Alexander Parris, B. Henry Latrobe, and the John Wickham House in Richmond, Virginia." *Journal of the Society of Architectural Historians* 41 (October 1982): 202–11. http://www.jstor.org/stable/989874.

House Museum Addresses and Contact Information

Alphabetically by State

Alabama

Fendall Hall
 917 West Barbour Street
 Eufaula, Alabama 36027
 www.fendallhall.com
Gaineswood
 805 South Cedar Avenue
 Demopolis, Alabama 36732
 www.preserveala.org/gaineswood.aspx

Florida

Cà d'Zan
 The John and Mable Ringling Museum of Art
 5401 Bay Shore Road
 Sarasota, Florida 34243
 www.ringling.org/CadMansion.aspx
The Ernest Hemingway House
 907 Whitehead Street
 Key West, Florida 33040
 www.hemingwayhome.com
Vizcaya Museum and Gardens
 3251 South Miami Avenue
 Miami, Florida 33129
 www.vizcayamuseum.org
Whitehall, The Henry Morrison Flagler Museum
 One Whitehall Way
 Palm Beach, Florida 33480
 www.flaglermuseum.us

Georgia

The Isaiah Davenport House Museum
 324 East State Street
 Savannah, Georgia 31401
 www.davenporthousemuseum.org
The Owens-Thomas House
 124 Abercorn Street
 Savannah, Georgia 31401
 www.telfair.org/visit/owens-thomas-house/overview
Swan House
 130 West Paces Ferry Road NW
 Atlanta, Georgia 30305
 www.atlantahistorycenter.com
The Wren's Nest
 1050 Ralph David Abernathy Boulevard SW
 Atlanta, Georgia 30310
 www.wrensnestonline.com

Kentucky

Ashland: The Henry Clay Estate
 120 Sycamore Road
 Lexington, Kentucky 40502
 www.henryclay.org
Farmington
 3033 Bardstown Road
 Louisville, Kentucky 40205
 www.historichomes.org/farmington/house.html

The Hunt-Morgan House
 201 North Mill Street
 Lexington, Kentucky 40507
 www.bluegrasstrust.org/hunt-morgan.html

Louisiana

The Gallier House
 1132 Royal Street
 New Orleans, Louisiana 70116
 www.hgghh.org
Longue Vue
 7 Bamboo Road
 New Orleans, Louisiana 70124
 www.longuevue.com
The Hermann-Grima House
 820 Saint Louis Street
 New Orleans, Louisiana 70112
 www.hgghh.org
Oak Alley
 3645 Highway 18 (Great River Road)
 Vacherie, Louisiana 70090
 www.oakalleyplantation.com

Maryland

The Hammond-Harwood House
 19 Maryland Avenue
 Annapolis, Maryland 21401
 www.hammondharwoodhouse.org
Homewood
 3400 North Charles Street
 Baltimore, Maryland 21218
 www.museums.jhu.edu/homewood

Mississippi

Longwood
 140 Lower Woodville Road
 Natchez, Mississippi 39120
 www.natchezpilgrimage.com
Melrose
 1 Melrose Montebello Parkway
 Natchez, Mississippi 39120
 www.nps.gov/natc
Stanton Hall
 401 High Street
 Natchez, Mississippi 39120
 www.natchezpilgrimage.com

North Carolina

Biltmore
 1 Approach Road
 Asheville, North Carolina 28803
 www.biltmore.com
Reynolda House Museum of American Art
 2250 Reynolda Road
 Winston-Salem, North Carolina 27106
 www.reynoldahouse.org/index
Tryon Palace
 610 Pollock Street
 New Bern, North Carolina 28562
 www.tryonpalace.org/index

South Carolina

The Aiken-Rhett House
 48 Elizabeth Street
 Charleston, South Carolina 29403
 www.historiccharleston.org/experience/arh
Drayton Hall
 3380 Ashley River Road
 Charleston, South Carolina 29414
 www.draytonhall.org
The Nathaniel Russell House
 51 Meeting Street
 Charleston, South Carolina 29401
 www.historiccharleston.org/experience/nrh

Tennessee

Belle Meade Plantation
 5025 Harding Road
 Nashville, Tennessee 37205
 www.bellemeadeplantation.com
The Hermitage
 4580 Rachel's Lane
 Nashville, Tennessee 37076
 www.thehermitage.com

Virginia

The Governor's Palace
 Palace Green (Colonial Williamsburg
 Historic District)
 Williamsburg, Virginia 23185
 www.history.org/Almanack/places/hb/hbpal.cfm
Maymont
 1700 Hampton Street
 Richmond, Virginia 23220
 www.maymont.org
Monticello
 931 Thomas Jefferson Parkway
 Charlottesville, Virginia 22902
 www.monticello.org
Mount Vernon
 3200 Mount Vernon Memorial Highway
 Mount Vernon, Virginia 22309
 www.mountvernon.org
Shirley Plantation
 501 Shirley Plantation Road
 Charles City, Virginia 23030
 www.shirleyplantation.com
The 1812 Wickham House
 1015 East Clay Street
 Richmond, Virginia 23219
 www.richmondhistorycenter.com/wickham.asp

Washington, DC

Decatur House
 1610 H Street NW
 Washington, DC 20006
 www.decaturhouse.org
The Frederick Douglass National Historic Site
 1411 W Street SE
 Washington, DC 20020
 www.nps.gov/frdo
Tudor Place
 1644 31st Street NW
 Washington, DC 20007
 www.tudorplace.org

FACING PAGE
Parlor dome, Gaineswood, Demopolis, Alabama

Index

First published in the United States of America in 2010 by
RIZZOLI INTERNATIONAL PUBLICATIONS, INC.
300 Park Avenue South, New York, NY 10010
www.rizzoliusa.com

ISBN-13: 978-0-8478-3309-2
Library of Congress Control Number: 2009935761

Distributed to the U. S. Trade by Random House, New York

Designed by Abigail Sturges

Printed and bound in China

2022 2023 2024 2025 / 15 14 13 12 11